MASTER CLASS IN WATERCOLOR

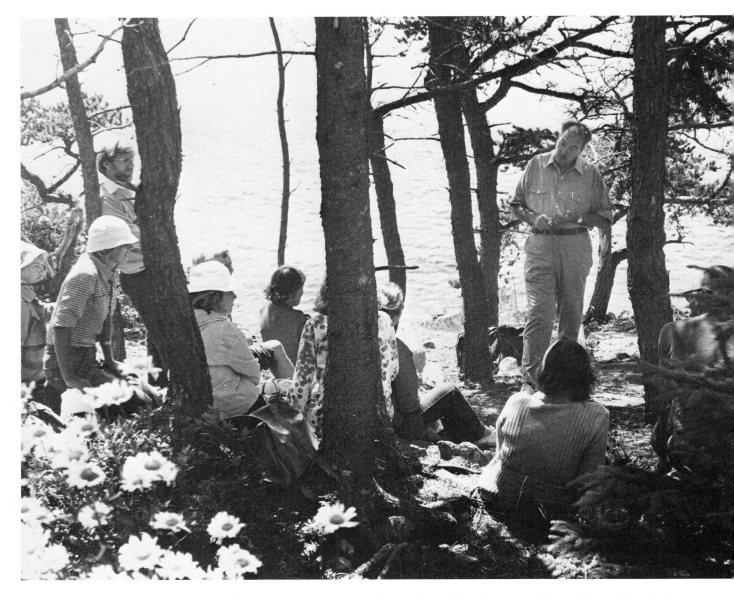

The author conducts a critique for members of the Rangemark Master Class at the end of a morning of painting on location at "Rangemark," the summer studio property of the late Barse Miller, N.A., A.W.S., eminent watercolorist and teacher. Founded by Miller in 1965, the Master Class is limited to eighteen professional artists, many of whom are members of the American Watercolor Society. (Photo Charles McCaughtry, courtesy the Rangemark Master Class, Inc.)

MASTER CLASS IN WATERCOLOR

by Edward Betts N.A., A.W.S.

Watson-Guptill Publications/New York

Copyright © 1975 by Watson-Guptill Publications

First published 1975 in the United States and Canada by Watson-Guptill Publications
a division of Billboard Publications, Inc.

One Astor Plaza, New York, N.Y. 10036

Library of Congress Cataloging in Publication Data

Betts, Edward H 1920–
 Master class in watercolor.
 Bibliography: p.
 Includes index.
 1. Water-color painting—Technique. I. Title.
ND2420.B47 751.4'22 75-15873
ISBN 0-8230-3013-X

Manufactured in U.S.A.

First Printing, 1975

For Jane

ACKNOWLEDGMENTS

My deepest thanks to my working editor, Diane Casella Hines, who constantly provided me with all possible guidance and encouragement, and also to Donald Holden, Editorial Director of Watson-Guptill Publications, who first proposed the idea of my undertaking this venture; but for his creative vision and his contagious enthusiasm, this book would not have been written.

To those sixteen artists who so kindly consented to have their work reproduced in color in the first Color Gallery section, I am indebted more than I can say. They are some of the finest watercolorists of our time, and their paintings are a truly impressive contribution to the book as a whole. I am honored by their presence here.

Contents

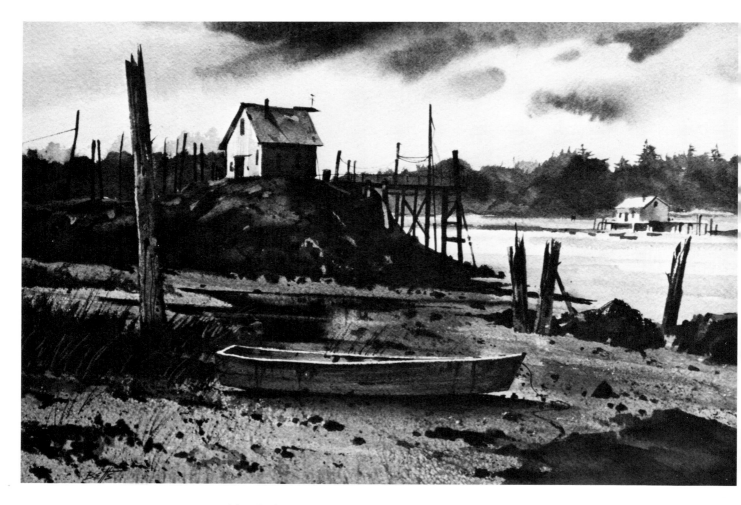

After the Storm *Watercolor on 300-lb Arches rough, 15″ x 22″. Private collection. This recent watercolor is a typical example of my realist style in what I will always consider one of my favorite media. Because I was trained to paint representationally, and because I still respond deeply to the natural world around me, I continue to paint what I see and to share those responses through the directness and sparkle of watercolor on paper. I am hopelessly addicted to painting pictures such as this, but principally as a means of relaxation and a change of pace from my abstract painting.*

Introduction

This book came to be written as an indirect result of my serving on the juries for two major watercolor exhibitions in recent years.

In both instances, the jury members rejected a great many paintings that were thoroughly competent—in fact, well above average. It might even be said that a very respectable exhibition could have been formed out of the work that had been rejected. What struck me at the time—and has lingered since in my mind—was that a jury of professional artists felt it was simply not enough for an artist to have a virtuoso technique or a dazzling control of the medium. There seemed to be an unspoken agreement on the part of those jury members that in paintings submitted to large national exhibitions, technical competence is assumed, taken for granted. Given that skill, the big question then was: What has the artist done with that skill? What is he saying?

It was the feeling of the jury members, I think, that there is an obligation to go beyond craftsmanship, to push the medium beyond descriptive imitation toward a transformation of nature into solely pictorial terms, to form images that have urgency and communicative power and in which poetry or geometry is of more concern than an unimaginative list of visual facts.

In response to what happened on those juries, my own teaching in classes and workshops has stressed more than ever the need to acquire a strong foundation in all the disciplines of drawing and painting—and then to use these disciplines in a spirit of awareness, invention, improvisation, and discovery. This spirit is not an end in itself, of course, but a way for the artist to synthesize the outer world around him with his own inner world. It is almost certain to become evident as you read further in this book, so I may as well confess right now that I am a split personality: I paint both representationally and abstractly and fully enjoy looking at paintings of both persuasions, responding to the special qualities of each. On my bookshelves, Corot, Turner, Boudin, and Degas are next to Marin, Pollock, Frankenthaler, and de Kooning. I have no ax to grind for any particular style of art, whether it be traditional or modern. I look only for the one thing that transcends styles: quality.

I had an extremely academic, disciplined foundation in the study of art. I studied life drawing with Reginald Marsh, anatomy with George Bridgman, still life painting with Robert Brackman, portraiture with Wayman Adams, and figure painting with Robert Philipp, Jerry Farnsworth, and John Carroll. In those years I was thoroughly committed to representational painting.

Later on, painter and printmaker Harry Sternberg opened my eyes to the possibilities of abstract art. Although the major part of my work for the past thirty years has been inclined toward the abstract, I still continue to paint representationally, happily and with a perfectly clear conscience. I paint representationally not so much as a secret vice, but as a form of recreation—some people play golf, I paint watercolors—and also as a means of periodically renewing my contact with nature.

My use of representational paintings primarily as source material may be related to the idea that the Latin root of the word "abstract" refers to a "taking from" something. When painting, an artist observes nature, whether it is landscape, interior, still life, figure, or whatever. He selects, extracts, and manipulates certain elements to give a heightened sense of the subject in terms of design rather than description.

This composition may be formally structured or spontaneous and splashy, but the general procedure involved is usually a taking apart of the subject and then reorganizing it into a new form that has a stronger emphasis on interrelationships of line, plane, shape, pattern, color, and texture. The subject matter acts not so much as the predominant idea but more as the framework on which to construct a pictorial arrangement—not a report or an inventory or a document, but a work of art.

I am not at all in favor of the separation of, or the creation of an imaginary gulf between, figurative, descriptive art and abstract or nonobjective art. There is certainly plenty of room in this world for both styles to exist side by side, or even to exist within the same artist. It is not that realist painting is necessarily objectionable, but rather that in many cases it is done without taste or imagination. In the long run, however, an artist should not be concerned with whether or not he is a traditionalist or a modernist or something in between; he should paint in whatever manner he finds most natural and true to himself. I suppose you might say it is a matter of painting the way you feel you *must* paint in spite of yourself, not the way you think you *ought* to paint.

This book is not an attempt to win over readers to the abstract viewpoint. What it comes down to is this: I am convinced that as artists we should be primarily involved with picturebuilding rather than with reproducing what we see in postcard views, that art, not anecdote, is our principal concern, and that a painting takes precedence over its subject matter. I often think of the painter Jack Tworkov, who said in answer to a question from an audience, "To ask for paintings which are understandable to all people everywhere, is to ask of the artist infinitely less than what he is capable of doing."

I think it is important for you as a painter to develop the finest technique possible in drawing and painting and

then to use it toward some purpose other than a display of virtuosity, or trying to compete with the camera. I would like to think that if you paint abstractly, it is because you have already demonstrated that you can paint authoritatively in traditional modes; you have chosen to paint abstractly because you believe that it is your most natural means of creative expression, not because you hope it will be a means of disguising your deficiencies as a representational painter.

I urge you to think of tradition as a point of departure, to have love and respect for it but not to repeat it mindlessly. As the contemporary composer Hans Werner Henze has said, "When I study the score of, say, 'Figaro,' it is not to learn how to imitate Mozart. It is to find out what is in the music that is timeless."

I am directing this book, therefore, primarily to artists who have behind them a fundamental knowledge of representational drawing, composition, color, and painting techniques. I am not interested in the presentation of a 1-2-3 method for getting things done. Rather, by demonstration and example, I hope to open up other avenues and attitudes, other possibilities than those that have been so well discussed already in the many books on basic watercolor and acrylic techniques that are available.

The kind of painting I respect most cannot be taught in a "canned" fashion. The painters whose work is reproduced here have arrived at their art after long search, struggle, trial and error, and considerable thought and introspection—and, incidentally, after having painted hundreds of pictures. There is no one method that will guarantee success or acceptance in national shows; it just is not that simple. But it is my intention to suggest various ways of handling transparent and opaque water media and to present the work of some distinguished artists whose paintings will be a source of inspiration to the reader. This, then, is a book principally for the experi-

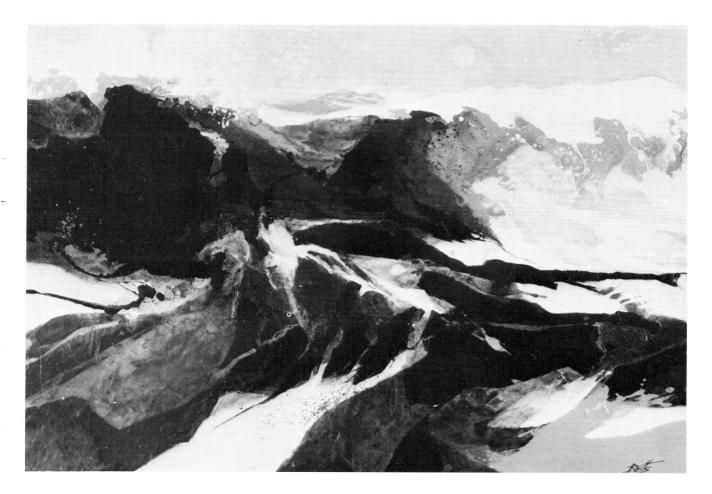

Storm Surf *Mixed media and acrylic on illustration board, 20" x 28". Private collection. This picture represents the other side of my "split personality." Rather than being entirely descriptive of what the eye sees, it is an attempt to bring some kind of formal order out of the chaos of nature, to view things in terms of abstract design, and to reorganize rather than report. I have always found this far more exciting and challenging than representational painting, but both these aspects of my art, as different as they might seem at first, are mutually interdependent.*

enced watercolorist who wishes to broaden his horizons and enrich his art, to get out of old habits and into fresh ways of seeing and painting.

Less experienced painters will also benefit from the ideas suggested in the following pages. But, in all fairness, I must remind them that experimental methods are most successfully used by those who have their artistic skills so highly developed, so much a part of them, that these skills almost cease to be important any longer. In any event, creative techniques cannot be used as a coverup for lack of knowledge or experience, nor can they serve as an evasion of the demands and disciplines of picturemaking.

The concept of a master class is of course not a new one. Pablo Casals, Jascha Heifetz, and Pierre Monteux all conducted such classes in the field of music, and I know of similar courses in the fields of photography, dance, and the other arts.

Barse Miller, the eminent American artist and for years a leading member of the West Coast group of watercolor painters, founded the first Master Class for Advanced Watercolorists in 1965 at "Rangemark," his summer studio near Birch Harbor, Maine. When he first built his studio there, he wrote me that in all his travels he had never found so beautiful a place or one so rich in varied subject matter. When I became his successor in conducting the master class after his sudden and untimely death in 1973, I found he had been absolutely right. This was not tourist Maine with beaches and golf courses, it was an impressively rugged, dramatic coastal environment of cliffs, rocks, pines, and sea, not very distant from areas already celebrated in the paintings of John Marin and Marsden Hartley.

The classes held at Rangemark have been restricted to a very limited number of carefully selected students, mostly professional painters, who work intensively for a two-week period with the aim of developing a personal style and achieving a higher level of creative quality in their watercolor paintings. This book is by no means a written version of how the Rangemark Master Class currently functions, but it is a bringing together of a sequence of projects or lessons that relate to the class at Rangemark and that are characteristic of the philosophy underlying my teaching there.

HOW YOU CAN USE THIS BOOK MOST EFFECTIVELY

Chapters 1 through 4 are devoted to the source material of art: contact with nature in sketches and photographs and other methods of stimulating pictorial ideas.

Chapters 5 through 9 deal with the various aqueous media and methods of using them.

Chapters 10 and 11 synthesize and put into practice what has been learned from all the previous lessons.

Then there is a general summation, and finally, the Gallery sections illustrate a broad spectrum of styles and concepts seen in American watercolor painting today.

You should move from chapter to chapter, trying each method and absorbing the material at your own speed, based on your own past training and experience. Thus you will go step-by-step from standard sketching methods to the more complex and experimental appraoches to painting. You can set up your own time schedule in regard to the eleven practice chapters, but the following schedule might be recommended:

	Chapter 1: two weeks
	Chapter 2: two weeks
Source material	Chapter 3: one week
	Chapter 4: one week
	Chapter 5: two weeks
	Chapter 6: two weeks
	Chapter 6: four weeks
Media and methods	Chapter 7: one week
	Chapter 8: two weeks
	Chapter 9: two weeks
	Chapter 10: three weeks
Practice	Chapter 11: five weeks
	Total: 25 weeks

This schedule is flexible and can be compressed or expanded at any point according to your own needs and interests.

Having completed this "course," the next step is to begin building toward a personal viewpoint and style. This book is merely a point of departure; what follows is the most challenging and exciting part—and the most difficult—and that is entirely up to you.

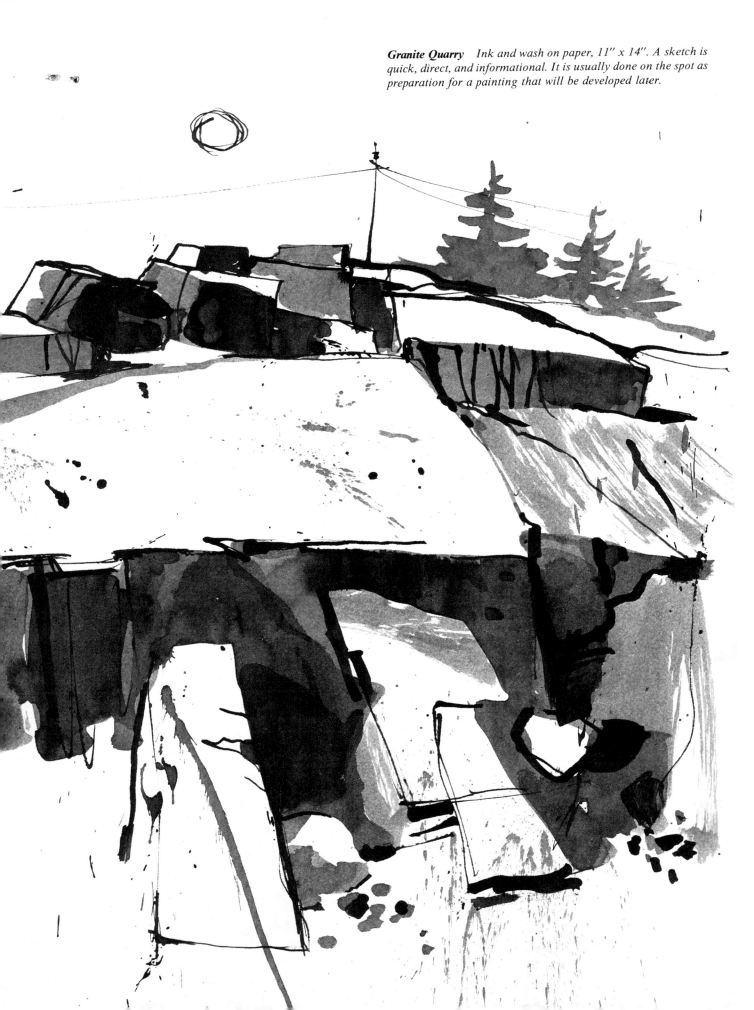

Granite Quarry Ink and wash on paper, 11" x 14". A sketch is quick, direct, and informational. It is usually done on the spot as preparation for a painting that will be developed later.

1. Sketching on Location

Because nature is the prime source for most artists' creative impulses, the sketchbook is a basic piece of equipment. On-the-spot sketching is not just for beginners; it should be an activity that continues for a lifetime.

Drawing or painting from imagination is not sufficient. The only forms we can work with are those we have already observed, even unconsciously, and the majority of pictures based on purely imagined forms or situations lack conviction and authenticity. So it is important to sketch habitually and constantly, and to build a library of sketchbooks that can be referred to repeatedly through the years.

Let me first define what I mean by a *sketch* as opposed to a *drawing*. I think of a sketch as being a brief statement done from direct observation of the subject. It is relaxed and informal. Its main function is to convey essential information and to serve as an aid to memory later in the studio. The sketch is not as fully developed as a drawing and usually takes, at the most, not more than 15 or 20 minutes to do. It may have written on it color notations and symbols that are meaningful to the artist. The sketch is for the artist's private use, and this, of course, is what gives many sketches the quality that is so much admired by collectors; in sketches the artist draws for himself without the world looking over his shoulder, and therefore the sketch usually has far more spontaneity than a fully developed drawing.

A drawing, in contrast with a sketch, is done as a work of art in its own right. It is more consciously executed and pushed farther as to detail and formal structure. Some drawings are done in an hour or two; others may take weeks or even months. It is quite understandable that drawings of the latter sort are almost exclusively done in the studio.

WHY A SKETCHBOOK?

Convenience. There are quite a number of reasons for doing sketches from nature. Most obvious is the matter of convenience—the materials involved are few and light to carry and they are easy to set up. Painting outdoors in oils is a very complex undertaking, and even with watercolor there is the matter of the palette, board with paper stretched on it, paint tubes, brushes, jar, rags, and so on.

Simple sketch materials, on the other hand, can be carried in one hand and perhaps a pocket or two. Where there might be time for a sketch, there might not be time enough to do a painting—a storm coming up, the light changing, things in movement. A sketch can sometimes capture the moment where a painting could not.

Selecting Subject Matter. Aside from the matter of convenience, there are other reasons for sketching. One is that through sketching you can select subject matter. You can note down whatever you respond to, and the sketch can indicate to you whether or not a particular subject has possibilities for working up as a painting. It is a means of sorting out and recording motifs that have appeal for one reason or another, so that at a later date the sketch can serve as a reminder of what the subject looked like, and perhaps even more important, of how it affected you and what mood or idea it might be used to express.

Information. A sketch can also be a way of storing information—the general arrangement of the subject, the distribution and placement of major forms, shapes, and masses, and the effect of lighting on those forms.

On another level, a sketch can record very specific things, such as texture or intricate detail that would be hard to remember. Informational or research drawings are descriptive in character, and while they may entail some degree of selection, simplification, and elimination, they are ordinarily rather literal and straightforward in their rendering of visual facts.

Composition. Another use for sketching is in composition: finding a viewpoint toward the subject and arranging the subject to its maximum advantage within the rectangle of the sheet of paper. Sketches of this sort are the first step in seeing the subject as a possible painting; it is here that you determine whether it would look best in a horizontal or vertical format and also which elements should be suppressed or left out altogether. A series of sketches of a single motif can clarify which view is most appropriate in respect to readability of the subject, lighting, surface pattern, dramatic possibilities, or underlying abstract structure.

Vocabulary of Forms. Still another important reason for acquiring the sketching habit is that it adds to the artist's vocabulary of forms. He constantly renews and refreshes his mental reservoir of shapes, forms, and textures; he will most certainly draw on those resources, consciously or unconsciously, during the process of painting a picture. Thus, while many sketches may not apply to any particular painting, they are, in a sense, the broadest preparation for painting in general.

Reference. Finally, a sketchbook is used for later reference and as an aid to memory. Very often, in going through his sketchbook for ideas, an artist will bypass certain drawings that do not "speak" to him. Then, perhaps ten or twenty years later, he will suddenly see the

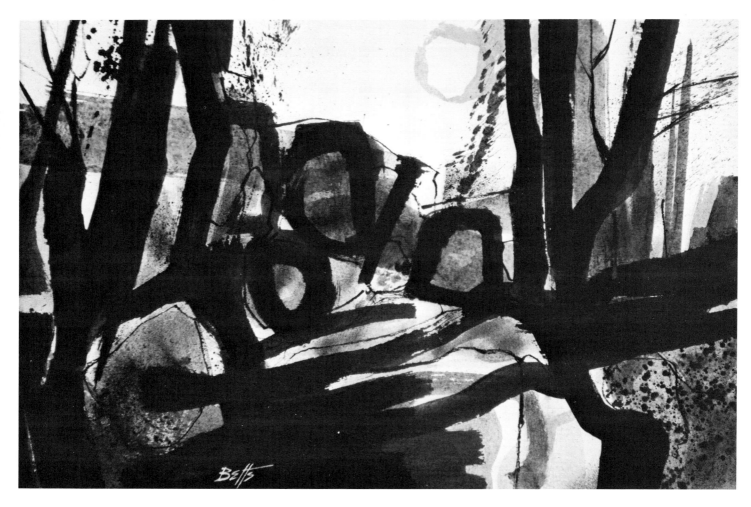

Rocks and Trees Ink and wash on paper, 15″ x 22″. A drawing is done as a complete statement in itself, pushed farther in terms of detail and finish, or to achieve a more fully realized sense of pictorial structure.

possibilities in them revealed fully for the first time. Sketches mean different things to an artist at different stages of his life, depending on his current interests and outlook.

Written Notes. There are those times when even a quick sketch is impractical for any one of a number of reasons—subtlety of lighting, rapidly changing effects of light or color, and pressure of time. So occasionally I use written notes rather than a sketch to describe effects that I feel I cannot record in any other way.

For instance, in one of my sketchbooks there is a page with a few hasty scribbles, together with the following written material:

Hull's Cove, Bar Harbor 7:30 PM

Very dark clouds at top, merging hard and soft with white clouds turning to fog or haze directly above farthest outer islands.

Thin strip of white light along water at lower edge of distant islands.

Dark rocks at lower right, water middle gray. Beach very dark (wet gravel).

Nearer islands dark, distant islands lighter.

Long horizontal composition, showing whole stretch of Hull's Cove. 8″ x 30″?

OBJECTIVES

1. To build a repertory of subjects for use as paintings, which will be developed later in the studio.

2. To search for design and structure in nature and to increase awareness of natural forms and patterns.

3. To develop facility in a variety of drawing media suitable to on-the-spot sketching methods.

MATERIALS

I am listing here two sketching kits that I use: one is very basic and one is an expanded set of sketch equipment for a wider range of media and effects:

Basic Kit

Sketchbook, spiralbound 11″ x 14″

Sketchbook, bound 8½″ x 11″

Pencils: 6B or Ebony sketching pencil

Razor blade, single-edge (for sharpening pencils on location)

Pens: felt-tip pen with black ink and India ink sketching pen

Expanded Kit

(In addition to items listed above)

Basic sketch kit. The advantage of the basic sketching kit—pens, pencils, a pad, and a razor blade for sharpening the pencils—is its simplicity and portability.

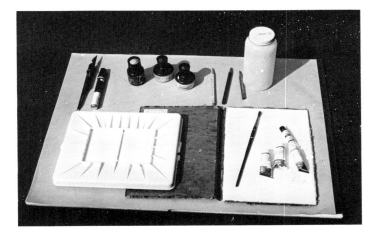

Expanded sketch kit. The expanded sketching kit is still easily portable, but it offers a wider range of media and includes a small 7″ x 10″ watercolor block, a few watercolor tubes, a small palette, and a water container.

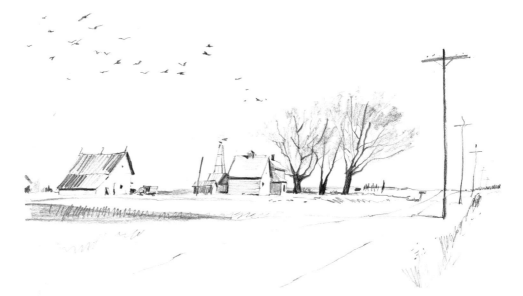

Road to Thomasboro *(Above) Pencil on paper, 11″ x 14″. Here is a sketch done on location in fifteen or twenty minutes. The subject struck me as being material for a watercolor, so I set down the essential facts.*

Country Road *(Right) Watercolor on 300-lb Arches rough, 15″ x 22″. This watercolor, done indoors as a demonstration for a beginners' watercolor class was based quite closely on the outdoor sketch above. After doing the sketch, but before starting the painting, I put considerable thought and planning into the patterning of values throughout the picture.*

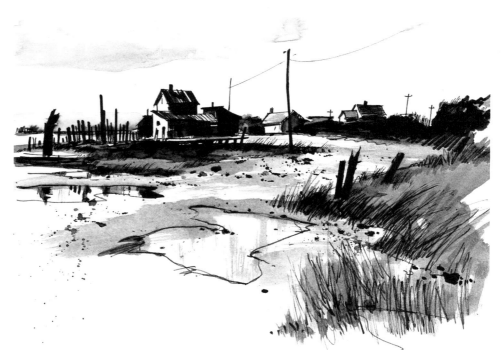

Shacks, Turbot's Creek *(Above) Felt-tip pen and ink wash, 11″ x 14″. With the extended sketch kit it is possible to go beyond pen or pencil and do informal wash or watercolor sketches. Sometimes these are done on a 7″ x 10″ rough watercolor block, sometimes in the 11″ x 14″ sketchbook. This sketch was drawn with a felt-tip pen, developed with washes of neutral-tint India ink, and then touched up with more felt-tip pen.*

Morning Sky, Turbot's Creek *(Right) Watercolor on 140-lb Arches cold-pressed, 18″ x 24″. Private collection. Using the sketch above as a reminder, I painted this watercolor in the studio, inserting the boats for added interest, and giving the scene a little more room in which to breathe.*

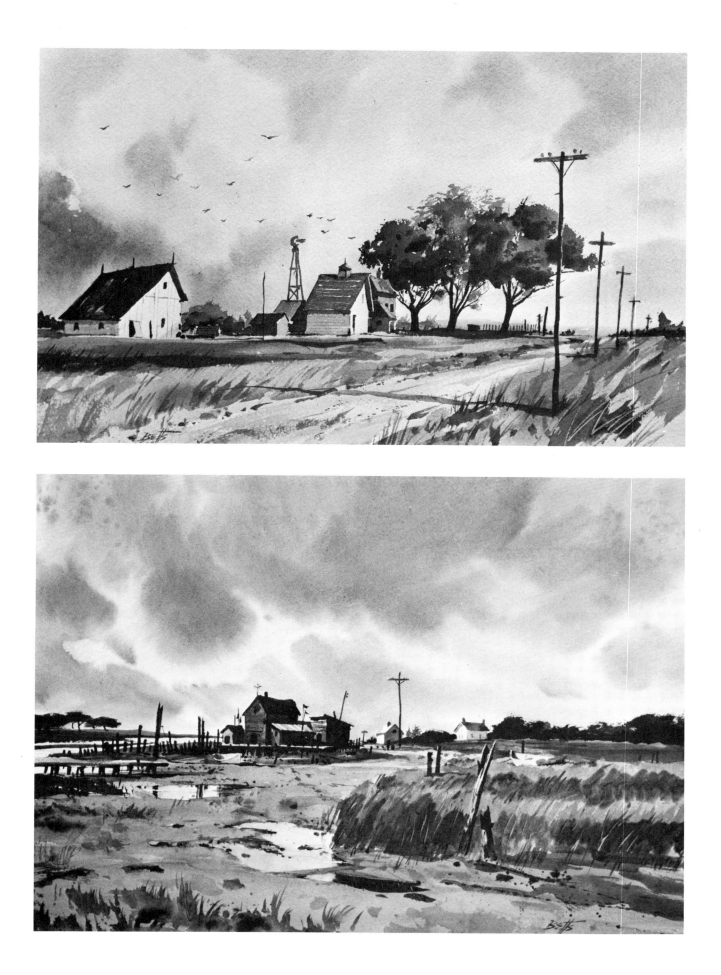

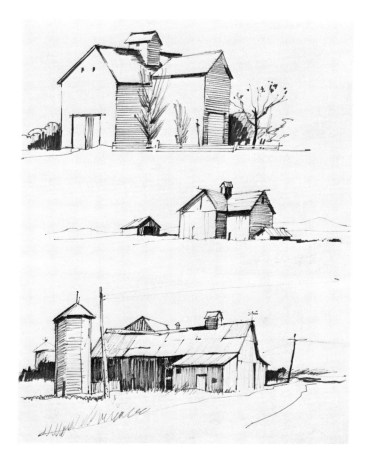

A page of barn sketches. Felt-tip pen on paper, 14" x 11".

Sketchpad, 13" x 26"

Watercolor block, rough, 9" x 12"

Pencils: 2B and carbon (Wolff)

Pens: bamboo pen and felt-tip marking pen

India inks: black, neutral tint, and sepia

Tube watercolors: ivory black, burnt sienna, yellow ochre, and ultramarine blue

Brush: No. 5 sable

Small plastic watercolor palette

Plastic water jar (1 pint), with lid

NOTES

Sketchbooks and Sketchpads. I customarily use the spiralbound variety, although because of that very binding they are somewhat awkward to store. On the other hand, unsuccessful drawings are more easily removed than from a bound sketchbook, where pages that are torn out can loosen the other pages farther along in the book.

In addition to my regular sketchbook, I keep a small sketchpad in the glove compartment of my car. In the past, there have been several occasions when I wanted to stop and note something down quickly as a sketch and found to my dismay that I had nothing more to draw on than a frayed matchbook pulled somewhere from the depths of the front seat! In recent years, therefore, I have always kept an extra pad available for just such emergencies.

Pencils. I like a soft pencil for its ease of handling, breadth, versatility, and ability to produce a full range of tones. Over the course of a few years, however, pencil sketches tend to smudge and smear. For that reason I frequently use a felt-tip pen.

Pens. With a pen it is harder to build up masses of tone and there is less line variation than with a pencil, but the drawings stay clear and sharp indefinitely, as long as they are kept in a closed sketchbook. Most of the standard felt-tip pens I have used have ink that fades when exposed to daylight for a few months. The black ink, for instance, does not fade out completely, but turns a pale version of burnt sienna or burnt umber. These drawings are quite satisfactory while they remain within the sketchbook, but if one should be torn out and sold, it is quite likely that the irate buyer will soon come around demanding his money back.

I use felt-tip pens nevertheless—either alone or in conjunction with an India ink sketching pen, whose ink, of course, is absolutely permanent.

Felt-tip marker pens have very broad points and are excellent for quickly blocking in large, dark masses.

In addition to pens, I occasionally draw with the stopper from the ink bottle or with a sharpened matchstick of

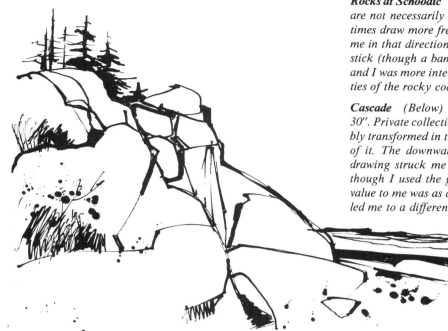

Rocks at Schoodic *(Left) Ink on paper, 11" x 14". My sketches are not necessarily the standard representational kind; I sometimes draw more freely or abstractly if the subject's forms move me in that direction. This was done with ink and a long match-stick (though a bamboo pen would give much the same effect), and I was more interested in stressing some of the abstract qualities of the rocky coast than I was in doing a literal rendering.*

Cascade *(Below) Mixed media on illustration board, 22" x 30". Private collection. The material in the sketch was considerably transformed in the acrylic and collage painting that grew out of it. The downward-tumbling movement of the rocks in the drawing struck me as being reminiscent of a waterfall, so although I used the general composition of the drawing, its real value to me was as a stimulus for a free association of ideas that led me to a different subject than the one originally sketched.*

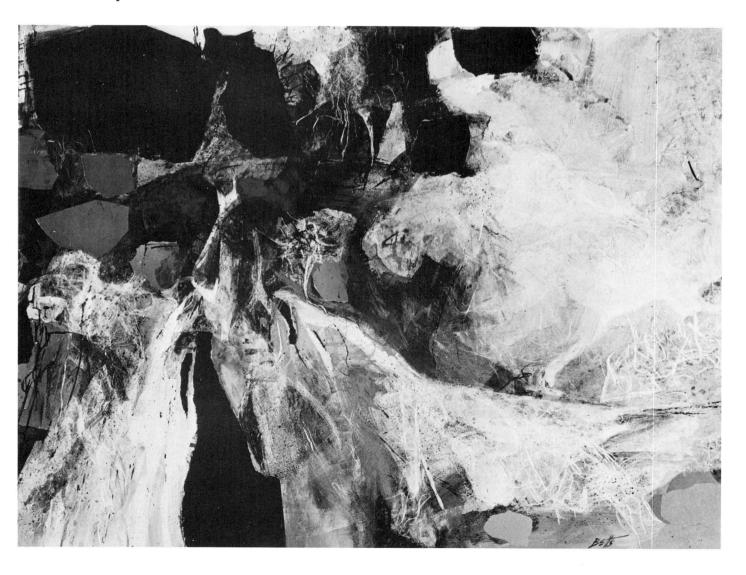

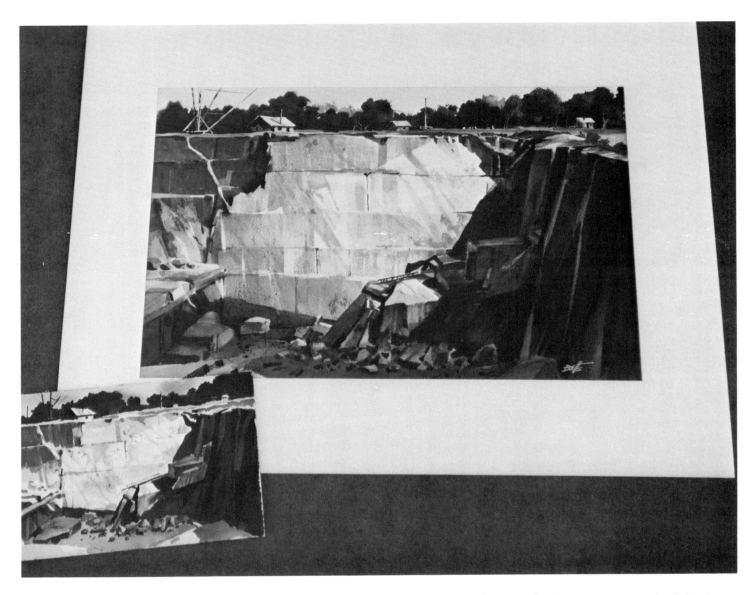

Watercolor study for Swenson's Quarry, *7" x 10". The study, shown here next to the finished painting, is so tiny that there is no room for detail or refinement of texture, but it does emphasize the strong light-and-dark pattern upon which the finished watercolor was built. I have a sneaking suspicion that the study, as usual, is better than the painting which resulted from it.*

the 9″ decorator variety. I like them for the varied, unusual line quality I can get with them. Somehow they help me draw in a freer, more explorative, abstract manner.

Inks and Watercolors. For a painterly type of sketching I use either India inks and brush and pen or a limited palette of watercolors. There is no particular basis for deciding when watercolors are to be used; either my mood of the moment or the subject itself will suggest that a wash treatment is appropriate. These are not color notes (I rely on memory for that), but sketches stressing tone and pattern rather than line and detail.

Palette. On sketching trips I carry along a tiny (8″ x 9½″) plastic watercolor palette that was once part of a watercolor sampler set. It has two central mixing areas and quite a number of depressions around the edge to hold the pigments. It is more than sufficient for the small scale in which I work and the very limited number of colors I use. If I need to isolate the dirty palette from other equipment—to keep the paint and water from leaking off onto other things in my sketchbag—I wrap the palette in a plastic envelope.

Water Jar. Here I prefer a 1-pint plastic jar, with lid. The main idea is to have a water container that is unbreakable and as light as possible.

Watercolor Block. Since the average sketchbook does not have paper sufficiently heavy to take watercolor without wrinkling or buckling, I like to have on hand a very small watercolor block of rough paper. As a rule, I have no fondness for watercolor blocks, but in terms of convenience and portability during travels they are quite satisfactory.

SUGGESTIONS

I do not believe that exhibition paintings can be done outdoors, so your sketchbook is the main link between your first view of a subject and its subsequent evolution into a painting. Note in your sketchbook anything and everything that might be of possible value to you later in the studio, and try also for a wide variety of subjects. In a single sketchbook of mine there are drawings of rocks and surf, dune grass, a dead seagull, a boatyard, driftwood, burnt trees, and a farmhouse.

Even if something strikes you as being only vaguely interesting or useful it may be worth drawing anyway; you never know when you might need it.

Walk as much as possible rather than drive. You see a great deal more when going at a leisurely pace in areas a car cannot get to, and you have many more opportunities to stop and look behind you at things you have already passed, possibly getting a more interesting viewpoint than the one you had as you first approached them.

Use your sketchbooks as a means of familiarizing yourself not only with the look of things but also with their less-tangible attributes—light, mood, atmosphere, the feel of weather, and the seasons. Your sensitivity to such things can differentiate your work from that of painters who see only the surface aspects of their world.

Toward Ontio Beach
Pencil on paper, 11″ x 14″.

Pine Island *Lithographic crayon on cameo paper, 13" x 20": Private collection.*

2. Sketching in the Studio

While sketching on location is an observational, descriptive kind of drawing, studio drawing and sketching should be more creative, more experimental. Once the subject matter has been assimilated in outdoor sketches and in the artist's mind, then it is time to explore the material further; to condense, intensify, organize, and transform it with the idea of discovering its full potential as a painting.

Aside from being preparation specifically for paintings, studio sketches can also be done simply for their own sake. These visual exercises drawn in an improvisational spirit can evolve new forms, establish new relationships between forms already known, and reveal more personal ways of relating random brushstrokes, blots, and accidental effects to the natural forms that have been observed during sketching trips.

The greatest advantage of doing drawings in a studio environment, of course, is that the working conditions are fully controlled, and all necessary art materials are conveniently at hand. This permits the artist to concentrate fully on his ideas and drawings, without being distracted by wind, dust, rain, irritable dogs, and amateur art critics. Also, at a distance from the subject matter, the artist is less inclined to be a slave to his sources—there is more opportunity for thought and planning and for developing fresh ways of dealing with the subject.

OBJECTIVES

1. To stimulate new ideas as to compositional possibilities.

2. To become better acquainted with the subject through analysis of shapes and patterns.

3. To push earlier sketches toward a more clearly organized pictorial structure by means of simplification, elimination, and distortion.

4. To explore other, related ways of approaching the subject by doing independent drawings that utilize accident and improvisation.

MATERIALS

Sketchbook, spiralbound 11″ x 14″

Drawing pads and paper, assorted

Tissue paper and newspaper

Pencils: 2B, 6B, and carbon (Wolff)

Crayons: wax and Conté

Pens: India ink sketching and felt-tip pens and markers

India inks, assorted colors

Watercolors and/or acrylic paints

Brushes: sable, bristle, sumi

Painting knife

Palette or enamel butcher's tray

Water containers

Rags or paper towels

Roller (brayer)

Turpentine (used with Conté crayon for wash effects)

NOTES

Sketchbook. Your studio sketchbook is another 11″ x 14″ spiralbound book, a supplement to the ones used for sketching on location. The drawings in this book are not done from nature, but are a collection of compositional studies, thumbnail sketches, tentative ventures into abstract reorganization, and intuitional drawings or "doodles." I keep the two sketchbooks completely separate as to both the material contained in them and the function they serve: Sketchbook No. 2 functions principally as a mini-laboratory for visual experiments, a workshop for testing pictorial ideas.

Drawing Pads and Papers. Studio sketching has none of the restrictions inherent in sketching outdoors, so large (18″ x 24″) drawing pads can be used, as well as any other sheets of drawing or printing paper favored by the artist. In addition to large newsprint and Monroe pads, I have an assortment of various papers of different sizes, weights, and surfaces, and I select whichever seems best for the ideas and the medium I am working with.

Tissue Paper and Newspaper. In addition to standard drawing methods, I often place tissue paper over the drawing and paint heavily on it with ink, watercolor, or acrylic paint. The tissue lets a good part of the ink soak directly through onto the sheet beneath it, creating interesting shapes and strangely mottled textures. These in turn stimulate me to pursue the ideas suggested and to elaborate further with washes and ink lines.

I use newspaper to lift up ink or paint from the drawing (a good method for achieving textured halftones), or I apply paint directly to the newspaper then flip it over quickly and transfer it onto the drawing surface, again in order to create accidental effects which I can respond to

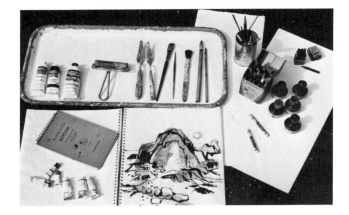

Studio sketching materials. Anything I feel like using for drawing is readily available to me in my studio, but shown here are the materials I use most: watercolor, gouache, acrylic, India inks, drawing pads, wax crayons, Conté crayons, and a variety of brushes and drawing tools.

Drawing tools. Among the drawing tools I most prefer are these: graphite pencils, carbon pencil, felt-tip pen, marking pen, bamboo pen, long matchsticks, and Conté crayon.

Brayer. A brayer, or ink roller, is used for making wide strokes on large-scale abstract drawings.

and incorporate into the finished drawing. Occasionally such improvisations turn out to be nothing more than ugly blobs or smears, but more often they are quite fascinating in the possibilities they suggest. It then becomes a challenge to attempt to work out an integrated relationship between the accidentally-arrived-at forms and those forms which derive from my on-the-spot sketches.

Pencils. Carbon, or Wolff, pencil, works well in combination with watercolor wash to produce a sketch with deeper blacks and richer surfaces than can be obtained with graphite pencils.

Crayons. I use wax crayons in the lighter color range mainly as a resist method, rather than for application of color.

Conté crayon in stick form can be used alone, or the surface of the Conté drawing can be brushed with turpentine for wash effects.

Brushes. I tend to favor a type of drawing that is closely related to the spirit of my painting, so I am more involved in what might be called a painterly approach to drawing in contrast, say, to traditional draftsmanship featuring the beautifully wrought line in pencil, pen, or silverpoint. I therefore use a number of brushes of various kinds— sable, bristle, and Japanese sumi—many of them so incredibly worn that to anyone but another artist they might seem virtually unusable.

Painting Knife. Although this is primarily a painting tool, I like the sharp, incisive lines I can make by drawing with its edge held against the paper. To paint broadly with the knife in ink or watercolor would be suitable only in a format larger than that of a sketch, so here I limit its use to linear accents.

Water Containers. I keep four 1-quart glass jars filled with water on hand at all times, for diluting inks or paints and for rinsing brushes. I also use plastic ½-gallon containers such as those in which ice cream is sold: these are especially useful because they are so wide that a quickly aimed brush finds its mark without difficulty.

Roller, or Brayer. A hard rubber ink roller, or brayer, is sometimes good to use, both for the breadth of application and for the textural masses that are possible with it. I prefer opaque acrylic paint with the roller rather than drawing inks, which are too thin and runny for maximum control.

DRAWING AS PREPARATION FOR PAINTING

It may be possible to leap directly from a sketch into a representational painting but in abstract painting it is not ordinarily advisable. There should be a period during which the artist absorbs the subject matter, sorting out alternatives, clarifying attitudes and objectives, determining what is to be expressed and by which means. These same processes can be worked out overtly in the form of drawings, and toward the same purposes.

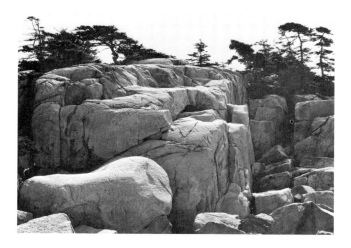

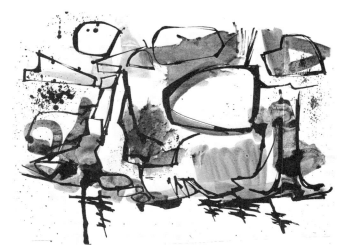

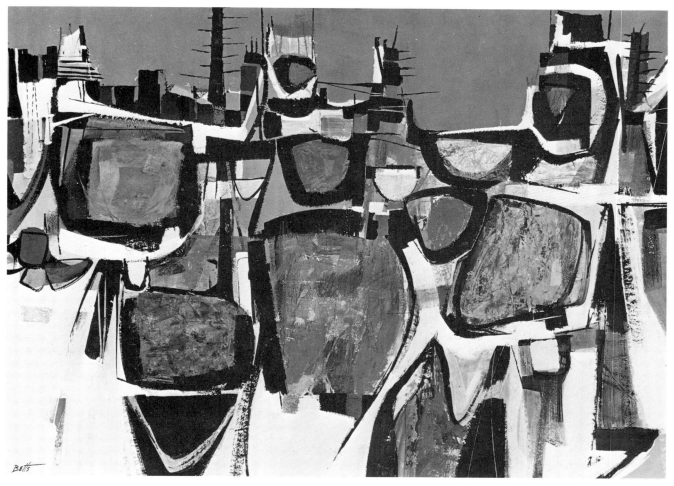

(Top Left) Photograph of rocks at Schoodic. Rocks on the coast of Maine vary considerably from area to area, both as to form and as to color and texture. In this case I responded strongly to the full, curved forms and the spiky trees sharply defined against the sky.

Rocks at Schoodic *(Top Right) Ink and acrylic wash on paper, 11" x 14". In the studio I assembled a group of pencil sketches and other photographs of the same motif, and in a sequence of four or five rapid sketches I played about with the forms, pushing them toward more conscious design and an interplay of lines and values.*

Rocks and Snow *(Above) Casein on illustration board, 22" x 30". Collection California National Watercolor Society. In the painting that finally resulted from the sketching explorations, the subject became a snow scene in which the rocks were treated as linear symbols.*

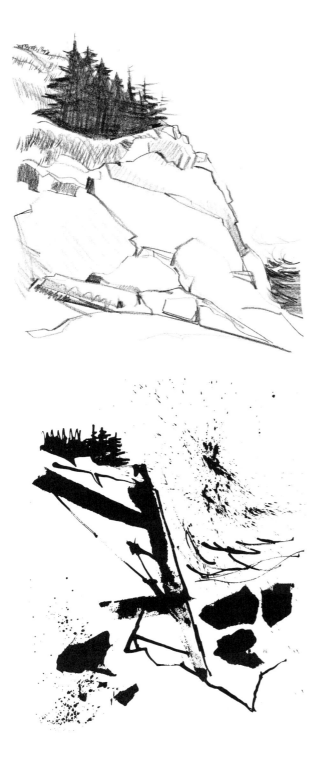

Monhegan Cliff (Top) Pencil on paper, 14″ x 11″. This is a representational on-the-spot pencil drawing made on a week's visit to Monhegan Island off the coast of Maine. The theme is a familiar one, but it led to quite a different sort of painting than the preceding one (bottom of page 25).

Cliffs and Surf, Monhegan (Above) Ink on paper, 14″ x 11″. Here the attempt was to extract and dramatize the dynamics of the meeting of sky, rocks, trees, and surf. Strong opposing diagonals were used to intensify the steep, downward drop of the high cliffs.

If you find that preparatory studio drawings tend to lessen the force of your creativity while painting—that some of the air is let out of the balloon, so to speak, because you gave everything to the drawings and have nothing left for the actual painting—then it might be best for you to dispense with this phase altogether and prepare yourself for painting through a period of contemplation and meditation. Letting your subconscious faculties work on the material over a long period of time can be just as productive for the creative imagination as days or weeks at the drawing table.

EXPLORING SUBJECT THROUGH DRAWING

If you choose to do sketches and studies as a means of exploring your subject, there are three general approaches:

Analysis. The first approach to drawing is more or less intellectual: analyzing the motif in regard to line, shape, and value.

Line analysis can range anywhere from severely simplified contour drawings to a very complex, overall linear network, depending on which seems best to express the subject.

Shape analysis is concerned with simplifying, distorting, and overlapping shapes, changing their scale, and examining how they can be related to each other. The artist plans a wide range of shape sizes and sets up oppositions that range from tiny areas to large, open spaces.

Value analysis is important for planning the total pattern, for working out a contrast of values from shape to shape. The aim here is a constant alternation of lights and darks throughout the entire surface, which is designed so that no two areas of similar value are adjacent to each other.

Break-up and Reorganization. The second approach to drawing is one of break-up and reorganization: the subject is broken down, pulled apart, shifted about, and put back together in another order. This is comparable to smashing an object on the floor then reassembling all the shattered parts into a different structure that is more esthetically effective than the original form. Some artists carry this method even further. They do a drawing and then tear it or cut it up and push the pieces of paper around into an arrangement that suggests new approaches to their composition. This is one way of getting out ot stale habits and allowing unpremeditated combinations of parts in the drawing to provoke further creative decisions.

Intuitive Drawings. The third approach to drawing is intuitional, evoking a flow of ideas by doing a series of variations on a theme in spontaneous fashion. Consider it a matter of probing, feeling your way into the motif, of being uninhibited, trying out all sorts of wild notions, however impractical they may seem. Work quickly, keeping your mind open and pliable, ready to be stimu-

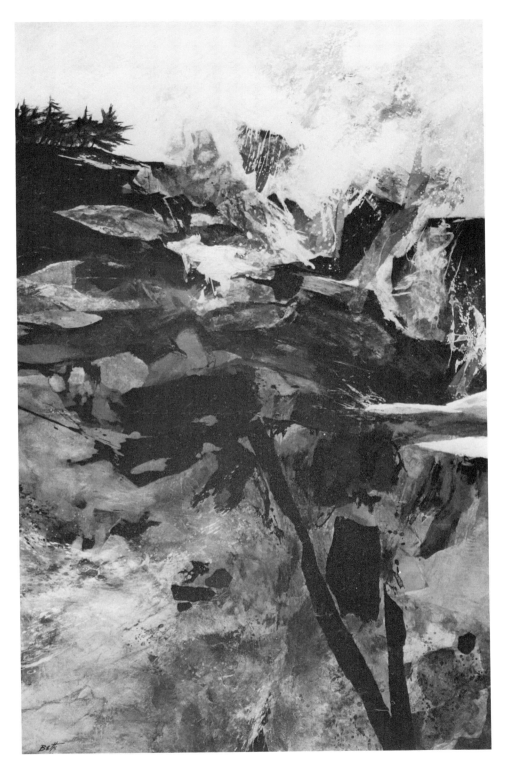

Northeaster, Monhegan *Acrylic and collage on Masonite, 48″ x 30″. Photo courtesy Midtown Galleries, New York. In an effort to further intensify the content in the original drawing, the rock forms were freely rearranged and the ocean spray was purposely exaggerated. Nevertheless the finished picture, though it is an expressive interpretation of the outdoor pencil sketch, bears a close relation to the drawing from which it originated without slavishly imitating it. The studio sketches opened the way toward a more creative approach to handling a traditional subject.*

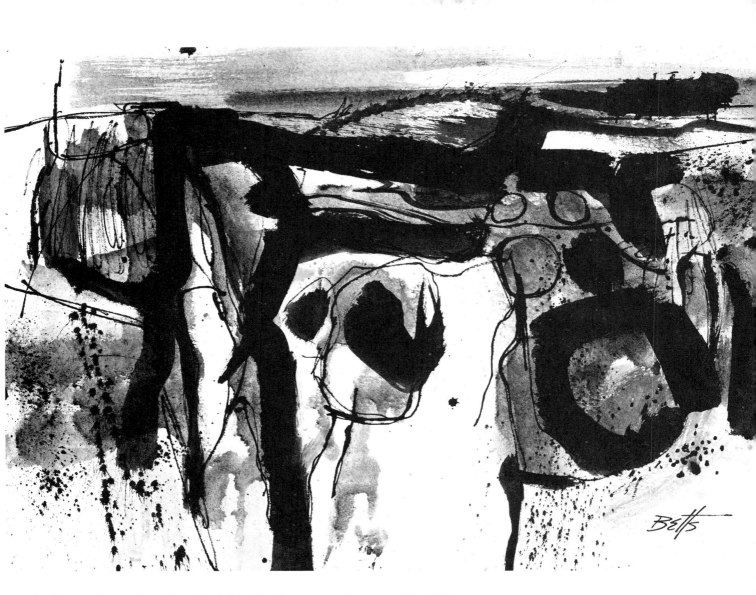

Rocks at Stillwater Cove, Carmel *Ink and wash on watercolor paper, 15" x 22".*

Snow Tide *Acrylic wash on watercolor paper, 22" x 15".*

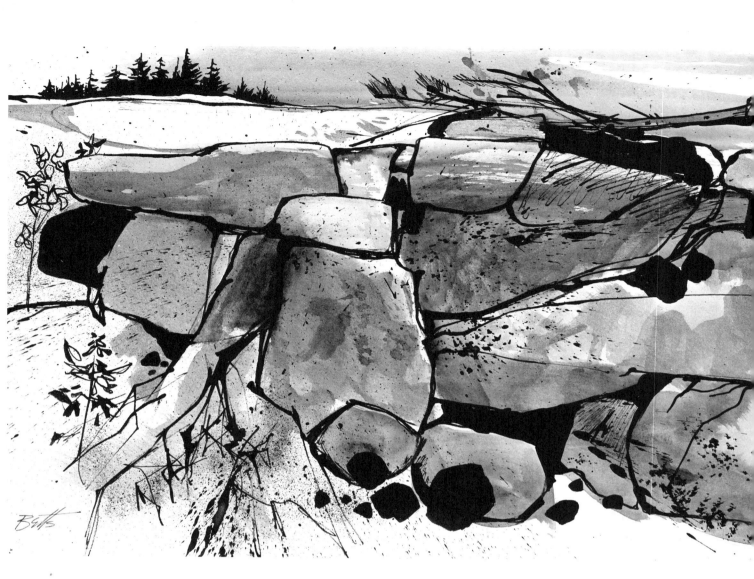

Rock Wall *Ink and wash on paper, 12" x 18".*

*Waterfall Acrylic wash on watercolor paper, 22" x 15".
Many of my studio drawings are frankly experimental and are
not related to sketchbook material. Here there is no urge to make
a sketch or a drawing in the customary sense. The function of
exercises such as this is to search out new forms and to refresh my
mind. I let accidents happen and then intuitively respond to those
accidents, toying with images that are sensed but not yet visible,
and generally playing improvisationally with lines, shapes, and
patterns. The ideas that result from these sessions often find their
way into my paintings—but most of these drawings, once they
have served their purpose, find their way into the wastebasket.*

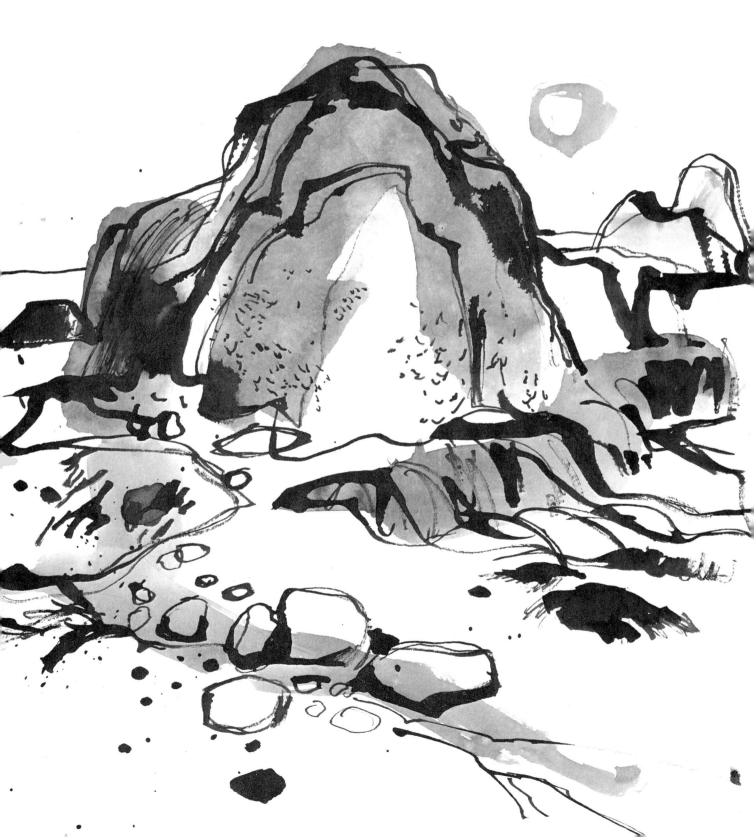

Beach Rock *Ink and wash on paper, 14" x 11".*

lated. As the sketches pile up, select and reject rigorously: Which sketches have genuine promise as paintings? Which ones are personal solutions and which are clichés?

In these drawings you may even reverse the standard procedure: begin with seemingly aimless forms and gradually direct the picture back toward recognizable images; the subject is implied rather than described or identified.

The act of painting must be prepared for, but at the same time keep in mind that you should not push these drawings so far that you exhaust all your creativity on them and have nothing left for the painting, which is meant to be the climax of all this activity. Your aim should be to provide yourself with general, not specific,

solutions before you begin painting. If all your conceptual and technical problems are too completely solved at this stage, you may find that the painting is merely a stiffly rendered version, a mechanical filling-in, executed without a sense of real involvement on your part.

Conserve yourself in the drawings. Leave a few things unresolved. You will be sure enough about your own intentions and feelings, and about the general format, so that while you are painting there will be no fumbling or indecision. Instead of plodding through the picture unthinkingly, you will preserve the risk and excitement of dealing with unexpected situations and the chance to project with intensity and enthusiasm your original responses to your subject.

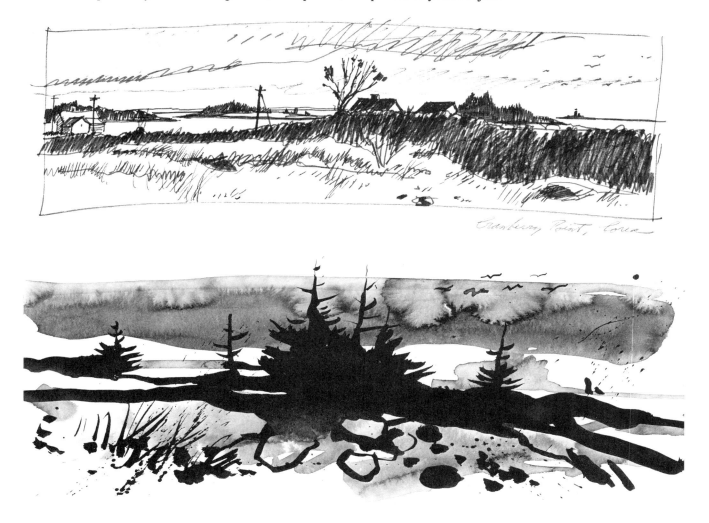

Cranberry Point, Corea, Maine *Felt-tip pen on paper (upper portion) and Japanese ink and sumi brush on paper (lower portion), 11" x 14". The upper drawing on this page was an on-the-spot drawing. Later, back at the studio, I did the ink and sumi brush drawing as a variation on the theme from the first sketch. Both sketches refer to the same general subject, but there is material here for two quite different paintings.*

Etretat *Acrylic and collage on Masonite, 19″ x 33″. Private collection.*

3. Working Creatively From Photographs

Some artists look upon the camera as a form of cheating; others consider it a boon to the modern painter in that it liberates him from having to imitate nature and leaves him free to spend his efforts in more profoundly creative pursuits. Of course, the artist's use of mechanical aids in drawing goes back many centuries. Leonardo da Vinci was well acquainted with the *camera obscura*, and there is good reason to believe that Vermeer and others of his period used a similar device.

After the invention of the camera in the nineteenth century, photographs were used as a source of reference by such artists as Delacroix, Degas, Eakins, Toulouse-Lautrec, and Sickert. In more recent times, photographs have inspired such noted artists as Charles Sheeler, Ben Shahn (both excellent photographers as well as painters), Francis Bacon, Rico Lebrun, Ellsworth Kelly, and Andy Warhol, to name only a few.

A camera used responsibly and creatively can be a constructive tool for any painter. But the reasons for strong feelings against using cameras in painting are not difficult to imagine. Some painters, and particularly amateurs, tend to use a camera as a substitute for a sketchbook. It becomes a kind of crutch that spares them the trouble of having to observe carefully and draw skillfully. They rely on photographic effects, which they transfer literally and thoughtlessly to their paintings. They deceive themselves into believing if something is there in the snapshot, or on the color slide, then certainly it must be worth copying into the painting. And finally, they forget that what the human eye perceives and what the camera sees are two quite different things. The camera view is a distortion, and this is something the inexperienced painter cannot afford to ignore.

There are ways, however, in which the camera can function as a legitimate part of an artist's equipment, providing it plays the part of servant, not master; the artist must feel free (or even obligated) to rearrange and distort, to add or leave out. In other words, he must learn to treat photographic material inventively, and perhaps most important of all, to take his own pictures and not rely on secondary photo sources such as books, magazines, newspapers, and calendars.

It is far better to respond to your own subject matter, compose it yourself, and photograph it yourself as a record of your experience and with a view to its application to your painting, than to use someone else's photograph, already experienced, composed, and recorded by an eye and a personality other than your own. Gathering source material in second-hand fashion can never lead to full growth of individual creative talent.

THE CAMERA AS PAINTER'S TOOL

There are two principal uses for the camera by the contemporary painter. First, it can provide a documentation of visual facts—snapshots of nature and details that are an aid to memory—that would be too time-consuming to draw fully in a sketchbook.

Second, the camera is excellent in helping the artist seek out the design that exists in nature, mainly through closeups that stress pattern and texture. This development of an awareness of abstract elements and phenomena, found not in panoramas but in the world at our very feet, is bound to have a beneficial effect on the art that results.

I have found that the camera functions most effectively when it is used not just by itself but in conjunction with a sketchbook. The two form a team: the drawing records the look of things to the eye, and the composition is exactly as the artist viewed it and responded to it, with an undistorted sense of the size and scale of things in true relation to each other; the camera records the details and fills in whatever the sketch may have missed. Between the sketch and the photo, just about all the needed material is on record. One without the other might not adequately furnish all the information or jog the memory or offer insights into ways of synthesizing nature and design.

The camera can be taken along as a routine piece of equipment in gathering source material for paintings, but that does not mean that the sketchbook should be left at home.

OBJECTIVES

1. To record what has been observed, using the camera as a supplement to drawing and sketching.

2. To study photographs with the aim of understanding the essence of form, pattern, light and shadow, and texture. This will stimulate ideas for compositions.

3. To build a reference file of subject matter and of forms in nature as a source of abstract imagery.

4. To alter photographic material freely and imaginatively as a basis for the development of paintings.

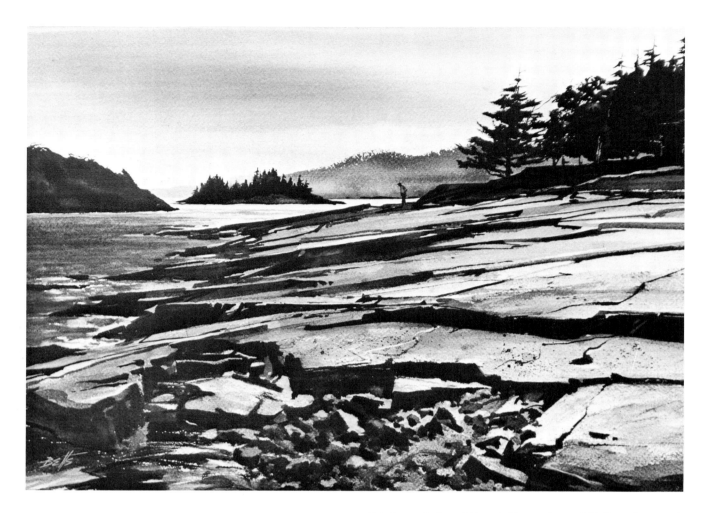

Grindstone Point (Above) Watercolor on 300-lb Arches rough, 17" x 24". Collection Mrs. Edward Betts. This watercolor was blocked in very simply with the fewest possible number of pencil lines. I used the photo mainly to get a clear understanding of the structure of the foreground rocks. Note that I tilted the rocks slightly downward to show more of their surface and that I enlarged and rearranged the offshore islands to create stronger forms that would occupy the sheet more fully.

(Left) Photograph of Grindstone Point, Maine. The play of sunlight over the flat slabs of rock appealed to me strongly as a possibility for a watercolor, but time was short and the light was changing. My camera seemed the best method of recording the scene for future reference.

MATERIALS

Camera: 35mm single-lens reflex

Film: 35mm Plus-X (outdoors) and Tri-X (indoors) for black and white prints; 35mm Kodachrome 25 (outdoors) for color transparencies

Slide viewer

Photo album

Telephoto lens (optional)

NOTES

Camera. The 35mm single-lens reflex is an extremely versatile camera, and one with which I feel very comfortable. I use a camera frequently, but not so much as a direct source for my painting as simply for recording the things that interest me—a foggy evening in a harbor, lichen on a rock, the depths of tidepools, a three-dimensional collage of junk in a boatyard, patterns in the sand at the water's edge.

I divide my photographic work about equally between color and black and white, but rarely refer to either while I am painting in the studio. The black and white prints are occasionally useful in my realistic watercolors or gouaches. For some reason I feel more willing to remember colors or to invent them when referring to black and white; with color slides I am more inclined to feel that the slide is so complete in every sense that it needs no tampering with on my part.

A 35mm camera, because of its convenient size and weight, can be carried anywhere very easliy and takes sharp photographs under almost any conditions. The camera I own cost slightly over $100 a number of years ago; it has no built-in exposure meter to ensure correct lens settings, but I must confess I have done very well simply by referring to the exposure table listed on the information sheet packed with each roll of film. Then, too, I have used a camera so long that I can usually estimate with a fair degree of accuracy what the correct exposure should be, even under difficult light conditions. Obviously, investing in a high-quality exposure meter would virtually eliminate all guesswork, but then I like to live dangerously.

Since a camera of this sort can be purchased for as little as $60, it does not by any means have to represent a major expenditure and is far superior to the general-purpose "instamatic" types. These are adequate for minimal requirements, but since they have a single, generalized exposure setting and are severely limited when it comes to taking closeups, they cannot be considered very versatile, and the quality of the photos themselves leaves a lot to be desired.

Although I have never used a Polaroid camera, I would think that it might sometimes be an advantage to be able to ascertain on the spot the success of the photo without having to wait for the film to be processed.

My 35mm single-lens reflex is a versatile camera, easy to carry, simple to operate, and best of all, inexpensive. I prefer Plus-X film for black and white work, and Kodachrome 25 film for color slides.

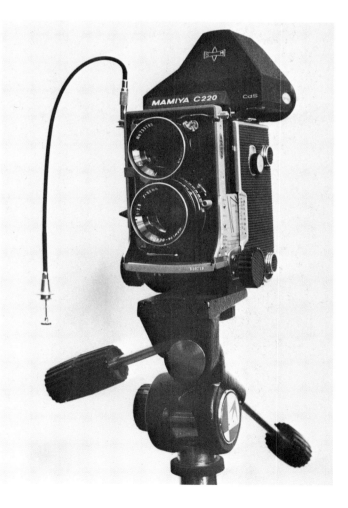

Finished paintings are photographed with this 2¼" x 2¼" twin-lens reflex camera, equipped with a cable release to ensure sharp negatives, and a clip-on CdS porrofinder with light meter to ensure accurate exposures.

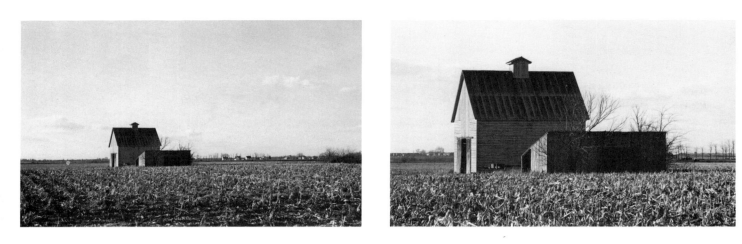

A telephoto lens is a help in bringing distant objects closer and filling the frame to better advantage. These two snapshots were taken from exactly the same spot with the same camera. The one on the left was taken with my camera's standard lens (50mm). The one on the right was taken with a 135mm telephoto lens. The photo taken with the telephoto lens has all the information clearly visible and without wasted space, whereas the photo taken with the standard lens includes much more of the surroundings than I really need to remember.

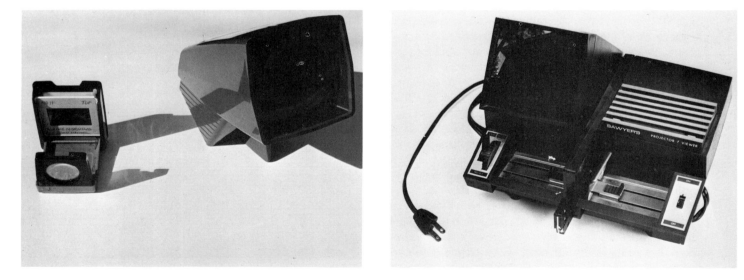

My slide viewers are shown at left. They include a small hand viewer that must be held up to a strong light (left side of photograph) and a hand viewer that operates either on battery or electricity (right side of photograph). On the right is a combination viewer and projector. The slide can be viewed in the screen (left side), or by pushing a lever the slide can be projected ahead on a wall or projection screen.

When it comes to selecting a camera, the one to buy is the one that best suits your particular purposes and the one you feel most at ease with, whether it be a box Brownie or a Leica.

Film. For black and white work outdoors I use Plus-X film, which is medium speed, very fine grain, and quite adaptable to most light conditions. For work in less than ordinary daylight, a faster film such as Tri-X (high speed, fine grain) would be advisable.

Since I never use a flash attachment, I am referring to photography in which the only light source is natural or "available" light. Flash bulbs cause glare and flatten out and distort images. To me they are highly objectionable and should be avoided unless very unusual circumstances require their use.

For black and white prints I specify the "jumbo" size, which is 3½ x 5″, but excellent enlargements up to 8″ x 10″ are also possible.

All my color work is done outdoors. For color slides I prefer Kodachrome 25, which I have found to be extremely accurate in color and very satisfying under a wide variety of light conditions. Color prints can be made from Kodachrome 25 transparencies.

Slide Viewer. Mounted 2″ x 2″ color transparencies are difficult to see without the aid of a slide viewer. I have three of them: a small hand viewer that has to be held up against a strong light, a hand-held viewer that operates on either batteries or electric current, and a table model that is a combination viewer and projector.

I use the first of these only for preliminary viewing, to check the quality of the slides and for selection and elimination. The other two viewers are for more general use when referring to slides as the basis for sketches or drawings or for checking detail or other specific information.

When showing slides for lecture purposes, I use a standard slide projector of the "carrousel" variety, but I would never recommend projecting slides as a way of blocking in a painting. For one thing, any distortions present in the slide are perpetuated in the painting. For another, slides inhibit the artist's impulse toward creative drawing, and he is less free to make the instinctive, subtle changes that relate the drawing to the rectangle of the sheet of paper on which he is working. Projection is about the most unimaginative method of drawing that I can think of; it should not be seriously considered for any genuinely artistic purpose.

Photo Album. There are many albums available for filing away jumbo-size prints. I group them according to subject or geographical area and replace older ones that no longer interest me with newer ones that I find more meaningful. The rejects are not discarded but are kept in envelopes, sorted in a general way: trees, surf, rock studies, farms, boats, harbors, fishing gear, etc.

My slides are stored in metal slide boxes that hold 150 or 200 slides per box. Slides that are of general interest but used infrequently are sorted and labeled as to sub-

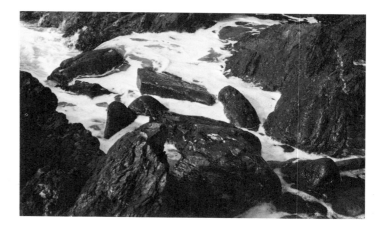

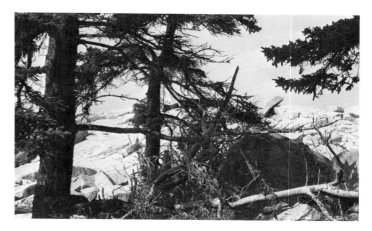

Photos such as these are stored in my files until such time as I need them for reference material. I prefer black and white prints to color slides, because with black and white I feel freer to invent my own color.

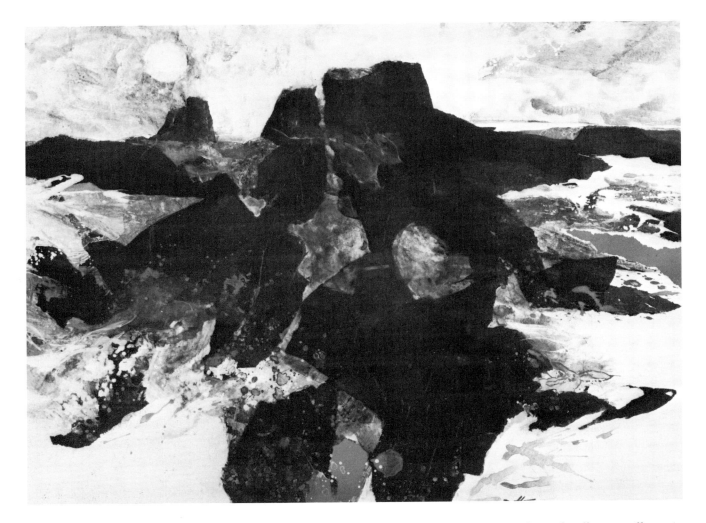

Oarweed Cove *(Above) Acrylic and collage on illustration board, 20″ x 27″. Collection of Mrs. Edward Betts. In this painting the rocks have been very freely interpreted; instead of presenting a rather flat silhouette against the sky and receding back into deep space, the rock forms have been altered to become a strong vertical mass that is closer to the picture plane and provides a more dramatic break-up of the picture area. There is no wasted space here as there is in the photograph at left, and I did whatever I could to activate the surface with dramatic shapes, color accents of torn paper, oppositions of opaque and wet-in-wet, and flung or spattered paint. In this instance the material contained in the photograph was merely the point of departure for creative distortion.*

(Left) Photograph of Gull Rock, Oarweed Cove. I lived in a shack on this beach for four months and had ample time to study these rocks and the tides that came and went around them. At first glance it would not seem to be too interesting a subject for a painting.

Coastal Storm *(Above) Mixed media on Masonite, 30″ x 45″. Photo courtesy Midtown Galleries, New York. Here again memory plays the most important part in the creative process; the photo at right serves as little more than an extra reminder. Rather than include a horizon, which would give the picture a rigid, static quality, I introduced the fogbound coast at left and made the splash a stronger element in the composition. The rocks were consolidated as a dark mass, with no light areas to distract from the action taking place in the upper part of the picture. Acrylic paint was combined with sand-and-rice-paper collage to make this picture as much an experience in texture and surface as it is an evocation of the coastal storm. If a painting does not intensify, improve upon, or in some way transcend its sources, then it is not worth doing at all.*

(Right) Photograph of rocks and surf, Ogunquit, Maine. These rocks are a five-minute walk from my Maine studio. Whenever the surf is high I go there to sit and watch the incoming waves, and sometimes I take pictures such as this to record the patterns and textures of granite and sea foam.

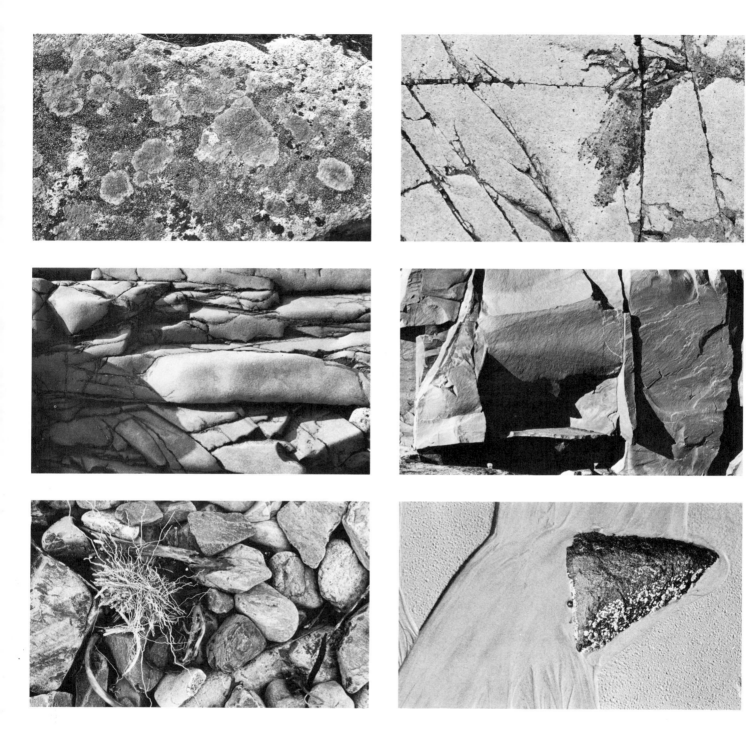

The photographs reproduced here are a sampling of several hundred closeup details of nature that I have taken for no specific purpose other than the fact that I responded to them. Photos such as these never directly influence a painting, but the awareness of such forms and surfaces certainly becomes a part of the creative process, a part of the reservoir of forms that is constantly drawn upon, both consciously and unconsciously. In addition to discovering suggestions for abstract imagery in nature details, using the camera in this way is excellent for developing an eye continually sensitive to its surroundings.

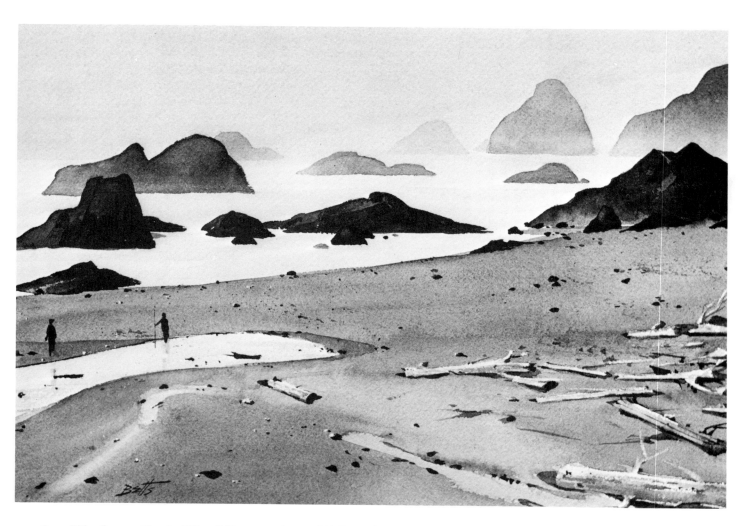

Low Tide, Oregon Coast *19" x 24", watercolor on 240-lb Arches rough. Although our trip up the Oregon coast a few years ago was a most leisurely one, there was nevertheless very little opportunity for me to do any watercolor notes directly from the subjects, so I had to rely on my camera and my sketchbook to record the many sea-edge compositions and the various effects of light and fog that are characteristic of that region. This painting is not of any one specific beach but rather is a composite of elements taken from three different slides (which were of quite indifferent quality) and a very fragmentary pencil sketch. Two of the photographs provided me with some of the rock formations, while the third slide was of a beach at low tide. That information was then filled out by the material suggested in the rough sketch, which served to remind me of the way in which rocks often recede into the coastal mists. Bringing all this information together resulted in the kind of painting that is far richer in its total atmospheric effect, and more controlled technically, than would have been possible in a picture painted on the spot at just a single geographical location.*

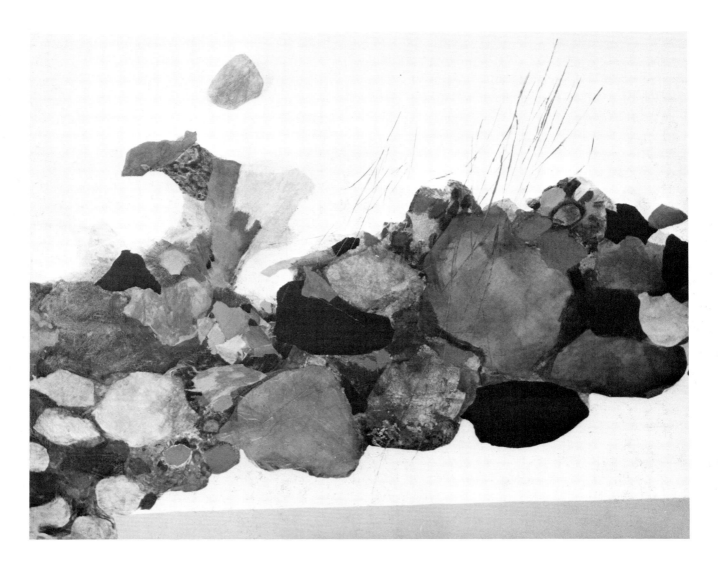

Rock Wall—Winter (Above) Acrylic and collage on Masonite, 40″ x 50″. Private collection. Photo courtesy Midtown Galleries, New York. In going through my files of snapshots, the photograph of the rock wall at left struck me unexpectedly—but as a snow scene. The first step was to strip the composition down to essentials and get rid of all trees and shrubbery in order to concentrate on the starkness of the wall against the flat snowy field and the tilted horizon. I depended on the torn collage shapes to create the rock forms and made no effort to stick to their arrangement in the photograph. The volumes were minimized to stress, above all else, textural differences and color and shape relationships. The snapshot was put aside and forgotten very early in the progress of this painting, but it had already given me the stimulus I needed.

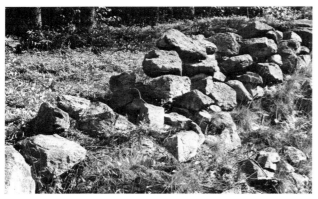

(Left) Photograph of rock wall, Pine Hill Road. Maine has many rock walls, and they were a recurrent theme in my work for a number of years. This one is very near my summer studio.

ject, then stored in the boxes in which slides are returned from the processing lab.

Telephoto Lens (optional). A 135mm telephoto lens is extremely helpful in bringing distant subjects closer. In contrast to the regular lens that is part of the camera, the telephoto has a more restricted angle of vision, including less of the subject in the frame than the standard lens. It is thus most useful in cutting out nonessential material and enlarging a distant subject so that it fills the frame to better advantage. In thirty years of using cameras, I have owned a telephoto lens for only the past eight or ten years, and now I would not be without it.

PHOTOGRAPHING PAINTINGS

I should mention in passing that I photograph all my paintings for my own records, taking color slides with the 35mm camera. I bind the finished slides with silver tape to mask out extraneous elements immediately surrounding the painting itself.

For shooting the same paintings in black and white, I use a 2¼″ x 2¼″ twin-lens reflex and 120-roll film, along with tripod and cable release, to ensure sharply focussed prints. I prefer to photograph paintings outdoors, in open shade, rather than try to cope with floodlights indoors.

FURTHER SUGGESTIONS

Since a camera is only one of several means of collecting material for future paintings, do not allow yourself to become too dependent on it alone or to resort to it too readily. Use it only when you feel you really need it, when circumstances indicate to you that the camera will do the job better than a drawing.

Keep in mind, too, that the camera is not only for documentary purposes. You can also utilize it to sharpen your powers of observation and to expand the range of your design conceptions. Do not shoot pictures at random. Put a great deal of care and thought into the selection and composition of the material. Search out the unusual, make very personal choices, and concentrate on those patterns, forms, and textures that relate to your painting generally.

When referring to the photographs as you draw or paint, treat them casually, as fragments of form, as bits and pieces that may contribute to your work. Do not fall into the trap of sticking too closely to the information they contain. Condense and revise the photographic images into simpler, more abstract forms; translate them, play with them freely to set your mind in motion. As much as possible, think of them more as a creative stimulus than as models that must be rigidly followed.

Turn the photos upside down, change around the dark and light values to suit yourself, combine several elements from several photos into a single drawing. Use them as a starting point for evolving formal relationships that in the long run may bear very little resemblance to the photos from which they originated. Once they have revealed things to you, and once a series of experimental drawings is on its way, the photographic sources can be put away and forgotten. Then the only important consideration is planning toward the painting that lies ahead.

If you use your camera with integrity and imagination as one step in the process of forming your art, there is no need to apologize to anyone.

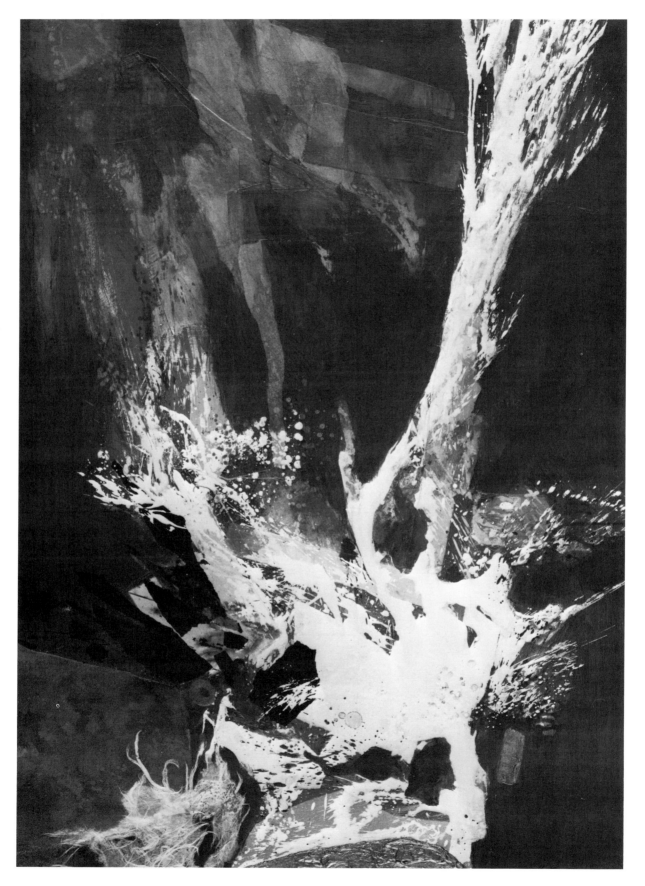

White Burst *Mixed media on Masonite, 39″ x 28″. Photo courtesy Midtown Galleries, New York.*

4. Other Sources for Pictorial Images

Aside from direct contact with nature through observation, drawing, and photography, there are other methods of stimulating the creative impulse. Consider, for instance, this passage from the notebooks of Leonardo da Vinci:

> I shall not refrain from including among these precepts a new and speculative idea, which although it may seem trivial and almost laughable, is nonetheless of great value in quickening the spirit of invention. It is this: that you should look at certain walls stained with damp or at stones of uneven color. If you have to invent some setting you will be able to see in these the likeness of divine landscapes, adorned with mountains, ruins, rocks, woods, great plains, hills and valleys in great variety; and then again you will see there battles and strange figures in violent action, expressions of faces and clothes, and an infinity of things which you will be able to reduce to their complete and proper forms.

He later advises the painter to study "the embers of the fire, or clouds or mud, or other similar objects from which you will find most admirable ideas . . . because from a confusion of shapes the spirit is quickened to new inventions."

Delacroix was widely read in both prose and poetry, and most of his work clearly reflects his knowledge. The British watercolorist Alexander Cozens recommended starting a painting with accidental blots of paint, which would suggest scenes that could be developed and finished in a traditional manner. Degas often used his monotypes, done with blurry and ambiguous shapes, as the beginnings of small landscapes that he elaborated slightly and clarified with touches of pastel.

In the twentieth century, Joan Miró and Paul Klee used automatist techniques to elicit forms and compositions from their personal, subconscious worlds rather than from the outer world. Jean Arp utilized the "laws of chance" as a major factor in a series of collages. He dropped pieces of paper randomly onto the picture surface then glued them in place wherever they happened to land, an acceptance of the unplanned and irrational that characterized much painting during the 1950s.

Many contemporary painters feel that their landscapes come from within and are brought to the surface and given form as a result of any one of a variety of stimuli. The artist's internal world is waiting to be evoked by whatever means the artist finds most productive, and it must be realized that this world is just as important to him as the outer, visible world. It is quite possible that the truest and most eloquent art is a successful fusion of both these worlds, visible and visionary, each enhancing and reinforcing the other.

Just as perception is one way to start the creative juices flowing, mental stimuli can be another and equally effective prelude to the act of painting.

OBJECTIVES

1. To broaden the range of pictorial ideas by several means other than direct observation and study of nature.

2. To discover ways of coordinating the internal world of memory, association, and intuition with the external world of visual forms.

3. To use chance and accident as a beginning procedure in developing unanticipated formal relationships.

4. To sharpen responses to all kinds of experiences that may serve as potential sources for paintings.

MATERIALS AND METHODS

The materials possible for this chapter are so general and so varied that I shall omit a specific list and deal directly with methods I have used most frequently and to best advantage:

Memory. In utilizing memory, especially in the production of representational paintings, it is essential to have a deep reservoir of visual experience based on many years of observation of people, places, and things. Memories that are not very broad or deep (and slightly inaccurate) lead to paintings that are not too convincing. If a student brings me a painting that was started outdoors but for one reason or another finished indoors from memory, I can instantly spot which areas were done where—the parts done from memory usually lack the authenticity, the feeling of having been there, that could imbue the picture with a consistent feeling of immediacy and conviction. Paintings done by an artist with a well-trained memory, on the other hand, can be of a very high order indeed.

Another aspect of the use of memory is that nonessentials are eliminated and only essences remain. Memory tends to sift and sort out in a kind of unconscious process

Collage Sketch *Collage on illustration board, 12" x 19". This is an example of forming a design according to the "laws of chance." In order to avoid habitual ways of placing shapes together I looked out the window as I worked, so that both the selection and placement of shapes were pure accident. Applying glue to each piece of paper was the only act that was conscious and intentional; once the glue was on, I turned my head, placed the paper somewhere on the picture, and fastened it in place. This is not as striking a composition as it might be, but very often relationships occur in a chance design that can be used more consciously in the course of my more serious painting. This is probably an experimental frivolity—a sort of pin-the-tail-on-the-donkey technique—but if it is at all productive at times, then I think it is still worth doing.*

Black Reef (Above) Mixed media on Masonite, 24″ x 48″. Private collection. Reading a magazine or newspaper upside down can shock those who are watching you, but I frequently do it in order to get a fresh view of the photographs, one in which I am not at all aware of subject but only of unusual shapes and patterns and designs. Sports sections of newspapers are excellent sources because many of the photographs have arresting contrasts of values and unexpected combinations of forms. I squint at the photo with my eyes nearly closed, so that the composition is reduced to its simplest terms. Very often certain arrangements or movements will suggest a subject to me; or they may suggest no more than a general design structure on which a painting can be built, whether it be realistic or abstract. Since an upside-down photograph is really nothing more than the initial spark for the creative impulse, there is nothing to be gained by copying it; once the painting is on its way, I set the clipping aside and complete the picture on its own terms.

(Right) Newspaper clipping, upside down.

A group of photos from my "upside-down" file.

of selection, with the result that the artist's mind is not cluttered by trivia that might weaken a picture's total impact. The important elements are retained and emphasized, and the unimportant things which do not contribute to expressivity are subordinated or even omitted altogether. In this way, memory acts as a partner in the intellectual business of ordering and arranging the raw material of art, and it is one good reason why I often favor memory in preference to sketches as a preparation for my paintings.

Memory, when used in conjunction with improvisational painting or drawing methods, can be of considerable help in identifying forms or giving the picture a push in the direction of a motif previously seen and experienced. Through memory, a jumble of shapes can be given a sense of reality or a reference to recognizable things. In this sense, memory and association are inseparably linked and are a way to order chaos into some kind of form with which the spectator can make contact.

I use memory as a bank from which to draw impressions and images at a later time. These are not necessarily specific details of scenes, but memories of a more general kind: a quality of light, weather, seasons, winds, shorelines, skies, textures of rocks and grasses, coastal fog, the distant glint of a band of light across a shadowed ocean.

Reading. Reading can also be a source of imagery for painting. I am very fond of the works of Henry Thoreau, Rachel Carson, Henry Beston, Loren Eiseley, and John Hay. Poet Robinson Jeffers has caught the spirit of the Big Sur area in California, and Robert Lowell, Philip Booth, and T.S. Eliot have written various poems that vividly project the mood of the New England coast. The notebooks of Gerard Manley Hopkins contain intensely observed and delineated closeups of nature, literary parallels to Edward Weston's photographs at Point Lobos. Then, too, there are many references to sea and shore in passages from Herman Melville, Walt Whitman, Joseph Conrad, Virginia Woolf, St. John Perse, Gavin Maxell, and John Steinbeck, to list a few.

All these and a great many other poets and writers spark my mind to conceive paintings that could be the visual equivalents—but *not illustrations*—of environments, lyrical moods, and human feelings depicted in writing. My finished painting may have no direct reference to the passage that was its inspiration, but the point is that the reading generated something in the way of an abstract mental image, hazy and unformed though it might be, that could be used as a working premise in getting a painting underway.

List of Picture Titles. My studio notebook contains not only a record of my paintings as they are done, month by month and year by year, but also a section devoted to possible titles for paintings. I never title my pictures until they are completely finished, and if by that time I have no definite title in mind I consult the list to see what might be appropriate, something that might furnish a

clue to any person viewing the picture as to what was generally in my mind while I was painting it.

The list also performs a second function: it is a springboard for imagery. The list is made up of two main categories: phrases that I have heard or encountered in my reading and those that I have composed myself. Most of them have a poetic quality that I respond strongly to, and they are vague enough to permit a free development of the painting. All the titles can be dealt with in terms of my own experience of the shores of California, Oregon, and especially Maine, with occasional isolated references to New Mexico or Florida.

Here are some titles I have already used: "Drowned Coast," "Edge of Winter," "Morningshore," "Night Surf," "Sea Quarry," "January Thaw," "Northern Mists," "Frozen Garden," "Summerscape," "Spring Snow."

And here are titles that have not yet made connection with specific paintings: "Summertime Sea," "Burnt Coast," "Moonshadow," "Sunken Forest," "Ledge Split," "Morning Moon," "Fog at Schoodic," "Fresh Snow, Deep Pool," "Granite Shore."

Before I start painting for the day, I sometimes check over my title list, and frequently some title will seem particularly arresting or provocative. Associations are brought to mind, and at that moment I am eager to get into my painting, with a clear purpose behind what I will be doing. As we shall see in later chapters, the forms may gradually change into something quite different as the picture progresses, but a reading of the titles kindles my imagination and provides an impetus for work.

Upside-Down Newspaper and Magazine Photos. Another means I use to refresh my compositional ideas is to go through photographic illustrations in magazines and newspapers—holding them upside down—the principal goal being to escape old habits and predictable compositions and to discover new ways of organizing paintings.

Many photographs that are perfectly ordinary when viewed in their normal position can offer quite unexpected and exciting designs when seen upside down or on their side. It is a way of looking at them with the subjects disguised or eliminated, so that it is possible to consider the photos strictly as arrangements of mass and pattern that can be enjoyed for their abstract qualities.

Striking distributions of shapes and of large, open spaces in opposition to clusters of small forms, as well as the interplay of line against mass, can suggest not only ways of dividing up a picture surface but also ideas as to the actual subject matter of a painting.

Magazine Photos Treated with Lacquer Thinner. A variation on the techniques of improvisational drawing is the treatment of magazine photographs with swipes, spatters, or splashes of lacquer thinner, followed immediately by a wipe with a paint rag or paper towel. When used on glossy magazine pages, this treatment yields a variety of accidentally-arrived-at compositions that serve as still

Photographs clipped from fashion magazines that have been brushed or spattered with lacquer thinner and then wiped immediately with a rag. Viewing these is not a psychological test, but a means of arousing associations that might lead to a painting.

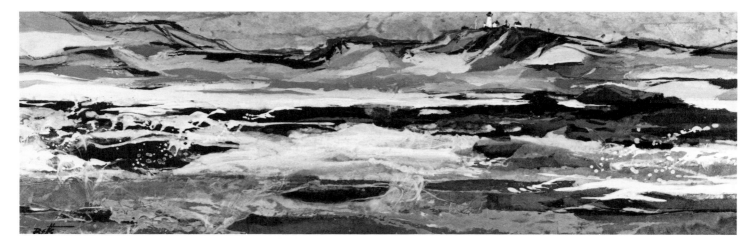

Highland Light, North Truro *Mixed media on illustration board, 10¼″ x 30″. I lived at North Truro for a summer and painted several versions of Highland Light in both oil and watercolor, but it was not until several years later that I felt impelled to do a mixed-media interpretation of that part of Cape Cod as seen from the water. Although the passage from Henry Beston quoted here is what stirred me to action, there was no attempt to illustrate the passage literally—I did not want a picture-postcard view of the dunes at North Truro—but rather to paint a picture that related to the spirit of the prose in the most general sense.*

At the foot of this cliff a great ocean beach runs north and south unbroken, mile lengthening into mile. Solitary and elemental, unsullied and remote, visited and possessed by the outer sea, these sands might be the end or the beginning of a world. Age by age, the sea here gives battle to the land; age by age, the earth struggles for her own, calling to her defence her energies and her creations, bidding her plants steal down upon the beach, and holding the frontier sands in a net of grass and roots which the storms wash free. The great rhythms of nature, today so dully disregarded, wounded even, have here their spacious and primeval liberty; cloud and shadow of cloud, wind and tide, tremor of night and day. Journeying birds alight here and fly away again all unseen, schools of great fish move beneath the waves, the surf flings its spray against the sun.

<div align="right">

Henry Beston, The Outermost House *(New York: Holt, Rinehart and Winston).*

</div>

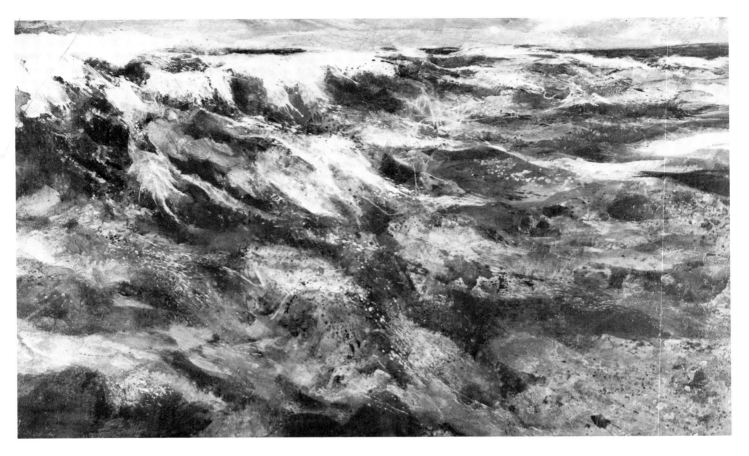

Sea Flow *Mixed media on Masonite, 36″ x 60″. Photo courtesy Midtown Galleries, New York. Pictorial images can be generated by reading. This, for instance, was painted in November, 1963, several weeks after re-reading* The Outermost House. *Henry Beston's writings about beaches and the sea are intensely lyrical and conjure up a wealth of images that are intimately connected with my own memories and observations. To be honest, I was not thinking of any specific passage when I painted this picture, though the passage quoted here seems to me a very close parallel to the mood of the painting. But I was thinking about offshore Cape Cod and Maine, Beston's writings, and of course my own remembrances of the ocean's vastness and its surge and flow. All these elements combine, on a mostly unconscious level, and then a picture is born.*

The sea has many voices. Listen to the surf, really lend it your ears, and you will hear in it a world of sounds: hollow boomings and heavy roarings, great watery tumblings and tramplings, long hissing seethes, sharp, rifle-shot reports, splashes, whispers, the grinding undertone of stones, and sometimes vocal sounds that might be the half-heard talk of people in the sea. And not only is the great sound varied in the manner of its making, it is also constantly changing its tempo, its pitch, its accent, and its rhythm, being now loud and thundering, now almost placid, now furious, now grave and solemn-slow, now a simple measure, now a rhythm monstrous with a sense of purpose and elemental will.

Beston, The Outermost House.

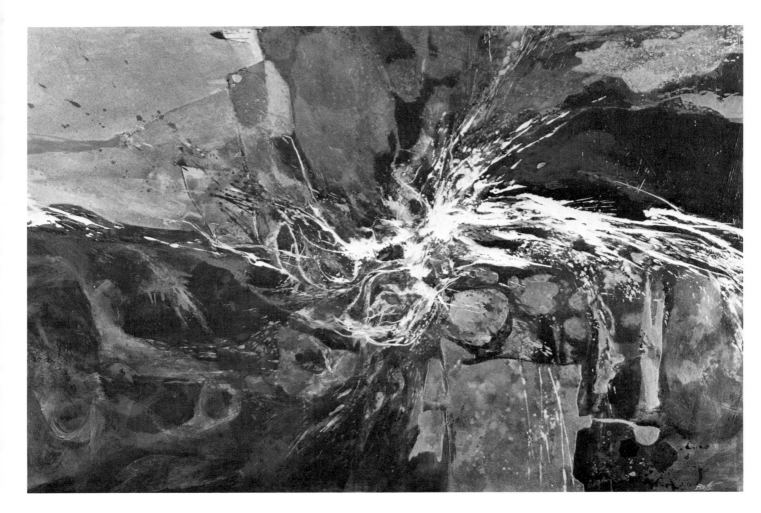

Coastal Reef *Mixed media on Masonite, 32" x 48". Collection Atlanta University, Atlanta, Georgia. I no longer have at hand the page treated with lacquer thinner that was the stimulus for this painting, but it was very similar to those that are shown here. I was not interested in repeating the blobs and spatters in the treated photo, but the general composition seemed to me to contain the bare bones of a painting, and from there it was a matter of filling it out, rearranging it, and allowing the media used (acrylic, sand, and rice paper) to further affect the character of the forms. Every once in a while I glue a treated photo to illustration board, and in response to its patterns I paint into it and glaze over it with acrylics until a satisfying image emerges; such works are to be taken more as experimental studies than as paintings.*

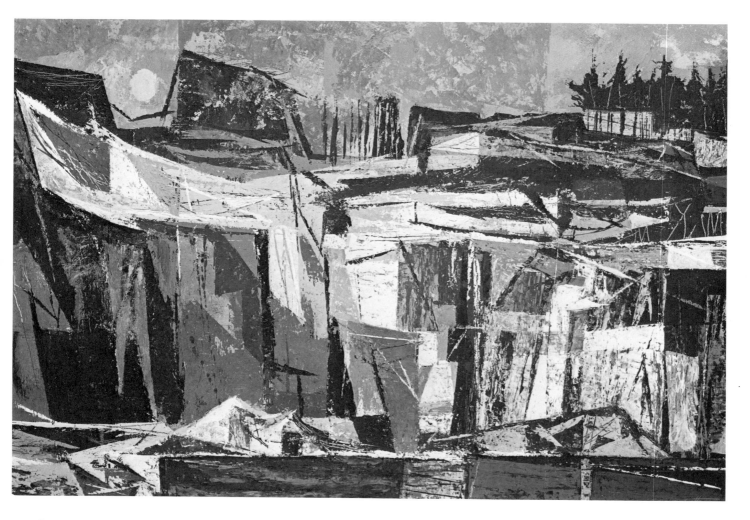

Coastal Cliffs *(Above) Casein on Masonite, 24" x 34". Private collection. This is an example of observing a fragment of nature and seeing in it the possibilities for a fully developed landscape of larger scale than the original fragment. Here the character of the forms in the photograph at right suggested enlargement to a more monumental scale, and that was enough to get me preparing a panel, taking up a painting knife, and playing with a variety of sharp-faceted forms that eventually became a textured, chalky cliff against a deep red sky. All of which is reminiscent of the old phrase about "seeing a universe in a grain of sand."*

(Right) Photograph of rocks at Schoodic. A closeup view of light-and-dark patterns in a rock formation.

The photograph on the left shows an altered skeleton of a bryozoan Schizoporella, magnified 1,000 times. (Scanning electron micrograph by Prof. Philip A. Sandberg, Department of Geology, University of Illinois.) The photograph on the right shows a thin section of serpentine rock, magnified 200 times. (Photo courtesy Walter C. McCrone Associates, Chicago.) Photographs of this kind are a rich source of material for abstract paintings. Some of these photographs are very organic and painterly, others are decorative and precise, but it would be meaningless folly to take these as direct sources, in the manner of the photorealist painters, and painstakingly reproduce them as paintings.

Detail from an acrylic painting. This section of one of my recent paintings is obviously related to the surfaces seen in some photomicrographs, but nevertheless I have never felt an impulse to duplicate the effects in such photographs or to incorporate them in my work; it is just that I respond deeply to what I see in them, and such responses are bound to influence my acceptance or rejection of whatever similar forms and surfaces appear spontaneously in my paintings. The images seen under the lens of a microscope should be merely an indirect source of inspiration for starting the creative juices flowing, but nothing more than that.

Aerial photographs. Abstract qualities are also evident in aerial photographs, with land and sea forms all but obliterated. Swirling rhythms, atmospheric textures, and the counterpoint of hard and soft edges and small shapes and large masses all function as part of an immense organic design. The photograph at the top shows a one-third-nautical-mile resolution visual picture of the western United States. Note features of the Baja Peninsula, Los Angeles, and San Francisco areas, and Puget Sound. The photograph above is a two-nautical-miles visual sensor view of the eastern United States at night, taken with the aid of the reflected moonlight, three days before a full moon. (Photos: United States Air Force.)

Winter Mist *Acrylic on Masonite, 40" x 50". Private collection. Photo courtesy Midtown Galleries, New York. Almost from the start,* Winter Mist *took on the look of an aerial view, similar to the viewpoints in some other paintings of mine. Aside from commercial flying, I was frequently a passenger on glider flights during World War II, and aerial views have always fascinated me. I have a small file of aerial photos, too, taken from heights ranging from a few thousand feet to several miles above the earth, many of them with even bolder shapes and patterns than the ones reproduced here. So it is fairly natural then that aerial views should crop up in my work now and then. While I was doing the picture shown here I was thinking specifically of fog drifting in over Point Lobos, just south of Carmel, California, with the ocean rolling in at the bottom of the painting, the land mass in the central area, and gray mists entering at upper left. Even if there is no available landscape motif as definite as that, a perusal of aerial photographs can suggest forms and compositions that provide the artist with a general format out of which a painting can be begun, whatever course it may take later.*

another means of beginning an abstract painting.

The lacquer thinner dissolves and lifts the printed inks, black and white or colored, and leaves the page with intriguing shapes, patterns, and transitions. The original subject matter of the photo is lost completely; what remains is a loosely formed composition that quite often is something to which the creative imagination can respond. Some of these exercises I toss out immediately, but many others are kept for future reference. Whether or not I ever use them in paintings, as a file of compositional variations they are another way to stimulate my mind, getting my form concepts in readiness for another day's painting.

Photomicrographs and Aerial Photographs. Although I am opposed to using secondary photo sources, there are two exceptions I would allow, although even in these instances I would never recommend direct copying. I refer here to two kinds of photographs that represent extreme opposites of scale: photomicrography and aerial photography.

Artists have been aware for some time of images recorded from the air or outer space and images made visible under the microscope. In both cases there is now available to us an astonishing wealth of abstract color structures, patterns, and textures, all of which have close affinities with the field of contemporary art. In many cases these photos could easily be mistaken for actual paintings. Science, then, has revealed to the artist whole new worlds of forms, other environments that provide rich, new sources of signs and symbols—an enlarged view of "one vast natural landscape," to borrow a phrase from John Constable.

As I have said before, this does not mean that as painters we simply copy the forms seen in these photographs. They are not to be imitated literally but to be used as a basis for interpretation and transformation into symbols, structures, and surfaces that can be employed to arrive at an art that has greater powers of suggestion and expression.

I enjoy looking at these photographs in the same way that I enjoy looking at paintings in a gallery or in a book. They are esthetically satisfying, and the ones that affect me most either possess very strong design qualities or a deeply poetic feeling. They might influence my concept of form, space, and color, but they are too beautiful and too complete to tempt me to try to improve on them. I accept them for what they are, enjoy them fully, and absorb and assimilate whatever they have to offer me, storing them all within me until such time as they may seem pertinent to the picture I happen to be working on. In the meantime, they may suggest an overall layout or format for a painting about to be undertaken. Once the picture is on its way, however, it will take its own form and the photograph will no longer be relevant to it.

OTHER SUGGESTIONS

Each artist finds his own sources from which to work up ideas for paintings. You may find that listening to music can be very rewarding in that respect—perhaps especially those composers, such as Delius, Debussy, Sibelius, or Mahler, whose works are most evocative of nature and its moods and atmospheric effects. Or you might try some of the works of Stravinsky, Ravel, de Falla, Holst, Ives, Copland, or Barber. Remember, however, this is not "music to paint by" but a point of departure for devising visual equivalents, which might range anywhere from implications of landscape to nonobjective compositions.

Study reflections in water or the way flowers and other objects cast shadows diagonally across a wall; make rubbings; invent improvisational methods of your own. Be aware of design possibilities all around you. Keep yourself exceptionally alert to any source, however unorthodox or unexpected, that arouses in you the urge to paint.

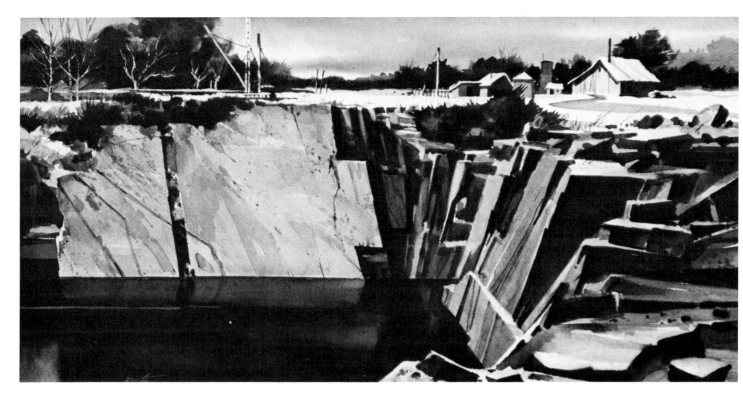

Quarry Pool—Winter *Watercolor on 140-lb Arches cold-pressed, 11½″ x 21½″.*

5. Transparent Watercolor

My feelings about my own work in watercolor have always been a little mixed. On one hand, I have always felt the greatest enjoyment in using this medium, and for all the usual reasons: its speed, sparkle, luminosity, and freshness. Contrary to its general reputation, watercolor has never struck me as being difficult. The reason why many painters find it a demanding medium is because it requires forethought and planning. There is very limited latitude for change and correction, or for improvising as you go along.

It might be noted in passing that I am completely self-taught as a watercolorist. Growing up in New York, I learned what I could simply by reading instructional books and constantly studying watercolor paintings at national exhibitions. My technique is based on the traditional methods that reflect the basic watercolor styles of Winslow Homer and John Singer Sargent, both of them outstanding masters of this medium. Unfortunately, however, between the two of them they virtually set the pattern for several generations of American watercolorists, many of whom paint so much alike they are almost indistinguishable from one another.

So my view toward my own watercolors is based on my style, which is very similar indeed to that of a great many other painters who are technically far more accomplished than I feel I am. As much as I personally enjoy using the medium, I have come to accept my transparent watercolor paintings as being a separate part of my total art production: a means of staying in frequent contact with nature and sharpening my perception, and a form of recreation. Since this reduces my use of watercolor to preliminary exercises for more ambitious statements or to little more than an activity engaged in for personal pleasure, I have made no effort at all to exhibit my watercolors nationally.

Having shared with you these private reservations concerning my own watercolors, let us consider in the next few chapters the various options available to the advanced watercolorist, starting first with watercolor used as transparent medium, and always keeping in mind that there is more than one way to paint a watercolor.

OBJECTIVES

1. To use transparent watercolor for a thoroughly planned and fully resolved painting, an enduring statement and not simply a sketch.

2. To take full advantage of the effects possible only with watercolor (wet-in-wet, luminous washes and glazes, untouched white paper, etc.) and to use the behavior of the medium itself as a means of arriving at forms and textures.

3. To avoid watercolor clichés by selecting subjects and stylistic treatments that are as uniquely personal as possible.

MATERIALS

Paper: 300-lb Arches rough; 140-lb Arches cold-pressed

Paints: Winsor & Newton tubes, or artists-quality Grumbacher or Permanent Pigments

Brushes: flat and round sable

Palette: white enamel butcher's tray or plastic watercolor palette

Drawing board

Gummed tape

Water container

Rags or paper towels

2B Pencil

Artgum eraser

Miscellaneous materials for special effects: see chart on page 68

NOTES

Paper. The papers I use most regularly are the handmade, imported French Arches 300-lb rough or 140-lb cold-pressed. I choose the latter when I am aiming for more subtlety and nuance in the washes. I am also very fond of R.W.S. (Royal Watercolour Society) 300-lb rough, which is handmade English paper with a beautiful surface that is a shade whiter than Arches. It does not take scratching with a razor blade very well, however; the surface tends to shred rather than to scrape smooth and clean.

I am assuming the reader is already well acquainted with the various papers, both domestic and imported. If not, it is advisable to acquire some sheets produced by different paper manufacturers and discover as soon as possible which papers seem to give the best results—which are the most enjoyable to work on, and which ones not only take color well but also retain their sparkle. Other papers that I can recommend are the Fabriano 300-lb rough or 140-lb cold-pressed; Whatman in as heavy a weight as is obtainable (this fine paper is no

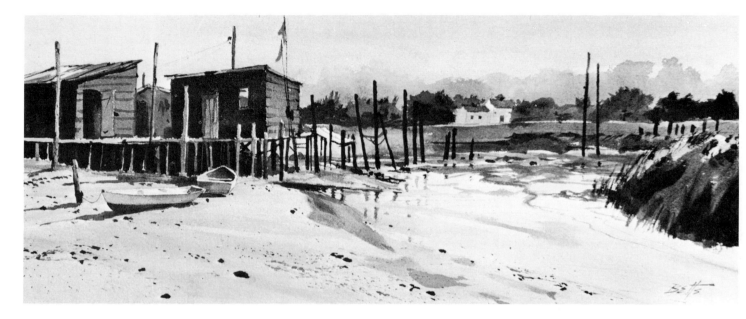

Low Tide *Watercolor on 140-lb Arches cold-pressed, 9" x 21". Collection of the artist. As an occasional change from rough paper I use 140-lb cold-pressed paper, which, though it lacks the textural richness of the rough, has other compensations. The cold-pressed seems to me to be capable of greater nuance in the washes, so where I want more delicate color or subtle gradations of value, I choose the smoother paper, the choice being determined largely by the subject matter. Also, it is possible to lift color from this paper with sponge or rag with greater sensitivity than from rough surfaces. It is worth keeping in mind, too, that clear water spatter on dried washes produces interesting dappled effects and textures that are not quite as easily achieved on rough paper.*

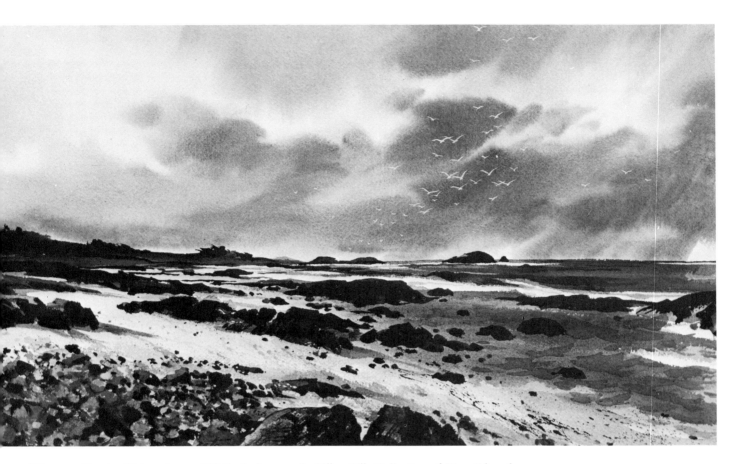

Monterey Coast *Watercolor on 300-lb Arches rough, 18″ x 29″. Collection of Mrs. Edward Betts. Most of my watercolors are done for sheer enjoyment and relaxation, and this is one that is mostly a souvenir painting of the beach our family walked almost every day during the time we lived at Pebble Beach. The coast there has a different character than the Maine coast, but it is equally dramatic and picturesque. I believe in using as big a brush as can be controlled, both for speed and simplicity, so this entire picture was painted with my two largest brushes, a 1″ flat and a Winsor & Newton No. 12 sable. Although I ordinarily avoid using opaque paint in a transparent watercolor, here I used designers gouache white for the seagulls.*

longer made, but now and then there is a chance of finding it in some art stores); or some of the Japanese white rice papers, such as Sekishu or Kozo, both of which come in 25″ x 39″ size. Strathmore makes a synthetic paper called "Aquarius," whose major advantage is that it never requires stretching.

Standard or imperial-size watercolor paper is 22″ x 30″, but the double-elephant-size Arches comes in a 240-lb weight and measures 26″ x 40″. Despite its size, it is quite reasonable in price, especially considering that it is possible to use it full size for major works, to divide up a sheet into quite a number of smaller sizes, or to cut unusually proportioned sheets that are not as easily obtained from the standard-size papers.

Economizing on paper is foolish to say the least. The cheaper, lighter papers do not take brushwork or color very well, and the machine-made papers have a monotonous surface. A fine paper, however, can make the most casual brushstroke look more beautiful than it actually is. Even a beginner in watercolor should use the best quality paper he can afford. Cheap paper will not in any way enhance the look of the painting and the money saved is not worth the time that may be wasted.

Paints. Another area in which to avoid false economies is in watercolor paints. Student-grade paints lack the intensity and richness of the artists-grade, which make up for their higher price by lasting longer. It takes a smaller amount of intense pigment to get a fully saturated color mixture than it does of weaker pigment. A tube of the latter can sometimes be used up in two days of painting!

Tube colors are the only acceptable paints. Watercolor in cakes is not as rich and is very hard on brushes. The best tube watercolors, by consensus, are made in England by Winsor & Newton, but artists-grade colors by any of the major American firms are undoubtedly excellent.

My basic transparent watercolor palette is as follows:

Raw sienna

Burnt sienna

Hooker's green deep

Ultramarine blue

New Gamboge

Yellow ochre

Cadmium orange

Alizarin crimson

Colors that I may sometimes use as supplements, depending on the subject I am painting, are:

Warm sepia

Winsor (phthalocyanine) green

Viridian

Winsor (phthalocyanine) blue

Cobalt blue

Indigo

Cerulean blue

Cadmium red extra scarlet

Designer's gouache white

(No black, no Payne's gray)

The simpler the palette, the better. I know several prominent watercolorists who never lay out more than five pigments on their palette; the five vary from painting to painting, but that is the limit they set themselves. This is possibly a bit stricter than necessary, but there is no doubt that it is one way of achieving color harmony.

I lay out all eight or nine colors whether I think I will need them or not, plus any others I feel might possibly be used. You cannot start a painting, as one of my students did, by squeezing out some "sky color," and later squeezing out some "grass color," and then later putting out some "roof color" on the palette. Every color that might conceivably be required should be set out on the palette at the very start. It really is surprising how quickly they are all put to use.

There may be times, though, when a limited palette is needed—for on-location sketches, for subjects whose color range is very restricted, or perhaps for those painters who have not yet mastered full-palette color orchestration. Here are some limited palettes I use from time to time:

Warm and Cool

 Phthalocyanine blue or indigo

 Burnt sienna

Primaries

 Winsor blue

 Winsor red

 Winsor yellow

 Cobalt blue

 Alizarin crimson

 Cadmium yellow medium

Expanded Primaries (warm and cool of each)

 Ultramarine blue (warm)

 Winsor blue (cool)

 Cadmium red extra scarlet (warm)

 Alizarin crimson (cool)

 Cadmium yellow light (warm)

 Yellow ochre (cool)

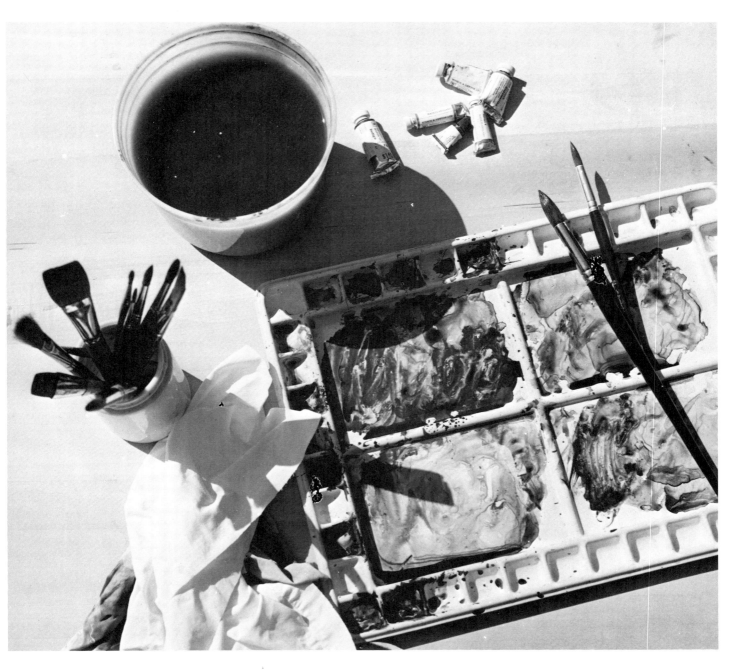

At the end of an afternoon of painting, my watercolor palette, brushes, plastic water container, paint rags, and tubes of Winsor & Newton paint.

These are my watercolor brushes (from left to right): 1″ flat sable, No. 12 round sable, No. 9 round sable, No. 4 round sable, ¾″ flat, and ½″ flat. Having a few fine brushes is better than owning many cheap ones.

Sumi brushes are used as supplementary brushes. They handle somewhat differently than the more resilient sables, and many of them take getting used to. The larger sizes hold a lot of color yet come to a very sharp point.

Burnt sienna (warm)

Raw umber (cool)

Miscellaneous Color Groups

Indigo

Hooker's green deep

Alizarin crimson

Burnt sienna

Ultramarine blue

Viridian

Cadmium yellow light

Cadmium orange

Cadmium red extra scarlet

Alizarin crimson

Supplementary materials: artgum eraser, 2B pencil, sponges in two sizes, and gummed tape.

Brushes. This is the third item where quality should be considered before cost. If properly cared for, a watercolor brush of fine quality can last almost indefinitely—I am still using two that I have had since 1935—so it is worth purchasing brushes with the attitude that they are a lifetime investment. If brushes are rinsed thoroughly at the end of each painting session, washed with mild soap and warm water about once a month, and carefully shaped before drying, they will give many years of use. Cheap watercolor brushes have very little spring or resilience, lose their point relatively soon, and in general deteriorate quickly.

The brushes I use are Winsor & Newton round sables Nos. 12, 9, and 5, and a 1″ flat sable brush for large areas. (The No. 12 retails now at something over $50, but it is in itself a work of art—a full, fat brush that comes to a fine point and is capable of laying in broad washes or making the smallest accents.) In addiiton to those four brushes, I also have a ¾″ flat oxhair and an assortment of brushes of various sizes.

Palette. For may years I used a folding metal watercolor sketch box as my palette. Later I switched to an enamel butcher's tray. Most recently, however, I have come to prefer a 12″ x 16″ plastic watercolor palette, rimmed with depressions for holding the pigments and having four large mixing areas in the center. The main advantage of such a design is that the paint mixtures are well separated from the pigment compartments and the paints cannot flow into each other. Adequate mixing space is the first thing to look for in selecting a palette; the one I use has plenty of mixing areas and more than a sufficient number of depressions to hold the number of paints I set out.

My system of laying out paints for both oil and watercolor was standardized early in my career. Raw sienna and burnt sienna are in the lower left-hand corner; the greens and blues are along the left-hand edge of the pal-

Half-gallon plastic containers, with lids, are excellent for outdoor painting since they are light and unbreakable.

ette; and across the far side of the palette are the warm colors, yellows at the left, oranges, and then reds over at the right. The particular system used is not as important as that it be a *consistent* system, so that the brush automatically heads in the direction of a specific color like a homing pigeon. This should be so instinctive that no precious time is lost in trying to figure out where the color has been set out.

Drawing Boards. No matter how heavy my paper, I always stretch it before painting. I make a habit of keeping seven or eight sheets stretched in advance upon drawing boards, thin plywood, Celotex, or Upson board. I prefer to use gummed tape to attach the dampened paper to the board, though there are some papers that buckle so severely when wet that only staples or thumbtacks are effective. The fiber boards such as Celotex, Homasote, or Upson are so porous and loose in texture that tacks will not grip tightly, and taping is the only method of securing the paper to the board. It is in their favor, however, that they are of lighter weight than a wooden drawing board and consequently more convenient for sketching trips where portability is a major consideration.

Gummed Tape. Only heavy, gummed wrapping tape can be used to hold wet paper, which exerts strong tensions as it dries and tightens. Masking or drafting tape simply will not adhere to damp paper nor hold it tightly enough to the board.

Water Container. Here again I use a ½-gallon plastic container because it holds plenty of water and is almost 7″ wide. When painting watercolors outdoors, though, I use a 1-gallon plastic jug with lid and handle.

The other materials are, I think, self-explanatory: absorbent rags or paper towels for wiping brushes or lifting paint; a 2B pencil with which to block in the preparatory drawing on the paper; and an Artgum eraser for removing unwanted pencil lines after the painting has been completed.

TEXTURES AND SPECIAL EFFECTS

The miscellaneous materials for corrections and special textures and effects are to be used only when needed and not as gimmicks that merely call attention to themselves without really serving any expressive function in the painting. Nevertheless, attention to textures and differentiation of surfaces is an important part of a watercolor painting, since this lends the picture greater richness and variety than is possible with washes alone.

Here are the materials with which to produce textures and special effects, grouped according to their uses.

Materials	Uses
Razor blade	
Penknife (point as well as broad edge)	Lines, corrections, textures
Painting knife	
Paper towel	
Facial tissues } *on wet surfaces*	Lifting, lightening, textures, and corrections
Cellulose sponge	
Sandpaper (fine) } *on dry surfaces*	
Pink Pearl eraser	
Salt	Textures
Epsom salts	
Ink roller (brayer)	Textures
Matboard strips	Lines, stamped textures
Corrugated cardboard strips	
Inks	Lines, flow textures
Toothbrush	Stippling, spatter, lifting, scrubbing out, textures
Bristle brush	
Wax crayons	
Maskoid*	Frisket, resists
Masking tape	
Spray bottle	Paint spray
Fixative blower	
Chinese white or designers permanent white	Opaque retouching
Ruler	Scratching straight lines (with razor blade)

Caution: Maskoid or other liquid friskets are preferable to rubber cement because rubber cement often leaves a yellow stain on the paper that does not show up immediately, but appears a year or so later.

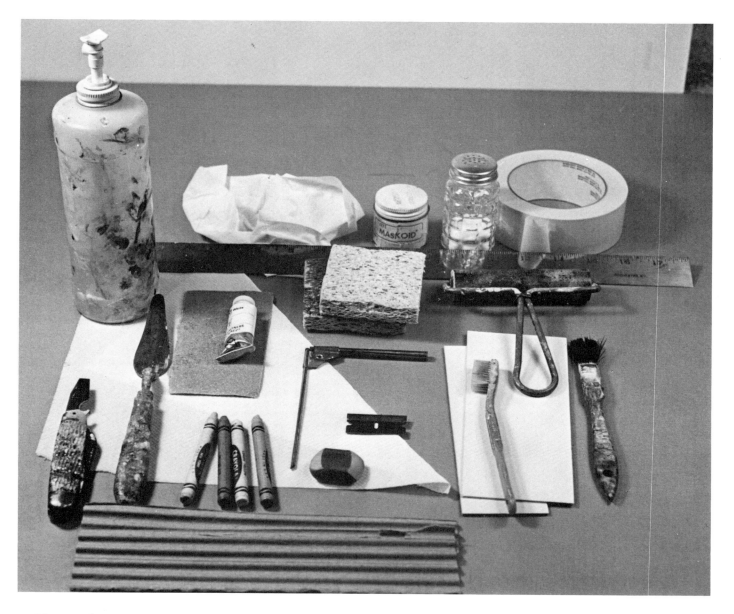

These are the extra materials and tools used for textures or paint effects not ordinarily obtainable with brushes alone. Included here are the items listed opposite, such as masking tape, Maskoid, wax crayons, toothbrush, salt, tissues, and sponge.

Watercolor Textures

Lines with a painting knife.

Use of ruler and razor blade to scratch lines into dry paint.

Stampings with corrugated cardboard.

Scraping with knife blade into wet paint.

Stampings with edge of matboard.

Razor blade scratching and scraping, both point and broadside.

Liquid frisket (Maskoid).

Cut and torn masking tape as a frisket.

Wax crayon resist.

Toothbrush for stipple and brushed effects.

Lifting and wiping with facial tissue.

Lifting and wiping with sponge.

Salt.

Sandpaper.

Ink flow.

Painting Outdoors vs. Indoors. While many professional watercolorists still work outdoors, their on-location paintings are more in the nature of sketches that are preparatory to finished work done later in the studio. In my own case, I look upon my representational watercolors as a form of note-taking and a way of remaining in touch with the visual aspects of nature, and I hope that the knowledge gained from such an experiencing of nature will ultimately enrich my abstract paintings. I feel that it is quite possible for painters to drift away from their primary sources and end up painting pictures about painting, with the result that their art begins to feed off itself, eventually becoming sterile and repetitious.

You must keep in mind that watercolor should be used as creatively as possible so that your paintings will stand out from the mass of highly competent work that is so uniform in content, style, and viewpoint. With the aim of fully exploiting the possibilities of the medium, but without opportunities for opaque overpainting, it is not very likely that a highly complex image can be worked out casually in a painting done on location. This means that a good amount of preparation on your part, artistic as well as practical, must precede a well-constructed and controlled but expressive painting. In a transparent medium it is essential to plan sufficiently so that the full freshness and clarity of the washes is maintained right to the end. When I say "plan sufficiently," however, I do not mean to the extent that nothing is left to chance and you find yourself filling in the colors as you would in a coloring book.

If, in the long run, you find that work done on the spot has the freedom and directness you are after, then that is the best method for you. In general, though, working up a watercolor in the studio based on sketches and color notes seems to be the method most painters prefer.

Between these two approaches, however, there lies still a third way, used successfully by several watercolorists of my acquaintance: they begin the painting on location, carry it only to a certain point, then return to the studio to finish work there. The advantage of this method is that it combines the assets of both methods previously mentioned: the inspiration and authenticity derived from direct contact with nature, together with the opportunity for deliberation, contemplation, and precise adjustments of color and value afforded by studio conditions.

The disadvantage of this method is that there is an interruption in the continuity of the painting process. This continuity is often important in sustaining both the conception of the picture and the consistency of technical or stylistic treatment. Nevertheless, it is a perfectly valid way of bringing forth a painting and is worth a fair trial if you are to discover which of the three methods is most congenial to both your painting and your personality.

Preparation vs. Spontaneity. There are two general methods for approaching the creation of a watercolor. The

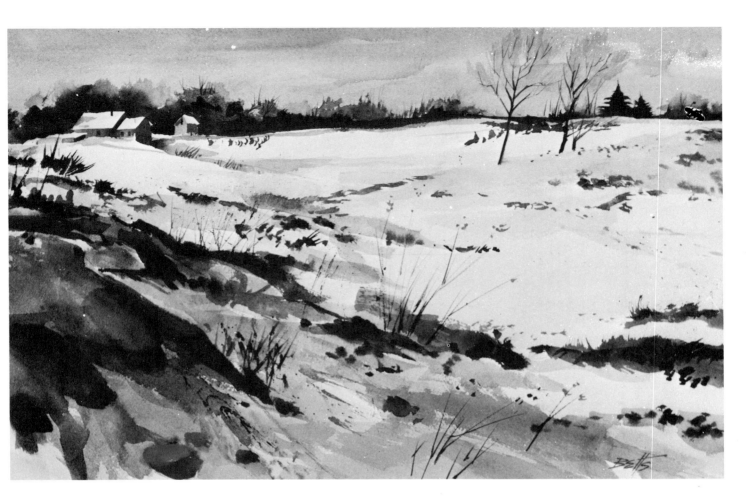

Snow Field *Watercolor on 140-lb Arches cold-pressed, 15" x 22". I keep the preliminary block-ing-in as simple and concise as possible. The only drawing for this watercolor was a brief indication of the distant rolling edge of the field, and the house and barn. Everything else was improvised in paint as I went along. I had a clear mental idea of what the composition would be, but with a subject as basically simple as this there seemed to be no need to clutter up the sheet with a lot of pencil lines that might inhibit free brushwork. In snow scenes I keep skies either a deep blue or a middle-to-dark gray in order to emphasize the whiteness of the snow.*

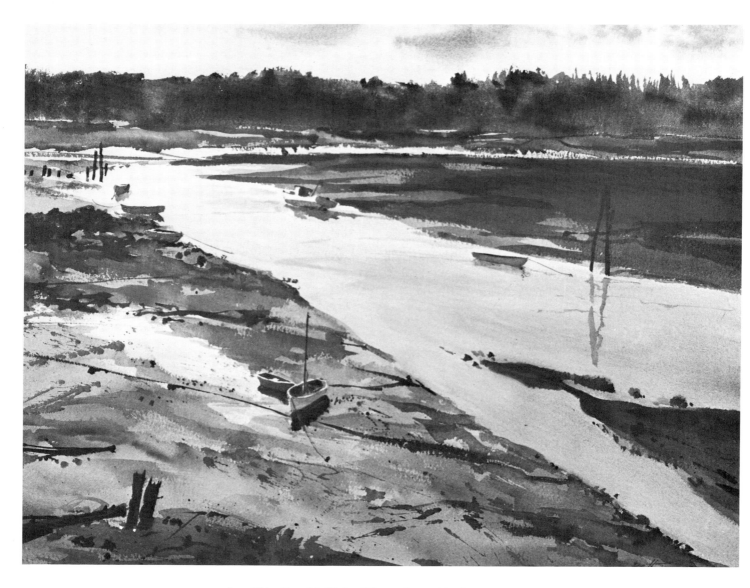

Low Tide, Cape Neddick *Watercolor on 300-lb Arches rough, 22" x 30". This was sketched very late in the afternoon from a bridge overlooking a river at low tide. What intrigued me most was the glare of the sun on both the water and the dark, wet mudflats, and the shape of the river cutting across and into the marshes. Some areas were kept simple or out of focus in order to make the most out of the texture and spattered paint at left.*

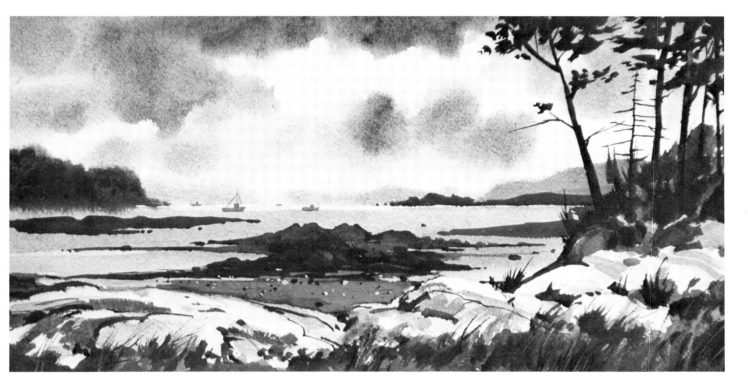

View of the Bay *Watercolor on 300-lb Arches rough, 9½″ x 17½″. Private collection. Wet-in-wet technique was used for the sky, intermixing several strong colors directly into the wet paper, and it was also used to give an effect of haze and distance that contrasted with the sharpness of edges in the foreground trees. In the lower middle area of wet sand, some of the small rocks were indicated with touches of opaque watercolor.*

Detail of Noon Glare, Turbot's Creek *(page 217). Using the largest brush possible, effects of sunlight and shadow were brushed in broadly and simply. The brush was handled differently from area to area to give the picture textural variety.*

Detail of Grindstone Point *(page 36). This shows the use of drybrush to soften the top edge of the far island, and the use of spattered and scraped textures in the foreground. The central part of the painting is seen with greater clarity and crispness than the less important rocks at the bottom.*

Detail of Nubble Light *(page 84 and in color on page 216). I am most concerned with simple masses and breadth of treatment, saying as much as possible with the greatest economy of means. Here again a contrast of hard and soft edges adds variety and aids in the emphasis and suppression of different areas.*

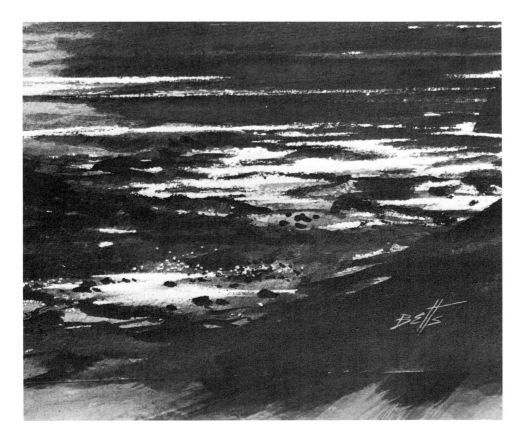

Detail of Nubble Light. *To achieve the look of the glint of bright light on water, rocks and sea-weed, I employed direct wash, wet-in-wet, lifting, drybrush, and scraping and picking with the razor blade. There is no opaque white, only the white of the paper, which had to be tough to take this much punishment.*

first is one in which you immerse yourself in your subject: observe it, meditate on it, and get to know it thoroughly through sketches and a series of preparatory studies. You develop a vision of the subject, how it will look as a painting and what it will express, and then just before you start to paint, you plan the picture clearly as to color, values, and pattern, and the sequence in which the washes will be applied. With these preliminaries behind you, you can begin the painting with all your energies intent upon projecting your vision through the immediacy of the watercolor medium. You have decided what you are after, and you pursue that idea with singleness of purpose, treating the subject matter so that there are no distractions from the idea you are determined to put across. You can paint at white heat because you have the security of knowing where everything will be, and accidents are held to a minimum.

The other method is the spontaneous approach. Here again you should thoroughly explore your subject, but this time you will not carry the advance planning of the technical details quite so far. Here the dependence is upon inspiration during the act of painting—a more intuitive way of attacking the picture. You are closely attuned to your subject, and the aim is to capture both your idea and your emotional response through the most direct means, without hesitancies or second thoughts.

If you adopt this method, however, you must be prepared to accept the many risks involved. This is transparent watercolor, and one misstep can be fatal to the entire picture. It is very likely that three or four attempts at painting will have to be discarded and the picture begun over again—and to be able to sustain genuine enthusiasm and spontaneity for that length of time is not easy. With this unplanned approach you stake everything on the chance that even though you may lose a few, when you *do* succeed, the painting will have an inescapable impact, touching the spectator with its inspired blending of painterly technique, observational insight, and intense emotional response.

Both these methods have their strengths and weaknesses. The planned method may be *too* well planned and turn out to be dull and unexciting if not carried off with a certain degree of flair and vigor. Still, it assures control during the evolution of the painting, as well as a readable, ordered assembling of its elements.

The spontaneous approach can get out of hand, relying as it does perhaps a bit too much on happy accidents, and the mortality rate of such paintings is relatively high. On the other hand, in those few pictures that are brought off successfully the effect can be an extraordinarily powerful esthetic experience. By trying both these methods over a period of time, you will find the one that is most natural to you and produces the most effective results.

Exploring the Resources of Watercolor. Feel free to experiment with watercolor and make an effort to use the watercolor medium itself to create forms and textures in your pictures. I think it goes without saying that any

painting should be true to its medium, stressing its special qualities, whether it is watercolor, acrylic, oil, encaustic, or egg tempera. And I think it should be added that whenever possible the forms, shapes, and surface appearance of the painting should be to some extent the direct result of a manipulation of the medium.

In the case of transparent watercolor, the wet-in-wet treatment produces transitions, blendings, and gradations. The paint spreads of its own accord, forming shapes and areas that can be seized and used as part of the picture, and these effects occur partially as a result of the behavior of the medium itself. The same idea holds when you spatter or fling paint, or use stipple or drybrush. In a certain sense your painting can be considered the outcome of a collaboration between you, nature, and the intrinsic qualities of the medium in which you are painting. All three collaborators have something vital to contribute to the look of the picture.

The very fluidity of watercolor makes it an ideal medium for gestural painting—the brush in combination with movement of the fingers, wrist, and entire arm swinging freely over large expanses of paper. You can be thinking of nature in the back of your mind, but you are working with paint. You are first and foremost using the watercolor medium, but at the same time you are fusing it with nature's own forms and movements—the hard planes of a rock, a tree thrusting upward, the flow of water, grasses bent in the wind—making the two inseparable. Now you are really *painting* in the deepest sense, not just using paint as a vehicle for rendering a surface view of things.

Selecting Subject Matter. Above all, paint the things that move you—genuinely move you—not those things that are obvious or merely fashionable. Paint them because you *must* paint them, not because you have seen them done well by someone else. The greatest painters paint out of necessity, out of almost obsessional urges. Picasso acknowledged this artistic truth when he said, "The artist does not choose his subject; his subject chooses him."

A number of years ago Andrew Wyeth painted a picture of a wagon in a barnyard. Wyeth painted it beautifully because it meant something to him; it was part of the environment to which he responds so sensitively and with which he has so many associations. One thing he did not foresee was this scene's impact on a multitude of lesser painters.

During my last three art juries, I saw countless wagons—wagons in barnyards and in deep grass; wagons seen from the front, back, side, and three-quarter view; wagons of all colors and varying stages of weathered decay. It all seemed too coincidental. Barring the idea that one classic wagon had been taken on a nationwide tour for the edification of artists everywhere, the only logical assumption seemed to be that Andrew Wyeth had had a disastrous influence on painters looking for a sure-fire subject with built-in appeal and a seal of approval.

What these painters had missed was that Wyeth had seen it first, in terms of his personal vision and style. The imitators saw only the obviously picturesque aspects of the subject, and their versions of it added little or nothing in the way of a viewpoint, idea, meaning, or technical skill.

Therefore, when selecting subjects try to avoid the things that have been done too often or too well. Or, if you must paint them despite all warnings, try to find some attitude behind your painting that will lift those subjects out of the routine and the overdone. Stress the mood or atmosphere, the drama of light, the feeling of weather; use color and space or shape relationships as your prime reasons for painting, or approach the subject with the idea of revealing its essential design structure.

The important thing is to look deeply into *yourself*; ascertain exactly what qualities of your subject appeal strongly to you and just what the nature of your response is. Then enjoy every means at your disposal to concentrate on transmitting, in painterly terms, your involvement with your subject matter with the utmost economy, vividness, and clarity.

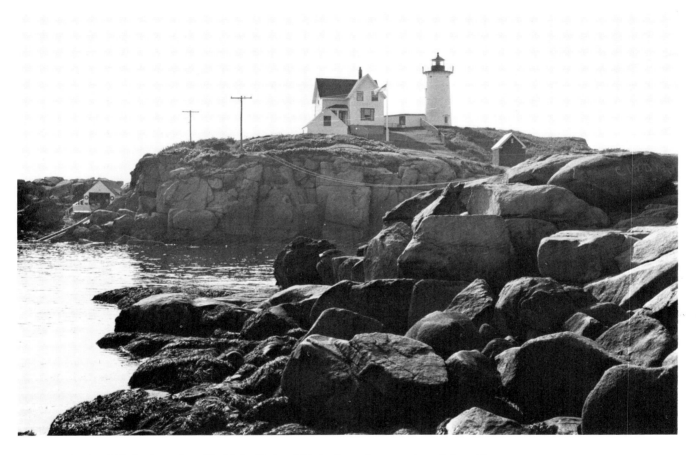

Photograph of Nubble Light at Cape Neddick, Maine. This is about the same view of the subject as that from which the following demonstration was painted.

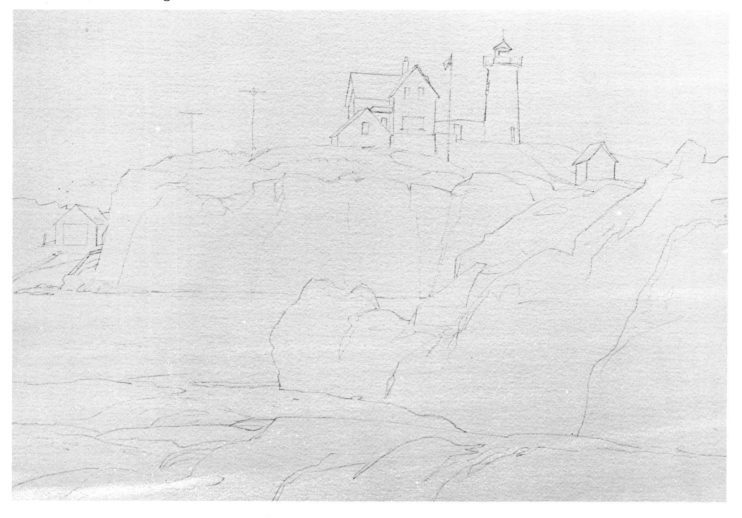

Step 1. The paper used for this painting was 300-lb Arches rough, stretched and taped on a large drawing board. The preliminary drawing was done in less than ten minutes with a 2B pencil. Ordinarily I keep the pencil blocking-in as simple and concise as possible (often only three or four lines will suffice), since I want to provide myself with no more than the really necessary information. In this case, however, the complexity of the subject, with its lighthouse and the jumble of rock forms, seemed to demand a more specific drawing, so that every area would be clearly understood both on the paper and in my own mind. Although this stage of the picture is rather carefully delineated, the shapes are not "filled in" tightly or mechanically. Quite the opposite: the very fact that all the areas have been completely established in line means that I can then swing the brush freely, with possibilities for greater enjoyment of the act of painting itself and less constant attention to the matter of drawing during the actual execution of the picture.

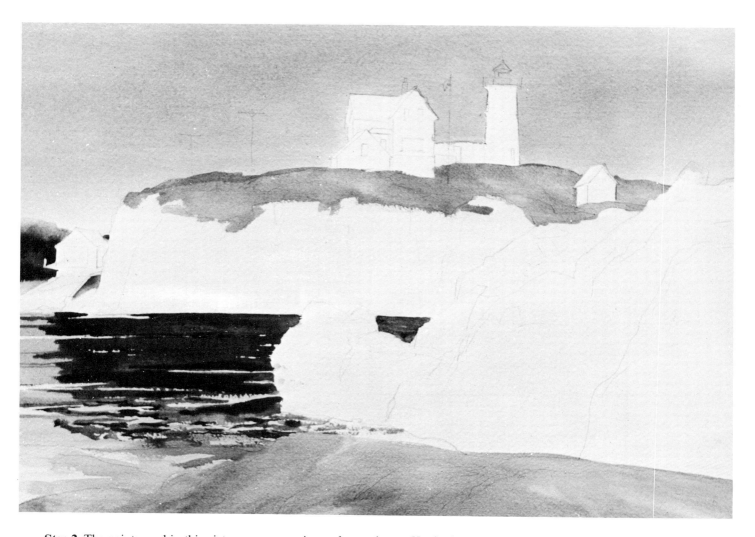

Step 2. The paints used in this picture were raw sienna, burnt sienna, Hooker's green No. 2, permanent blue, cerulean blue, new gamboge, yellow ochre, cadmium orange, cadmium red light, and alizarin crimson. First of all, a wash of water was put over the entire sky area with a large flat brush, working carefully around the buildings. Then the sky was painted in, beginning with a light wash of gray-blue followed by a darker wet-in-wet wash of the same color. While the sky was drying, I painted the lighter tones of the rock in the immediate foreground, again using a wet-in-wet flowing of one color into another. After the sky was thoroughly dry, the grass was laid in with a preliminary tone, then the rocks adjacent to the boathouse at left, keeping the upper edge of those rocks in softer focus than the edge of the grass against the sky. While those areas dried, I painted the water, starting with the lighter tones at extreme left, then immediately laying in the dark reflection in the water, leaving occasional streaks of white paper running horizontally across it to suggest the glint of light on the surface of the water. Even at this stage I was attentive to the distribution of contrasting values and to establishing the foundations for a dramatic pattern. All areas at this stage were done with a No. 12 sable brush.

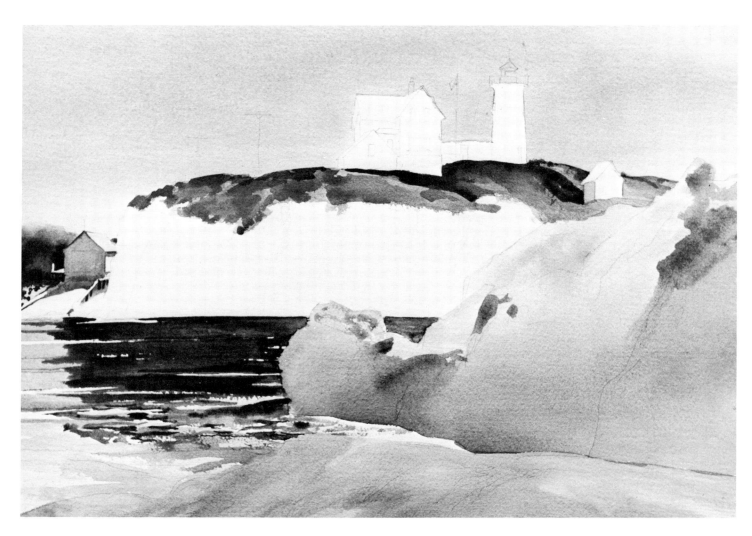

Step 3. Still working with the large brush, I went on to develop the middle values in the grass, not as a flat wash, but as a series of direct brushstrokes in varying colors, so that there would be some irregularity and roughness. A few very dark shadow accents on the grass were also painted in boldly, following the contours of the land and expressing its form, to begin to set up a sense of light and dark. Then I painted the light side of the small shed at right, and the shadow side of the boathouse, treating the latter as wet-in-wet in order to obtain greater luminosity of color mixtures within the shadow. Next I tackled the large mass of rocks at the right, floating in a variety of wet-in-wet mixtures mostly as foundation color for the washes that were to follow. There was no effort at this point to define the planes of the rocks; I simply wanted to get rid of the white paper and to set up the lighter tones of the rocks. I had no clear idea of exactly where the lights and darks in the rocks would be, except in the most general terms.

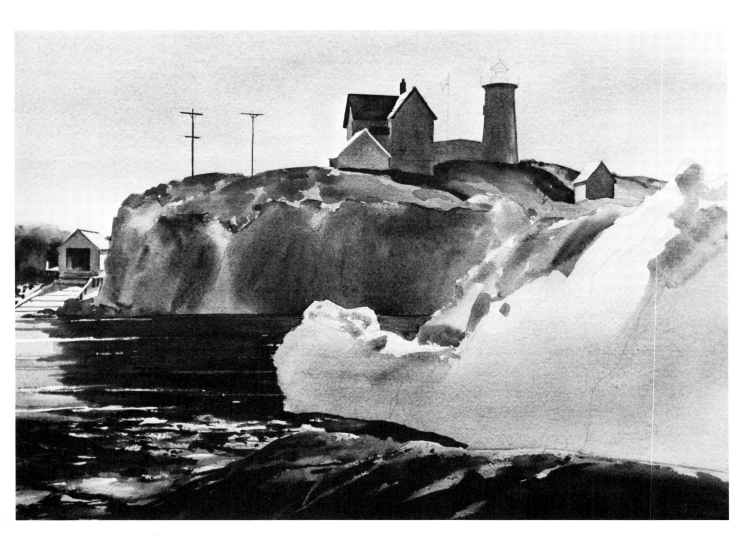

Step 4. Now that some of the necessary drudgery is out of the way, the picture begins to take shape and some of the really enjoyable painting begins. I broadly and simply painted the mass of buildings against the sky, using wet-in-wet, and added the dark roof and other accents as it dried. Next I did the shadow side of the shed at right, then developed the area at left in and around the boathouse. With details of this sort behind me, I once again returned to masses, painting a middle value over the island rocks, and flooded in some broad darks that were purposely kept out of focus so that they would stay in their place behind all the foreground rocks. Moving around the picture, never staying in one area too long, I returned to painting further in the water and in the seaweed at lower left, and brushing in the dark form of the long rock at the base of the painting, treating it partly as direct wash with hard edges and partly as wet-in-wet for softer transitions. Finally, I went back to the rocks at right and painted the area where they touched the more distant rocks, then I worked more in the water, suppressing some of the light streaks.

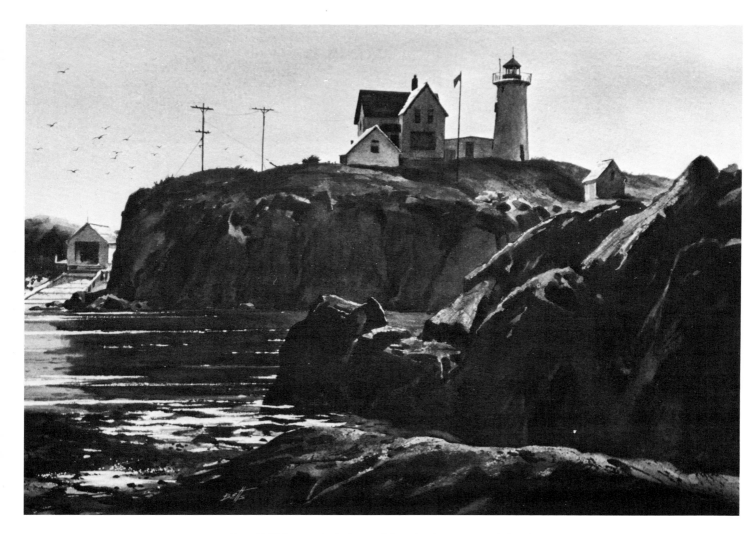

Step 5. This step includes revisions in the grass and development of the island rocks so that they have a suggestion of detail yet remain softer and a shade lighter than the foreground rocks. Once that area had dried, I could tell how dark the rocks at right would have to be, so first I established the middle tones and then did the main shadow mass with a large brush, lots of paint, and not very much water. Where the darks became too dense, I moistened the area with clear water and lifted off the paint with a clean brush; this kept the darks from being too flat and formless and gave an effect of sunlight reflected back into the shadows. Finally, the finishing touches: notes of spatter and drybrush texture here and there, windows and doors and the top of the lighthouse, seagulls, and rock accents, all done with a No. 9 brush. At the very end I used a razor blade to sharpen and lighten some edges throughout the picture, but most particularly I used it to scratch out more glint and dots of light on the water, and to bring out clearer shapes in the foreground water as well as a suggestion of more light glare and textures in the pool of seaweed at lower left. At this point I studied the picture as a total surface, and with a No. 5 brush I made a few minor adjustments of tone and value so that all the elements of the picture fitted together as well as possible in a purely pictorial sense, not necessarily in terms of what had actually been there. (For color reproduction of this painting, see page 216.)

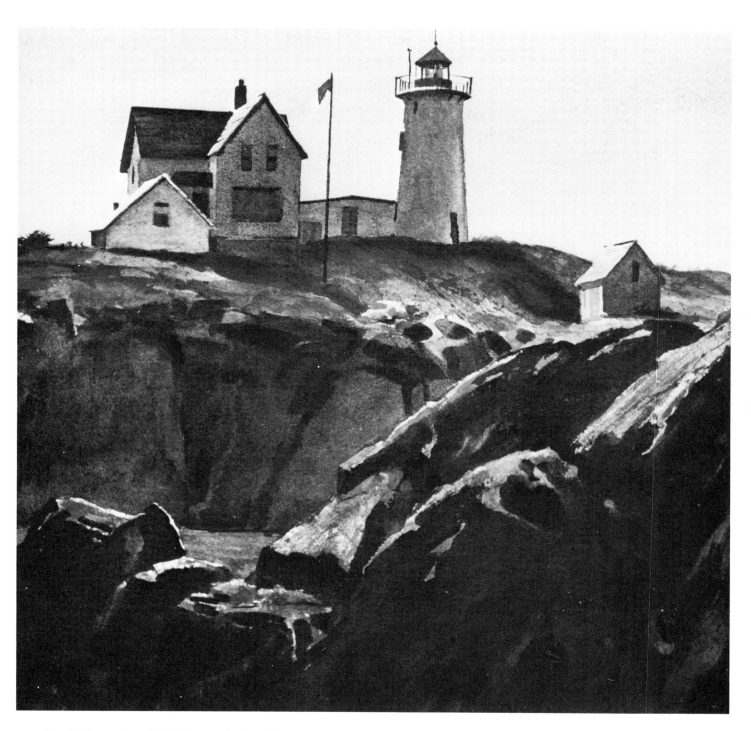

Detail. Strength and solidity are obtained by working in broad washes, treating lights and darks as masses, and avoiding or simplifying all unimportant details. When painting against the light, with the darks so closely related to each other, it is essential that subtle differentiations of value be clearly separated and defined.

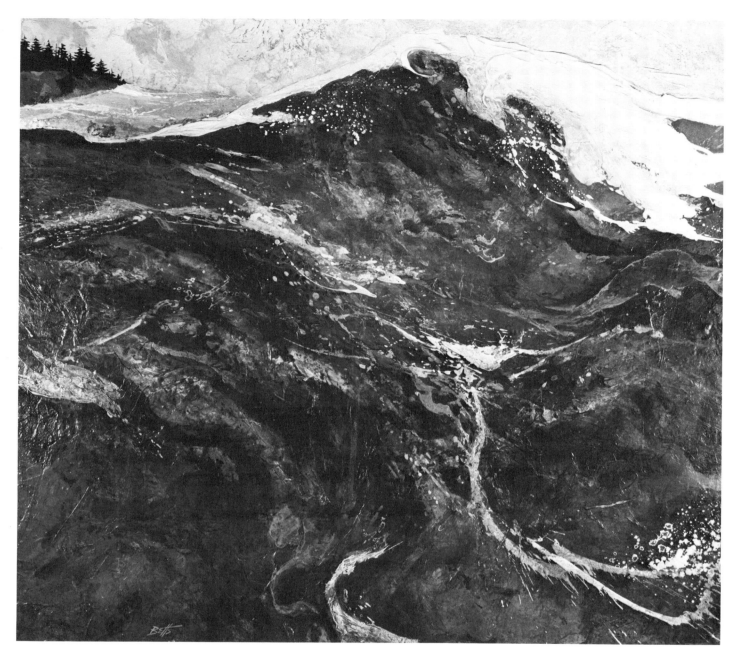

Great Wave *Acrylic and collage on Masonite, 36″ x 40″. Private collection.*

6. The Opaque Media: Gouache, Casein, and Acrylic

Transparent watercolor is quite versatile up to a point, but every watercolorist will admit that it does have limitations. The opaque aqueous media, because they do not depend on utilization of the paper for whites and lighter tones, have far greater flexibility and an almost unlimited range of paint textures and color effects, as well as possibilities for juxtaposing opaque and transparent passages in the same picture.

The principal difference between transparent watercolor and the opaque media is self-evident: watercolor is done with transparent washes that show the white paper beneath, and water is added to dilute and lighten the colors; in the opaque media the paint covers the surface with a thicker application, and it is white paint that is used to lighten the colors.

Opaque water paints have several advantages, the most obvious being that unsatisfactory areas can be painted over and corrected, and this overpainting can continue for as long as necessary to achieve the desired effect. In addition, opaque paints give an appearance of solidity and substance; in contrast to the thin, washy look of transparent watercolor, these colors have more the look of oil paint.

Because of their ability to build up layer upon layer of opaque color, opaque water paints provide a far greater variety of surfaces and textures than is possible in transparent watercolor. These range from transparent glazes to semitransparent washes, scumbling, and moderate impastos. And finally, two of the three most commonly used opaque paints (casein and acrylic) become waterproof and washable after they have dried.

The three opaque media most suitable for use by professional artists are gouache, casein, and acrylic.

GOUACHE

Gouache is a general term that refers to *any* opaque watercolor technique, but is usually applied most specifically to ordinary transparent watercolor paints to which opaque white has been added. Therefore, any painting in which Chinese (zinc) white or designers gouache white has been mixed with colors in greater quantity than simply for accents or retouching can be called a gouache.

Although this is more a manner of painting than a particular type of paint, some manufacturers, such as Winsor & Newton, produce gouache-tempera, or "Designers" colors—paints made with a filler that gives them more body or covering power than watercolor. These are of quite satisfactory quality, and the paints in which standard, approved pigments have been used are considered permanent and not subject to fading; however, those made with dyes or artificial pigment should be viewed with suspicion. Designers gouache colors remain water-soluble after drying, so a coat of paint tends to pick up and merge with previous paint films unless applied heavily and quickly enough to reduce the chance of lifting earlier applications of paint. A note of caution, however: when used too thickly, gouache paints are likely to chip or crack.

CASEIN

Casein is a binder made from curd of skim milk, and before the development of the acrylic paints it was regarded as the best of the opaque aqueous paints. It has slightly more covering power than most of the acrylics: it dries matte and a bit lighter than when it is wet, and the paint film is comparatively brittle. Heavy impastos are possible, but to avoid cracking, casein should be built up in several successive moderate layers rather than in a single pastose application.

Excellent casein paints are made by Shiva and by Grumbacher. Unfortunately, since casein has been largely displaced by the newer acrylic paints, it is becoming increasingly difficult to find in art supply stores.

ACRYLIC

Acrylic, or acrylic polymer, paint has as its binder a synthetic resin emulsified in water. Although artists' acrylics have been in use only a relatively short time, they appear to be durable and permanent and just about the most versatile paints imaginable.

Acrylic is quick-drying and becomes waterproof as soon as it is dry to the touch. Therefore, since it cannot pick up previous paint films and since prolonged drying periods are unnecessary, it is possible to glaze or overpaint immediately. Some acrylic paint manufacturers produce a retarder that slows down the drying so that the paint can be blended and manipulated for a longer period than would ordinarily be possible, but to most watercolorists this is of no particular advantage. A retarder would probably have more appeal to painters who want to use acrylic as a substitute for oils.

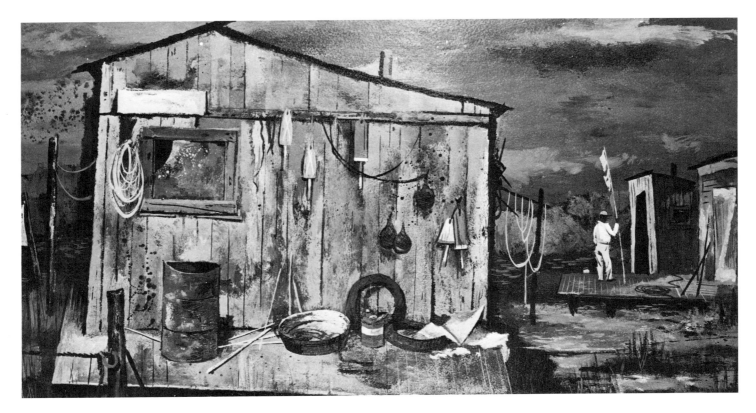

Fishing Shacks *Gouache on illustration board, 20″ x 28″. Collection Butler Institute of American Art, Youngstown, Ohio. The painting shown here was painted in 1949 from a group of quick sketches made on the spot, and it is interesting to me that even then I was familiar with the use of spattered paint to create arbitrary textures in the sky and for more descriptive textures in the fishing shack. As is my custom with opaque media, I omitted any preliminary blocking-in and started right in painting the sky and distant background. Next was the main fishing shack, which I painted with a flat undercoat of dark neutral brown over which I planned to scumble light grays and build suggestions of weathered textures. Painting the darks first and ending with the lightest lights last is a natural and characteristic sequence for opaque media and is quite the reverse of the traditional light-to-dark sequence used in transparent media. In spite of the wealth of detail in this subject, I tried not to let the painting look like a scattered, disorganized collection of unrelated pieces. Though the color is generally deep and tonal, that tonality was relieved by accents of pure, bright colors in quite a number of small areas throughout the surface.*

Acrylic has notable adhesive properties which makes it ideal for collage techniques and ensures permanent adhesion of paint films to their grounds. Acrylics adhere well to any absorbent, nonoily, nongreasy surface, whether rigid or flexible: paper illustration board, canvas, Masonite, plaster, wood, or cloth. In contrast to oil paints, acrylic paint layers do not lie one on top of the other; upon drying they fuse into a single paint film. This quality, together with their great flexibility, just about eliminates any chance of cracking.

Unusual opportunities for broken color, scumbling, and obtaining rich, luminous glazes, are possible with acrylic, affording a very wide range of surface textures, an interplay of opacity and transparency, and an illusion of depth. Impasto can be built up with acrylic modeling paste or with gel emulsion, which is a concentrated form of acrylic medium that may also be mixed with color for glazing techniques.

Finally, it should be mentioned that acrylic is non-flammable, nonyellowing, nontoxic, and will not darken, and that either a gloss or matte surface finish is possible. It seems to be an ideal medium from a number of viewpoints and by now is the most commonly used of all the aqueous media, particularly because it is capable of being used for traditional transparent watercolor techniques as well as for opaque treatments that rival the effects of oil painting.

OBJECTIVES

1. To explore the properties of opaque paints as an alternative to transparent watercolor techniques.

2. To take full advantage of the opaque media's potential for revisions and corrections.

3. To work for a picture surface with richer paint quality than is possible in transparent watercolor.

4. To exploit the medium's possibilities for oppositions of transparency and opacity.

MATERIALS

For All Opaque Aqueous Media
Supports: watercolor paper, illustration board, or Masonite

Paints:

(for gouache) watercolor, with designers gouache permanent white (or Chinese white), or Winsor & Newton "Designers" gouache colors

(for casein) Shiva or Grumbacher casein paints

(for acrylic) Liquitex or Hyplar acrylic paints in tube or jar

Brushes: bristle and sable, flat and round

Painting Knife

Palette: white enamel butcher's tray

Drawing Board

Thumbtacks or masking tape

Water Containers

Rags or paper towels

Toothbrush

For Acrylics

Acrylic Gesso

Gloss medium or matte medium

Gel medium

Modeling paste

Matte varnish

Denatured alcohol

NOTES

Supports. The most widely used painting supports for opaque aqueous media are watercolor paper and illustration board. I happen to prefer the latter for casein and acrylic, mainly because there is less warping and buckling of the picture surface, but when I do use paper, I select a medium or medium-rough surface. It is more difficult to paint on a very rough surface because the paint, being thicker than watercolor, tends to hit only the high spots and has to be worked into the little pits and depressions in order to cover an area thoroughly. So unless very fluid paint is used, rough paper is not very practical and can even be annoying. For small paintings I use standard-weight illustration board; for anything over 15″ x 20″ I use the double-thick heavier-weight (110-lb) board.

Masonite can be used as a support for casein or acrylic, but it is important to remember that only the standard, or *untempered*, Masonite "Presdwood" should be used. Tempered Masonite has never been considered as a support for fine arts paintings because of oils that are present in it which might react unfavorably with the paints used. There is always the risk of discoloration of the paint film or of poor adhesion of the gesso ground to the support. The manufacture of untempered Masonite in this country was discontinued a few years ago, but it is available here once again, being manufactured in three factories in the East, Midwest, and West. During the time when only tempered Masonite was obtainable, I decided to take my chances and use it anyhow. I would sand the surface thoroughly with rough sandpaper and then with medium sandpaper, followed by an application of three or four coats of acrylic gesso on the picture side of the panel, and one coat of gesso on the reverse side.

If paper or illustration board are used, there is no need to apply gesso before painting, unless a more "brushy," or textured, surface is preferred to that of the untouched paper.

Storm Over the Cove *Gouache on illustration board, 11½″ x 26″. Private collection. Painted in 1950, this picture represents what could probably be termed my romantic realist phase. I was also in the process of giving up oil painting and going more and more to the water media—gouache and casein. The scene depicted here, with its threatening sky and eerie light on the shack, is a much simplified, highly selective view of the shore at Turbot's Creek, one of my favorite sketching spots. A great deal was eliminated in the way of other shacks, pilings, and rocks, and I retained only those few elements that seemed necessary to project the idea I had in mind. Over a toned surface of middle gray, I painted the entire sky just as though there were to be nothing else in the painting, and then I brushed in the far shore, indicating water and foreground; only after this did I refer to sketches done the previous summer and paint in the shack—not by drawing and filling in tones, but by directly painting the planes and surfaces in terms of basic lights, darks and middle tones. Everything was directed toward bringing out the glare of light on the weathered textures of the shack. After that, it was a matter of developing the foreground in greater detail while leaving the rest of the picture simple and undistracting.*

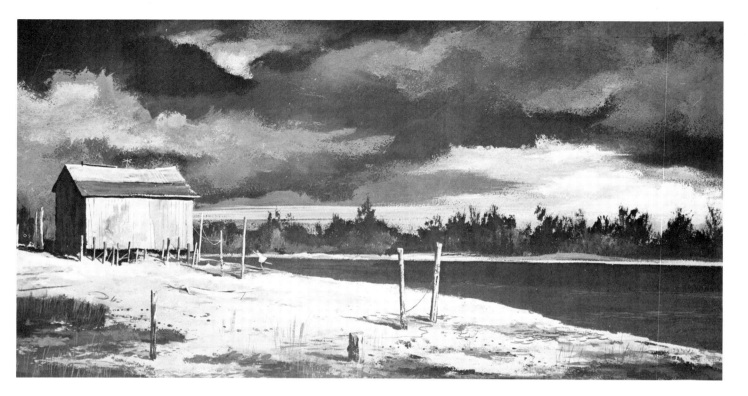

Winter Woods *Gouache on illustration board, 14½" x 23". Private collection. Gouache lends itself well to improvisational techniques because it permits opaque overpainting and the opportunity to try out ideas and then paint them out and revise them whenever necessary. Some gouache paintings are a blend of both transparent and opaque areas, but the one reproduced here is handled opaquely throughout. Before the painting was begun, the illustration board was given an undercoat of several thinly applied bright colors. Once it was dry, I took flat watercolor brushes and heavier gouache paint, and began to paint quickly and intuitively. As the painting gradually developed into a snow scene with rocks and trees, gestural strokes were used to suggest landscape elements through a stylized rather than a descriptive handling of shape and line, and bits of the colorful underpainting were allowed to show through occasionally as color accents against the whites, grays, and blacks.*

Paints. The choice of paints for the aqueous media of course depends on which medium you use:

Gouache. For gouache techniques there is a considerable latitude of choice as to what paints to use. I have used watercolors in conjunction with designers gouache permanent white, or Chinese white, for small, informal paintings, using the same palette as the one used for transparent watercolors. White added to those paints produces soft grays and delicate tints that are quite unlike anything possible in watercolor alone. Also available for gouache methods are sets of gouache paints from several of the major paint manufacturers here and abroad.

Casein. I used casein paints exclusively for about twelve years and still return to them occasionally. They seem to be particularly effective on rice paper, and the quality and covering power of the washes and glazes is actually slightly superior to those obtainable with acrylics. Casein is adaptable to both knife and brush application, and dries to a matte finish which I find very pleasant. Ammonia is the only solvent for casein after it has dried for a time.

My casein palette consists of the following:

Titanium white

Raw sienna

Burnt sienna

Shiva (phthalocyanine) green

Shiva (phthalocyanine) blue

Ultramarine blue

Cobalt blue

Cerulean blue

Cadmium yellow light

Yellow ochre

Cadmium orange

Cadmium red light

Alizarin crimson

Acrylic. Acrylic colors are made with permanent pigments approved for artists' use, and although some of the paints have mysterious names, they are nothing more than chemical substitutes for some of the colors that were found to be of questionable permanence or that did not intermix satisfactorily with other colors.

Like oils and watercolors, individual acrylic colors vary as to opacity and covering power, and if I object to some of these paints it is because sometimes certain areas have to be painted two or even three times in order to get a completely opaque film that successfully hides the color beneath. But this is a small price to pay for all their advantages.

Opaque paints. The most generally used opaque paints are designers gouache, casein, and acrylics. Tempera poster, or show-card, colors are unsatisfactory for fine-arts purposes.

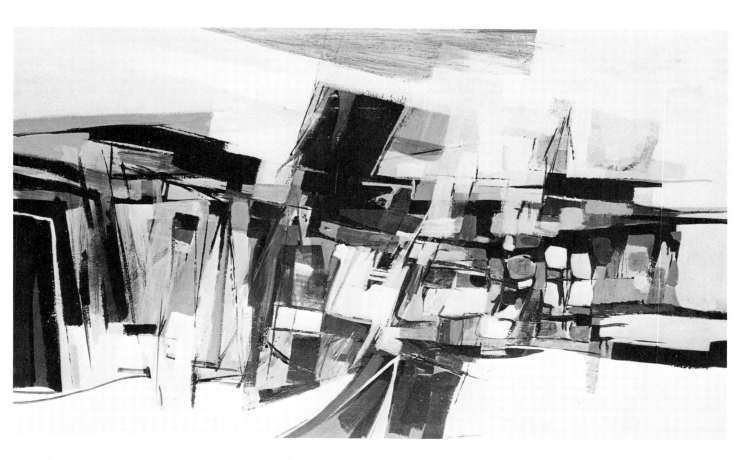

Hudson River Landscape *Casein on illustration board, 18″ x 30″. Private collection. The paint-brush and painting knife were combined here, where brilliant color weaves in and out of the linear structure in a loose and casual way. The painting developed out of a multitude of superimposed applications of both transparent and opaque color, accented every now and then with lines drawn with a brush or knife. Areas that became too busy or too muddy were painted out and new shapes and washes were substituted until the whole surface began to look unified. Whole masses were eliminated to simplify the surface and keep it from having too equal an emphasis on all the parts. Working in an opaque medium gave me the chance to try out a succession of pictorial ideas, all on the same surface, and to constantly accept or reject them without slowing down the painting process. Casein dries to a matte finish that for some reason seems to automatically ensure successful color relationships. Once waxed or varnished, however, the surface would become jumpy; light colors generally remain as they were, but middle and dark colors turn much darker, so that the relationships are no longer in adjustment to each other. In this instance, that aspect was not very important to me, and I eventually varnished the painting with acrylic matte varnish.*

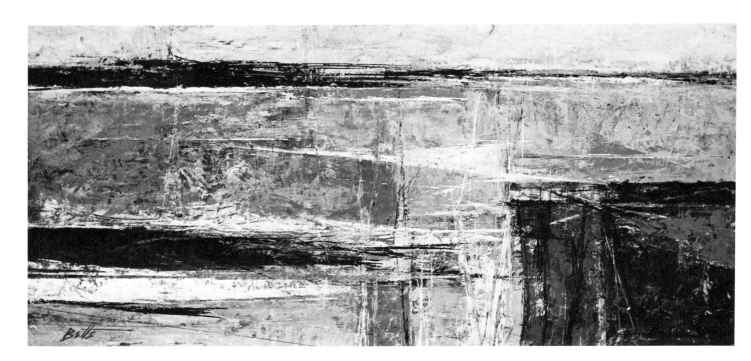

Sun and Sea (Above) Casein on illustration board, 12" x 25". Collection Springfield Art Museum, Springfield, Missouri. The painting shown here was done entirely with a painting knife. The surface was prepared by putting on enough preliminary color to build up a fairly rough impasto texture that would take full advantage of the scumbled and scraped-on paint that would be applied later. The painting knife was used broadside for general paint application; it was used on-edge for scraping off color to partially reveal the jewellike color beneath, or to scumble on thick paint; it was also used to cut lines into the wet paint and create a web of linear patterns. Painting with a knife does not mean the paint has to be thick and gooey—some of the most effective scumbles or broken color come from scraping on a thin, semiopaque film that is far more subtle than the crudity of too heavy an impasto.

Entrance (Right) Casein on Masonite, 20" x 16". Private collection. Casein is even more versatile than gouache, since it is of a thicker consistency that allows use of the painting knife as well as the brush, and opportunities for a wider range of paint textures and glazing techniques. Entrance was painted in the studio from a quick sketch in a Maine boatyard. What particularly struck me was the bright blue sky in the distance, seen through and beyond the interior gloom of the shed, and the textured facade around the doorway which acted as a frame for what amounted to a picture within a picture. Here again I worked on a toned ground, painting over the entire picture at once, keeping the distant area simple but very strong in color as an opposition to the deep neutral tones of the interior. Most enjoyable of all was painting the textures on the exterior of the boatshed. I built from dark colors toward a variety of lighter grays, applying the paint by means of brushing, scumbling, glazing, and spatter and using a painting knife for both dragged paint and linear accents.

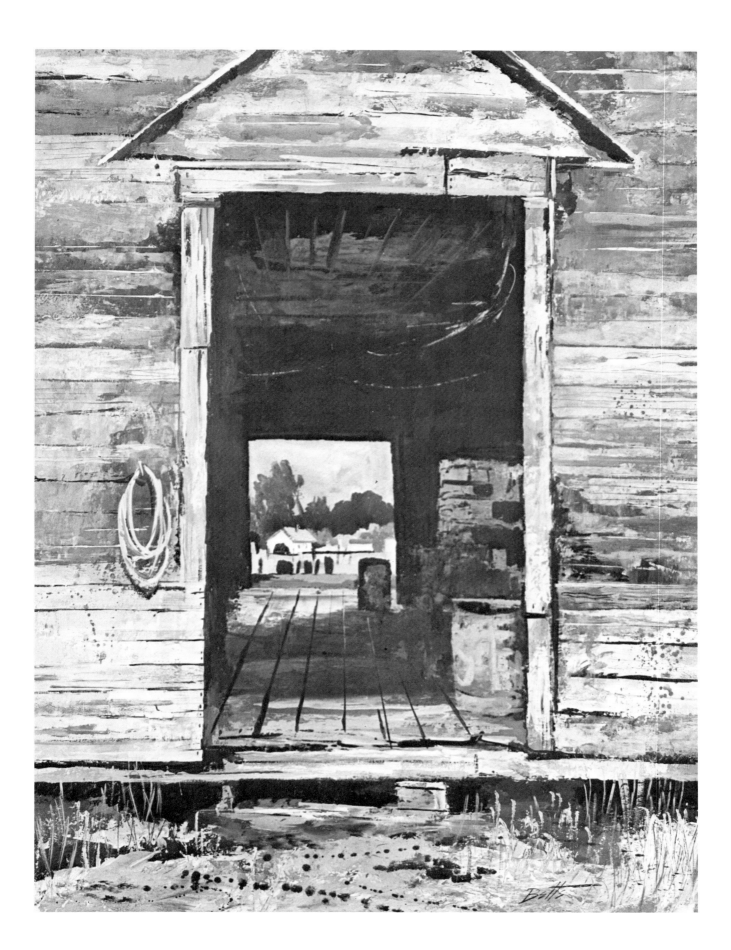

My palette for painting representationally in acrylics is as follows:

Titanium white

Raw sienna

Burnt sienna

Hooker's green

Green oxide

Cobalt blue

Ultramarine blue

Cerulean blue

Cadmium yellow light

Yellow oxide

Cadmium orange

Naphthol red light

Naphthol crimson

My palette for painting abstractions in acrylics is as follows:

Titanium white

Phthalocyanine green

Permanent green light

Phthalocyanine blue

Cobalt blue

Ultramarine blue

Cadmium yellow light

Cadmium yellow medium

Orange yellow AZO

Indo orange

Cadmium orange

Naphthol red light

Naphthol crimson

Acra red

Acra violet

Dioxazine purple

Mars black

It can be readily noted that the first palette is the standard one used in representational painting. The second palette eliminates some of the subdued colors and tends toward a more brilliant group of pigments.

Since most of these latter colors are used full, or almost full, strength without much intermixing, the addition of black is permissible; it is used as a pure color in its own

right for abstract purposes, rather than for modifying other colors. When painting realistically, I generally select colors with an eye to *tonal* relationships; when painting abstractly, I employ a more *coloristic* range, selecting colors for their richness and intensity.

The two brands of acrylic paint that are most to my liking are made by Permanent Pigments (Liquitex) and Grumbacher (Hyplar), and though these brands do not have precisely the same chemical formulas, I have been assured that they are compatible and may be freely intermixed. Both are sold in jars as well as tubes. The paint that comes in jars is more fluid than that in tubes, which has more gel in it and has more the brushy consistency of oils. I use the paint from 8-ounce jars for my abstractions, since here I generally work on a larger scale, but I prefer tube colors for my smaller, representational paintings and studies.

Brushes. I use a great variety: oil bristle brushes, flat and round red sable or imitation sable, and a selection of housepainting brushes ranging from ¾″ to 3″ in width. For my gouaches I like to use mostly bristle brushes, with an occasional touch of the sable mainly for accents or details. For my large abstractions I use housepainting or nylon utility brushes exclusively. The majority of my acrylic brushes are in disreputable shape, but they seem to accomplish what I demand of them. If I worked in a somewhat more polished style, it would be more important to have brushes that were in prime condition.

Painting Knife. Most opaque watercolors are best done with brushes, though a painting knife can be very useful in casein and acrylic for applying color either thinly or thickly, or for scraping and scratching into paint to reveal color beneath.

Drawing Board, Tacks, and Tape. Since paper and illustration board will buckle when wet, I always mount them on a drawing board or on plywood, Masonite, or Celotex. Dampened paper is stretched on a board with gummed tape; illustration board in small sizes is attached to the board with thumbtacks placed around the outside edge of the illustration board, not pushed through it as in stretching watercolor paper. With larger-size illustration board, I attach paper to the drawing board with masking tape. Although large amounts of paint cause paper to buckle temporarily, it flattens out again after drying and remains flat once the surface is covered with acrylic paint and made fully waterproof.

Water Containers. For the average gouache painting, a single water container will suffice, but for acrylic painting any brushes not in active use should be kept submerged in water; once acrylic paint dries and hardens on a brush, the brush becomes unusable and must be discarded. So it is a good idea to keep three or four quart jars handy, two for rinsing brushes and diluting paint and two for keeping brushes wet until they are needed again.

Toothbrush. I have always found an old toothbrush to be

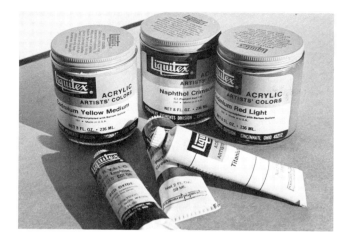

Acrylic paints come in both tubes and jars. The tube paints have a consistency similar to that of oil paints; the jar colors are a little more fluid.

The palette is an enamel surgical or butcher's tray. Brushes used are both bristle and sable, and a painting knife serves both for painting and cleaning paint off the tray.

Here are my most-used acrylic brushes: Nos. 8, 12, and 6 oil bristle brushes, an old ½" flat sable watercolor brush, a No. 5 round sable and a 1" housepainting brush.

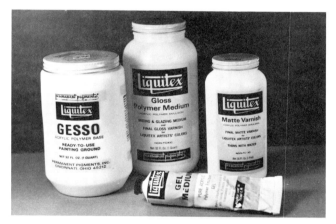

Accessories to painting in acrylic include gesso, gloss medium, matte varnish, and gel medium.

Putty knife. A useful tool for applying thin or thick paint in a manner similar to that of a painting knife, but with its own capacities for producing crisp strokes, edges, and dragged color.

The palette laid out with colors. Cool colors at left; white in upper left corner; warm colors across far edge; neutrals in lower left corner.

indispensable for fine stipple work. Areas not meant to receive paint are masked off with newspaper or paint rags. The very fine, controlled spray or stipple passages do wonders in achieving subtle color effects, edges, and transitions.

OTHER ACRYLIC MEDIA AND EQUIPMENT

Acrylic Gesso. Work that is being done on paper or illustration board does not require a gesso ground, but when I work on Masonite or other hardboard I always give the panel at least three coats of acrylic gesso to act as a binder between the Masonite support and the paint application and to provide the white undercoat which any kind of painting should have as a base for colors.

I like a rather brushy, textured surface, so I put the acrylic gesso on generously with a wide nylon brush. If smoother surfaces are needed, then each coat of gesso must be thoroughly sanded before applying the next coat, and the gesso should be brushed on in alternate horizontal and vertical layers—that is, each layer stroked on at a right angle to the preceding layer. Some painters apply as many as seven coats of gesso in this fashion— and by the time the preparation has been completed and given a final sanding, the gesso surface is almost too beautiful to paint on.

For informal studies or preliminary gouache sketches, I often gesso scraps of old matboard, coating both sides thoroughly. This protects the material, which is not rag content but wood pulp, from the effects of air and moisture and pretty well assures the permanence of the material. I would not recommend this procedure for major paintings since it does have its risks, but for sketches whose purpose may be ephemeral anyhow, it is a perfectly satisfactory—and cheap—surface for painting.

Gesso can be applied in its pure white state, or some neutral acrylic color, such as raw umber, can be added to it to provide a toned surface on which to paint.

Gloss Medium. This is the pure form of acrylic emulsion before any paint has been mixed with it. It is milky in appearance but dries to a clear, glassy finish. It is used as an alternative to water for diluting color, particularly in glazing. It can also be used as a final gloss varnish.

I use gloss medium principally for two other purposes: as an adhesive in collages (see Chapters 7 and 8) and as an isolating coat between paint layers, most especially in abstractions. Since it hardly ever needs to be used full strength, I dilute the gloss medium with about ½ to ⅓ water and brush it over the entire painting every so often. By that means I achieve an illusion of considerable depth in the picture: with all the layers of color locked between layers of clear plastic medium, looking at the painting can be like looking into a deep pool. Because of its excessive shine, I never use gloss medium as a final varnish on my work.

Any water paint can be transformed into an acrylic paint by the addition of some gloss medium to each paint

mixture. This gives casein, for example, the extra water-resistance of acrylic. There is no need for alarm if the medium gives casein a temporary milky appearance; as it dries, the milkiness vanishes and the color emerges as it was intended to be. For more luminous washes or glazes, a greater proportion of medium can be added to the casein or gouache paint, and as it dries it will become clear and transparent.

Matte Medium. This is the same gloss medium, except that wax or other inert substances have been added to remove what is, to most artists, the objectionable shine of acrylic medium. It simply means that any paint surfaces in which matte medium had a part will dry dull, or matte, instead of glossy. The choice of gloss or matte medium is purely a matter of personal taste.

Gel Medium. Acrylic medium in a more pastose, jellylike form is called gel medium; it is more concentrated and has more body to it than the gloss or matte mediums, which are more liquid.

Gel is added to tube acrylic paints to make them brushable and more the consistency of oil paints. It is useful not only for adding body to the paint for moderate impastos but also for pastose glazing—adding some color to the gel and applying it with a painting knife over a lighter underpainting. This produces a textured surface with deep, transparent colors built right into it—a unification of color and texture.

Gel can also be used as an adhesive, replacing acrylic medium in collages where heavy materials such as thick papers or cardboard are being used.

Modeling Paste. For very heavy impastos, modeling paste (which is marbledust combined with acrylic medium) can be applied and then covered with paint, either opaquely or with transparent glazes, or paint can be mixed directly into it before applying it to the picture.

It has been my experience that modeling paste, if built up too thickly, will sometimes crack. This can usually be avoided by mixing the modeling paste with an equal amount of gel medium. It is not ordinarily desirable in water media paintings to have very thick, impastoed areas because the paintings will look too much like oils and not enough like watercolors. However where textures are needed, modeling paste is the most efficient way to achieve them.

When as an art student I first discovered textures, I went wild. Every square inch of my oil paintings had sumptuous gobs of paint, festoons of gooey pigment, stuccolike paint applications, sand mixed with pigment, and very generous applications with the painting knife. They were like overly rich meals, too much of a good thing to be really digestible, and it was only later on that I learned that texture has to be used with restraint. I have never lost my love of texture, but now I keep it in its proper place as only one of many elements in a painting.

Matte Varnish. Although a gloss varnish is available, shiny finishes are no longer very popular; in addition to

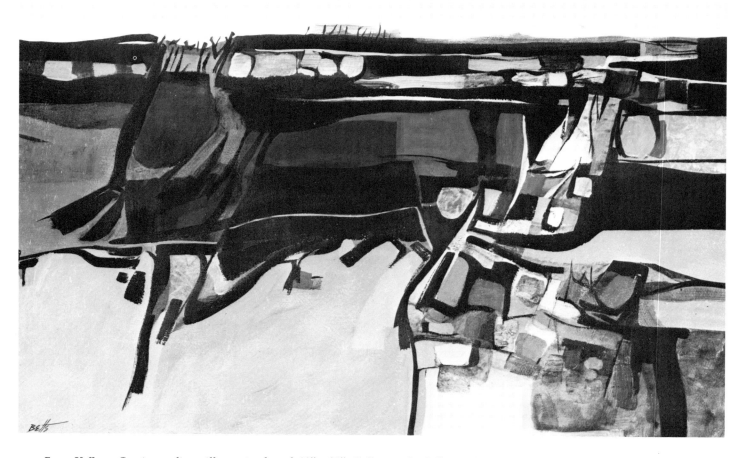

Stone Valley *Casein acrylic on illustration board, 19″ x 31″. Collection La Jolla Art Center, La Jolla, California. Any water-soluble paint can be mixed with acrylic medium to make an acrylic paint that has all the properties of the manufactured acrylics. Here I mixed casein with acrylic gloss medium simply by adding a brushful of medium to each paint mixture as it was being mixed on the palette. Since the medium has a slightly milky look while it is wet, I found it best to mix the exact color I wanted, then add some medium, and then apply the paint to the picture. If the medium is added too soon it is a little more difficult to get an accurate idea of the color being mixed. For ordinary paint applications, a brushful of medium is usually sufficient, but where glazing is needed for more transparent passages, a greater amount of medium should be used. The most conspicuous use of glazing can be seen here in the areas at lower right.*

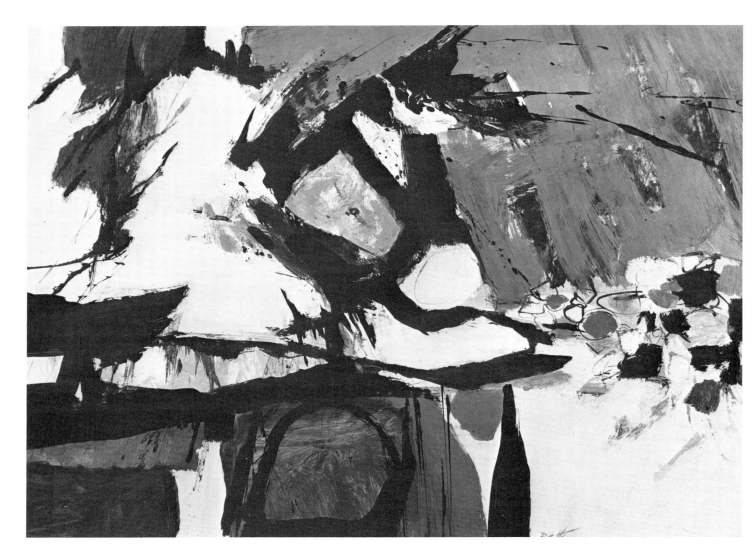

Island Beach *Acrylic and India ink on Texoprint paper, 18″ x 24″. Private collection. This started out as a drawing but gradually turned into a painting done mainly in red and black and white, with accents of blue. In the early stages, I drew with an ink-bottle stopper dipped in various colored inks, and then made some additions and revisions using tube acrylic paint and a large bristle brush. Tube acrylics have a more brushy consistency than those in jars, so I took advantage of that fact in my loose handling of the paint. At the very end I added a few more linear accents in colored inks. The purpose of the painting had been to try out a new brand of acrylics and a new synthetic paper I had not used before, so I was far less concerned with imagery than I was with exploring the possibilities of the paint, its covering power and consistency, and with seeing how the paper accepted paint and inks. At the end, however, the picture had overtones of boulders and beach stones and the whites of sea foam, so finding a title was a simple matter. Picture titles, by the way, are primarily for nothing more than identification purposes—and sometimes they furnish a clue as to what an abstraction refers—but I am always put off by pretentious titles that seem self-conscious and pompous, or by wisecracking titles that are less than droll.*

the slick, commercial effect they give, they do make it more difficult to see the picture. Matte varnish, however, has a dull gloss, a kind of velvety finish, which is very pleasant. It gives the picture a consistent, all-over finish, not glossy here and matte there, as frequently happens.

Since matte varnish has wax in it, and wax resists water, varnish should not be applied to the picture until the artist is satisfied that his painting is absolutely and irrevocably finished. Once matte varnish is applied, no further painting is possible. Moreover, because the acrylic varnish fuses into a single film with the acrylic paint, it cannot be removed in order to make revisions. I sometimes apply the varnish fairly soon after the picture is done, just to keep myself from "tickling" the picture for another four weeks, adding refinements that may be academically correct and make it more perfect in one sense, but which at the same time diminish the painting's freshness and vitality.

Denatured Alcohol. The solvent for most acrylic paints is denatured alcohol. Water has no effect on acrylic paint after it has completely dried, but alcohol can be used to remove paint. In most instances, I repaint any areas I want to change, but sometimes accidental blots or splashes have to be taken out, and it may be easier to wipe them off with alcohol on a rag or a cotton swab than to cover them over with more paint. Some delicacy is required here since there is always a chance of taking off more paint than is intended.

A final word on materials, this concerning my painting table. I have not used an easel for many years. All my work is done on a 4 x 8 foot painting table situated next to the studio wall. Although paintings done with tube acrylics can be executed on an easel, most of my large abstractions are done in such a fluid technique that they must be done flat, on a table. Since my transparent watercolors, too, are done horizontally, I have simply gotten into the habit of doing all my drawings and paintings in that position and propping them upright against the wall when I want to study them for a time. I always stand, never sit, while I am painting. I prefer to be free to move around easily and to stay at arm's length from my work, thereby maintaining a more overall view of the entire picture surface.

GENERAL NOTES ON OPAQUE PAINTING TECHNIQUES

Working on a Toned Ground. Gesso is necessary as a ground for acrylic painting on board or canvas, but I do not care for the glaring whiteness of a gesso panel nor the whiteness of illustration board. In transparent media, of course, that whiteness is required and accepted, but in opaque painting I consider it something of a nuisance, to be gotten rid of as soon as possible. I choose instead to tone the gesso with a transparent wash of ochre, sienna, or gray in my representational paintings and to flow or brush on random areas of bright color as a preparation for my abstract pictures.

Aside from finding a toned ground more pleasant to work on, I like a surface with a middle-range tonality that can be painted into with both light and dark right from the very start. Lights show up clearly against the toned ground and so do darks, so a three-value pattern is established almost from the first stroke of the brush. There is no covering up and filling in of little white spots, but just a painterly brushing in of color masses.

Glazing. Glazing, the application of transparent washes over light underpainting, is the basic part of traditional watercolor technique. It is not quite as applicable to gouache, however, because it is not water-resistant or waterproof when dry, and glazes lift the undercolor much too easily.

With casein, though, and especially with acrylics, glazing is an additional technical method for achieving greater subtlety, depth, and a variety of surfaces in a painting: areas that are a bit too bright can be subdued with a glaze; colors washed one over the other have greater depth and luminosity than if they had been mixed together on the palette first and then transferred to the painting; and the use of transparent passages contrasted to opaque ones makes the picture more varied, more visually interesting as a surface.

It is not necessary to use gloss or matte medium with color for glazing. In most cases I use hardly any water to thin the paint. I apply the color full strength directly from jar or tube, and depend on wiping or rubbing with a paint rag to adjust the color glaze to the desired value. While glazing, I paint with the brush in one hand and a paint rag in the other, constantly ready to wipe at the paint. Sometimes both hands are working simultaneously, side by side, on the painting panel.

The only other glazing method I have used with some frequency is to combine color with acrylic gel medium and apply it with a painting knife.

Acrylic Used as Transparent Watercolor. Although acrylic paints are classed as an opaque medium, it should be mentioned again that they can also be used for traditional transparent watercolor techniques—still another example of their unusual versatility. When they are greatly diluted with water, not acrylic medium, they are capable of producing the look and all the effects of transparent watercolor, with the added advantage that since the paint is immediately waterproof, subsequent washes or glazes cannot dissolve or pick up the earlier washes. (For those who like to work back into washes, lifting or sponging out, this would not be considered an advantage. In such a case, they had better stick with pure watercolor.)

My reason for thinning acrylics with water rather than medium is that the medium, even the nongloss variety, gives the watercolor washes a very faint sheen which I personally find objectionable in a transparent watercolor. Water does the job just as well, and apparently without destroying the bond between pigment and medium.

Acrylic Paint Textures

Direct opaque application.

Impasto.

Scumbling.

Drybrush.

Transparent Wash.

Stain.

Wet-in-wet opaque blending.

Spattered and flung.

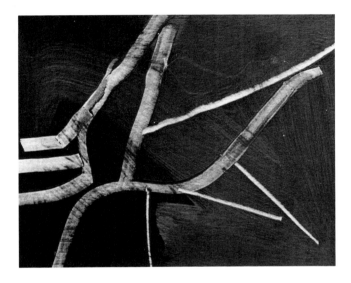

Scraping through to reveal undercolor.

Lifting with paper towel.

Glazing.

Impasto glazed and wiped.

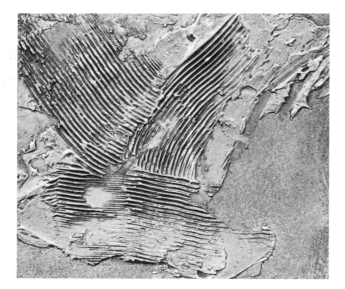

Impasto combed, glazed, and wiped.

Sand.

Lifting with crumpled paper.

Spattered with clear water and wiped.

The other advantage to using acrylics transparently is that whole passages that turned out less than satisfactory can be painted out with thin gesso or white acrylic paint and repainted with transparent color washes. My sole reservation concerning the use of such corrective techniques is that the surface texture of the paper itself is often lost in the process; it is up to each artist to decide for himself just how important that is to him, and to his painting.

For those interested in learning more about acrylic used in transparent techniques, I can most heartily recommend Wendon Blake's *Acrylic Watercolor Painting*, which is the most thorough discussion of this aspect of acrylic painting and, incidentally, in my opinion just about the finest book on watercolor generally, even though acrylic happens to be the specific medium dealt with.

Painting Outdoors with Acrylics. Here is one of the limitations of acrylic paint: although it is possible to paint outdoors on a gray, humid day, to paint with acrylic in the sun on a breezy day is almost impossible. Acrylics dry rapidly enough under studio conditions, but outdoors in the sun and wind the paints laid out on the palette can dry into rocklike lumps in a matter of minutes, thereby causing all sorts of frustrations for an artist. I would not advise outdoor painting with acrylics, but if you want to take the chance, and the weather does not seem too much against you, go ahead. I wish you luck!

TRANSPARENT OR OPAQUE?

An experienced painter can look at a subject and instantly visualize it as a painting, determining whether it is more suited to a transparent wash treatment as a watercolor or could be better realized with opaque paints.

Any watercolorist will admit that watercolor as a medium does have its limitations—there are certain subjects, certain textures, that are best avoided because watercolor cannot do them justice. In such situations perhaps an opaque medium would be far more appropriate for dealing with them successfully.

From a purely stylistic standpoint, watercolor may not necessarily be the right medium for building up color surfaces in a detailed, complex manner. It is too likely to lapse into dirty color or look too tired and worked-over. Gouache or acrylic may be just the answer for a painter who wants to develop a painting slowly and thoughtfully, changing, revising, relishing texture and exquisite subtleties that might be out of his range in watercolor.

On the other hand, some subjects and some painting styles lend themselves about equally well to both transparent and opaque techniques, so in the final analysis it is up to each individual artist to assess his subject and in terms of his own skills and outlook decide for himself which is the most appropriate medium for that subject.

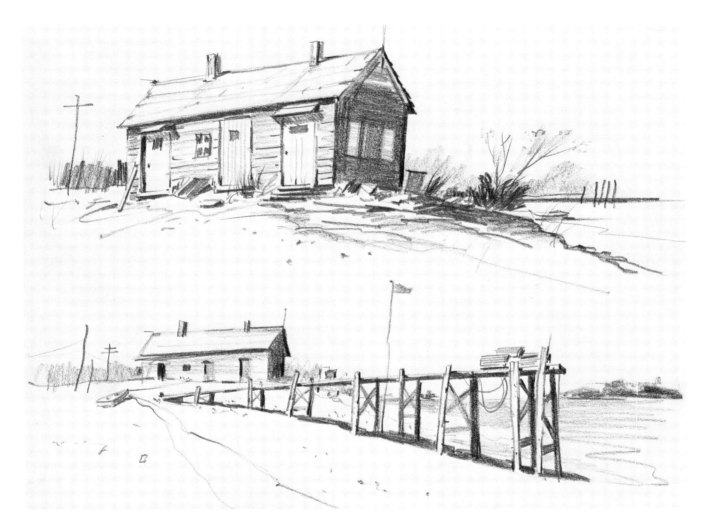

Shack at Cape Neddick *Pencil on paper, 11″ x 14″. These on-the-spot sketches were done for the demonstration painting that follows.*

Demonstration: Fishing Shack, Cape Neddick

Step 1. For this acrylic painting I worked on heavyweight (110-lb) illustration board, tacked to a drawing board to prevent warping while painting, and to maintain its flatness until it is thoroughly dry. My method of painting with opaque paints is the reverse of transparent painting in watercolor, where the preservation of the white of the paper is so important. Since I prefer to paint my acrylics on a toned surface, the first step is to coat the panel with a thin film of color so that as I paint, a color rather than the white of the ground will show through between any loose brushstrokes. In this case, I brushed on a blob of yellow ochre and then used a paint rag to distribute it over the entire surface. Aside from ochre, I often use chrome oxide green, Mars red, burnt sienna, or a gray mixed from ultramarine blue and burnt sienna. This toned surface gives me an all-over value that is generally in the middle tonal range, so that in beginning the painting I can work simultaneously with both light and dark paint, both of which will show up equally well against the colored ground.

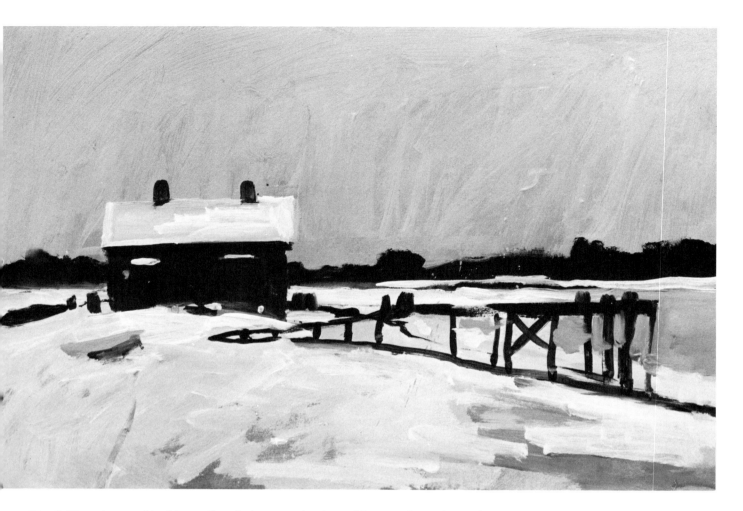

Step 2. The colors used in this acrylic painting were titanium white, raw sienna, burnt sienna, Hooker's green No. 2, phthalocyanine green, phthalocyanine blue, ultramarine blue, cobalt blue, cadmium yellow light, yellow oxide, cadmium orange, naphthol ITR red light, and naphthol ITR crimson. Without any preliminary drawing whatsoever, I started right in with a No. 8 bristle brush and lots of paint and set to work broadly blocking in not lines but whole areas. I painted the sky first, bringing it down the board until I had the horizon about where I wanted it, then I placed in the strip of water running through the picture. Next was a general brushing-in of the foreground using free brushstrokes and broken color, followed by a blocking-in of the line of trees against the sky. Last of all I did the fishing shack and the wharf, adding a couple of hasty dabs of paint to remind myself where the rowboat would be. My idea at this stage was to dispense with drawing and arrive at the subject in purely painterly terms, indicating only the most important masses as quickly and directly as possible (this whole phase took less than fifteen minutes), with the aim being to determine the composition and color of the picture, as well as the dominant light-and-dark pattern. Even though I knew I could repaint and revise to my heart's content, I avoided approximate paint mixtures and tried to hit as closely as possible to what the final colors and values would probably be. At the end of the first few minutes of painting, by stepping back far enough, I could already get a pretty clear idea of what the finished painting would look like.

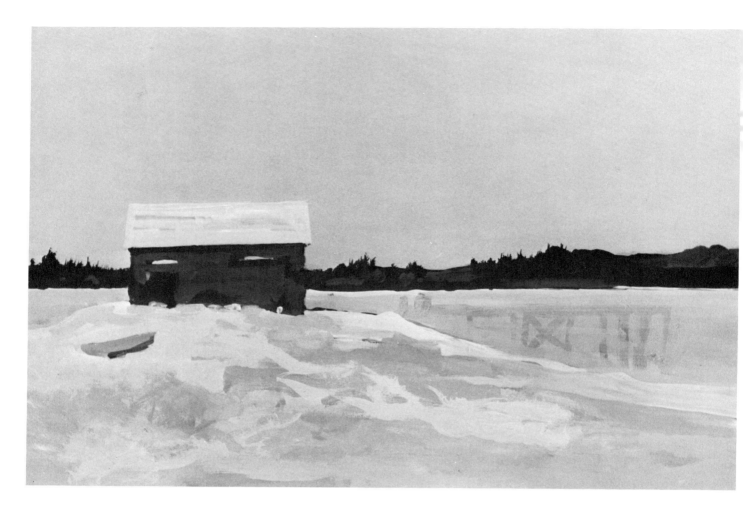

Step 3. This step is a redevelopment and refinement of the blocking-in phase. Here, although the painting approach is still broad and there is no specific drawing, the colors are mixed with greater exactness and fitted into the pattern of values set up in the earlier stages. The sky was painted in its final form, flatly and simply in this instance, so as not to be a distraction to foreground elements. The silhouette of the trees against the sky was formed in more specific detail, and the water was repainted more simply, covering some of the earlier painting, though the wharf is still partially visible. I also repainted the fishing shack, sharpening the roof and suggesting reflected light in the shadow. Still painting loosely and still using the large brush, I reworked the foreground again, adjusting the tones and colors more sensitively, with special attention given to the gradual transition from shore to shallow water. Since it has been lost in the midst of these revisions, the rowboat was once again briefly indicated. Even though I was pinning down areas more accurately, I still tried to keep the surface relatively loose and open, developing the subject slowly and generally, with no attempt to finish one area more than the others.

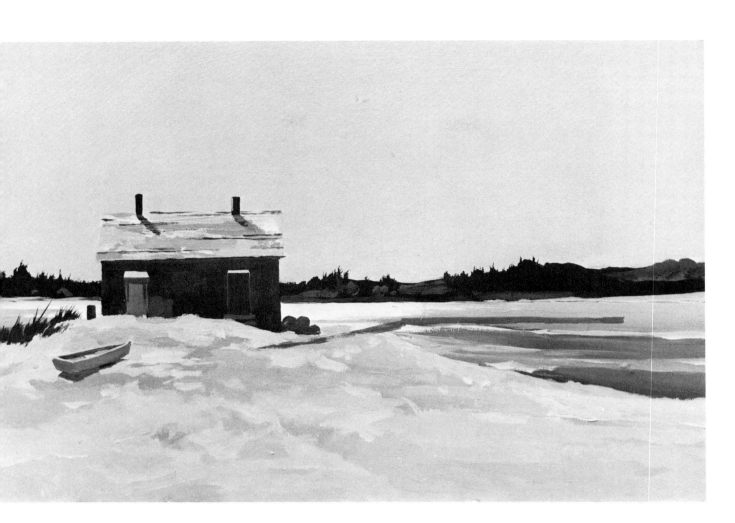

Step 4. Because the water is situated behind all the principal areas in the picture, I painted it next, starting with a basic middle value and adding lights and darks afterward, painting directly and in wet-in-wet. Since other forms had to be superimposed on the water, it had to be completely finished, or very nearly so, before the painting could be continued. Once the water had been done to my satisfaction, I repainted the roof of the shack using a No. 6 bristle brush, and refined the colors and values within the shack itself. Then I worked more on the beach, stressing surface textures and interweaving several halftones to keep it from looking too flat and uninteresting. Next I returned to the rowboat, bringing it out not by drawing, but by placing brushstroke against brushstroke and light against dark until it began to feel right—I did not push it too far along, though, because the shore needed considerable further repainting, and the boat would surely be smudged or partly lost in the process. Sensing that most of the emphasis in the picture seemed to be at the left, I slashed in a bright yellow shore at the extreme right so that the strong color there would enable that part of the picture to hold its own against the stronger forms at the left. The wharf was drawn in with dark paint but was not developed until I had fully completed the entire foreground; once that was done, I was able to finish the wharf and add the selective details throughout the picture that would give the scene its particular character.

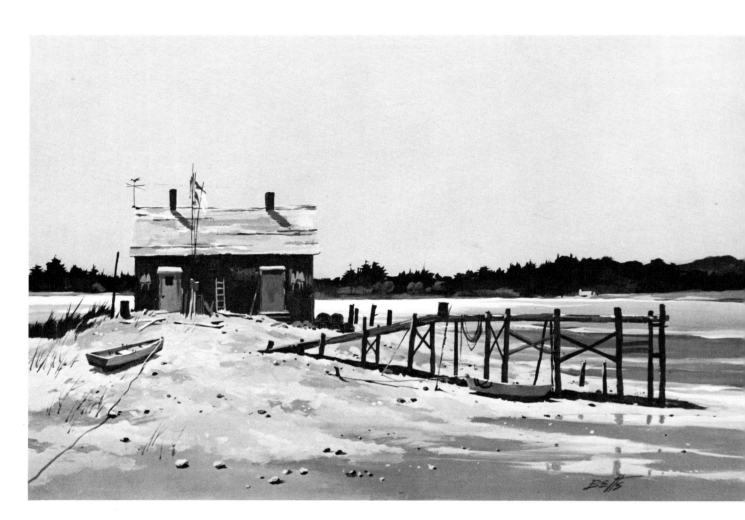

Step 5. By painting the picture in only the most general terms in the early stages, by working first with major forms and relationships and then proceeding later on to the smaller forms, the final adjustments and details of local color fall into place naturally as parts of the whole, instead of being inserted too early, with the likelihood of becoming isolated fragments that are not fully integrated into the total surface. When the foreground was almost finished, it seemed a bit uneventful, so I added the water and reflections at lower right. After that it became a matter of introducing details and accents with a No. 6 bristle and a No. 5 sable brush. Painting opaquely allows for indefinite revisions and precise corrections, but I tried as much as possible to suggest detail in a casual, painterly spirit consistent with that in which the preliminary phases of the picture had been built up. The brushwork was kept loose, no matter how specific the object represented, and variety of paint quality—thin vs. thick, smooth vs. rough—was used to add further interest to the surface. In spite of the presence of the wharf and the reflections in the water, it occurred to me that the distant shore was still too empty, so I placed a note of pure color there in the form of a tiny fishing shack. Although rich color was uppermost in my mind as I developed the picture, the colors were invariably anchored to the overall pattern structure and to the idea of achieving maximum impact of the light-and-dark relationships. (For color reproduction of this painting, see page 220.)

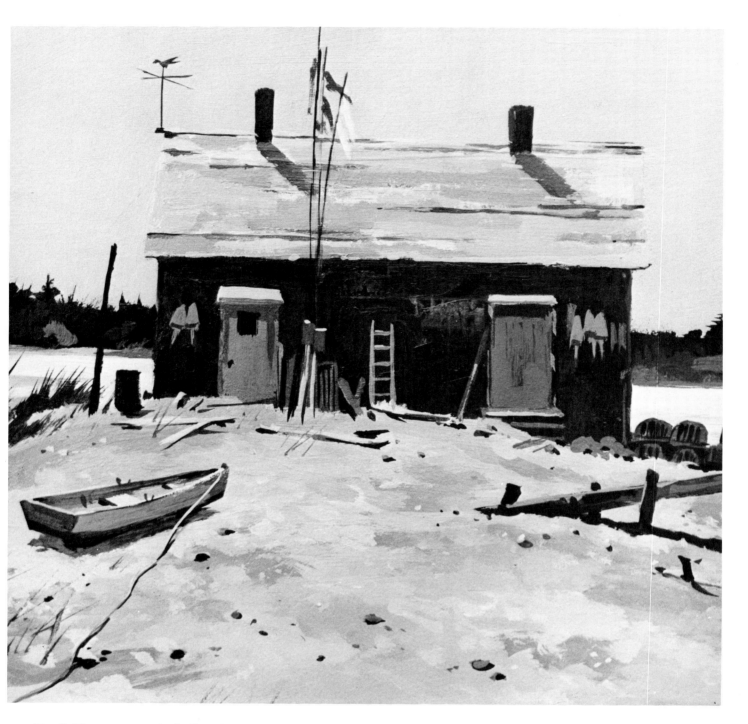

Detail. The opaque method offers almost unlimited possiblities for varied paint textures and building up a sense of solid form. Although there is a seeming wealth of detail, it is handled in a brushy manner, so that the picture can be read as spots and strokes of color coming together, rather than as an inventory of objects.

Color Gallery I

I find that the art instruction books I recommend most often to my students include reproductions of work by artists other than just the author himself. I feel this gives a book more breadth and exposes the reader to a wider variety of pictorial ideas than might be available in a book of more limited outlook. Toward that end I have selected for this color section a group of watercolorists whose paintings should serve as a rich source of additional inspiration and, incidentally, illustrate the diverse esthetic viewpoints mentioned in the main body of this book. All these artists do what they do far better than I ever could, and I am grateful to them for consenting to have their work reproduced here. They are distinguished painters, every one of them, and I am certain that whatever merit this book may possess will owe a great deal to their presence in these pages.

My intentions will have been fulfilled if after studying these color reproductions you have an overwhelming and irresistible urge to rush to your studio and start painting.

Red Oak, Turning by Lee Weiss, A.W.S. *Watercolor, 40″ x 30″*. Although Lee Weiss started out as a rather traditional painter, she no longer views nature in its panoramic aspects. In her own words, she now looks "*into* nature rather than *at* it." This kind of intense observation and immersion in a close-up world of forms and textures, combined with images that result from accidental manipulations of the watercolor medium, have produced an art that is often singularly poetic and affecting. In recent years, Weiss has been using rolls of a hard-surfaced Morilla watercolor paper that are 42″ wide and 10 yards long, so that many of her watercolors are gigantic compared with the size of an imperial or double-elephant sheet. Her paintings are initiated by a transfer, or monoprint process, in which she paints some basic color areas on the wet paper, flips it over directly onto her Formica painting table and paints on the rear of the sheet, then flips it over again to reveal wet paint from the slick-surfaced table transferred to the paper in mottled textures and patterns. She has even found it possible to remember a mirror image of the initially-worked side so that as she flips the paper repeatedly what she paints on the rear will, when it is transferred, be coordinated with what she has already painted on the front. Experimental techniques of this sort, though they are wholly accidental in the beginning, provoke forms that can be defined, developed, washed out, repainted, and refined. Eventually, those forms begin to stimulate memory and imagination, and the picture moves away from formless abstraction toward a very personal kind of realism.

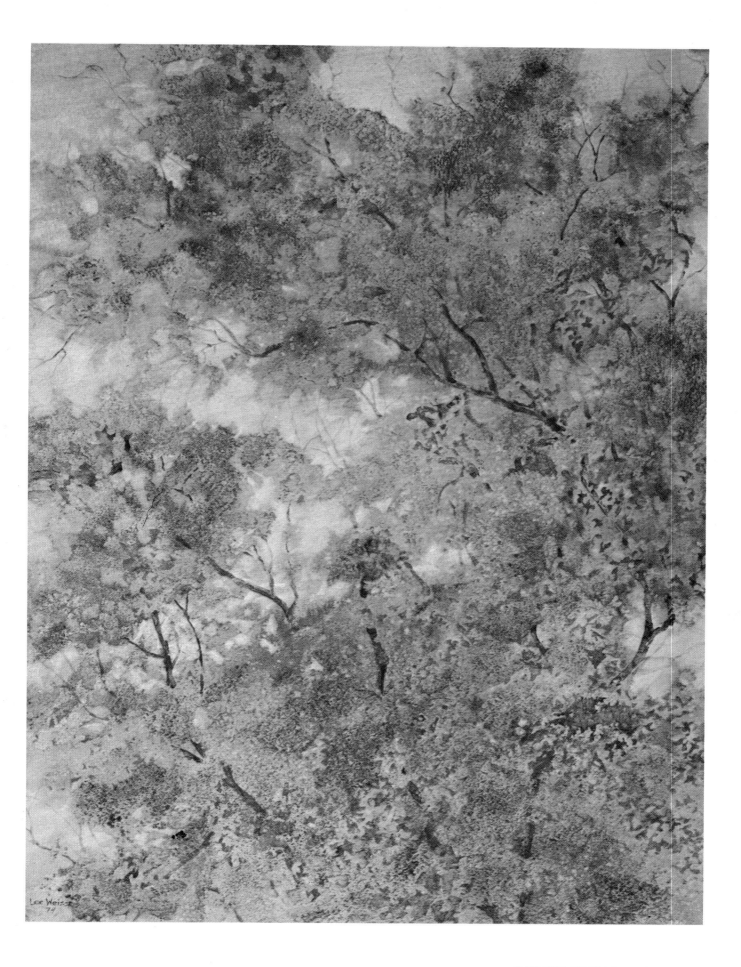

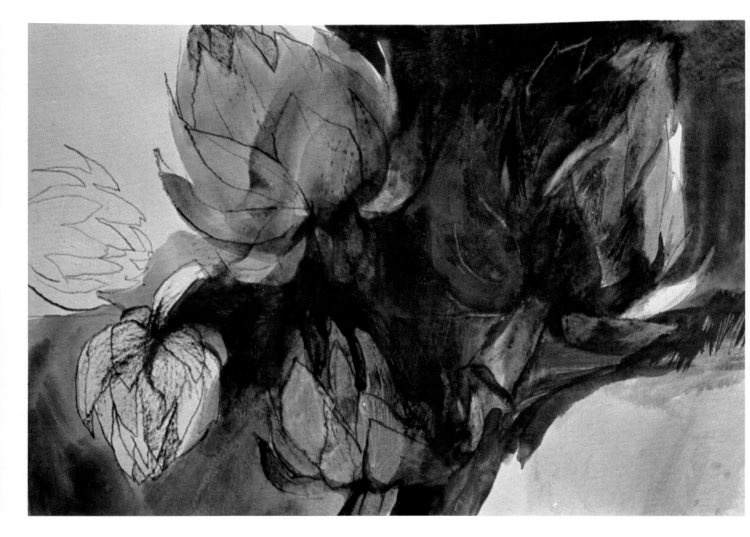

Palate's Pleasure *by Pat San Soucie. Watercolor, 22″ x 30″. Collection of the artist.* Pat San Soucie's watercolors are invariably the result of a very personal response to the world about her. The picture reproduced here is an excellent demonstration of the fact that it is not at all necessary to confront a vast, panoramic landscape in order to find material for a painting. In this case, a close-up view of several artichokes provided the artist with sufficient theme for an award-winning watercolor. One of San Soucie's strengths lies in her understatement: she habitually uses gently muted earth colors that are perfectly suited to the vegetal forms, marshes, and hilly landscapes with which she has been most concerned. Her materials here were Winsor & Newton watercolors on Wachung No. 536 140-lb paper, with additional use of Artone tempera and a 2B pencil. In regard to this painting she comments: "Many of my paintings show a heavy handling of paint in a manner much like fingerpainting, a scrubbing action with a pigment-laden brush achieving the effect. *Palate's Pleasure* uses this, with the pushing of the paint following the shapes of the artichoke leaves. The semiopaquely pigmented areas are relieved by transparent washes and the white of the paper. Strong pencil strokes delineate the forms, at times scratching through the wet pigment to layers below, in some parts digging deep into the paper. Within the pencil-defined forms, a razor blade was used to scrape certain white areas and raise a linear texture. Where portions of the subject matter had not been resolved satisfactorily, raw umber tempera paint was used to redefine the shapes and to complement transparent passages."

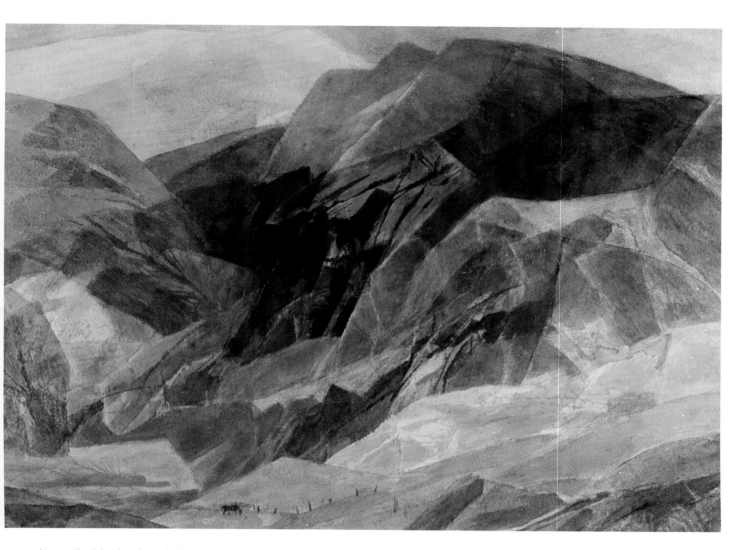

Across the Meadow by Ethel Magafan, N.A., A.W.S. *Watercolor, 22″ x 30″. Courtesy Midtown Galleries, New York.* Ethel Magafan's mountain landscapes are based mostly on her intimate knowledge of the area in and around Colorado Springs, where she grew up. Mountains, like skies and ocean waves, are a ready source for abstract images. Magafan deals with them as facets and color planes conceived as flat, two-dimensional shapes which interlock and overlap, yet at the same time project the quality of sculptural mass. In spite of the complexity of her compositions, she always imposes on nature an overriding sense of order, an organized composition in which the forms are clearly positioned in their relation to each other and also to the total pictorial space. She writes: "Long before my paintings begin there is a great deal of sketching from nature. I need this contact with the endless variety and strength of natural forms to enrich my work. I make many drawings right on the spot. Later when painting in the studio I let my imagination take over. I interpret my sketches with inventions of new forms and colors. But the solid structure of my studies from nature is always with me. When working in the watercolor medium I try to keep my colors clear and brilliant."

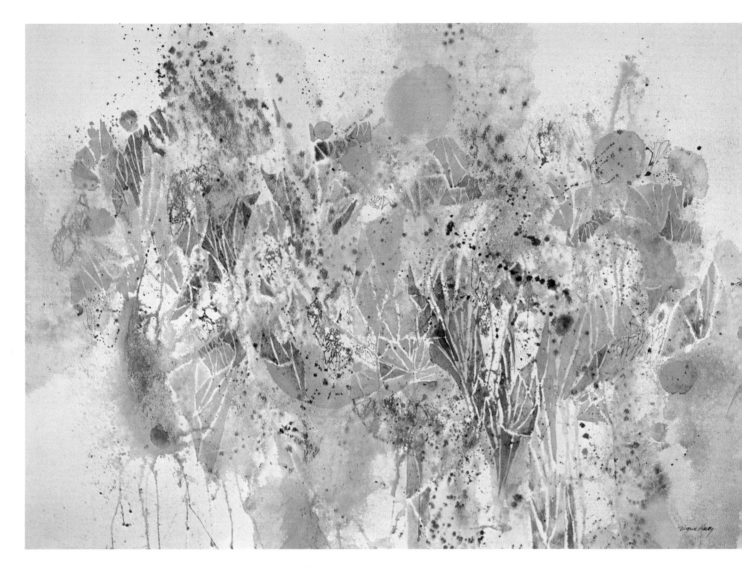

Yellow Landscape *by Patience Haley. Watercolor, 28″ x 36″. Collection of the artist.* Patience Haley makes full use of all the possibilities of transparent watercolor to evolve her high-keyed, lyrical evocations of nature. Without descending to obvious description, there is always a sense in her work of the things to which she responds most deeply: flowers, rocks, water reflections, and patterns of sea and shore. Her favorite paper is full-size J. Green in both cold-pressed and rough, though she occasionally uses Arches as well. For color, she uses Winsor & Newton watercolors, Luma watercolors (the permanent colors only), and Pelikan inks. Since she likes the unpredictable ways in which water can affect the paper, she always works on unstretched paper, which facilitiates lifting and turning the paper for drip and flow effects. In the early stages of a painting, she will use a brush or spray bottle, dribbling and spattering, often building up several layers of transparent washes, but careful to preserve some white paper here and there and to oppose sharply defined areas with freer, looser wash areas.

Phenomena Sri Sri Sri *by Paul Jenkins. Watercolor, 72″ x 36″. Collection of the artist.* This is perhaps the purest kind of watercolor painting, in which the flow of luminous color is itself the subject of the picture rather than any observable aspects of nature. The use of the prefatory word "phenomena" in all his picture titles since 1960 further suggests that Jenkins' art should be regarded as an occurrence, or a bringing together of events in paint. The force of gravity, for instance, plays just as important a role in the evolution of forms as the artist's intense awareness of—and response to—what is happening on the paper. The painting reproduced here was done on heavy Japanese mulberry paper, which was mounted on a very light shoji screen. The color was applied with a sable brush and occasionally guided by an ivory knife, which is Jenkins' principal and most indispensable painting tool.

Jewels in My Garden *by Alexander Ross,* A.N.A., A.W.S. *Watercolor and acrylic, 21″ x 29″. Collection of Dr. and Mrs. Martin Zeluck, Haddonfield, New Jersey.* Radiant color patterns, a relaxed but sensitive control of design, and an almost Oriental use of line contribute to the joyous sparkle and zest for living that animates the paintings of Alexander Ross. The color ranges from the brilliant to the subtle, and his brush traverses the surface with alternating boldness and delicacy. Working always on a gesso surface, Ross paints entirely from imagination, even when dealing with the human figure. He uses only two types of brushes: the square, chisled-end variety and 2″ striper brushes. He uses acrylic paint much like watercolor—transparently—since he prefers a thin application to a heavy impasto effect. Ross writes of his work: "For many years I have been fascinated by the abstract in painting, just as I have by the unknown in the world about us, but I have never been quite able to lose myself completely in a nonobjective manner, because reality fascinates me, too. As a result, my creative energies are directed toward the exploration of both fact and fantasy in the world I know."

Maine Morning by John Maxwell, N.A., A.W.S. *Watercolor, 26½" x 40'*. This painting started as a casual pencil sketch and a year later was attempted as a tiny watercolor. At one point, Maxwell tore it up, but soon he found himself restoring the torn pieces to their original positions and seeing new possibilities in the work. The present picture began as a transparent watercolor on 140-lb Arches double-elephant-size paper and was further developed in gouache, with matte acrylic medium added to the water in a proportion of about one to ten, so that later overpainting would not dissolve the earlier layers. When the picture appeared to be finished, Maxwell tore the sheet into pieces, and the uneven fragments were placed face up on a gessoed Masonite panel. These fragments were shifted about until they were almost, but not quite, in their original positions, and were then mounted on the panel with matte medium. As the painting progressed, Maxwell bottled extra mixtures of each key color and used them to coat hundreds of very thin sheets of pure rag paper, which were then cut or torn so as to duplicate some of the actual brushstrokes already on the panel. These pieces were carefully superimposed on the picture to precisely match the existing brushstrokes, using acrylic medium as the adhesive. John Maxwell himself comments: "Some of my more successful work has resulted from flops I was just too stubborn to give up on. Of course, this quest for direction has to be unending. The steps described here seem to have worked out for *Maine Morning*, but something entirely different will doubtless be indicated for my next painting. Such seems to be the preordained lot of one who has long realized that he is an incorrigible member of The Experimenters Club. But this is where the excitement is!"

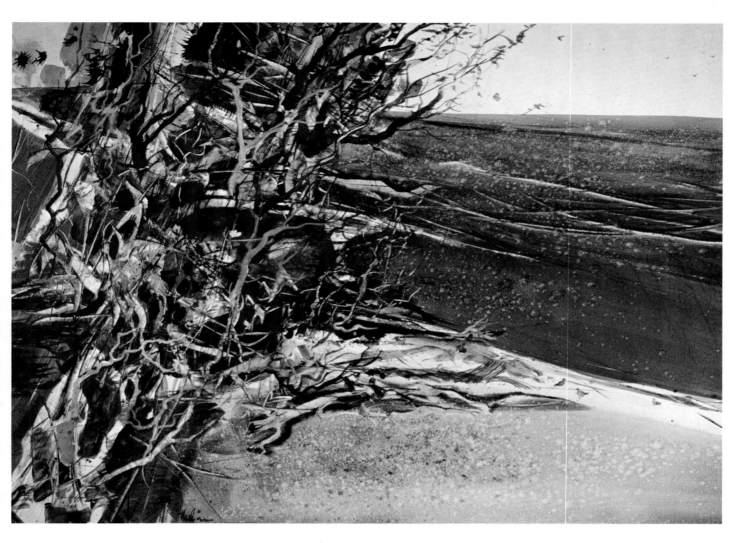

Tide's In *by Valfred Thelin. Watercolor and acrylic, 38" x 48". Collection Dr. and Mrs. Bernard Weisskopf, Louisville, Kentucky.* Valfred Thelin refers to himself as an "abstract realist," since he reverses the usual practice of translating reality into abstraction and starts out instead with improvisational abstract washes. He then carries them toward recognizable imagery, so that what some painters might consider the final picture is to Thelin merely the very beginning. His most recent paintings are almost invariably begun in watercolor but later modified with white acrylic extremely diluted with water.

Windows *by Nanci Blair Closson. Watercolor, 30" x 22". Collection Springfield Art Museum, Springfield, Missouri.* Nanci Closson's series of paintings on window motifs are a very personal view of space, both real and imaginary, which flows ambiguously within an implied architectural framework. Compositions are arrived at through an intricate interplay of accident (on the part of the medium) and control (on the part of the artist). Closson prefers 300-lb Arches cold-pressed paper, and she uses both Liquitex and Hyplar acrylic paints. The paints are mixed in several combinations, diluted to different strengths, and kept in plastic glasses; some tube colors, for richer mixtures, are squeezed out on a palette of waxed paper taped to cardboard. Where white, free-form solid areas are desired, starch, used as a frisket, is applied with a brush and left to dry. Masking tape, for hard-edged lines, is applied to the paper, colored over, removed, let dry, and followed by further taping and glazing. Closson always works from lighter to darker washes as the picture develops. When she feels the time is right, she soaks the paper to remove the starch, and while the paper is still wet, areas are faded in or out to achieve a feeling of depth, or the prominent white form left by the starch is rounded with hazy color to make it float, come forward, or recede. This is also a good stage for texturing or sprinkling with salt. When the paper is thoroughly dry again, the tape is reapplied, followed by more glazing, retaping, and repainting

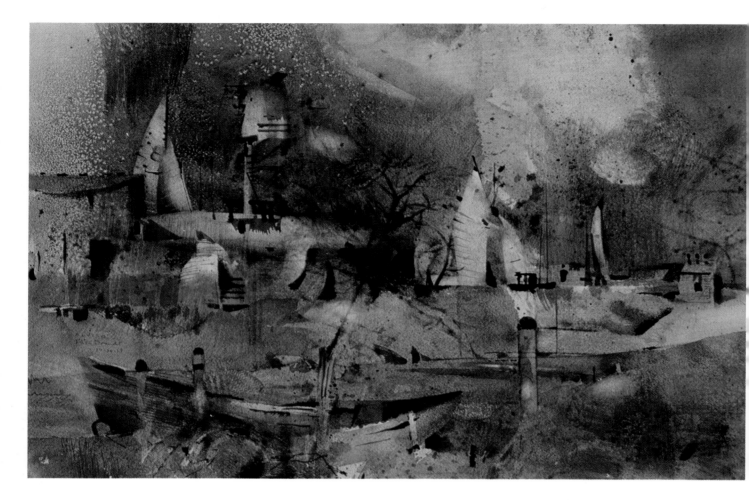

Alviso *by Rex Brandt*, N.A., A.W.S. *Watercolor, 18½" x 27½". Collection E. Gene Crain, Laguna Beach, California.* This is a painting in which Rex Brandt has fully exploited textures, distressed surfaces, and abstract design, while at the same time retaining the look of nature, so that both these aspects of the picture blend into and reinforce each other. He refers to his semi-abstract watercolors as "indirect" paintings, as distinguished from the fluid, virtuoso watercolors for which he is so justly famous. He has written of his procedures: "I am learning to 'listen' for the questions which are produced by random relationships of pigment, water, and rough paper, and to use these configurations as an overture to my investigations of nature. Some devices I employ to provoke the paper to provoke me: pigment flung, spattered, or dropped on the moist sheet; clusters of pigment and water allowed to dry in random congeries; bleaching out or washing off sections of earlier washes; folding, crinkling, scraping, or sandpapering parts of the sheet prior to stretching it; veiling or even eliminating wash areas with laminations of paper (collage). These operations are not left entirely to accident, but are evaluated at every step in relation to the mood I endeavor to create. Once a mood is established (like chords in music), I allow the sheet to dry and then I take it out to find its complement in nature. I see this second step as analogous to finding the lyrics for a musical score. . . . Somehow we must find a way to unlock the secrets of man's relationship to his environment." (Excerpted from *Rex Brandt—A Portfolio of Recent Works*, Santa Ana, California, 1972)

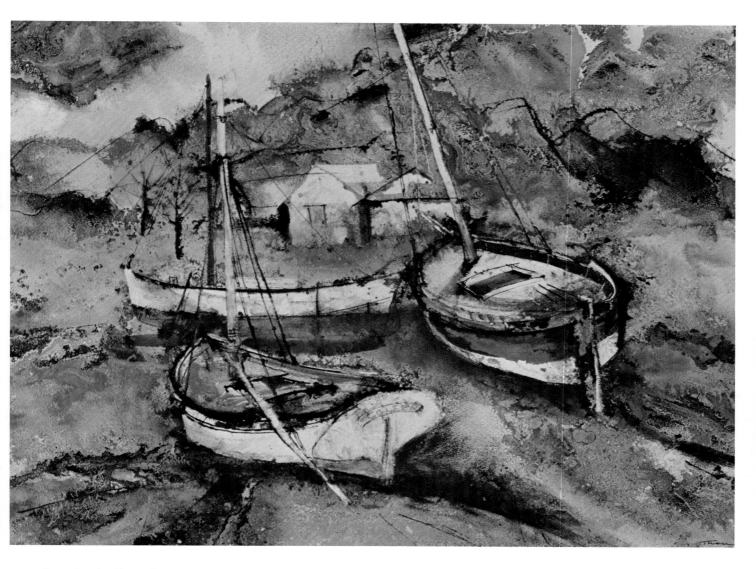

Coastal Ireland *by William Thon,* A.N.A., A.W.S. *Watercolor, 20" x 27". Courtesy Midtown Galleries, New York.* Boats and the sea are as much a part of William Thon as his art. Although Maine is the principal source for his subject matter, his many sketchbooks are filled with the results of his trips to Italy, Greece, Portugal, and Ireland. Since none of his oils or watercolors are ever painted directly from nature, the material contained in those sketchbooks is fundamental to his painting. Many of the intriguing textures in his watercolors are the result of his method of floating color over paper that is partially submerged in water, allowing the pigments to mingle and settle into the paper as it dries. Thon welcomes accidental and improvisation as he works, but he always has a clear idea of what he will be painting, and he is careful to preserve the white of his paper in some areas, feeling that it is easier to paint it later than it is to lighten it once it has been covered. He very seldom uses touches of opaque white paint; he depends instead on scraping, scratching out, or occasional sponging, and he is very willing to spend weeks or even months working and reworking a watercolor. The fine black ink lines are applied with a sable brush or a pen.

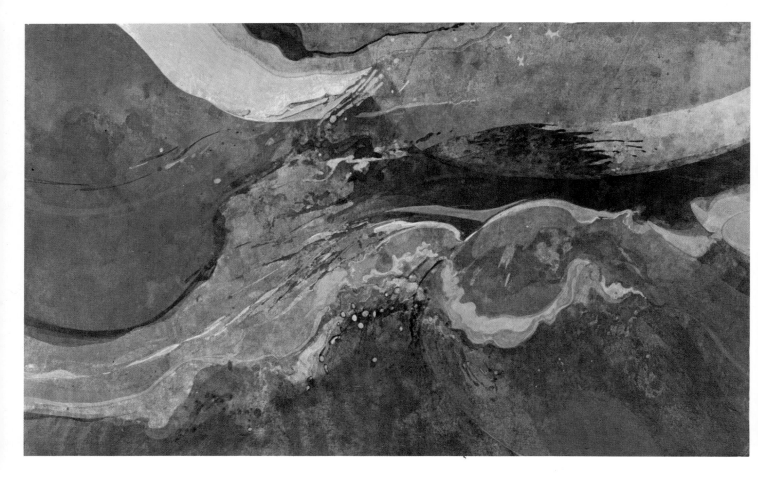

Captured Sky II *by Glenn R. Bradshaw,* A.W.S. *Casein on rice paper, 24″ x 38″.* The paintings of Glenn R. Bradshaw deal with rhythmic movements of earth, water, and sky, seen in terms of glowing color and flowing organic forms. Although his work derives almost exclusively from the lake areas of northern Michigan, this is landscape by implication, not description. Somewhat Oriental in his approach to nature, Bradshaw arrives at his images through freely improvisational painting methods. The indirect references to nature, which are to be sensed rather than perceived, result in landscapes that transcend the specific and tend toward the universal. Painting in casein on white Sekishu or Kozo rice paper, he usually has as many as twenty or more pictures in progress at a time, though some are put away for long periods until he responds to them freshly and finds a way to bring them to completion. Since Bradshaw's own spontaneous gestures and the paint itself are the prime instigators of the landscape forms, Bradshaw has no need to begin a painting by working from outdoor sketches or compositional plans. He is content to have at most only a hazy conception of what the major movements or surface divisions might be—and even those are subject to ready change, should the picture require it. While working, he blots with a paper towel almost as much as he applies paint, not only to prevent a build-up of thick paint, but also to effect the sensuous glazes and semitransparencies of color that invest his surfaces with such subtle nuances.

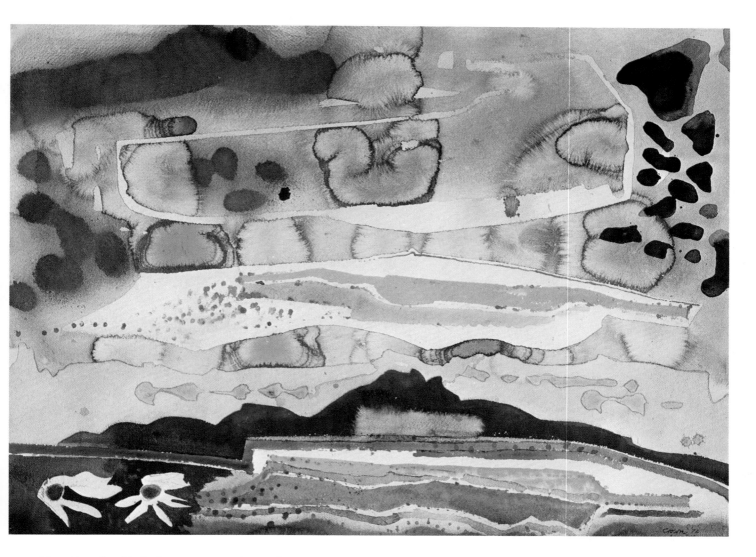

Near Taos by Keith Crown. *Watercolor, 22" x 30". Collection Springfield Art Museum, Springfield, Missouri.* Keith Crown is one of the very few abstract watercolorists who insist on always painting their exhibition watercolors directly from nature to guarantee the immediacy of their response to the subject matter, and it is the intensity of that response that is the crucial factor in getting the picture underway. To watch Crown paint a watercolor on location is a dramatic lesson in instant creativity. His decorative patterns and personal symbols derive from impulsive decisions. He peers at his subject and then unhesitatingly transforms it into shapes and colors that sometimes only remotely suggest their origin, but that nevertheless would not have been formed without the reference to visible things. Where some artists succumb to the grandeur of the Southwest, Crown shuns the obviously picturesque and is relentlessly adventurous in his handling of the watercolor medium. His unique method is to periodically wash the picture surface with water sprayed from a hose attached to an overinflated spare tire and then permit the generous pools of water and color to dry without interference on the unstretched Arches paper. Occasionally, before starting to paint he may use cut or torn masking tape to mask out several shapes, noticeable here in both the sky and foreground. This protects them from the washing, blotting, and hosing procedures until he is ready to incorporate them into the total composition.

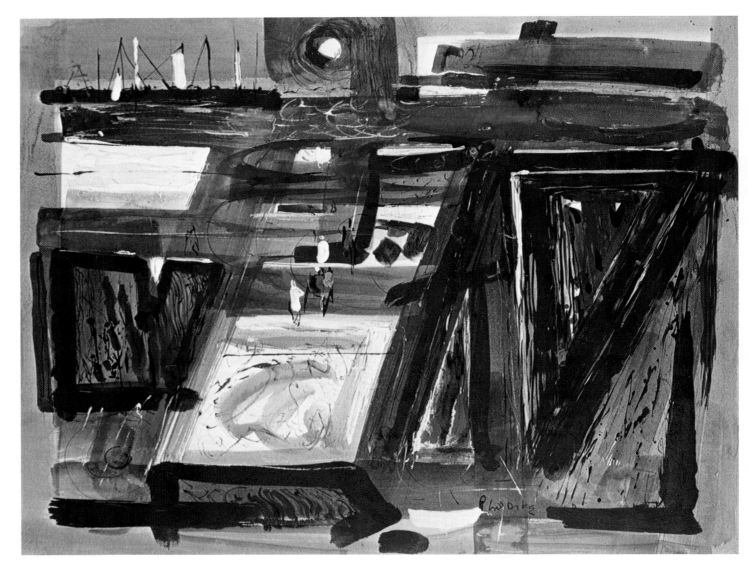

Harbor Configurations *by Phil Dike,* N.A., A.W.S. *Watercolor and ink, 23″ x 29″. Collection of E. Gene Crain, Laguna Beach, California.* Phil Dike, a charter member of the "California Group" of watercolorists, is equally at home in either the representational or abstract approach to painting, but even his most realistic pictures have a clearly discernible abstract structure. This painting is one of a series of paintings of rocks and sea suggested by the Big Sur area. It successfully evokes that rugged, dramatic coast by reducing the beach forms to gestural brushstrokes and strong surface divisions that are more symbolic than descriptive. The style is breezy and dashing, yet at the same time the picture, partly because of its color range, is somewhat moody and forbidding. The figures are briskly indicated, not entirely realistically but consistent with the spirit in which the rest of the picture was done. Dike mentions that this painting was done on two-ply Strathmore paper, using adulterated ink washes and ink lines and texture, and that the watercolor was limited to burnt sienna, raw sienna, green, and blue-green, with areas of white paper and accents of opaque white paint.

View from Jack's Cove *by George Kunkel. Acrylic collage, 47″ x 40″.* Austerity, clarity, and a continuing obsession with the shore, sea, and sky characterize the paintings of George Kunkel, who works in a collage method that he has developed and refined in recent years. Nature has been reduced to minimal forms that suggest the essences of various coastal elements. In this case, Kunkel is concerned with expressing the spaces and expanses associated with Wells Bay, off the coast of Maine. His shapes of four-ply museum board (100% rag content) are assembled beforehand on a gessoed Masonite panel, and after the exact placement of each has been carefully determined, shapes are glued on with acrylic gel medium, sometimes built up to a thickness of five or six layers. The result is something resembling a sculptural relief.

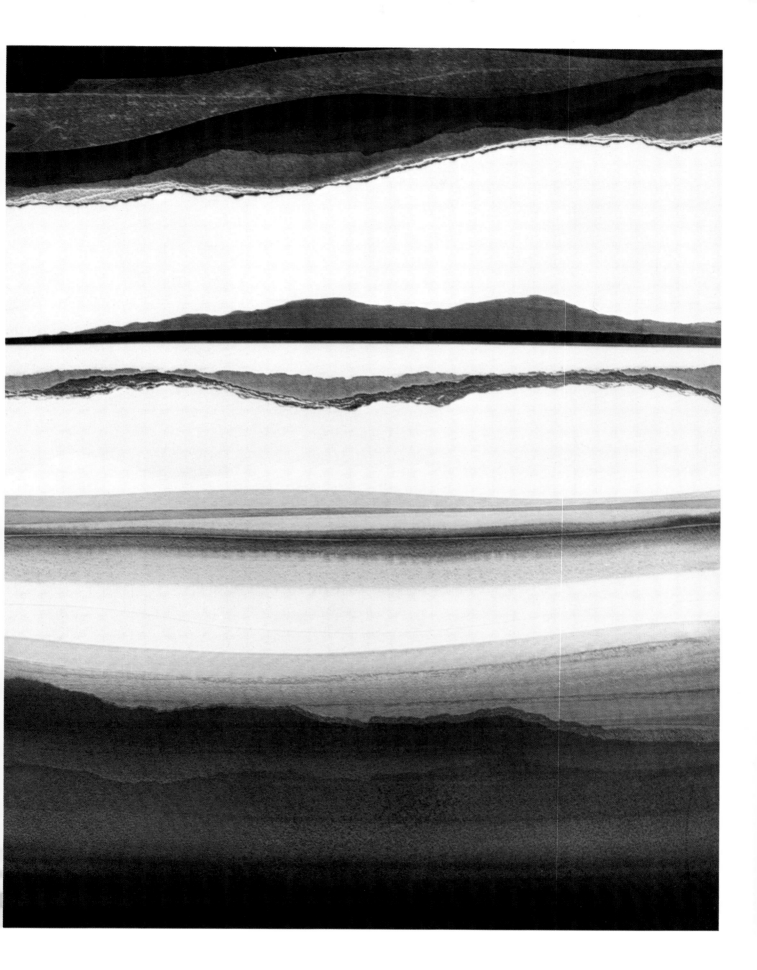

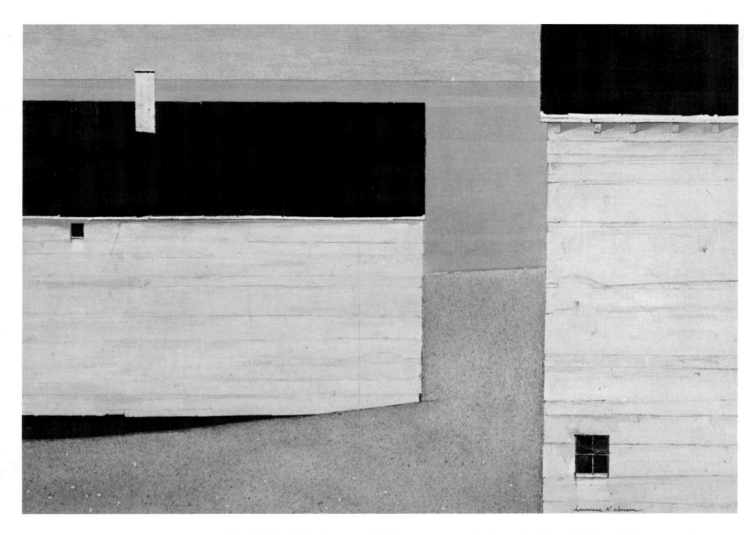

Block Island II by Lawrence N. Jensen, A.W.S. *Acrylic and collage, 17½″ x 24⅜″. Collection of Elise McKibbin, Jackson Heights, New York.* When one first views the acrylic and collage paintings of Lawrence Jensen, one is immediately struck by their reticence, severity, and economy of means. Jensen's reduction of forms to the simplest and fewest shape relationships is disarming: on one hand his pictures appear to be convincingly realistic, but at the same time they have been formally designed with such rigorous exactitude that they often verge on the totally abstract. With such a limited number of shapes, it is an absolute necessity that those few be adjusted with meticulous precision. There can be no loose ends or distractions. Jensen's paintings are done on ⅛″ untempered hardboard, covered with a ground of either flat-finish acrylic housepaint or acrylic gesso. Most of his collage papers are glued to the board with acrylic medium, while gel is used to glue thicker, heavier materials. In this painting, the sand used is actually beach sand, covered with washes of color; the roofs are black construction paper; the clapboards are underlayed with white bond paper; and the sky is tissue paper. All collage materials were glazed or given heavier coats of paint in order to build up the forms. The color is as spare and subtle as the design itself.

7. Collage Analysis of Nature

Collage in its purest form can be classified as still another aqueous medium. After all, paper is a major part of the surface; the papers are customarily colored with water-based paints; and because of the somewhat fragile nature of the materials used, collages are usually framed under glass.

The word "collage" derives from the French *papiers collés* ("glued papers"), referring to the early cubist works of Picasso and Braque in pasted papers. Collage has since become a major art form and has evolved from simple paper shapes combined with charcoal lines or a bit of paint to a more complex type of surface that is frequently large in scale and involves an incredible range of materials (sandpaper, canvas, bus tickets, fabrics, paper currency, string, glass, metal, beads, wood, tar, oil paint, stone, flowers, and scorched plastic are only a sampling).

A number of the most distinguished artists of our times have done some of their finest work in collage: Henri Matisse, Nicolas de Stael, Alberto Burri, Antoni Tapies, Conrad Marca-Relli, Willem de Kooning, Lee Gatch, and Robert Motherwell. Each of these artists has used the collage medium in a personal way and for quite different purposes.

Collage as a major medium is not our concern in this chapter. I am thinking of it here mainly as a means of analyzing nature's forms in terms of cut and torn paper (and some paint), done on an intimate scale no larger, say, than 16″ x 20″. Such collages would not necessarily even be done as an end in themselves, but more as a means of gaining deeper comprehension of the formal possibilities of subject matter in preparation for a more painterly treatment of it in watercolor or opaque media.

I see collage as a way of studying and grasping abstract relationships, using simple methods and materials and a minimum of paint, on a scale at which there is maximum control of the total surface design. Although collages of this sort are primarily studies, they often transcend their purpose and become works of art. Since such compositions are modest in size and framed under glass, they are eligible for submission in the watercolor category to regional and national exhibitions.

OBJECTIVES

1. To temporarily minimize painterly effects and work primarily in terms of flat areas and pattern.

2. To work toward the most severe and decisive simplifications of nature.

3. To analyze the subject matter from three principal viewpoints: shapes, color planes, and overall design.

4. To clarify thinking in regard to how natural forms can be translated into pictorial symbols.

MATERIALS

Papers: Color-Aid pack of assorted colored papers; black, white, and gray construction paper; prepainted papers

Glue: Elmer's glue; acrylic medium diluted with water

Illustration board

Drawing board

Acrylic paints

Razor blade, single-edge

Brown wrapping paper

NOTES

Papers. The main thing to consider in selecting papers for collage is whether and how much they fade when exposed to light for long periods. Although it could be argued that collage is to be used mostly as a form of study here and that permanence is of secondary concern, I think it is worthwhile to use high-quality materials, since there is always the possibility that a small collage study may turn out to be a gem worth keeping and perhaps even exhibiting.

Therefore I recommend a large pack of colored paper, such as the Color-Aid assortment, which has an enormous range of colors in different values and is probably reasonably colorfast. There are also packs of paper of varying quality, mostly construction paper, that come in a range of blacks, white, and grays only, which could also be used in these collage studies.

If such paper assortments are not available locally, it is possible to paint medium-weight paper with acrylic in whatever range of colors or neutral values is necessary. Though this may seem like a good deal of trouble just to have colored paper with which to work, acrylic-painted paper is the one form of colored paper I trust to be colorfast. And if acrylic is painted onto an all-rag paper, the result is not only colorfast but incredibly strong and durable as well.

For studies that are considered to be of only transitory use, to be thrown away as soon as they have served their purpose, almost any colored paper will do—wrapping paper, painted newsprint, colored tissue paper, pages torn from magazines, or whatever. Most of the colors used in magazine printing are made of ink dyes that are not ex-

Back Steps *(Above) Construction paper on illustration board, 12" x 16". Collage was used to analyze the most essential shapes and reduce the subject to very clearly separated values. There was no attempt here to cut paper shapes that would reflect exactly the original forms, but rather to simplify them or redesign them slightly in the interest of arriving at a composition that would be satisfying in its own right without requiring any knowledge of its sources. In doing studies of this sort, the collage medium enables the artist to physically move the paper shapes about in order to find the best placing for them, or to cut them to a different size or shape that will relate better to the design as a whole. These are both things that are accomplished more easily and directly with cut paper than with pencil, ink, or paint.*

(Left) Photograph taken at Prospect Harbor, Maine. This motif was chosen as a subject because it already contained a somewhat abstract patterning of light and dark shapes.

pected to last very well. They are comparable to some of the exceptionally brilliant colors that contemporary illustrators use: if they retain their brilliance just long enough to be processed at the photoengraving plant it does not matter that they will become pale and faded a month later.

Glue. Almost any glue or paste will do except rubber cement, which eventually dries out, loses its adhesive qualities, and bleeds through and stains the surface of the colored paper. I use Elmer's or acrylic medium, both diluted by half with water. Using them full strength just to paste paper is not at all necessary.

There are two methods for adhering paper to the support:

1. Take the paper that is to be glued and place it face down on cardboard or wrapping paper. Then apply white glue (such as Elmer's) or thinned acrylic medium all over the back of the collage paper, right out to the edges, either by brushing or smearing it on with the finger. For stiff, heavy papers, acrylic gel would be the preferred adhesive. Next, carefully place the paper face up on the picture surface, cover it with a protective piece of clean wrapping paper, and smooth it out with very firm pressure to distribute the glue evenly, fill in air pockets, and squeeze out any excess glue. Glue can be picked up with a finger or a damp piece of cloth; if done deftly enough, the procedure will not soil the surface of the paper or lift its color.

2. Brush the acrylic medium or glue generously all over the part of the picture surface that is to receive the collage shape. Then place the collage paper face down on a clean board or wrapping paper. Also brush the back of this collage paper with adhesive then quickly place it face up upon the picture panel, after which brush more adhesive over it. This fastens it into place and seals it there. Now brush the whole surface using extra pressure on the brush to force any air bubbles to the edges, where they can escape. After the paper has dried, it is taut and smooth and adheres firmly. Apply a final layer of acrylic medium to the entire collage to give it a consistent finish and sealer coat.

I use the first method for small collage studies and the second for mixed-media paintings. Collages done in the first method are left dry and unvarnished, with no final application of acrylic medium, and are framed under glass. Collages done in the second method can be treated with matte varnish and framed either with or without glass.

Illustration Board. The best surface to use as a support for the average collage is illustration board. Cardboard or other hardboard is usable, but after a time the chemical impurities in them can bleed through the papers and stain or discolor them. For large collages, a better support would be Masonite.

Collage papers. For collage analysis only a few papers are needed, and the simpler the range of values, the better—construction paper in white, black, and two grays is sufficient. For color work, papers can be prepainted, or sets of assorted colored papers such as the Color-Aid assortment shown here, are available.

Adhesives for collage. The most suitable adhesives are synthetic glues, such as Elmer's Glue-All or acrylic medium, either gloss or matte. For gluing paper on collages, both these adhesives can be partially diluted with water.

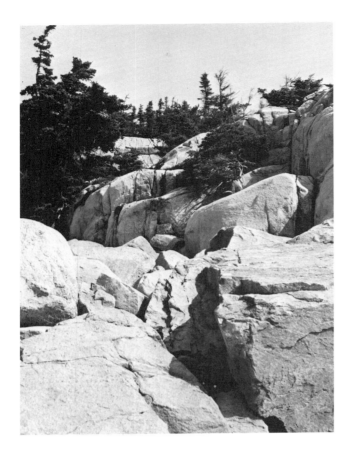

Rocks at Schoodic Point, Maine.

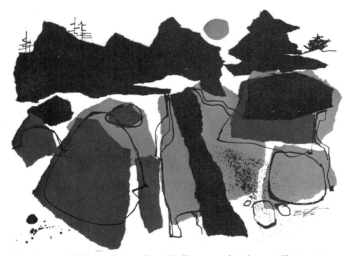

Rocks and Pines, Schoodic *Collage and ink on illustration board, 12" x 16". Once I have selected a motif I frequently do what I call a "collage sketch," which may or may not be accompanied by other analytical drawings and studies. Collage sketches are usually done with construction paper and then drawn into with India ink, working for an interplay of shapes, lines, and values; I have found this often brings me nearer the look and spirit of a painting than a drawing does. The character of a collage sketch such as this is loose and improvisational—a free, subjective analysis of the motif, not at all like the more precise, intellectual analysis seen in* Back Steps *on page 130. Of course the subject matter itself often determines the most suitable treatment for collage analysis.*

Drawing Board. Because collage papers will cause illustration board to bend or buckle, the board should be tacked or taped with masking tape to a drawing board or plywood board and left secured in place until dried out. If removed too soon, the illustration board may still buckle, perhaps ruining the collage.

Acrylic Paints. These paints are used to color the collage papers or to paint large-scale color masses as backgrounds for the paper shapes. If the collage is carried beyond the preliminary study stage to a more fully realized statement, then acrylic paints may be freely brushed on to partially submerge colored-paper areas, or they may be applied as glazes, linear accents, and textural spatter.

Razor Blade. When cutting paper I prefer to use a single-edge razor blade, with which I can cut freely and sweepingly, in a motion akin to drawing. To me this is more natural than carefully cutting with scissors, in which the motion, and consequently the shape, is somewhat cramped and stilted. A razor blade can be used for thin slicings and adjustments or to cut long arabesques. Also, it responds faster to mental or emotional impulses than does a pair of scissors. Of course, one of the greatest collagists of all time, Henri Matisse, used scissors to form his breathtaking, monumental last collages—so who am I to scorn scissors?

In most of my collages I try for a variety of edges. I utilize both cut and torn paper forms; the opposition of softer, more accidental edges with precise, clean-cut edges. Edges that are torn can be controlled to a certain extent by the manner in which they are torn. Also, you can add dimension to your collage by simply alternating the direction in which the paper is torn: if you hold the paper and tear it *away* from yourself, it leaves a shape on which color continues out to the very edge; if you tear the paper *toward* yourself, the outer edge is not colored, but reveals an irregular strip of white that generally follows or reflects the path of the torn edge. These ragged white areas left at the edges can be used as linear accents or separations in the composition.

Wrapping Paper. I keep a supply of brown wrapping paper on hand as a surface for gluing, always seeing to it that the colored papers are not put down on wet glue; I also use the wrapping paper on top of collage papers as they are being glued onto the picture so that I can rub my hand or a paint rag over the surface and exert heavy pressure to smooth the collage paper down as flat as possible, getting rid of excess glue. To rub the surface of the collage paper might remove color or streak it with disfiguring marks.

USES OF COLLAGE

Explorations. Working in collage can be of great help to you as a watercolorist in several ways. First of all, collage provides a means of exploring abstract relationships and clarifying your thinking in regard to some of the fundamental aspects of picture-building: shape, space, pattern,

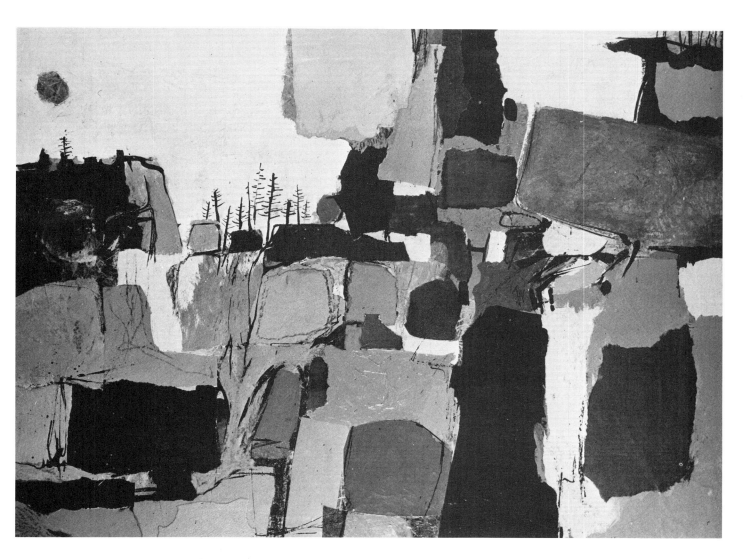

Boulders and Pines *Mixed media on Masonite, 18" x 24". Collection Davis Art Gallery, Stephens College, Columbia, Missouri. After I had explored the motif and clarified my ideas about the relationships of shape and pattern and the overall design. I put away the preliminary collage sketch and began the final version. I did not try to repeat the previous collage phase or use it as a direct reference, but let the painting grow on its own, with the knowledge, however, that it would eventually be a fresh version of boulders and pines based very freely on the original source. Too close an adherence to preliminary studies can sometimes restrict freedom to follow impulses or respond to something suggested by what is happening on the surface of the panel, so I build a composition with only the most general plan in mind and allow it to come to its own conclusion. The collage sketch, therefore, paved the way for a more direct route to a successful handling of the theme, and the finished painting in collage, crayon, ink, and acrylic strongly reflects the look of the sketch without being a mindless repetition of it.*

Creating Depth by Means of Planes in Pictorial Space

Recession into space by perspective. When planes converge in one- or two-point perspective, they create an illusion of depth and recession into the picture characteristic of most representational painting since the Renaissance. By the late 19th century many painters and muralists felt that this illusionistic space was a denial of the flatness of the canvas or wall on which the picture was painted, and there was a move to restore an awareness of the picture plane by translating three-dimensional volumes into frankly two-dimensional planes that were more consistent with the two-dimensionality of the actual surface of the painting.

Overlapping planes. If the planes are not allowed to shoot back into a deep space—no converging lines or reduction of the sizes of shapes—then those planes must be situated in front of and behind each other in a restricted, or controlled, depth. Planes can be staggered and overlapped or built vertically from the front planes at the bottom to the rear planes at the top in the manner of Oriental art. In any case, this is done without reference to linear or aerial perspective, and is comparable to several overlapped sheets of cardboard that recede only a short distance into the picture space.

Tilted planes. If the planes are slightly tilted along one edge or another, there is a more interesting and complex expression of the planes acting in space, but still within strictly two-dimensional terms. There is no attempt to deceive the eye with converging lines; in fact, often the lines purposely diverge in open disregard of the principles of standard perspective. In this design, certain tensions have been set up between the axis of one plane and the axis of another plane, which is a much less static way of positioning planes than in the preceding example, where with only horizontal-vertical axes, they were uniformly parallel to the picture plane.

Tilted planes combined with line. By combining lines with the tilted planes, even more tensions are brought into play. The lines are not used to define or contain planes but are an almost independent composition that is coordinated with the planes, and at the same time occasionally opposes the planes, resulting in an even more intricate visual and spatial activity than is possible by means of the planes alone. And if the element of color is added, so that the artist is dealing with color planes in space, he is then able to manipulate his forms in still another dimension, since colors advance and recede depending on their intensities and whether they are warm or cool.

color planes, and design. It is a means of manipulating those elements in a manner even more direct than drawing or painting. There is the opportunity to actually hold a shape in your hand, alter it if necessary, then place it in several trial positions until the precise placing is found.

By severely limiting the complexity of forms, by reducing forms to basic shapes or even symbols, you find yourself working with the very bricks and mortar of art and design rather than being diverted by the technical considerations of watercolor or acrylic. As a result, you can refresh your thinking and try out ideas that might not occur to you as readily or would not be possible to do as easily in the other two water media.

A few years ago, when I felt that my mixed-media paintings were becoming overly "busy" with too many little forms, I embarked on two collage series. One was called "Coastal Fragments," numbered from 1 through 36, and the other "Sea-Edge," numbered from 1 through 20. The purpose behind doing these was to get a change from painterly brushstrokes and a multiplicity of forms and to see with how few elements I could create a feeling of those places where land and sea meet.

The idea was not to change course in my work but to take a side-trip, so to speak, to investigate the possibilities of severely limiting forms and reducing natural forms to essential shapes or symbols—and, generally, to revitalize my thinking. I was not much interested in exhibiting my collages, though I did do so occasionally. Their principal function for me was a temporary period of exploration.

Shape Analysis. Collage can be a way of analyzing nature's forms through a process of extreme simplification. Look at a landscape, for example. Ask yourself about the general character of its forms: are they organic (natural, irregular) or geometric (regular, straight edges, circles, rectangles) or a mixture of both?

Through collage reduce the entire subject to only three, or at most four or five, shapes. Play with those few shapes until you arrive at the greatest intensification of the sense of place, as well as the most sensitive adjustment of the shapes to each other and to the intervals between them. Apply this same thinking to some barns, a city scene, or a room interior. Analyze, condense, and simplify, until only the most essential elements are left to form a strong design and yet express or suggest the original subject.

This is an excellent way to increase your awareness of shapes—the basic character of their form, their relative size and scale, and the importance of their interrelationships. Shapes are one of the most important considerations in any painting, and you cannot spend enough time observing and manipulating them.

Analysis of Color Planes. A plane is any flat shape or surface that is connected to the picture surface or moves into the space within the painting. The basis of cubism was a fracturing and analysis of planes, whether in still life, figure, or landscape, as a part of the translation of three-dimensional subjects onto a two-dimensional surface.

Where some planes remain parallel to the picture surface (or picture plane), other planes tilt in space, toward or away from each other, and set up tensions that imply space and movement within the imaginary picture space. Hans Hofmann called this "push-pull."

A sense of depth is created not by linear or aerial perspective but by the way planes shift and move into a limited or controlled pictorial depth. Volumes are no longer regarded as volumes, but are handled as though they were so many sheets of cardboard, positioned in front of or behind each other, overlapping or interpenetrating, projecting toward or receding from the spectator. All this, as I say, takes place in a shallow pictorial space rather than an illusionistic deep space.

In terms of the push-pull activity I have mentioned, an equilibrium must be established by these planes in relation to each other so that the flatness of the picture plane will not be violated. Just as in representational painting, every effort should be made to see that there are no holes or projections in the pciture: areas that recede too far back are brought forward with brighter color, and areas that pop out too far are suppressed by means of subdued color.

Therefore color, too, can be a means of implying depth within the picture. Instead of relying on light and dark to control the planes in space, you should think of the planes most specifically as being *color planes*. The old notion that warm colors advance and cool colors recede is a generalization that is not always true; certain intense, cool colors will obviously advance, whereas deep, warm ones will tend to recede.

Since planes occupy various spatial positions in the picture and since colors also take various spatial positions, analysis of these color planes is important to understanding your subject and its organization as a painting. Colored collage papers are the logical and most convenient method for investigating color-space-plane relationships and their variations.

Now take your landscape or room interior and look at it in terms not only of shape per se, but of shape considered as a colored plane. Try out a few exercises relating these color planes: do they read in a rational, ordered progression in space or does one shape step forward too far? If so, what color adjustment can be made to relate it more exactly to the other planes and to the picture space generally? Are you using color to create depth or are you still unconsciously hanging on to the idea of depth through linear or aerial perspective?

Try it again. Cut the shape so that no recession is suggested by the angles or contours of the shape. Now make it work as a plane that takes its position through color alone.

Design. The third viewpoint from which to analyze nature through collage is that of design—to do compositional variations that will express fundamental relationships of the forms in their largest, simplest sense and also

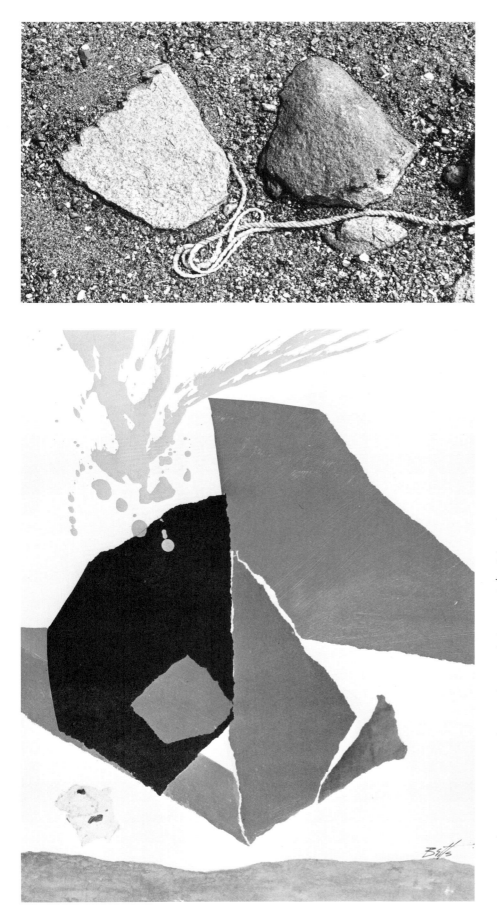

(Top) Three beach stones and rope.

Coastal Fragment #26 *(Bottom)*
*Collage and acrylic on illustration
board, 16" x 12". From 1968 to 1970 I
was engaged in doing two series of col-
lages that represented an effort to get
away from some of the complexity and
fussiness of my work in acrylic and in
mixed media. I wanted to use collage
in a very simple, compact way that
would reduce the ocean-shore subject
matter to a more condensed, almost
symbolic sort of imagery, and to elimi-
nate excess and clutter. The only thing
that tied all the collages together as a
series was the subject—ocean, beaches,
rocks, splashes, pebbles, suns, moons
and horizons. In my walks along the
seashore I look a great deal at the
things that lie near my feet, the close-
up view of nature, not the panoramic
view. Arrangements of forms and tex-
tures such as those in the photograph
are stored away in my mind and are
brought to the surface while I am
painting. There is no direct relation be-
tween the photo and this collage, but at
the same time I cannot help but feel
that if I had not observed the sort of
things seen in the photograph, I would
not have done the collage.*

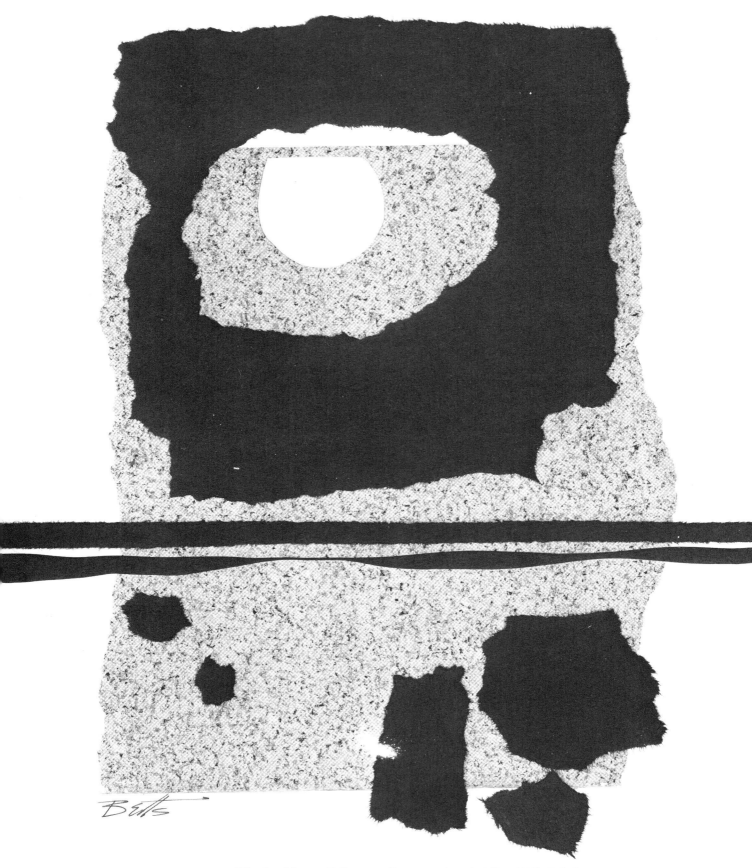

Morning Moon *Collage on illustration board, 14″ x 11½″. I find it stimulating to work with collage because of the way in which a piece of paper comes to hand out of chance or coincidence, or whatever, and causes a reaction in me that stimulates the formation of an image.*

suggest ideas as to arrangement and pattern that are inventive or daring. By moving collage shapes about, you can try out various compositional relationships of masses: overlap them, enlarge them, combine them into unanticipated new forms. Generally freshen your ideas as to what can be done with your subject in terms of its overall interaction of parts.

In drawing or painting, you are inhibited by old habits of seeing and composing, but in collage you can treat the components in your composition from a more imaginative view. You can turn shapes on their sides, or upside down, and set in motion ideas you would probably not think of if you drew or painted each changing possibility.

Aside from deriving your collage shapes directly from reference to the general basic forms of your subject, you can attack the problem from the other end. Instead of asking yourself what can be done to simplify or abstract the elements in your subject, start out with an area of random paint application as a background form, or sky, then tear or cut out collage shapes that may seem to have little or no reference to your subject. Now try to relate them to the painted area and at the same time relate them in some way to the subject that was your initial starting point. In other words, creep up on your subject in reverse, beginning with a chance situation and then bringing the composition back toward natural forms and arresting relationships of shape and pattern. It may take a little nerve on your part to try this, but it is a sure method for shaking yourself out of familiar, standardized attitudes toward analysis and design.

Collage exercises of this sort are not isolated games that have no application to your work in painting media. You can by means of them firm up and expand your design concepts and your personal synthesis of art and nature. What you learn through such exercises should be transferred and put to active use in any painting you do, whether it is representational or abstract.

This photograph of the subject, a barn on Route 1, Cape Neddick, Maine, was chosen as a motif because its abstract qualities are already evident. Using these relationships of rectangular patterns, my plan was to explore the subject in terms of shapes and colors, to analyze it by means of collage.

Demonstration: Maine Barn

Step 1. First, I securely taped the illustration board to a drawing board to prevent the panel from warping when the collage papers are pasted on it. If the finished collage is left to dry out completely while still attached to the board, the chances are that after it has been removed it will remain flat permanently. This collage analysis was not intended to be a painting in the customary sense; it is actually more of a study or an exercise in relating color planes in a two-dimensional design. In a collage such as this I do not begin with a preliminary drawing or any kind of blocking-in. I just start right in with the colored paper and Elmer's glue.

Since this collage was being done on a piece of illustration board that was larger than the papers in my Color-Aid assortment, I planned to use large sheets of a medium-weight watercolor paper prepainted with acrylic colors. I had a pile of perhaps two dozen such sheets in my collage portfolio, so I set them all out to be available for selection as I went along. To my left I had an old piece of matboard on which to lay the cut paper while I applied glue, and a sheet of clean brown wrapping paper to place over the colored paper after it was affixed to the surface so that I could press it in place by firmly rubbing my hand over the brown paper. The first step, then, was to fill most of the picture area with a large sheet of deep blue paper representing the rear plane farthest back from the picture plane, and—since I was to deal in optical color effects and color as space—an intense pink for the barn roof. I believe that if all colors in a painting are intensified to the same degree, then no one color is out of key with the rest; but if you start out with a strong color or two and then lose your nerve with those that follow, the color relationships will be inconsistent.

Step 2. That pink roof was my first departure from reality, and it reinforced my feelings about working with a range of color that was partly real and partly unreal or playful. I could use a blue for the sky and a red for the barn, but I could also force the color elsewhere for more decorative purposes, using color creatively rather than descriptively. (I would suggest, by the way, that while following the steps of this demonstration in particular, it would be advisable to refer at the same time to the color plate of the completed collage on page 221.) The major color plane was the barn: it was the largest, simplest shape in the composition and had to be precisely adjusted to the roof in regard to its size, scale, and color. In order to maintain the flatness of the picture, I aligned the left edge of the barn with the roof edge, though I indented it slightly under the roof at right. There was no attempt to overlap planes; I just placed them adjacent to each other and let the color do the work. Still concentrating on the biggest planes, I cut a long horizontal strip of bright green to establish a strong foreground color. Next, the barn door, which I treated not as a white door next to a deep space, but as two colored shapes, an orange and a black, each selected for its effect on the other and in relation to the red of the barn; a white next to a black, for instance, would have been too jumpy, or contrasty, and they would probably not have stayed anchored to their place on the red plane. Note that in general I was working with colors chosen for their intensity or saturation rather than their light-and-dark value, and that is why the black and white step-by-step photographs fail to give an adequate idea of the true color relationships.

Step 3. The lower part of the barn was a different color and texture than the upper part, so I felt free to choose an intense purple instead of another red. The white lower door was compacted to a slim yellow vertical. This divided the purple from the black shape that referred to the opening to the cellar under the barn. In order to achieve some visual continuity from area to area, I lined up the right edge of the lower black with the left edge of the orange barn door above it. Rather than try to suggest the clutter at the lower right corner of the barn, I decided in favor of colored strips and a long wedge of bright blue to indicate the slope of the ground at that point; this whole section was to be one of several vibrating colors rather than a simple color mass, but I used strips of color that would repeat other larger color areas already established in the composition. There was no need to bring in a whole new group of colors—the electric blue was the sole new color addition. At this stage of the picture it was particularly important to be extra sensitive to the size, scale, and proportion of each shape as it related to nearby shapes and to the surface as a whole, and to choose colors precisely so that they held their specific positions within the picture space—no holes and no projections without a compensating push or pull elsewhere on the surface. By this time the barn motif was of diminishing importance and my main concern was the color structure of the overall composition and in keeping the picture simple but not empty.

Step 4. I saw no need to retain all the windows in the barn, which would only chop up the space, so I condensed the upper windows into a single shape, placed so that its right edge lined up with the left edge of the black doorway below it. For that window I wanted a color vibration of just the right blue against the deep red, and finally found a blue that fulfilled my needs, an intense blue but not the same blue as those in the strips at lower right. A vertical block of dark green at the right edge of the picture referred to the background trees, but only as a color note, not as trees. After the two lower windows were translated into two black rectangular forms, I noticed that the lower black doorway was too large, or at least it was one black too many, so I covered it over with a shape of the same blue that had been used in the sky. The change somehow affected the veritcal strip next to it, so I subdued the light yellow to a bright orange, the only accent of that color in the whole picture. The left edge of the composition seemed flat and uneventful, so I introduced a sliver of red as a touch of warm color to contrast with the cool blues and greens. At the very end, although I do not generally believe in cropping, I cut an inch from the top of the panel to reduce the size of the roof, and also added a few refinements here and there, mostly thin bands of color, to help achieve a better balance between simplicity and complexity, mass and detail. (For color reproduction of this collage, see page 221.)

January Thaw *Mixed media on illustration board, 23" x 30". Private collection. Photo courtesy Midtown Galleries, New York.*

8. Mixed Media

Mixed-media painting combines several media and various materials within a single picture. It is basically an extension or amplification of the collage approach, but with a more even balance of paint and collage elements. I consider mixed media one of the most exciting and fascinating methods in the watercolorist's repertory.

In contrast to the somewhat limited textures of transparent watercolor, or the flatness of collage, the possibilities of mixed media are almost unlimited for achieving rich surfaces, combining opaque and transparent passages, and exploiting resists, glazes, impasto, and flung paint in addition to collage. The effects are far more varied than those obtainable in gouache, casein, or acrylic alone. There is an even greater illusion of color depth with mixed media, which together with the interplay of collage materials, provides an unusually handsome, complex surface with considerable tactile quality. A mixed-media painting appeals not only to the eye; it invites the touch.

Since this is an acrylic technique, continual experimentation and overpainting are possible. The concern here is not with the freshness and fluid washes of watercolor, but rather with a fully developed, intricate interweaving of many pictorial elements in a more solid, painterly sense than is characteristic of transparent media or even of the opaque media as we have previously used them.

With mixed media it is possible to build up areas of paint and collage and then add, subtract, scrub, paint out, wipe, spatter, scrape, scumble, and glaze until all the forms on the surface are functioning together exactly as the artist wants. As ideas come along, they can be tried out immediately; when something does not work, it can be repainted until it does. The only limits to this way of working are the artist's powers of invention and perhaps his skill as a scavenger when it comes to collecting materials to be introduced into the painting. Furthermore, unless dubious methods or materials are involved, a mixed-media picture is absolutely permanent. The acrylic medium used as a sealer and adhesive throughout protects the painting from air and moisture, and all the layers of paint and collage become a single film that is virtually indestructable. It should also be kept in mind that mixed-media works can be exhibited either as oils or watercolors, depending on how they are framed.

Objectives

1. To create a picture using not only paint but several other materials as well, working on a large and a small scale.

2. To combine a collage treatment with paints and inks, stressing variety of texture as a major element in the painting.

3. To permit the materials themselves to influence the development of the composition.

4. To provide opportunities for sustained exploration and discovery.

Materials

There are no holds barred in mixed-media painting, so everyone will have his own preferences. Here is my own list:

Acrylic paints

Masonite or heavy illustration board

India inks, assorted colors

Wax crayons

Papers: prepainted sheets of paper; Color-Aid papers; rice paper; onionskin typing paper; white tissue paper; synthetics (fiberglass, plastic, etc.); paper towels

Sand

Fabrics

Spray bottle

Acrylic medium, diluted (either gloss or matte)

Acrylic gesso

Gel

Modeling paste

Painting tray

Matte acrylic varnish

Brushes; painting knife, etc.

Notes

Colors. I use the usual palette of acrylic colors—the coloristic selection rather than the tonal.

India inks are brilliant and very useful, though they may lift or blur slightly when painted over. You should be able to capitalize on that effect rather than fight it. The only colored India inks that are truly permanent are those made from the same pigments that are traditionally acceptable for fine arts painting. The inks I prefer are made by Pelikan and contain pigments rather than dyes.

Main Shore Mixed media on illustration board, 26″ x 40″. Private collection. This Maine scene was painted in 1962 while I was living in Florida, and is one of the earliest of my attempts at combining paint with other media and materials. At that time the acrylic paints were a very new development, and many of the artists I knew were trying them. Most of the black, dark blue, and deep red shapes in this painting were cut from magazine advertisements, selected because they were solid color areas without texture or distractingly readable subjects. The sky was underpainted with ultramarine and phthalocyanine blue and then colored with layers of heavy rice paper that were to be glazed and stippled with color later. The remainder of the surface received a coat of several miscellaneous colors that were then covered with varying thicknesses of layers of both tissue and rice paper. Following a phase during which I drew improvisationally with colored inks, I applied the rock shapes and glazed large areas of the surface with both inks and paint. Stipple and spatter were used to further enliven the surface.

The best rule in selecting colored inks is to choose only those that are labeled according to pigment, rather than by vague hue designations.

Wax Crayons. I use these not only for color but also as resists.

Colored Papers. In selecting colored paper for mixed-media work, I try to avoid papers that will fade with prolonged exposure to light. It is best not to use pages torn from magazines, since they are often printed with inks or dyes that are not lightproof. Especially to be avoided are the bright-colored tissues sold as gift wrapping: these seem to contain the most fugitive colors of all. I admit they look very appealing, and they yield some very attractive effects of transparency, but they should be used only in experiments or studies which you expect to discard after they have served their purpose.

Years ago one of my major paintings—in which those colored tissues were used extensively—was hung in the south window of a New York art gallery for three weeks. When I eventually saw the painting, all the intense blues and greens and luscious purples had faded to a sort of mousy gray. The surface was so greatly changed that at first I scarcely recognized my own work.

Having learned my lesson, I now paint whole sheets of lightweight or medium-weight watercolor paper or rice paper with acrylic colors. These papers can be incorporated in a picture with full confidence that the colors will not change or fade.

Japanese Rice Papers. These papers are particularly fascinating for their wide range of textures and fibers and for their ability to produce the most delicate effects of transparency. There is a great variety to choose from, ranging from the most fragile to those containing thick, tough fibers that tear beautifully and can be guided and used as lines in a painting.

When wet, most rice papers become somewhat transparent. Thus, they can be used to subordinate or modify color areas and to achieve extremely subtle effects. After the paper has dried in place, I generally wash some color over to integrate it better with other areas. Occasionally, as I have mentioned before, I prepaint rice paper with thin acrylic color, closely approximating the look of colored tissues.

Onionskin. This 9-lb typing paper is partially transparent, but less so than tissue. It is excellent as a glaze over previous paint applications, and can, in turn, be given a wash of color. It tears well for collage shapes, but because of its relatively small size, several sheets have to be torn and overlapped randomly in order to cover a large area.

Paper Towels. These absorbent towels are useful in creating textures. However, they have somewhat too mechanically regular a surface for my taste.

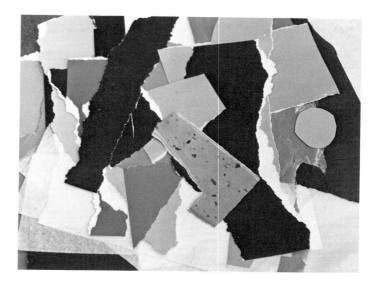

Collage papers. Collage papers can be obtained from a variety of sources: sets of assorted high-quality colored papers, paper towels, magazine clippings, synethetic papers, onionskin typing paper or tracing paper, sheets of drawing or watercolor paper coated with acrylic paints. In spite of the fact that I have used them, colored tissues are to be avoided because their colors fade rapidly under even the most ordinary light conditions. Coloring your own paper is the only way to ensure non-fugitive colors.

Rice papers. The Japanese rice or mulberry papers come in many weights, surfaces, and textures. Some are thin enough to be almost transparent after they have been adhered and dried, while others have very heavy fibers imbedded in them. Though these papers are usually selected for their glazing and transparent properties, or for their textures, the rice papers that are a flat white, heavier weight, and somewhat more opaque are excellent for prepainting with casein or acrylic colors.

Additional media and materials. There are almost unlimited possibilities for ways of creating a variety of textured surfaces, but among those materials that might be used to amplify the basic acrylic and collage are fabrics such as cotton or cheesecloth, sand, wax crayons, and India inks.

Colored inks containing the standard pigments that are acceptable for artists' use are preferable to those which have exotic names but are undoubtedly made of fugitive dye colors.

White Tissue Wrapping Paper. White tissues are something I often use to build up texture in the very earliest stages of the painting. I moisten the general area where the tissue paper will go, lay the tissue on it, and then seal it by brushing on diluted acrylic medium swiftly and casually, so that the wrinkling and crumbling of the paper remains. This creates linear textures that take subsequent glazing and scumbling very beautifully. The paper dries so transparent that it scarcely affects any color beneath it—the rough effect is what I am after—and fragile as the paper is, once sealed under acrylic medium it is hard and permanent.

Synthetic Papers. In recent years, several manufacturers have developed synthetic papers made of plastic or fiberglass, most of which I have enjoyed using. They are very much like other papers but usually are far less likely to buckle or wrinkle when wet. These papers are undoubtedly permanent and nonyellowing and they can often be used to obtain effects surprisingly similar to those of the rice papers. I have found that most of them tear easily in almost any direction, but there are a few that will tear only in parallel strips.

Sand and Other Textural Fillers. If I am going to use sand, I first brush diluted acrylic medium on any area that is to take the sand. While the surface is still wet, I sift sand over it—lightly for a thin, semiopaque surface or very generously for a heavier covering. After the medium has dried thoroughly, I tilt the panel and all the excess sand falls away. Only the areas where the sand came into contact with the wet acrylic medium remain covered. I then apply two more coats of acrylic medium to seal the sand thoroughly on the panel. If an almost sculpturally built-up area is desired, this can best be achieved by several successive applications of sand and diluted acrylic medium rather than a single coat.

Aside from sand, there are other textural fillers such as mica, talc, Celite, birdseed, sawdust, or wood flour. Experimentation will suggest when they can be used most appropriately or whether they are needed at all.

Fabrics. I do not use fabrics very often in my work, but when I do, it is usually in the form of old sheets, shirts, or used paint rags. To me, the most intriguing aspect of cloth collage is the loose threads at the torn, frayed edges of the material. The cloth can be applied to the picture by brushing diluted acrylic medium over it, just as though it were paper. As the acrylic medium is applied to fix the fabric in place, I watch for stray threads and guide them with finger, brush, or painting knife. I literally use the threads to draw with, creating lines that tie in with other parts of the composition. Once the placement of the lines looks right, threads are allowed to dry and become a permanent part of the painting. They can be left as they are or glazed with color.

Spray Bottle. A spray bottle or atomizer is useful for blowing water into wet painted areas to soften the edges

Detail of tissue paper. Tissues that are placed casually on the picture and quickly brushed on and adhered form a network of raised ridges that are totally accidental, creating linear textures that are an excellent surface for receiving future paint applications, whether transparent or opaque. When heavy paint is put on and then partially wiped off while still damp, the tops of the ridges are wiped almost clean but the valleys hold the color at its deepest values.

Detail of sand texture. Sand can be sifted either lightly or heavily onto areas prepared with acrylic medium. The sand adheres only to the medium, and after it has dried all excess sand is brushed away. The sand texture can then be left as is, glazed with color, or covered with opaque paint.

Details of fabric. Old sheets, shirts, or used paint rags can be used as pictorial elements and adhered to the picture in the same manner as collage papers. Once they have been sealed under a coat of diluted acrylic medium, they can be colored with washes, glazes, or spatter, Additional effects are possible by exploiting the use of frayed edges, and loose threads can be guided and incorporated as linear elements in the design.

Muslin or cheesecloth can be used as a fabric texture in different areas, or it can be applied with acrylic medium to cover the entire surface of a Masonite panel, providing very much the same painting surface as some types of artists' canvas.

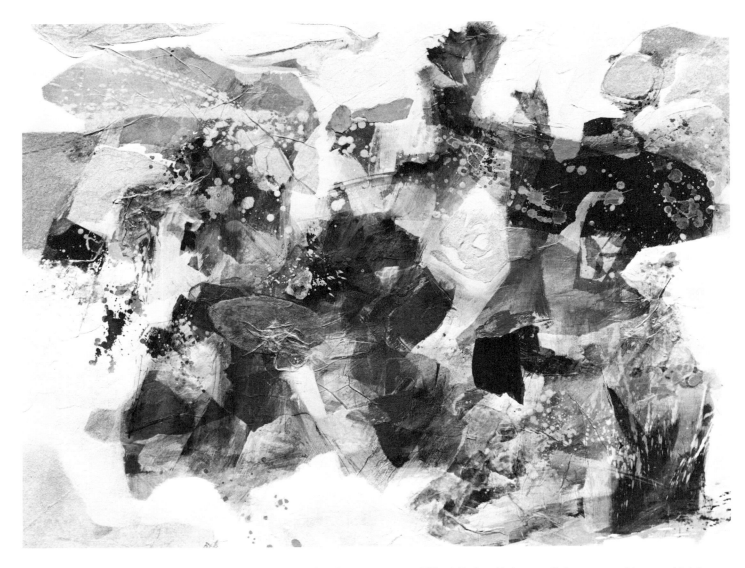

Rockpool *Mixed media on Masonite, 28″ x 36″. I really let out all the stops on this one, which is a veritable orgy of textures. The only thing that holds it together is the color, which unfortunately does not show here. Actually, I did not want it to be too controlled and ordered since I was working for that jumble of forms, colors, and textures, that tangle of lines, dots, and masses that one sees in the depths of a tidepool. There is no other medium I can think of that could so easily and quickly offer the richness, depth, and sheer diversity of elements that are present in this picture. Almost everything here has its equivalent in nature, in the real rockpool: water, seaweed, kelp, periwinkles, bubbles, encrusted rocks, and shadowy, half-seen forms that could be animal, vegetable, or mineral. Paint alone could scarcely have accomplished this kind of counterpoint between flat and sculptural, surface and depth, rugged and fragile.*

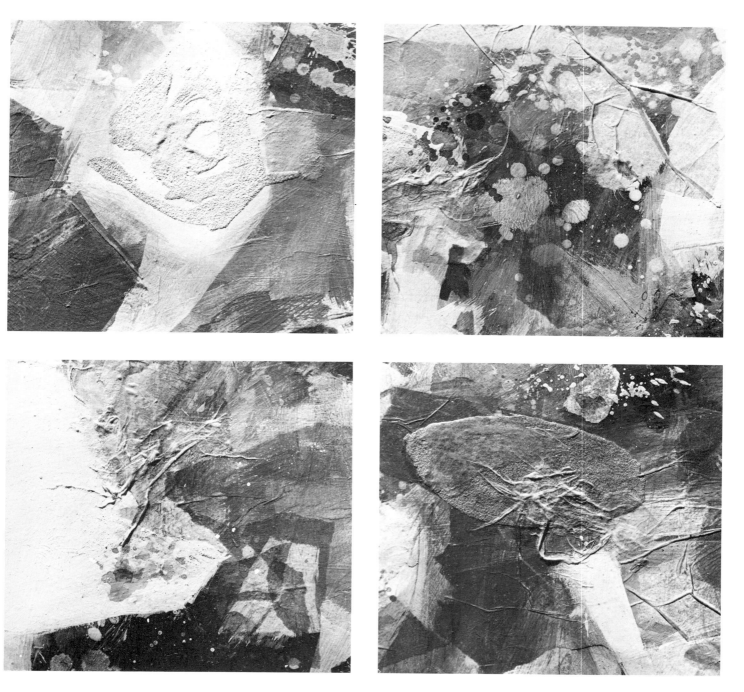

Details of other mixed-media surfaces from the painting Rockpool.

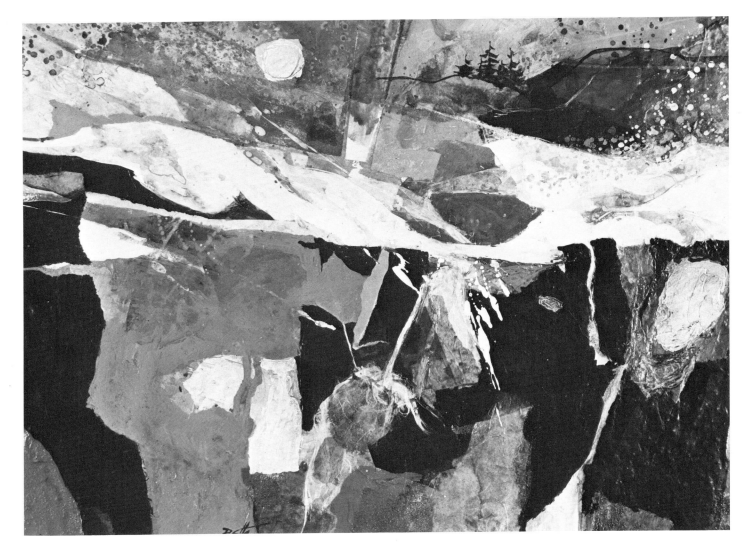

Offshore Island *Mixed media on illustration board, 15″ x 20″. Private collection. There is no room for inhibitions when it comes to painting in mixed media. If I find myself temporarily too constrained and fussy, I impulsively grab any piece of paper at hand, slap it on the picture and adhere it hastily to the surface just to set things in motion again. Unexpected occurrences happen that way—some good and some bad—but the point is that it forces the artist to relax, lose himself in the picture and deal with the unplanned, to get out of a rut and to solve problems never faced before. At least there is something to respond to, or to react against, and it just may help determine what shapes of colors might come next or how to find a way out of an awkward pictorial situation, how to make the unworkable workable. In this painting I had reached an impasse, and by getting mad and throwing caution to the winds, I tore into the picture unrestrainedly. Very shortly the picture returned to life and I could then finish it in a calmer mood, but without losing the freedom and energy that had already become an integral part of it.*

or thin the paint and cause it to blend or flow accidentally. The bottle can also be partially filled with very thin acrylic paint or ink and used to apply color as a spray. (Spray paint textures are occasionally useful and will be dealt with in more detail in the next chapter.) To prevent clogging, the spray mechanism must be cleaned out with very hot water after each day's painting.

IMPROVISATIONAL PAINTING IN MIXED MEDIA

In handling mixed media, I prefer an improvisational approach. Having cleared my mind of any preconceptions as to subject matter, I let my manipulation of paint, cut and torn papers, sand, and so on, provoke unexpected color and shape relationships out of which my composition evolves.

I regard the beginning of each new panel as a fresh adventure, an exploration into uncharted territory. I try to avoid habitual ways of working, allowing accidents to happen and then finding solutions, ways to incorporate new forms into the fabric of the picture. This is mentally stimulating and far more of a challenge to me than simply rendering a preconceived idea.

I feel that one of the drawbacks to representational painting is that the artist more or less knows before he starts what the finished picture will look like. To me, at least, this lessens some of the excitement of creation. With my approach to mixed media there is risk, a sense of walking a tightrope, perhaps, but one must be willing to take chances now and then. With my approach you do not force your will upon the painting; you cooperate with the materials and share in the challenging process of bringing order out of chaos.

BEGINNING THE PAINTING

After I prepare my panel with three coats of acrylic gesso (remember, no ground is required on illustration board), I begin the underpainting by brushing in big, haphazard areas of color with absolutely no subject matter at the back of my mind. Once those areas have been established in as accidental a way as possible, I coat the entire panel with an isolating layer of diluted acrylic medium.

When this has dried, I may draw into it improvisationally, using carbon pencil, India ink, or paint. Following that I add still another isolating coat of acrylic medium. It is these layers of acrylic medium between layers of paint and paper that help achieve a feeling of depth and luminosity in the finished painting.

DEVELOPING THE PAINTING

At this stage I begin to introduce collage elements, tearing out both large and small shapes in either tissue or colored papers and affixing them to the surface with diluted acrylic medium. Then I paint into the surfaces again, freely and playfully, responding intuitively to lines,

shapes, and masses which may (or may not) be forming relationships that suggest an image or design.

I try to postpone finding any image too soon. Instead, I continue the process of natural growth, keeping the painting open and flexible, susceptible to any changes and revisions that occur to me. If I have an impulse, I follow it. Anything is possible, because at this stage of the work nothing is fixed or permanent.

As the painting proceeds, an image begins to emerge that evokes ideas, memories, and associations, and this image or conception then becomes what I call the "control" for all subsequent decisions. Everything that I add to the painting from this point on refers very specifically to, and is determined by, that overriding concept or pictorial idea.

SUGGESTIONS ABOUT MIXED-MEDIA PAINTING

When you are painting in mixed media, especially in the early phases, your mood should be relaxed, carefree, and uninhibited. You must learn to trust your intuitions and tell yourself that the picture will come out beautifully even though at the moment it may look like a hopeless mess.

Feel free to block out any areas that are not functioning successfully. Moreover, if an unusually beautiful passage does not relate well to the total effect, then that, too, has to be eliminated or brought into adjustment. The effect of the whole is far more important than any one part.

Let the picture grow naturally—nudge it, baby it, guide it, but look upon it as being more like a Japanese garden than a formal French garden. If it becomes too neat and rigid, throw on some paint, get mad at it, loosen up the design, and bring it along less self-consciously. Take delight in handling the paint and collage. Immerse everything in rich color. Enjoy watching unplanned things appear. Later, you can settle down to the satisfying business of bringing out structure, order, and emphasis.

Although random actions may start the painting, they do not finish it. What was begun in a mood of playful accident should end in a mood of contemplation and cool calculation. The final painting should be carefully orchestrated, all the parts adjusted and interrelated, so that the viewer's first impression of the picture is not *here is a mixed-media painting*, but rather, *here is a painting—which just happens to have been executed in mixed media*. In other words, do not make the viewer too aware of your materials; they are the means to an end but should not be unduly apparent or distracting.

HOW DO YOU KNOW WHEN TO STOP?

I suppose the question most often asked about improvisational painting is: how do you know when you are finished? This is probably a very real problem to many people for two reasons: (1) there is no subject matter toward which the picture can be directed from the begin-

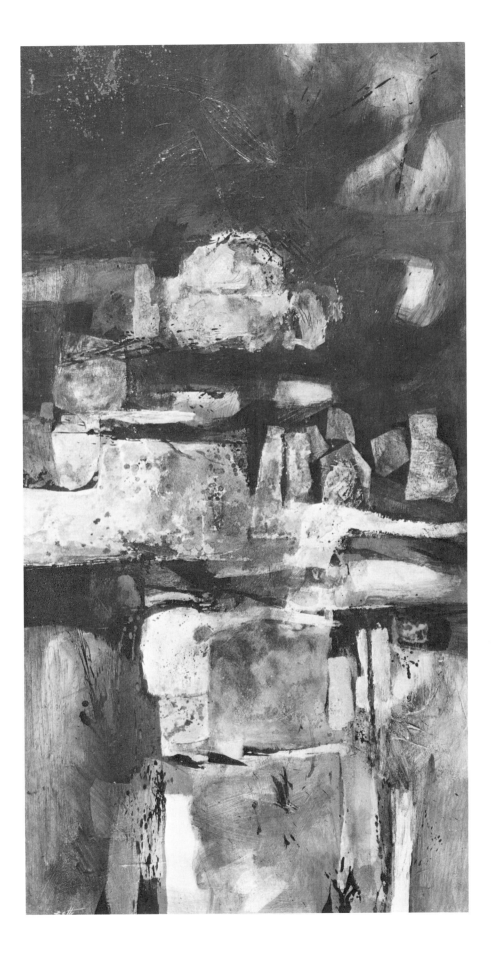

ning, and (2) a generous amount of accident plays a part in the development of the picture. There is a risk that the accidental effects, appealing as they might be, can go on happening almost interminably while the artist stands around waiting for something marvelous to appear.

This could be a frustrating situation, so it is therefore doubly important that you keep yourself attuned to what is happening on the painting surface. You must always be ready to act in answer to what arises there, to recognize and grasp those elements that suggest the route to order and structure in the painting. Once the control image has been found, the act of painting becomes more purposeful. Finally, a point is reached when you find yourself fussing with unimportant little things, when you have said all you wanted to say, when nothing can be added or subtracted without upsetting the picture's overall organization. At that point, your painting is finished.

FRAMING MIXED-MEDIA PAINTINGS

All exhibition prospectuses specify that acrylic paintings will be judged as oils if they are framed as oils, without glass, and as watercolors if they are framed with glass. This rule also applies to acrylic collages and mixed-media work.

Since it has been left up to the artist to decide just how he prefers to submit his painting, he should consider the general look and scale of the painting in question. In my own work, my only rule is that if the picture is on illustration board I frame it as a watercolor, and if it is on a large Masonite panel I have it framed as an oil.

Red Rockscape *Mixed media on Masonite, 48" x 28". Courtesy Midtown Galleries, New York. This is one of those paintings that one does every now and then that are quite mysteriously apart from any painting done before or after it. I am not even sure myself what it is all about, except that because of the form, or forms, emerging from deep, dark recesses, I called it* Red Rockscape. *The surface of the Masonite was prepared by adding some acrylic gel to the gesso, so it had a more brushy texture than most of my panels. Next I coated the whole surface with ITR red light, which, when dry, I glazed and wiped with ITR crimson and some Acra violet. Other forms were added, either in acrylic modeling paste, paper, or sand, all of which were glazed, scumbled, rubbed, scratched, and spattered, and at the very end I built up one area with gold powder mixed with acrylic medium. The final image eludes me—perhaps half rock, half person in an ambiguous environment—but to this day this painting remains one of my favorites.*

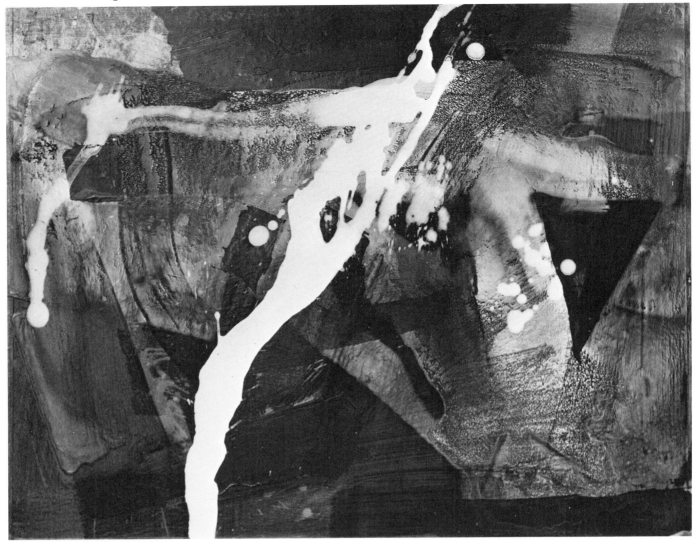

Step 1. In this painting I began with a coat of cadmium red light acrylic paint brushed loosely on the panel and then distributed more evenly by smearing the paint quickly with a paint rag. Once this was dry, using a 1½″ housepainting brush, I covered most of the surface with Acra violet; when this had barely dried, I spattered clear water onto it, waited for almost a minute, then wiped the surface vigorously with a paper towel, which removed paint from the water-spattered areas to reveal the bright red beneath the deeper red. When it was dry again, I floated an almost transparent film of thin white acrylic paint over large parts of the panel. After that film had dried I glazed once again with Acra violet. Just to disturb the surface further and to provide some contrast to the dark colors, I flung on some opaque white paint and spattered or flung on a few semitransparent whites. At this point I applied a sealer coat of acrylic medium diluted with water.

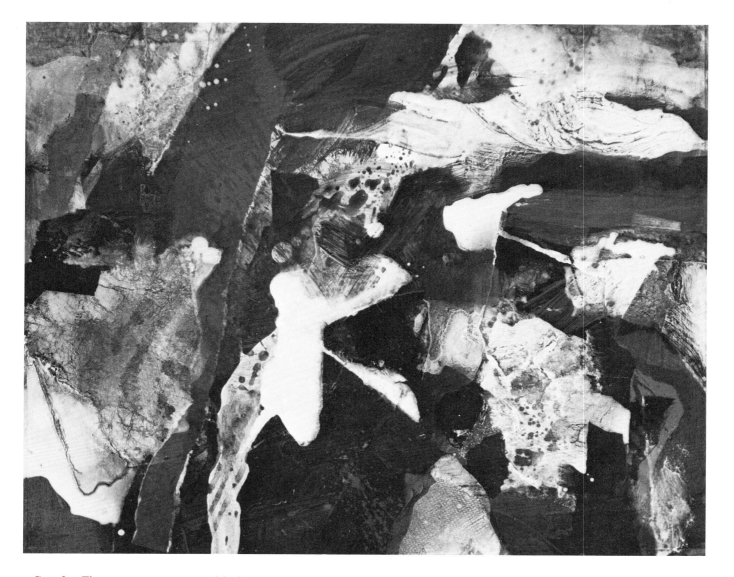

Step 2. The next stage was to enrich the picture surface by introducing collage elements in the form of unpainted rice papers and prepainted colored papers. Areas to receive these collage papers were first brushed with the mixture of diluted acrylic medium, the paper was placed on the panel, and then liberal amounts of diluted medium were brushed back and forth over the paper to seal it in place. Firm pressure with the brush worked any air bubbles out to the edges of the collage paper so that it was as smooth and flat as possible, with no bubbles or wrinkles visible. After drying in place, the papers were glazed with various acrylic colors to integrate them with the other color-shapes throughout the rest of the picture. My main idea in this step was to build up a sumptuous, complex surface of colors and textures, as sensuous and varied as I could make it, and at the same time to invite accidents that would produce configurations stimulating to my mind as well as to my eye. I continued to paint in a very relaxed manner, flowing on more transparent color, glazing, spattering, and lifting color with paper towels, followed by more glazing and wiping. All of this was merely preparatory for what was to come later, and I was in no rush to accept any passage, however luscious, as being final. Of course I was alert to any possible suggestions as to design or subject matter, but textural opulence was for the moment my primary concern.

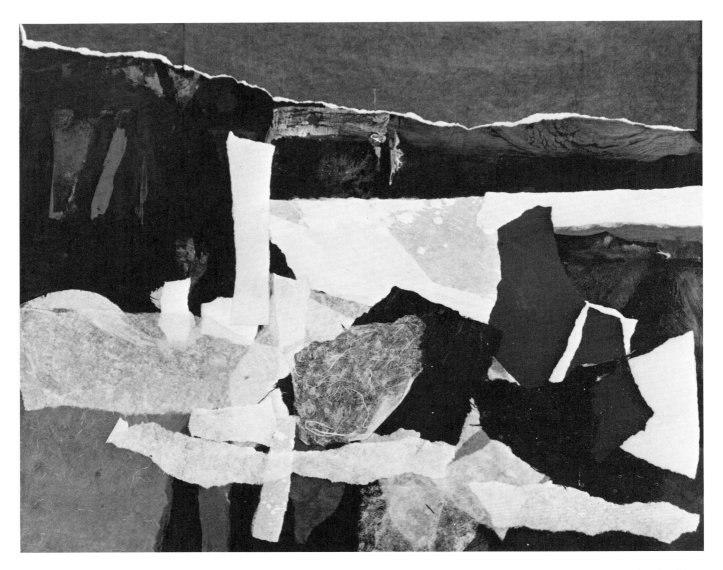

Step 3. On further consideration, the preceding step seemed to me to be too much a jumble of forms that were overly similar in size. The next step, therefore, was to create firmer, more decisive forms, clearer images and contours, and some larger, simpler masses. I proceeded to brush on some strong color with loose, open strokes, mostly to simplify the surface of the painting; then I again resorted to collage—a major shape of deep blue paper across the top, other shapes made of several kinds of rice paper of varying degrees of transparency, and toward the base of the picture a few torn strips of synthetic paper, manufactured from what I suppose are some kind of plastic fibers. The dark forms at right were torn from rice papers prepainted with reds and black. As I noted the splashes of white and the strong horizontal edge running across the upper portion of the painting, the picture began to have implications of rocks and beach, but somehow that struck me as being too obvious, too routine a path to follow. In order to get another view of the picture in this formative stage, I turned it around and around to check it from angles other than the one I had been seeing it from all along. Finally I decided that by turning it on its right edge, I was faced with a set of relationships that in some way struck a responsive chord; this view of the composition intrigued me more than any of the others. So that was it—from from here on I would be working in a vertical rather than a horizontal format.

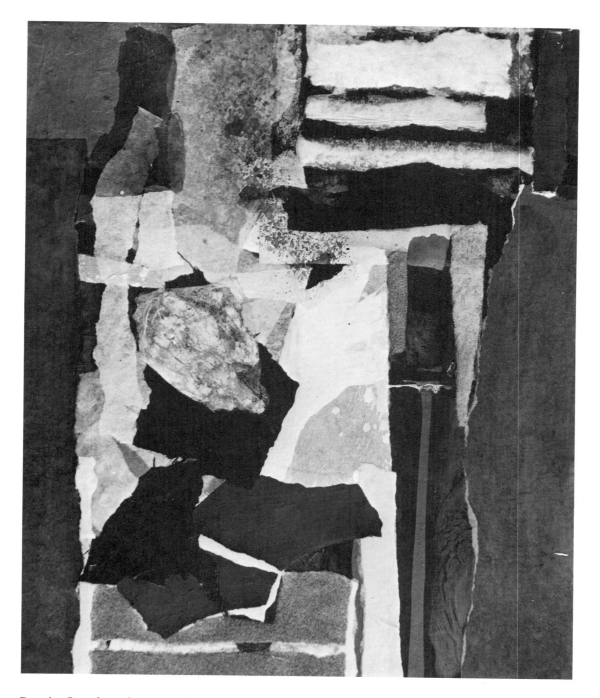

Step 4. Seen from the new angle, the composition tended to fall away at the left edge, so I applied a shape of the same blue paper that had been used at the right of the picture. This served to contain the design at the left, and at the same time it formed an edge to a sort of central panel occupying the major part of the picture. Although a few very indefinite suggestions as to subject matter occurred to me during this phase, it was too soon for a subject to dominate the development of the picture; I continued to work on it solely as a design, an arrangement of shapes and patterns. Three horizontal strips of synthetic paper were added at top right, and various other areas were glazed and spattered. The use of so many collage papers, however, seemed to call for texture of a different character, so I decided to use sand, both at the very bottom of the composition and in a small vertical strip at the upper right edge of the central white panel. The areas that were to receive sand were first painted with diluted acrylic medium, then fine sand was sprinkled onto those areas and allowed to set. Just to divide it into two unequal areas instead of a single solid block, I scratched into the damp sand with a horizontal stroke of my painting knife. After the sand had dried, the panel was tilted and excess sand brushed off. Two coats of diluted acrylic medium were then applied to seal the sand.

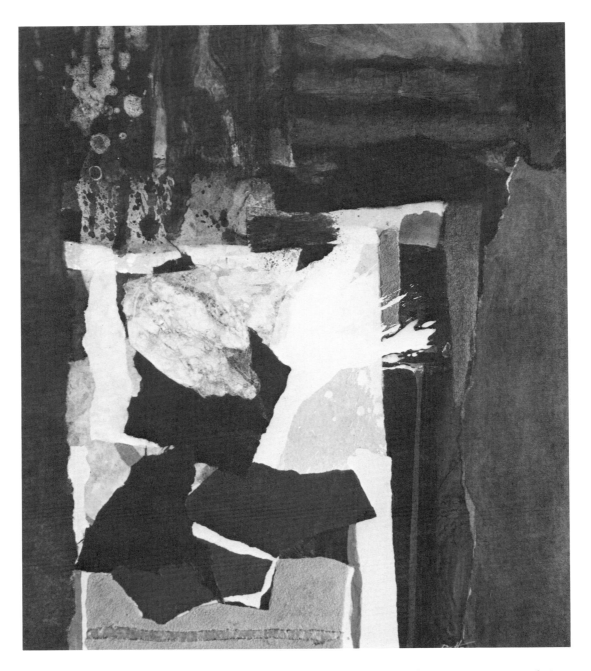

Step 5. The final step was the pulling together of all the parts into a strong coherent design. The upper right areas were given deep glazes and the upper left was simplified and partly redesigned into a more obviously vertical movement by means of flung and spattered whites that were subsequently glazed over to bring them into relation to other areas. Flung white was also used to break out across the right edge of the light vertical panel in the center of the picture. Some of the glazed synthetic papers were lightened with thin white paint, other passages were darkened or suppressed so as not to compete with the principal central form. The trough scraped into the sand at bottom was filled with gold powder mixed with acrylic medium, and the sand itself received two glazes of color, one green and one ochre. The picture in its final form remains a sensuous experience in mixed-media surfaces, but it should be noted that in the first three steps the mixed-media techniques were utilized in the search for the basic character of the forms that would ultimately prevail in the finished painting, and that once those forms had been determined then mixed-media methods were again used to control the design and to provide a range of textural variation. The orchestration of all the elements used is of the utmost importance, since the composition must read as a total organization, without any undue awareness of the wide variety of methods and materials used in its creation. (For color reproduction of this painting, see page 219.)

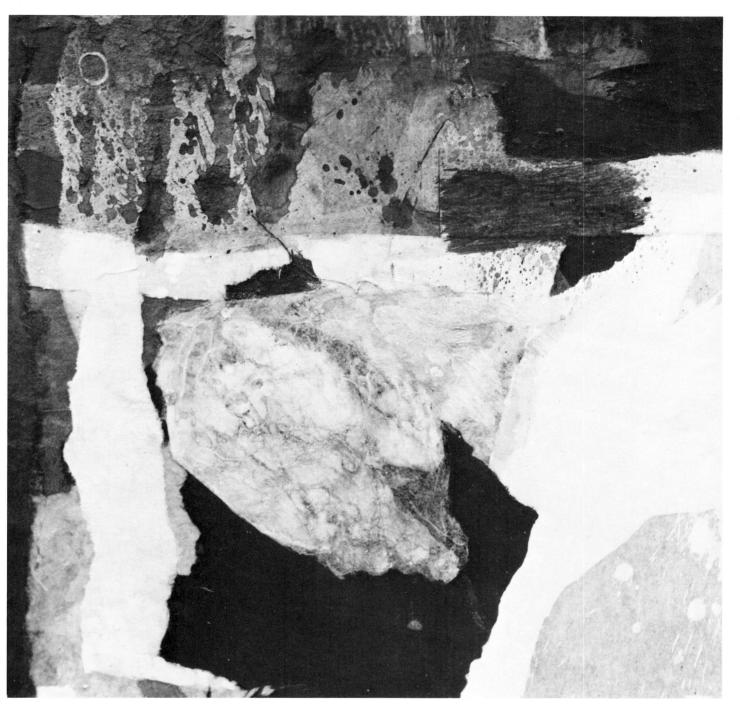

Detail.

Sunscape *Acrylic on Masonite,*
48" x 7½". Private collection.
Photo courtesy Midtown Galleries, New York.

9. Painting Without a Brush

Painting without a brush? Why not? It really is not as unusual as it may sound, and it is not very new either.

Centuries ago some of the great Oriental painters were fond of flung-ink techniques. In more recent times, Jackson Pollock—and before him, Hans Hofmann—demonstrated dramatically in their art that paintings could be made without the direct touch of brush to canvas. They poured, dribbled, and flung their paint, not with the intention of shocking their audiences but to achieve what they hoped was a greater immediacy of contact between artist and viewer, and also to rid themselves of the tyranny of traditional, conventional methods of applying paint only with a brush. Other major contemporary painters have hit on the same idea and have used it according to their own needs and artistic styles: artists such as Morris Louis, James Brooks, Helen Frankenthaler, Robert Motherwell, and Paul Jenkins are only a few.

To be sure, the brush is still an indispensable tool for the painter. I am not advocating an elimination of *all* use of the brush, which I believe will always remain the principal means not only for getting paint onto the picture surface but also for conveying—through the expressiveness of the brushstroke—the character of the artist.

Nevertheless, we painters tend to develop a habitual use of the brush. We repeat the same strokes, the same gestures, just as naturally as we sign our names. A certain amount of repetition begins to set in, and although this might be interpreted as a recognizable mark or style, there is always the danger that such repetitiveness can become monotonous and boring (for example, when paintings are seen as a group in a one-man show) or, at worst, the strokes can become meaningless in their relation to the subject matter.

It seems to me that if we are to be truly creative in our thinking, the same spirit of creativeness and experimentation should extend to the technical means used to put the color on paper. To limit ourselves to the brush just because it is the most obvious or natural method of applying paint—to simply succumb to force of habit—is to fall short of the goal of making personal discoveries in all the areas of picture-making. Experimentation with methods and materials must necessarily accompany experimentation with pictorial concepts, an expansion of means as well as of mind.

The brush can produce many effects, but it does have its limitations, and to press beyond them requires using the brush in combination with other tools or materials and trying out unorthodox methods that will extend the range of surface effects and textures. Experimentation means getting away from old, shopworn routines and taking chances, acting on impulses, responding to effects that might not have been possible with the brush. It means thinking inventively and looking for new solutions. Such experimentation is stimulating for the artist and for the viewer.

The various ways of painting without a brush are not a substitute for brush painting but are means to supplement brushwork and enrich the look of the various paint surfaces. So, how about taking a vacation from the brush? See what can be done through other methods that require a different way of thinking—that are less easily controlled perhaps, but which are just as applicable to painterly expression.

OBJECTIVES

1. To do a painting in which the brush does not make actual contact with the paper or panel.

2. To break away from established habits of using a brush and discover a wider range of tools and materials for applying color and forming shapes.

3. To work for effects and textures that are more visually interesting than those possible with the brush.

4. To use controlled accidents to develop an orderly pictorial structure rather than settle for a chaotic assemblage of unrelated parts.

MATERIALS

Here again the materials are virtually unlimited, but these are the ones I use most frequently:

Paints: watercolors and/or acrylic paints

Supports: watercolor paper, illustration board, or Masonite

Brushes: assorted sable and bristle brushes; toothbrush

Plastic ruler, 12″

Plastic containers (with lids)

Fixative blower or spray bottle

Newspapers

Ink roller (brayer)

Synthetic sponge

Paint rags

Palette; water containers; painting knife, etc.

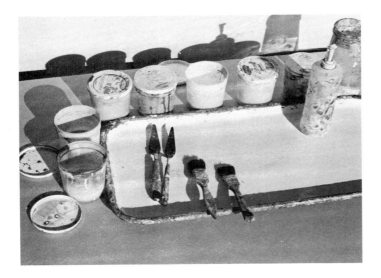

Plastic paint containers. Colors are premixed and stored in plastic containers. Some mixtures are opaque, others are very transparent for use as thin washes or glazes. The advantage of storing color in this manner is that when overpainting or corrections are necessary, there is no need to remix and match colors—just use some of the original mixture. Color can be poured directly onto the painting from the container.

Fixative blower. This is ordinarily used to spray fixative on a charcoal drawing or retouch varnish on an oil painting, but it is also handy for spraying color from the paint container to the pictures surface.

Paints. Either watercolor or acrylic paints can be used, or both can be combined in the same painting. Begin the picture with the thinner transparent paints and add the opaque colors as the picture develops.

If transparent watercolor alone is used, care must be taken to preserve some white paper, at least in the early stages, by masking off areas with liquid frisket (such as Maskoid), newspapers, or masking tape. Start painting with light, high-keyed washes and work toward the middle values and the darks later. This procedure is not necessary if only opaque paints are being used, since it is possible to alternate light and dark applications continually, retrieving lights that would probably have been lost with transparent techniques.

Brushes. True, brushes will not touch this picture, but they are often required for flinging or dribbling paint, or for spatter. Of course, a toothbrush is always a convenient instrument for stippling. Some experimentation with various brushes, both sable and bristle, will suggest which are best for specific purposes: paint flung from a watercolor brush, for instance, produces a splash quite different in character from that flung from a 2″ bristle brush.

Ruler. This is used somewhat as though it were a brush: a pool of paint can be poured onto the paper or panel and then spread across the surface by laying the ruler in the midst of it and sweeping the paint around in arcs or bands or whatever shape seems appropriate to what is happening in the painting. (I suppose this is a little akin to playing the piano with the entire forearm rather than the fingers, as the vanguard composer Henry Cowell sometimes did.) At any rate, the ruler pushes the paint around, thinning it out and distributing it in broad masses and shapes, sometimes dragging it over previous layers to create intriguing textures or broken color.

Although I use a 12″ plastic ruler, any ruler at all will serve, or even strips of cardboard, providing they are stiff enough and have edges straight enough to move the flow of paint as a wide mass rather than in streaks, as sometimes happens.

Plastic Containers. When paints are to be poured, dribbled, or flowed onto the picture, larger amounts of paint are needed than are normally mixed on the palette. Plastic containers or large paper cups are required to hold such quantities of paint.

Before beginning a series of paintings in acrylic, I premix about 25 colors, some of them pure colors straight from the jar and others that are mixtures, all of them in varying degrees of opacity and transparency, and then store them in a set of covered plastic jars. I place them to the left of my painting panel, somewhat as though they were pigments on a palette, to dip into or pour from when I'm working. It's important to keep the paints covered when not in actual use.

Sometimes an entire container is emptied to create a large area of color, but generally enough paint is left so that other areas can be painted with the same color, and retouching, if necessary, can be done very easily without having to remix and match the previously painted colors. Or these containers can be used to hold color mixtures that will be sprayed or poured in a one-shot operation and will not be needed over a prolonged period of time. (I find that my work is done either very rapidly, in a single session, or at the other extreme, over a period of six to ten months.)

Fixative Blower or Spray Bottle. There are two methods of applying a spray mist of color over the picture. One is to mix color in a container and use a fixative blower—the kind used for charcoal fixative or oil retouch varnish—to spray it. The other method is to mix color in a spray or atomizer bottle, such as a Windex bottle, and spray the color directly from it.

I tend to prefer the former method because not as much paint has to be mixed when I need only small or moderate amounts. With a spray bottle, however, a certain level of paint, often considerably more paint than is really needed for the picture, must be in the bottle before the spray mechanism will lift it up and expel it. Also, acrylic paint used in a spray bottle is likely to clog the mechanism unless special care is taken to clean it thoroughly with very hot water after each use.

Newspapers. I keep a small stack of old newspapers not far from my painting table. They are used for lifting color and blotting, or they can be painted and used to transfer color to the picture, usually with unpredictable but fascinating textural effects.

Ink Roller, or Brayer. The ink roller can be used to apply paint throughout, although I am apt to use it more frequently in the earlier stages of the painting and not at all as the picture nears completion. For certain geometrical designs, the roller, or a series of rollers of different widths, might conceivably be used to paint the entire picture.

Paint Rags. Paint rags are not just for cleaning brushes and wiping off palettes but also for painting. Crumpled in the hand and dipped into paint, the rag is a good tool for spreading on large washes of color. Obviously, it would not be very effective for work requiring detail or exactness.

METHODS OF APPLYING PAINT

As you might already suspect, painting without a brush is not as limiting as it might at first seem, and in fact it is even something of a challenge to see just how much can be done without recourse to more familiar methods of applying paint. Let us now examine what some of those alternative methods are (remember, all these methods are equally applicable to watercolor or acrylic, although

Spray bottles. Another spray method is the use of a spray bottle, or a spray mechanism that can be screwed onto a bottle. The bottle can be filled, or partially filled, with fairly diluted color then held about a foot above the surface while spraying the color across the picture. Because of the possibility of clogging, the atomizer must be removed after spraying and thoroughly cleaned out with very hot water.

Brayer. Paint can be rolled on in broad bands of color by means of the kind of roller used in inking wood or linoleum block prints. Brayers come in several sizes, making it possible to apply strokes of varying widths appropriate to the size of the painting.

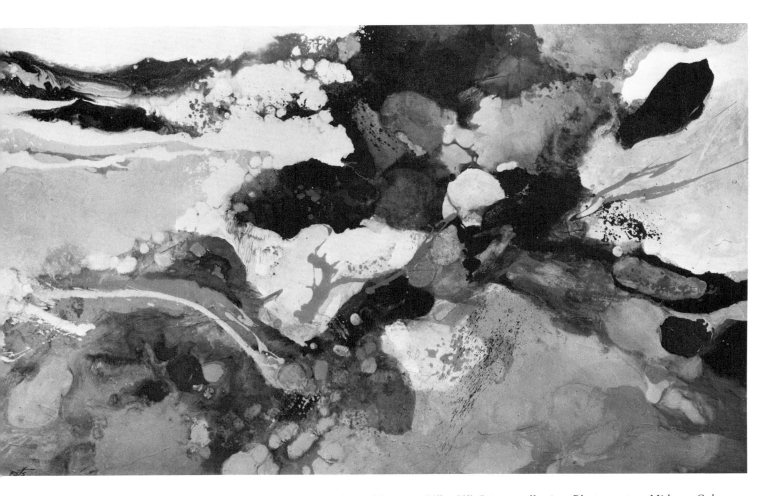

Summershore *Acrylic on Masonite, 30" x 50". Private collection. Photo courtesy Midtown Galleries, New York. Although there is some flung paint and spatter in this picture, the basic technique was that of poured paint. There are three different ways of pouring: (1) onto a dry surface; (2) onto a surface already moistened with water or with diluted acrylic medium; (3) wet-into-wet paint, in which case the color applied last should be of heavier consistency than the one applied first, so that more controlled spreading is assured. All three of these methods were used here. For smaller areas and even more contained spreading of the paint, I waited until the earlier color had dried fifteen minutes or more before I poured or dripped a new color into it. The painting had to be kept absolutely level to keep the paint from drifting in one direction. If really unacceptable effects begin to appear, I wipe up the whole area with a paper towel and begin again, or wait until it has dried overnight before repainting.*

it is the latter medium in which I use nonbrush methods the most):

Pouring. For pouring paint it is essential that the paper or panel be lying flat on an absolutely level surface. To assure that my surface is level, I check it very carefully with a carpenter's spirit level, placing the level in several positions on my painting table to make sure that not even the slightest tilt could affect the flow of paint once it has been poured. If there is to be any tilting of the panel, I want to control it myself and not have the paint accidentally flow off in a direction I had not intended. The idea is for the pool of color to stay where it was poured so that it can be left as is or guided slightly and possibly allowed to spread out to some extent. I do not want it wandering off on its own!

If acrylic paints are to be poured, mix the paint from jars in fairly large amounts, stir thoroughly to make sure the colors have been completely blended together, and store in covered containers. Pouring the paint from the container is something that can be done with sweeping gestures from a foot above the picture, or it can be done cautiously and slowly from only a few inches above the painting.

The paint can be poured on a dry surface, where it will more or less retain its shape with a minimum of spreading out and leveling. Or the surface can be moistened first—with a wet cloth, sprayed with water, or brushed with diluted acrylic medium—and the paint poured into the wet areas to spread naturally and form intricate, unusual patterns.

To control the spreading and flowing, the paint that is poured on should be thicker or heavier than the damp surface or wet paint that is to receive it. If the paints are *too* thick, however, they may dry into an ugly, encrusted surface, and since this is an effect I am not fond of, I mix my paints anywhere from a very thin, transparent wash containing a good amount of acrylic medium and some water to an opaque mixture about the consistency of heavy cream. I seldom use paint much thicker than that.

Once the paint has been poured, it must be allowed to dry and set. It is a good idea to check it every now and then to see that it is drying more or less according to plan. The drying process itself, because the paints are so very fluid, may take anywhere from a couple of hours to overnight. After the paint has dried, other colors can be poured on. Try not to be in a hurry; to pour on too much wet-in-wet at one time is to end up with a mess in which everything flows into everything else, losing all shape and pattern.

I recommend leaving the panel in place while it is drying rather than moving it to dry elsewhere in a spot that might not be as perfectly level as the painting table.

One technique I especially enjoy is underpainting large areas with dark colors and after the paint has dried flowing on a very thin, semiopaque wash of light color, sometimes tilting the board to let it drift even more

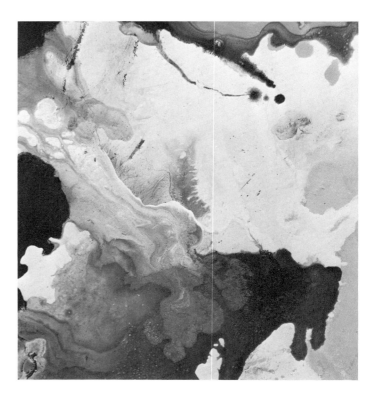

Detail of poured paint.

A thin wash of very diluted white paint over dry dark paint. The panel was briefly tilted to permit the white to flow and drift across the surface.

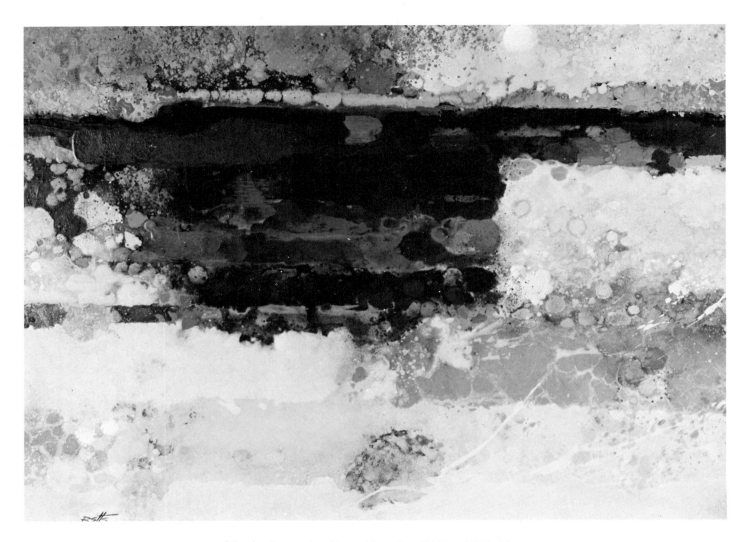

Morningshore *Acrylic on Masonite, 22½″ x 30½″. Photo courtesy Midtown Galleries, New York. Dripped paint is similar to poured, except that it is done with smaller amounts of paint, either from a loaded brush, a stick, or from the last dregs of a paint mixture at the bottom of a paint container. The drippings may look casual and random, as indeed they sometimes are, but they still must be fitted consciously into the pattern of values and colors that give structure to the picture. If dripped paint is too jumpy or spotty and tends to disrupt the surface, it should be removed and the process repeated until it relates properly. One of the most interesting effects of dripped paint is the vibrating color produced by dripping colors of equal intensity into each other, such as pink into orange, red into green, or pale green into bright yellow. Turn to page 213 to see this painting reproduced in color.*

thinly. When the latter wash dries, it usually produces a delicate, granular effect that can either be left as is or glazed over to excellent advantage.

Pouring color is a highly effective way of beginning a painting, of setting up shapes and color relationships. Pour freely and spontaneously at first; as the picture proceeds, the pouring should be done with greater care and precision.

Dripping. This is a variation of pouring, but with less paint, and is generally done when there is only a little paint left in the container or when only small spots of color are needed for small-scale areas. Here again, if the drips or droplets are of heavier paint consistency than the paint into which they fall, the spreading of the color is somewhat controlled and paint does not drift aimlessly. It retains more of the original shape it had when it first reached the picture surface. When I drip paint, I like to use color oppositions that have color vibration or bounce—for example, a pale, intense blue against a golden yellow, a pink against bright orange, or a brilliant orange-red against a blue-purple.

Some painters favor a plastic mustard or catsup dispenser with a pointed spout from which the paint can either be dripped or squirted. They feel this gives them greater control over the quantity and size of the color blobs.

Flinging. Flung ink or paint was used by Chinese artists several hundred years ago and was a technique very much in fashion at the height of American abstract expressionism during the 1950s. There is no doubt that tossing off paint with a sharp flick of the wrist gives the picture a sense of freedom and abandon, a sense of the paint acting on its own as a combined result of the force of the stroke, the fluidity of the paint, and the distance or angle at which it was tossed at the picture. (As a fringe benefit, it is also probably splendid therapy for the artist!)

In watercolor, the flung paint must be right the first time. If the splash looks ugly or formless or does not fulfill its function in enlivening an area, it can ruin the entire picture—unless it can be successfully wiped off without a trace.

In acrylic, since previous color layers are waterproof, flung paint that is not satisfactory can be completely cleaned off and the operation repeated until the artist is satisfied with the look of the "happy accident." Quite often I have flung acrylic paint at a picture ten, fifteen, or even twenty times before achieving a splash that felt right to me, that functioned properly as color and shape or line, and that gave the impression of having happened naturally and casually, without a hint of the effort required to achieve it.

In other words, just *any* splash or blot that is flung onto the picture will not do. It must be a fully integrated part of the painting; it must be expressive, or provide some kind of accent or change of pace, or activate an otherwise unremarkable passage. Most of all, it should have an in-

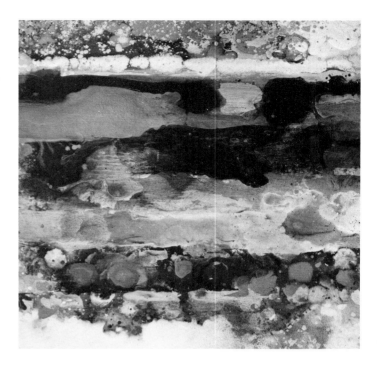

Detail of dripped paint in Morningshore.

Detail of Morningshore, *showing acrylic spatter, wet-in-wet, and flow techniques.*

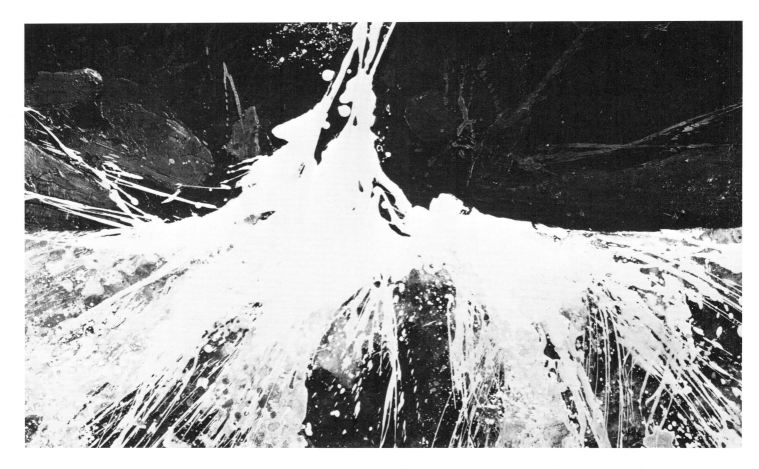

Shorepound (Above) Acrylic on Masonite, 19″ x 30″. Flung paint is a traditional technique, especially in Oriental painting, though there have been recent revivals of it in contemporary painting. After experiencing a coastal storm I decided to do a painting of the upward spray and splash of a wave against rocks. The upper area was kept very low in key as a contrast for the flung paint that would come later. The rocks were built up with dark paint and modeling paste, and some glazing over a middle-toned underpainting. When all was in readiness, I tackled the major area of flung whites, masking off the rocks with newspaper. After one application of whites had dried, I glazed over them with phthalocyanine blue and green, then flung on more whites. In that way the layers of splashes had more depth and did not appear to be all on the same plane. Any splashes that did not suit me were wiped off until I achieved the exact direction and weight of line I was after. As simple and direct as the flinging may seem, it was by no means accomplished in a single operation.

Frozen landscape (Right) Acrylic on Masonite, 46″ x 10″. Photo courtesy Midtown Galleries, New York. The upper half of this painting was done with the flow method, pouring paint onto a very wet surface and either letting it spread out of its own accord, or tilting the panel to cause the paint to flow in a particular direction. It takes a lot of experience to reach the point where flow effects are reasonably predictable—how wet the surface should be, how thin or thick the paint should be, how much to pour on so that it will spread only so far, whether to pour in one spot or whether the container should move during the pouring, how much the panel should be tilted to control the flow—all these things must be decided if flow painting is to be subject to some degree of conscious manipulation, rather than the product of a total lack of control in which the paint does whatever it wants to. There will be some surprises, of course, but the artist must have a hand in preparing and arranging for those surprises: he is the one who guides the picture, not the paint. It also takes constant vigilance to maintain a check on what the flow is doing; you cannot start the flow process and then leave the studio for a half-hour, because wiping up and correcting may be needed at almost any time. Flow paint, being so liquid, often requires long drying periods, usually overnight.

evitability and an esthetically satisfying look to it. To achieve all this in one stroke is not as easy as it might appear, and a very considerable amount of practice goes into getting a feel for how much paint should be used, how fluid it should be, which brush should be used, and what gesture of arm or wrist would best accomplish the desired effect.

Flowing. The methods of flowing paint are very similar to the wet-in-wet technique in transparent watercolor. One method is to pour or drop paint onto a surface already moistened with water or with acrylic medium diluted with water. If only water is used, the paint may spread and flow very freely with little control possible; if diluted medium is used, the paint does not flow quite as readily or freely. Instead of wetting a whole area in preparation for flowing paint, it is a simple matter to moisten only those areas where the flow is needed—in strips, circles, any shape at all—so that the flow effect is restricted within very clearly defined boundaries. Once the paint has dried, the same area can be wet again and glazed with repeated application of flow paint.

The other method of achieving flow effects is to pour, drop, or fling paint onto a dry surface and while the paint is still wet spray it with water from an atomizer bottle. Greater control is possible in this case since the amount of water sprayed is entirely up to the artist. With a little spraying the paint will not flow far, perhaps merely blurring an edge, but if a great deal of water is sprayed on, the paint can spread farther, over a broader surface. If the paint is very fluid, the water spreads it easily and permits freer flow. Conversely, the thicker the paint, the less the water affects it, and its flow is relatively confined.

This pour and spray method offers a greater latitude of choice as to hard and soft edges, since the spray can be applied selectively to only one edge or one part of a shape, leaving the rest of that area with a hard edge.

The flow process should be used on a level surface so that whatever flow takes place can be monitored by the artist. Intentionally tilting the paper or panel is always possible in order to assist the flow, but an unintentional tilt could ruin the whole picture. The artist has to remain watchful and blot or wipe up the color when it wanders into territory where it is not wanted.

Even though the flow method is essentially and profoundly accidental, capable of producing some handsome but fortuitous effects, it is still left up to the artist to impart some quality of order and color orchestration to the picture. Accident combined with esthetic intuition and a sense of selection and design can result in a meaningful work of art. To leave everything totally to chance is to remove the personal element and to relinquish all responsibility for creating a world of forms that is, if possible, both intellectually and emotionally satisfying.

Spatter. A technique used by even the most conventional watercolorists is spatter, in which the paint-filled brush is tapped sharply on the forefinger or some rigid object,

Flow paint. Flowed paint can be used either transparently or opaquely. Tilting and turning the panel while the paint is wet causes accidental effects that help to initiate design ideas in the early stages of painting.

Staining. Thin washes allowed to dry only partially were wiped up with a paint rag. The dried edges left stains or linear contours that added interest to the surface. Sprayed color was added later to further unify the area.

causing the paint to fly in spatters upon the picture. Using generous amounts of fluid paint on the brush will result in large blots scattered over a wide expanse, whereas somewhat thicker paint will result in a finer-textured spatter that is confined to a more restricted area. In either case it would be wise to mask off with paint rags or newspapers any parts of the picture where spatter is not desired.

Although spatter is usually employed in rather moderate amounts, either as descriptive texture or simply as a paint texture, I have on occasion used spattered paint to create very large areas of pointillistic broken color, areas perhaps 2 x 5 feet in size. To build up such areas solely by the spatter method is a long and laborious method, to be sure, but there is no other way I know of to achieve that special effect. (I have seen Chinese ink paintings in which an entire landscape composition was formed exclusively through the spatter technique, the spatter ranging in scale from massive blots to a very fine spray.)

Spattered passages can be applied in large areas, or liquid or paper friskets can be used to limit the area to be covered and to mask edges so as to form specific, designed shapes. Spatter, like spraying, can also be used effectively to create transitions between areas without having to blend paint—gradations from one color to another or from light to dark and dark to light.

Spray. Spraying paint is a refinement of the spatter method, a reduction of the small dots of paint to the finest spray mist imaginable. Spray is applied either with a mouth fixative blower or a spray bottle. Very subtle optical effects of superimposed colors are possible with spray paint, but ones quite different in appearance from those obtained by glazing. In addition to spraying large areas, edges and shapes can be created by masking off sections of the picture with pieces of torn newspaper randomly placed. This will produce an interplay of soft, blurry edges with sharper, crisp edges and gentle color transitions as the shapes fade from one to another.

A stencil technique can also be used. Here, a single cut-out or torn-out shape is placed on the picture, sprayed, then moved slightly and sprayed again. Various placements of the shape and the overlappings of the sprayed paint produce interesting repetitions and combinations of shapes, all related to each other through the original cut-out shape.

My sole reservation concerning spray techniques is that if they are overused they can create a look that is too slickly mechanical and posterlike, too smooth and anonymous to relate well to the more painterly, freely handled areas. Spray must be used with some discretion so as not to dominate the picture surface. It should remain in its place as one of many methods in the painter's repertory.

Stipple. Applying paint by scraping a knife blade along a toothbrush dipped in paint produces a pattern that is more delicate than spatter but not quite as fine, and not

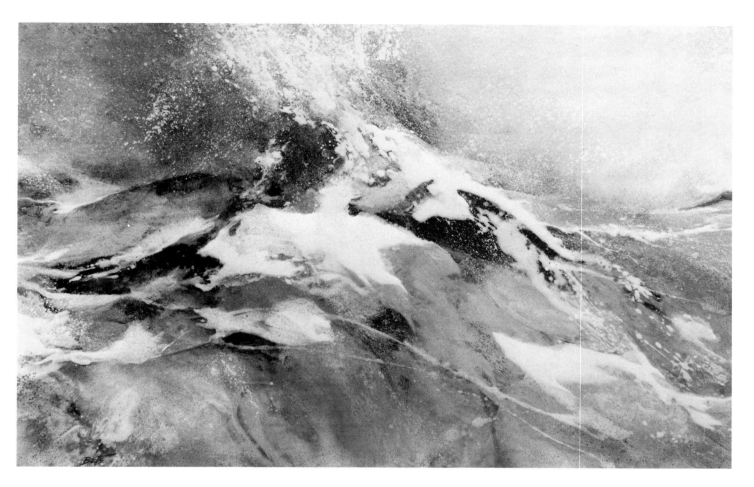

Winter Seascape *Acrylic on illustration board, 23" x 35". Private collection. Although there is some flung paint in this painting, most of it was built up out of spatter, stipple, and spray. The very beginning stages were done with flow techniques as well as lift and transfer methods, but once the wave image appeared, I found that spatter and stipple best achieved the feeling of mist and ocean-spray. The spatter was done directly from a small housepainting brush flicked sharply against a finger; all the stipple was done with an old toothbrush dipped into paint and scraped with a blade. The less paint there is on the brush, the finer the stipple and the greater control there is. Before spraying, stippling, or spattering, any areas not meant to receive paint are masked off with paint rags or newspaper so that paint application is as localized as possible. Paint that is sprayed on with a spray bottle or fixative blower is best for large areas where a fairly uniform paint film is wanted; spatter and stipple are both more irregular.*

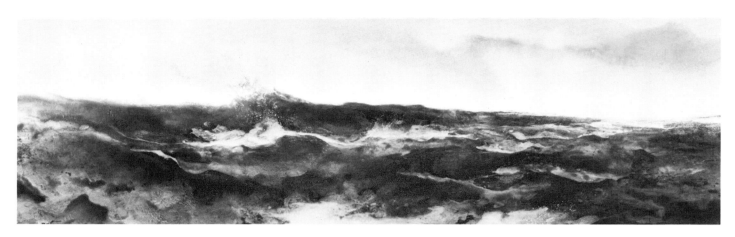

Sea Mist (Above) Acrylic on Masonite, 15½" x 48". Photo courtesy Midtown Galleries, New York. Whereas the sky in this painting was done with flow paint combined with spatter and stipple, the water was done first with flow techniques and then developed in more detail with blot-and-lift or transfer methods, followed by glazing. In the transfer application, paint is brushed onto newspaper and then laid face down on the surface of the painting, thereby transferring paint from the newspaper to the picture. In blotting and lifting, paint is poured on the panel, then newspaper is laid on top of it, spreading out the color slightly and removing some of the excess paint as the paper is lifted away. Some spatter followed by glazing with phtahlocyanine blue and green further unified the area and controlled the flow of lights and darks across the expanse of water.

(Left) Transfer method. Paint applied to paper and then pressed on the picture surface.

distributed as evenly, as spray. I use this method mainly for small areas, with or without a frisket, to break up color, provide a textured surface, or create transitions between areas.

Here again, it goes without saying that areas not meant to receive the stippling should be carefully masked off. Sometimes when I am not careful enough about that, I may be shocked to find that three or four maverick drops of paint have landed somewhere distant and spotted an area in which they obviously do not belong. Usually, if caught in time, these spots can easily be wiped off with water. When dry acrylic paint is stubborn about being removed, denatured alcohol will probably do the trick.

Transfer. The transfer method involves applying paint fairly generously to newspaper, cardboard, or matboard, then quickly placing it paint-side down on the picture. The paint will spread and form accidental shapes that can be turned to good account by the artist. Hand pressure on the newspaper or cardboard will cause the color to spread farther, influenced by the direction of the pressure.

I like to place a long, torn strip of painted newspaper on the panel, then lift it up and replace it in a slightly different position. Since the greatest part of the paint is deposited on the picture the first time, each succeeding time it is placed down there is less paint transferred to the picture. It remains a solid color no longer, but a beautifully mottled color-texture.

Lift and Blot. The reverse of painting newspaper and applying it *to* the picture is to use strips of newspaper to lift wet paint *from* the picture. The idea here is to get paint onto the surface by any means at all, then immediately tear some newspaper or a clean paint rag, lay it on the fresh paint, press or rub it with the hand, lightly or heavily, then lift it. This action accomplishes two things: it slightly alters the shape of the painted area and it lifts or blots up part of the paint, thinning it out and leaving a textured effect that is often quite handsome. More fresh paper can be used to lift off even more color if the first application did not lift a sufficient amount.

Or the newspaper originally used for lifting, with the wet paint still on it, can be used to deposit that paint elsewhere in the picture. Lay it right back down on the surface once or twice more, but shift the angle at which it is placed. In other words, use a single piece of paper for two immediately successive operations: to lift color here and to transfer it there.

Instead of using flat sheets or strips of newspaper, a variation would be to crumple the paper tightly, then open it up and press it briefly against the wet paint, creating strange shapes and textures within the color area. Such shapes often seem to have reference to geological formations and surfaces. Then, too, rags can be pressed into paint to lift color, leaving the woven texture of the fabric showing in the paint remaining on the picture.

Rolling. Applying paint with an ink roller, or brayer, is

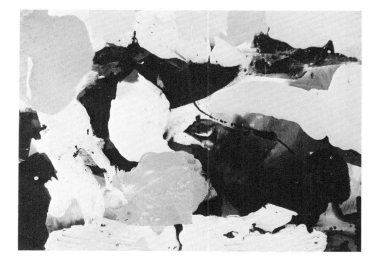

Blotting and lifting. This is the very beginning stage of one of my recent paintings, done entirely with poured-on paint that has been blotted and spread out by newspaper being laid on the wet paint. When the paper is lifted off, it leaves provocative forms and sometimes some subtle textures.

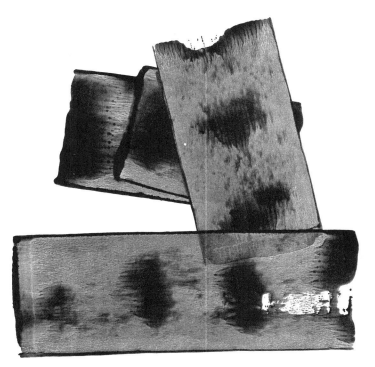

Brayer. I often use a brayer in the early phases of a painting to set up broad strokes and blocks of color (paint applied with a wide housepainting brush goes on quite differently). The roller-painted areas have a somewhat architectural or mechanistic look to them, and the paint is laid on with interesting textures resulting from the quantity of paint on the roller and how evenly it is distributed across the roller surface. These blocks, bands, and strips of color give me something to respond to as large movements and structures of color, though they are usually submerged or obliterated as the painting is carried further.

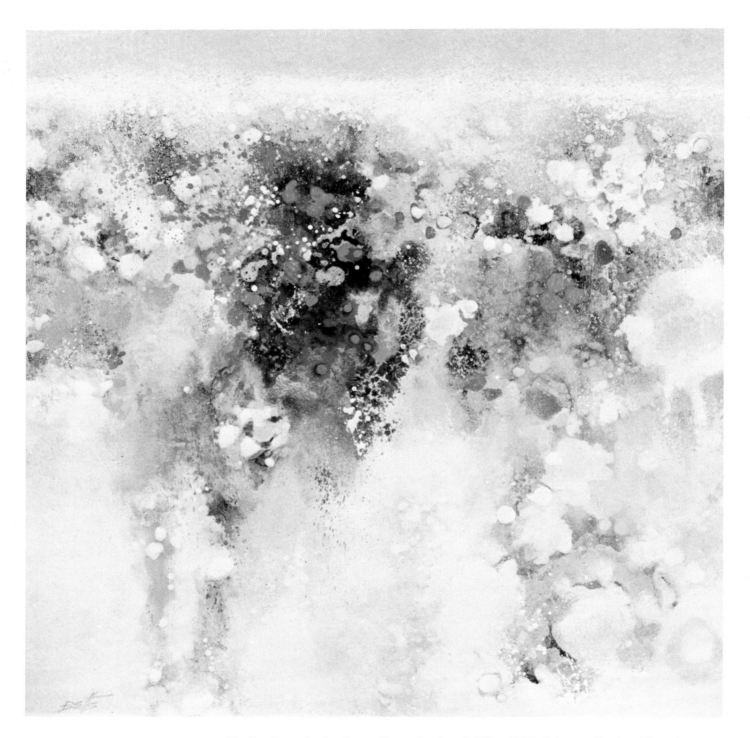

The Sea Beyond *Acrylic on illustration board, 22" x 22½". Private collection. The painting shown here is a compendium of just about all the nonbrush techniques mentioned in this chapter. The idea I was working with was a field of flowers set against a distant background of ocean and soft mist. The spots of color, both pastel and brilliant; the color vibrations between strong colors; the range in scale from tiny stippled dots of color to large pools and blobs of color; the varied edges and blendings—all were made possible by the use of paint applications that avoided the more conventional uses of brush or knife.*

relatively simple and is commonly done. As I mentioned before, it is most useful in getting a picture started, but the method is limited when it comes to the refinements that are usually necessary in the later stages. The paint should be fairly fluid so as to roll on easily: if it is too thick or stiff it goes on too dry and produces more of a ragged, spotty texture than a solid band of color. Some roughness or irregularity of texture could, of course, be very welcome, but too much of a broken-up color surface could destroy the feeling of solidity or mass.

Sponge. Synthetic (cellulose) kitchen sponges, which are standard equipment for most watercolorists, can be used not only to lift or wash off paint, but also to apply it. The sponge is saturated with paint and then wiped across the picture for broad strokes and general washes of color, or it is dipped into paint and dabbed on the picture to produce textural markings.

ADDITIONAL REMARKS

Whatever methods are used in painting without a brush, the main thing to keep in mind is that they should not be allowed to descend to the level of gimmicks or novelty devices, mannerisms that display the skill of the painter without expressing anything pictorially significant. As Gustave Moreau told his pupil Matisse, "The mannerisms of a style can turn against it after a while, and then the picture's qualities must be strong enough to prevent failure."

Since a picture as a totality is far more important than the methods or materials used in it, the painter must take care not to get carried away by his infatuation with sheer process. The methods suggested in this chapter are a means to an end, a supplement to and extension of the paintbrush, but they should be used only when the need for them is sincerely felt by the artist. Otherwise, the end product is not a work of art but little more than a decorative trifle—with no more substance than cotton candy.

Many of the painting techniques mentioned in this chapter lead to some gorgeous color and texture effects. It takes stern discipline on the painter's part not to fall in love with some appealing passage that has absolutely nothing to do with the rest of the picture; it takes courage to paint it out or repaint it so that it becomes fully integrated with all the other parts of the picture. The other problem can be to fall in love with an area but not know what to do with it or how to give it meaning. No matter how intriguing some small area may be, it may have to be sacrificed for the good of the whole picture—the whole picture, in the long run, is what counts most. It should function as a totality, not an assemblage of several isolated sections lacking coherent formal structure.

Using techniques in which accident plays such a prominent role requires that same stern discipline in still another respect: it is all too easy to be seduced, to relax and sit back and let the paint have its way, to accept the accident as the final statement. Admittedly, some areas appear to be complete in themselves, apparently not needing the artist's touch, but this, I think, is the exception rather than the rule. The artist's job is to scrutinize, deliberate, and then make tough decisions, remembering that technical methods are always subordinate to what is being expressed, that it is the artist who controls the paint, not the other way around.

Demonstration: Island Memory

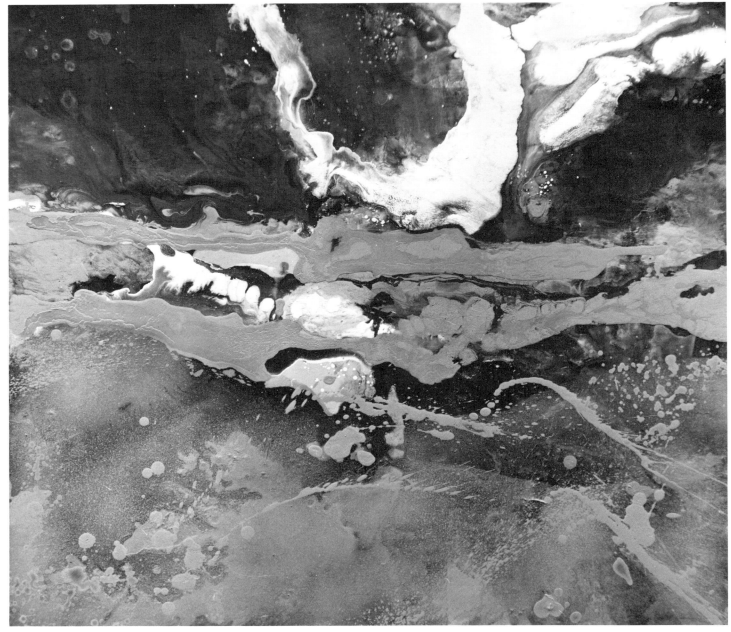

Step 1. When I begin a painting in which the brush will not touch the picture, I accept the fact that, especially in the earliest stages, it is not I who will generate the forms that appear in it, but the medium itself. Usually I have a dozen or more such paintings in progress at the same time, and I have no clear expectations for any of them—each is allowed to go its own way with a minimum of direction on my part. My feeling is that if I impose my will on the picture too early in the game I will probably repeat something I have seen or done before, consciously or unconsciously, so I have found that the best way for me to avoid habitual routine and repetition is to let the medium take over and suggest the route the picture will take; I am willing to go along for the ride and see where it takes me. My intuitive choices and decisions may enter into the process to a certain degree, but mainly I elect to cause accidents—tilt the panel, pour the paint, drip the color—and let chance and the force of gravity have the upper hand temporarily, and usually it is more interesting than anything I can devise, anyway. The painting at this stage was a formless mess, yet the color, which was a bit strange, began to appeal to me, and I could see a general division of the picture surface starting to appear.

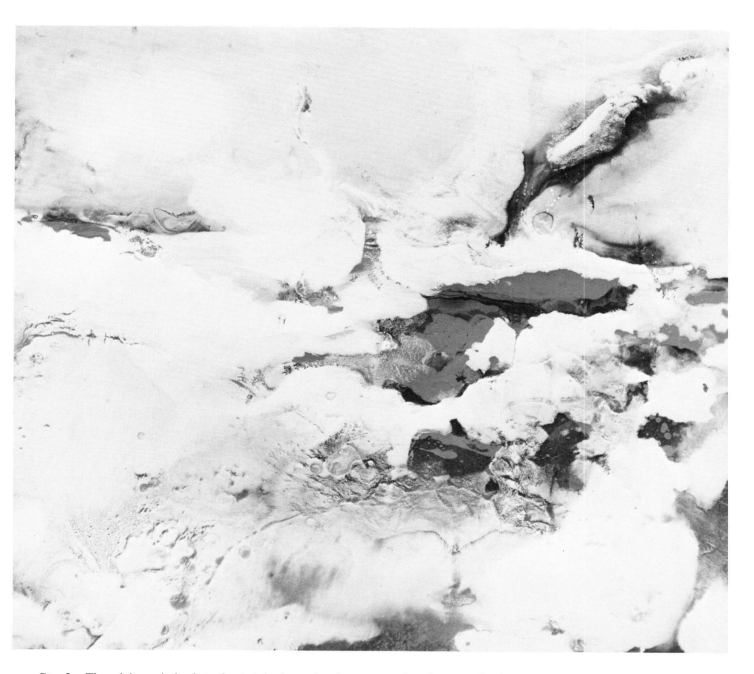

Step 2. Though it was indeed starting to take form, the picture seemed static, separating into three horizontal bands. But there was one small area that interested me, in the upper right corner. I was determined to preserve that area, at least for a while, but to continue to paint improvisationally elsewhere, to loosen up the surface again and lessen the rigidity of the design. I flowed very diluted white paint over the major part of the surface and then tilted the panel to let it drift across in a large, general mass. After it had dried, there were some fascinating textural passages, so beautiful as to color and surface that I hoped I would be able to incorporate them as part of the final painting—and yet I knew at the back of my mind that they would undoubtedly have to be removed eventually. It is essential that the artist resist temptations to fall in love with ravishing color accidents and delicious textures, because the inclination is to try to retain them at all costs, at the expense of the total organization of the painting; he must face the realization that however seductive the area, however impossible it would be to duplicate again, the fact remains that the painting as a whole is more important than lovely passages, and the courage must be there to paint them out and lose them forever if they cannot be successfully integrated as a part of the whole. I glazed over the whites with delicate yellows and greens and continued to paint. The color was working well, but as yet I had neither a composition nor a hint of a subject.

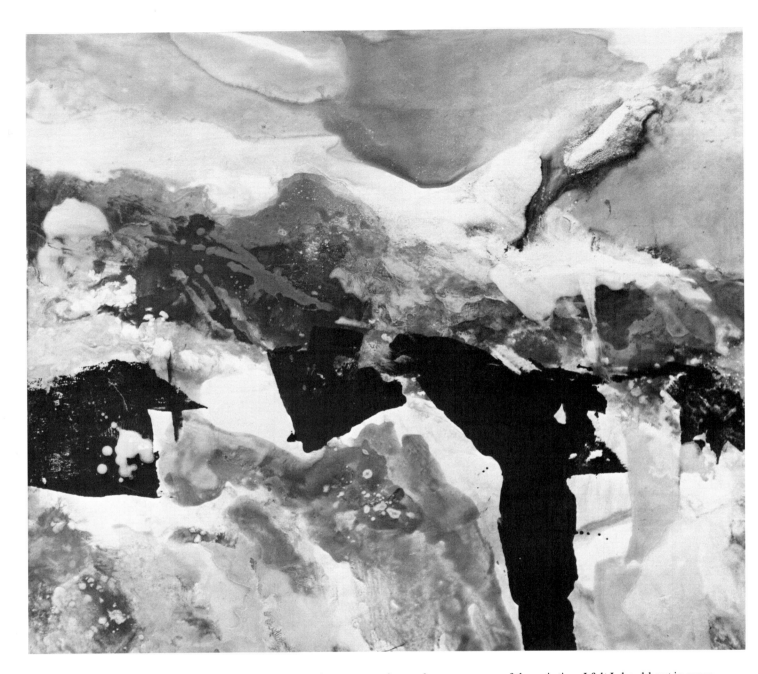

Step 3. Returning my attention to the upper areas of the painting, I felt I should put in something that would relate well in terms of flowing forms to the section at upper right that had appealed to me earlier. I flooded the left and middle sections adjacent to it with water, the poured in semiopaque phthalocyanine blue paint, thinking that it could become either a watery wave or a sky—I was prepared to accept whichever seemed best. The paint flowed interestingly and then dried. It had the look of clear, cold, swirling air currents, so that settled it . . . it was to be a sky. The next point to be settled was what sort of landscape forms would go along with the upper third of the painting; the icy blues of the sky naturally suggested to me a winter environment of some sort, and I felt that mountains, glaciers, or windy mists might be appropriate to what was already there in the painting. Just to get something started, I poured a long stripe of black paint on the panel, then used a piece of newspaper to blot it, and by placing the paper down again here and there I was able to guide and control the design of the slanting form. A bit of judicious wiping with a paint rag sharpened an occasional edge. I now felt I had a subject and a general design structure upon which to build a painting.

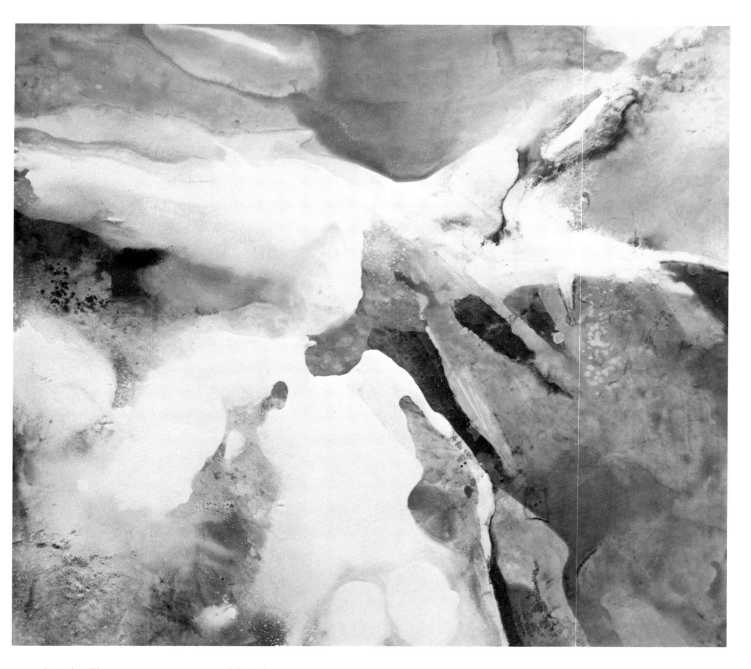

Step 4. The next step was to consolidate the surface, to work for masses that would relate to the upper part of the picture, and in keeping with the fluidity of that sky area, to soften some of the angularity of the forms in the lower two-thirds of the painting. I flowed a thin glaze of deep blue over the area at right, but not wishing to use the same treatment across the entire picture, I wet the lower left quadrant, poured opaque whites into it and sprayed water over them, hoping that their behavior would suggest ways in which to break up that area and also relate it to the rest of the painting. From here on I worked with blot and lift techniques, flung paint, some spray and stipple, as well as further glazing in the right half of the picture. I was refining it constantly, but at the same time I was alert to possibilities for shape and pattern that would relate well to the surface as a whole and at the same time be expressive of the subject matter; whatever I painted had to work on both levels or it was not acceptable. Immediately after this step I obliterated the lower left quadrant with white paint, then later poured on dark blues and purples which I blotted and lifted with pieces of torn newspaper. The jagged forms that resulted seemed to be what it needed, after all.

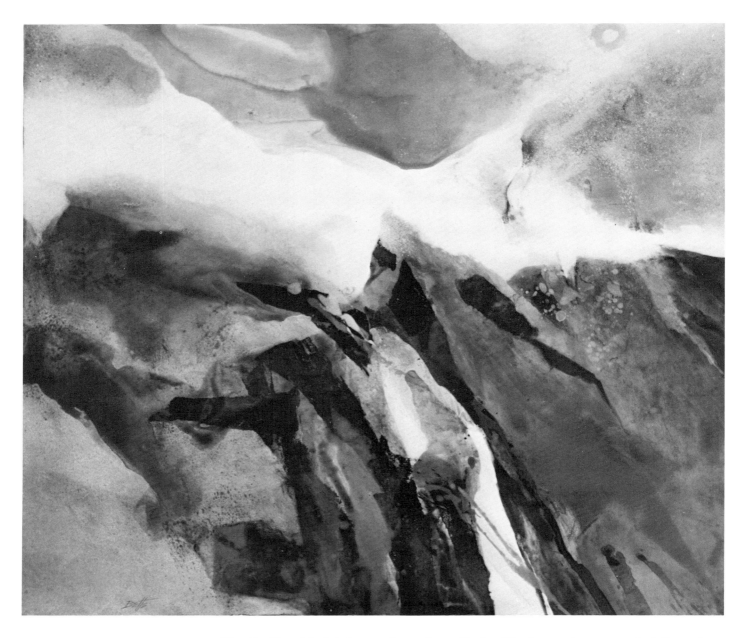

Step 5. Once I had shaken up the surface with simplifications and some new dark forms, I used a fixative blower to spray a film of light blue over the left section of the painting in order to pull it all together as a unit. Since the dominant blue tonality called for some warm accents, I dipped a strip of newspaper in red paint and painted in a fiery streak that glowed against the icy blues. The sky seemed to require a warm accent, too, so I introduced a tiny sun that would also help indicate the scale of the snowscape. From there on, more refining and adjusting. (I find that the very final finishing of a painting, what I suppose are called the "finishing touches," often take considerably longer than I expect!) At this stage I am particularly conscious of the character and quality of edges, transitions or blendings from one area to another, and to the way the various parts of the picture function as planes within the picture space. Attention to such things meant a succession of delicate decisions, more glazing, stippling, spraying, and wiping. I wanted the total effect to be controlled, but to look natural, easy and inevitable—a balance of the inherent qualities and behavior of the acrylic medium and the unobtrusively guiding hand of the artist. By sparing the use of the brush I felt I was better able to produce the kind of forms and surfaces I was after, and technically I avoided ingrained habits of applying paint and gave myself something to struggle against. I had had my dark moments along the way, but perhaps the picture was worth it. (For color reproduction of this painting, see page 213.)

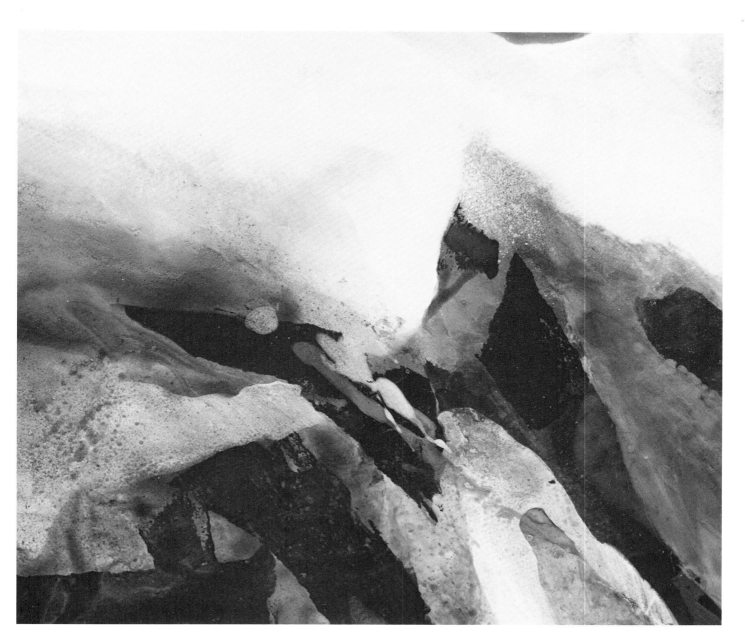

Detail.

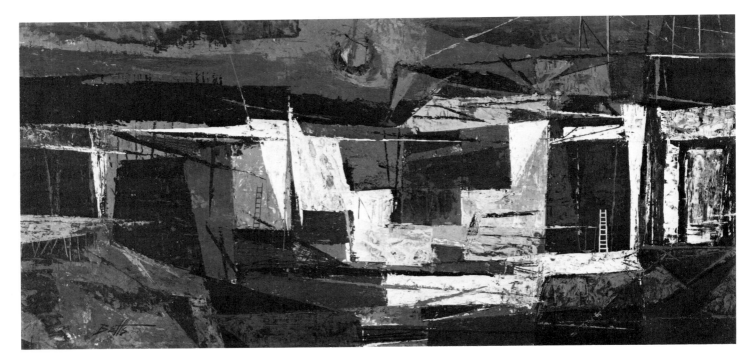

Quarry *Casein on illustration board, 13" x 26½". Private collection.*

10. Painting From Nature Toward Abstraction

There are two general ways to deal with subject matter in abstract painting. One is to begin with an observed motif and take it by stages—either mentally or through preliminary studies—from realism toward abstraction. That is the process that concerns us in this chapter. In the next chapter we will discuss the alternative procedure of beginning without a subject and discovering it through the act of painting.

In a sense, painting from nature toward abstraction can be considered as making variations on a theme, since the artist responds to a specific subject and then develops it, logically and intellectually, on several levels and through several phases: realism, simplification and analysis, semiabstraction, and nonobjective design. In short, he goes from descriptive realism at one extreme to pure design at the other.

Abstraction is not the sort of thing you leap into without acquiring a thorough understanding of the subject beforehand. The artist must understand what the subject looks like, analyze its forms and spaces, and identify the emotional response to be expressed. This chapter is a problem in several parts, an outward enactment of the mental processes a painter might go through in painting an abstraction based on a theme taken from nature. The first phase in the development of the motif is *research*, drawing and/or painting from nature. The second phase is *analysis*, in which shape, value, and pattern are explored. The final phase is *synthesis*, a bringing together and integration of the previous phases into a painting that is a combination of formal structure and expressiveness.

This systematic reorganization of the subject in abstract terms is not altogether coldly analytical, since it allows plenty of leeway for personal response and for experimentation with color and design. The principal advantage of such a process is that the painter knows what he is doing at all stages during the evolution of his picture and is therefore in complete control of the situation at all times. His control enables him to treat the final version very freely and loosely, if he chooses to, because of the knowledge and confidence that he has gained from thoughtful preparation. In music, such an approach is used by orchestra conductor Herbert von Karajan, who is said to rehearse his players with exactitude and precision to reach complete perfection of detail and then lets them play freely during actual performances.

The other advantages to this approach are that by the time the artist has explored his motif from several viewpoints and gotten to know it well, he has clarified in his own mind exactly what he wants to say. Now he can project his vision of that subject as forcefully and directly as possible, with no fumbling or ambiguity; moreover, he has considerable latitude as to just how far toward abstraction he cares to carry the motif—whether he wishes it to be stylized, semiabstract, symbolic, or even totally nonobjective.

OBJECTIVES

1. To do a series of at least four related paintings—realistic, simplified pattern analysis, semiabstract, and nonobjective—based on a single motif.

2. To become thoroughly acquainted with the subject through the variations-on-a-theme approach.

3. To gain greater understanding of the principles of abstraction by dealing with the subject in terms of progressive design analysis.

NOTES

In this chapter, as in the next, there is a free choice as to the materials that will be used. Obviously, all four phases can be done in watercolor or acrylic, but for the sake of variety and to get the most out of each medium, the following list might be used as a guide:

Realistic: watercolor or gouache

Simplification and pattern: gouache or acrylic

Semiabstraction: acrylic or collage

Nonobjective: acrylic or collage

PHASE 1: REALISTIC

I use representational drawing and painting as a means of familiarizing myself with the subject. Long before I attempt to paint an abstract version of a landscape motif, I have already observed and either sketched or painted the subject from several different viewpoints—walking around it to find the most dramatic effects of light and shadow and seeing which angles suggest the best compositional arrangement of the forms. Sometimes these viewpoints are combined in a single painting that portrays the subject from more than one angle simultaneously, as in one of the later phases of this exercise.

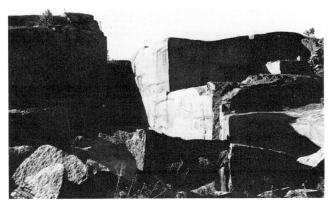

A quarry—like barns, bookshelves, surf, clouds, skyscrapers, sub-way stations, cliffs, flowers, or mountains—is already abstract to begin with. These photographs of the quarry motif give an idea of the basic forms that first attracted me, forms that are best seen in a strong, dramatic lighting that heightens the sense of shape and pattern. The blocky forms and diagonally cast shadows have a cu-bistic look to them that is irresistibly attractive to many abstract painters.

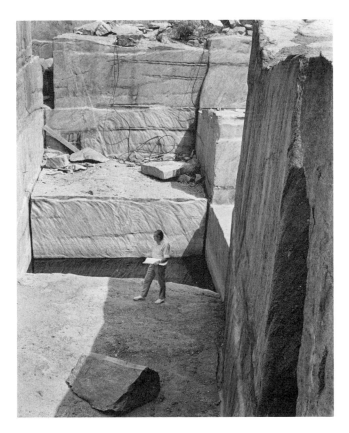

The author sketching at Swenson's marble quarry near his sum-mer studio in Ogunquit, Maine. (Photo James Bull.)

 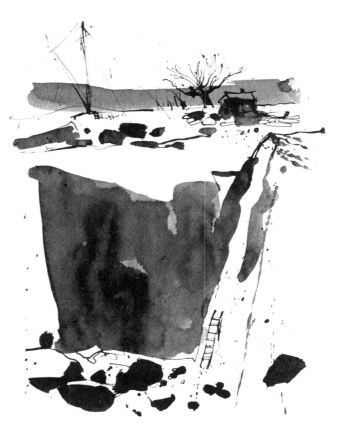

Two drawings of a marble quarry, 14" x 11". The drawings shown here are also a Swenson quarry, but one farther from my studio than the quarry shown in the earlier motif photos.

The pencil drawing (left) was done on the spot as a research drawing, indicating the scale and character of the forms. I wanted the sketch to give me information, but not so much detail and incident that I would become a slave to the visual facts when it came time to paint.

The ink and wash drawing (right) was done later from memory in the studio, executed entirely in neutral tint India ink and a sumi brush. This is a painterly kind of drawing, visualizing the scene as a winter composition and reducing the forms to stark black or dark gray against the white of the paper. This, incidentally, is approximately the same view of that quarry as the one seen in the watercolor reproduced on page 60.

Research drawings of this sort are the first visual contact with the motif, and since such first impressions are important, these sketches must catch and hold whatever the response was to that subject. From this point on, no matter what transformations may take place, that first vision must be retained, and frequently it is through such sketches as these that the artist goes back to remind himself just what it was he saw and felt.

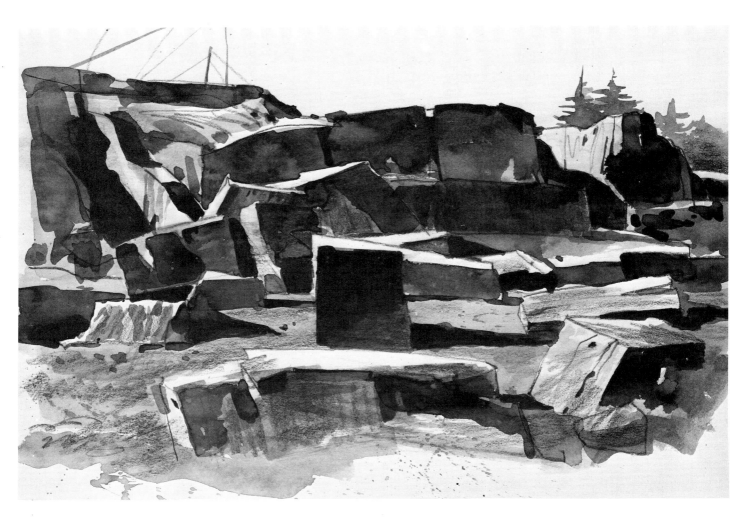

Quarry Stones *Wolff pencil and ink wash on paper, 11" x 14". This is primarily a value study. It was blocked in lightly in carbon (Wolff) pencil, then washes were built up, working from light to dark, and at the very end it was touched up with further tonal and textural indication in carbon pencil. A clear understanding of the forms and planes of the rock masses and the way light affects them is essential to extracting the fundamental aspects of the quarry—the "qaurriness" of the quarry.*

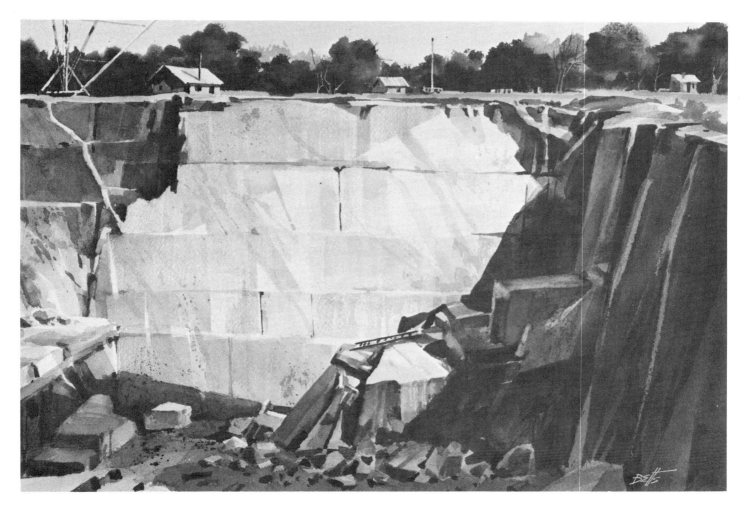

Swenson's Quarry *Watercolor on 300-lb Arches rough, 14" x 21". The culmination of the realistic research phase would probably be a fully developed watercolor or gouache. By this time there is a thorough understanding of the quarry, its form relationships and the way lighting reveals or obscures those forms. The fact that two different marble quarries were the source of the work reproduced in this section means that there will be no temptation to paint a particular quarry and all its specifics, but that eventually the final picture that is the outcome of all these preparatory phases will be the essence of quarry, going beyond the local to something more universal. Even though this painting is representationally conceived, it will be noted that slanting lights and shadows have been used to break up the surface almost arbitrarily; already there is a hint of abstract design beneath the apparent realism.*

I visit the subject at different times of day. As every painter and photographer knows, early morning and late afternoon usually provide the strongest shadows, which are of special importance to me. It is the shadows, or darks, that give a watercolor its drama and its compositional structure, so I try to make the most of them. Because I have always regarded watercolors as a tonal use of that medium, depending for their success on the design and patterning of the light and dark washes, I invariably am conscious of the lighting of the subject: how it reveals the basic form and how it can be utilized to give the picture a maximum of light and dark contrast.

Although my representational watercolors are meant to record the subject only in the most immediate visual terms—what it *looks* like—I also may do two or three other versions, trying for variations of mood or perhaps composition. Here I try out different vertical or horizontal formats to see how much of the subject might be included or omitted.

If it is feasible to see the subject at different seasons of the year, that is a vast help in developing other ideas and getting to know the subject as intimately as possible. The angle of the sun will change the lighting; snow may create new patterns and designs; the colors of fall or of rainy skies may suggest other schemes. All this should be recorded for later use in drawings or watercolors, or stored away in the memory.

PHASE 2: SIMPLIFICATION AND PATTERN ANALYSIS

Once the subject has been assimilated on a purely visual level, the time has come to examine it more schematically in two different respects, severe *simplification* of the essential forms and analysis of the light and dark *pattern*, as a means of searching out the structure that exists in nature.

To simplify the forms is to get rid of extraneous detail—unimportant incidents and accidental effects—and to concentrate on bringing out only the basic, elemental planes and shapes. You will discover some of their design potential, though still on a fundamentally realistic level. However, there is no need to push toward abstract reorganization too early; merely emphasize whatever relationships seem to express the subject in its very simplest terms.

At just this point, I change my attitude toward light and shadow. No longer is it a matter of light striking a sculptural volume; in my mind light and shadow have been transformed and are thought of only as an arrangement of pattern in a scale of three or four values. How light affects form is no longer important to me. What is important is the overall pattern. I use lights, darks, and middle tones to design the rectangle within which I am working, whether it be a page in my sketchbook or a sheet of watercolor paper or illustration board.

Most paintings need a clearly worked out pattern, not only to give the picture its strength but for visual variety, to keep the surface from looking flat and monotonous.

Analysis

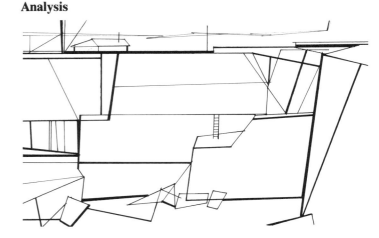

Quarry Study *Marking pen on paper, 15" x 24". An analysis of the linear elements of the preceding watercolor would produce a diagrammatic analysis something like this, though each artist's analysis is entirely personal and invariably quite different from one done by someone else. Here the lines of varying weight and thickness were drawn with a marking pen and ruler without a preliminary blocking-in. It developed without plan, and the only guide and inspiration for what lines did and where they were placed was constant reference to the watercolor that preceded this exercise.*

The main idea behind the line analysis is the emphasis on the major lines and shapes, simplified and stylized so that they activate the surface of the paper in a way that is close to abstract design but that never loses sight of the original subject. Planes are reduced to bare linear forms that intersect and overlap; the subject is flattened out so that volumes are treated in as two-dimensional a way as possible, denying their volume and insisting above all on the flatness of the paper surface on which the lines are drawn.

The analytical line design is the first time where purely pictorial considerations take precedence over the appearance of things in nature, and when finished, this line drawing should be interesting mostly as a manipulation of interacting line elements; the subject itself—a quarry in this case—is of only secondary interest. It has become a vehicle for design conceptions but is no longer the primary object of interest.

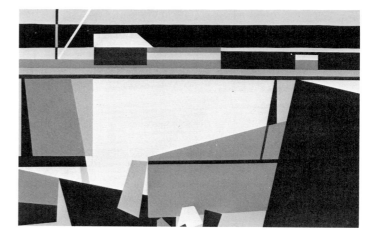

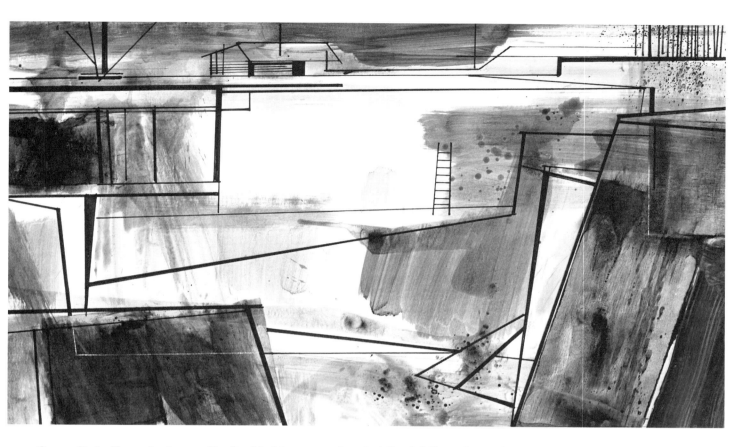

Quarry Study (line and value combined) *Marking pen and wash, 14" x 24½". In this study I combined free washes with a superimposed line analysis, an approach to the subject that comes nearer to a painterly treatment. The splashy washes were done without any drawing beforehand, and it is the straight ink lines that serve to give the composition a more disciplined sense of order; each acts as a foil for the other, setting up a tension between the loose patterning of the wash values as opposed to the control of the linear design. (It is like superimposing two quite different slides to form a more complex arrangement and interaction of parts than either one has alone.) Furthermore, this version was done in a decidedly horizontal format in order to try out a more distinctive proportion than that used in the preceding studies.*

Quarry Study (value) *Collage on cardboard, 12" x 18". In addition to line analysis, and equally, if not more, important is the analysis of values and shapes, for which collage is an ideal medium. Here the cardboard was given a coat of light middle gray, and then construction paper of white, light gray, dark gray, and black was laid out on the drawing table. There was no preliminary drawing as a basis for placement of shapes, and many of the values referred directly to the realistic watercolor version of the quarry. (Instead of using collage, gouache or acrylic can be used just as effectively.) Every effort was made to keep shapes strong and simple, to maintain contrasts of values so that no two adjacent values were the same (here again, to achieve that contrast it was necessary to alter some of the values established in the watercolor), and to arrive at a dramatic, readable design in which there was a varied range from very small shapes to very large masses. For me, the pattern of light and dark can often make or break a painting, so this value study is one on which I place the utmost importance.*

Very often it is the manipulation of pattern that opens the door to abstract design, and it is in the planning of this pattern that, for the first time, purely pictorial considerations take precedence over description of the subject as the eye sees it. These are the first departures from reality, where top priority is given to those decisions that relate to the total organization of the painting as a painting. The subject has dropped in importance; designing the surface has taken over.

I should point out that studies in simplification and pattern should be done monochromatically, in three or four values of a single color, so that there is no chance for a rainbow of colors to distract from the search for structure and pattern, the prevailing purpose of this phase.

PHASE 3: SEMIABSTRACTION

Semiabstraction is a matter of carrying the design farther in terms of pattern, paint texture, and especially color, though not so far as to make the original subject unrecognizable. Hence my use of "semiabstract," by which I mean halfway between descriptive realism and pure design.

In traditional watercolor painting, values and patterns are more important than color organization, but in abstractions it is color that in actuality constructs the picture, creates its mood, and establishes its spatial relationships. Even though the completed abstraction may have very muted or limited color, it is one brilliant color shape relating to other bright color shapes that initially gets the picture underway.

Colors here are nevertheless firmly anchored to the values in the preceding pattern study. If, however, color is to be the major concern, and if the color relationships are in themselves beautiful enough, pattern then becomes less important to the painting. Black and white reproductions of paintings by Bonnard would look like so many mudpies, since it is color alone that carries his pictures—color so shimmering and radiant that we are happily willing to overlook the fact that pattern, structure, or academically correct drawing are often missing.

When a painter is not an accomplished colorist, though, an understructure of pattern as a base for the color will give the picture visual drama, an abstract arrangement of values that will compensate for possible color deficiencies.

I know of no one book on the subject of color that answers all an artist's color problems. Most of the color books seem to lean too strongly toward the theoretical, and as fine as they are, they somehow have very little application to the actual problems faced in the studio from day to day. Many things that look so orderly and systematic on the printed page are almost impossible to carry over into a painting in progress.

The only way to learn about color is to deal with it intimately year in and year out and to discover its limitless potentialities, emotional and intellectual as well as opti-cal. The number of apparently natural-born colorists is depressingly small; most of us have to learn our use of color the hard way through years of trial and error; of thinking, looking, and painting; of solving new color problems as they arise in each picture. A strict and undeviating set of rules for color use is the kiss of death to creative painting. Color knowledge does not result from a scientific system but from each artist's personal struggle. I wish there were an easier way, but there isn't.

In this semiabstract study, color can be explored more freely than ever before because color can be divorced from subject matter if the artist's ideas so demand. Color does not have to be true to nature; it can be selected with consideration only for the requirements of the picture itself. This freedom to use color for its own sake is one of the liberating qualities of abstract painting, and it seems to me that if we are working with various colored paints then we should enjoy the use of color to the utmost—not simply tonal or descriptive color but *creative* color—using it as a reference to the visible world, of course, but mainly as a sensuous experience and for ordering of space.

If I give the impression that I like raw or crude color, that is a mistake. I do like rich, brilliant, opulent color, strong and vibrant, but if color becomes gaudy and cheap, then that means that the colors have not been successfully related to each other in terms of intensity and of proportion. I can tell a student that such and such a group of colors is handsome or exciting, and yet it turns out that the student's use of these very colors produces something less than handsome or exciting. He used the suggested colors, so what went wrong? Perhaps he used the colors in incorrect proportion to each other; he missed the fact that one of the major color considerations is *how much* pink, *how much* orange, *how much* green or brown or gray. As I have said, there are no color rules that guarantee success. It is mostly a matter of developing color sensitivity, learning to sense how much of a particular color should be used in relation to the others.

Aside from this, color has to be used intellectually to create spatial situations—a logical progression and recession of forms within the established pictorial space of the painting. Cézanne used his color touches in such a way that each dab of color took a very specific position in space, denoting a facet of volume, or form, as well.

According to the tenets of tonal painting, color becomes lighter and grayer as it recedes into space. In abstract color painting the situation can often be reversed, so that planes we know in our minds to be at the rear of the picture space are painted with intense color and planes near the front of the picture are painted in more subdued or neutral colors. The purpose is to keep those rear planes from receding too far back and the front planes from coming too far forward. This unexpected manipulation of space, this reversal of normal relationships, not only helps to maintain a limited depth in strictly pictorial terms, but is also another way of frankly departing from the look of things. It reorganizes nature

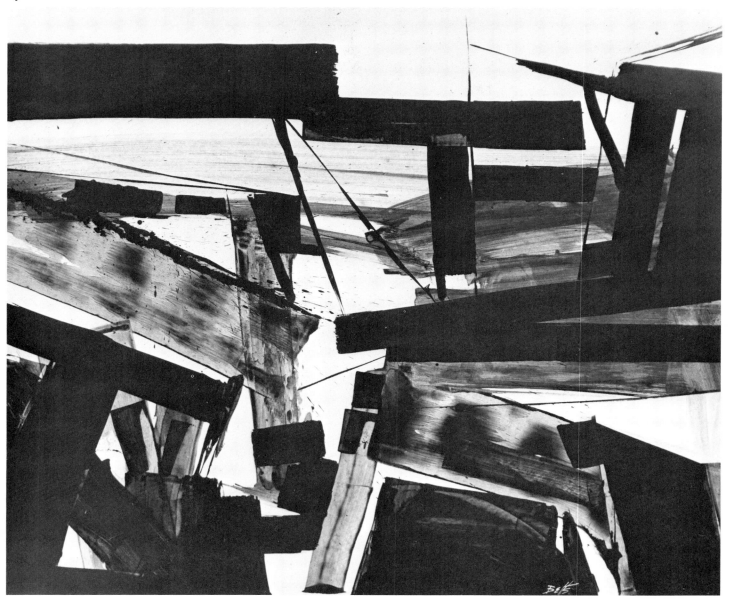

Maine Quarry *Black acrylic paint on paper, 24″ x 30″. With the research and analysis phases behind me, it was now time to bring together what had gone before in the way of all that was seen, known, and felt about the subject, and to explore avenues that would lead to a more fully realized treatment of the theme, one in which nature and design are more fully integrated.*

This rapid gestural drawing is a spontaneous, highly emotional interpretation of the quarry that emphasizes its dramatic contrasts of light and dark, its jumble of sharp forms, and that feeling of elemental forces at work that is characteristic of almost any quarry. Some of the areas were applied with a brayer, others with a 1½″ putty knife or a wide bristle brush, and the linear accents were struck in with a painting knife. The forms in this drawing were extracted from the forms in the quarry, and then intensified to the point where expressiveness was far more important than description. If the sources are known, this drawing can be seen as a meaningful abstraction rather than the nonobjective design which it might at first glance seem to be.

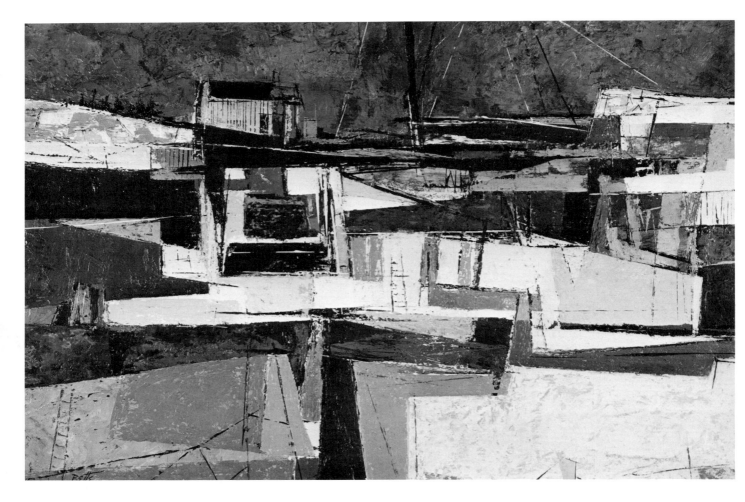

Swenson's Quarry *Casein on illustration board, 20″ x 30″. Private collection. Quarry shapes lend themselves easily to a sort of cubistic treatment. The painting seen here was done in casein applied with a painting knife, which was a help in bringing out sharp, clear-cut, faceted forms and creating a suggestion of stone textures. The picture grew out of improvisational color-shape relationships, but with the knowledge from the very beginning that it would be a quarry subject. It is a rather freely reorganized version of the original motif, partly because the forms had to be related to the accidents out of which the composition developed, and partly because the idea to be projected was more that of quarries in general than any particular one—despite the picture's final title. Swenson's Quarry falls into the category of semiabstract painting, where objects are more recognizable than they were in the preceding abstract-expressionist drawing, and instead of leaning toward either realism or pure design, it is somewhere midway between nature and geometry.*

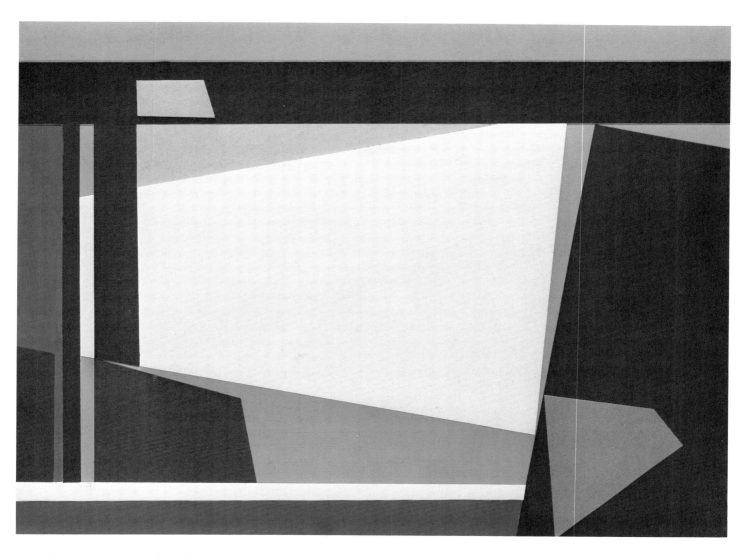

Quarry Pattern *Acrylic and collage on illustration board, 11″ x 15″. If the quarry forms are condensed, distilled, and purified to the point where they are reduced to abstract symbols, then we are dealing with painting in which the subject has been completely submerged in the interests of working exclusively with the most formal, intellectual relationships. This is a hard-edge nonobjective painting, but having seen some of the preliminary versions of the theme, it is nevertheless still possible to identify the sources of several of the shapes and planes. This is therefore an example of the artist using nature to derive suggestions for a nonobjective composition that is to be experienced as pure form, complete in itself. Obviously, if I had felt so inclined, I could have pushed this even further toward a minimal number of horizontal-vertical relationships, á la Mondrian, in which the quarry would disappear altogether.*

into a series of relationships that are complete in themselves, based on reality but dealt with from the viewpoint of creating a *painting*, not a report of what the eye has already seen.

The semiabstract phase, then, is where reality becomes secondary to imagination, invention, and an integration of visual reality with color and design.

PHASE 4: NONOBJECTIVE

In its purest form, nonobjective painting has no subject matter at all. A painting of this sort refers to nothing outside itself. It is totally self-sufficient: the relationship between the pictorial elements in their barest form is what constitutes the basis for enjoyment of the picture. For this reason there are many artists and critics who regard nonobjective art as the most elevated form of esthetic experience.

There are two basic categories of nonobjective painting: *geometric* (hard-edge) and *painterly* (abstract expressionist). The geometric is static, formal, decorative, and decidedly intellectual in its appeal. All elements in the painting are precisely and tightly organized, adjusted with highly refined taste. The painted surface is clean, mechanical, and anonymous. The purity of the conception and the color-shape relationships are of the utmost importance.

In contrast to that, painterly nonobjectivism is very loose and informal, highly emotional. Instead of developing in an orderly manner, the picture is a triumph of intuition and spontaneity over discipline and rational analysis. Freedom and excitement replace precision and calculation, and every effort is made to avoid the look of conscious organization. The paint surfaces are casual and vigorously brushed, with no attempt at nuance or refinement. There may even exist an intentional brutality that keeps the work from looking too polished or "artistic."

Although nonobjective art is supposed to have no sources in nature, some of the finest abstract expressionists do indeed draw their ideas from observation of the everyday world. Nevertheless, by the time they have finished dealing with it, the subject is no longer even faintly discernible. One of the greatest of our contemporary hard-edge painters, Ellsworth Kelly, readily admits that he constantly uses reality as the source for his severely geometric compositions: a shadow, a fragment of architecture, the spaces between objects, a scarf forming a triangle on a woman's shoulders, or the piping on a tennis sneaker.

It is then quite possible and legitimate to take the subject that has just been dealt with as a semiabstraction and push it all the way to total abstraction, where design is everything. Reality has now been banished from the picture, except insofar as it provided the initial idea. This can be accomplished either by a process of extreme simplification and distillation, or by closing in so near to the subject that enlarged detail eliminates any trace of recog-

nizability. All that remains now is a concentration on the design relationships, and the fewer the elements the more perfect the adjustment of the relationships between those elements must be.

In the more painterly approach it is possible, after having carried the subject through the three preliminary phases, to start a picture with a few random marks derived only generally from the original motif and then proceed to develop a nonobjective composition. One color stroke leads naturally to another. A red area here demands a blue touch there. A picture evolves spontaneously, to be enjoyed as pure paint, color, and shape. But nonetheless its beginnings are in reality, and if the subject is too apparent it must be painted out until the final picture stands on its own as pure design.

I am convinced that in order to keep the forms in nonobjective painting vital and varied, to prevent repetitious, sterile design, it is essential that the artist stay in constant contact with all things visual, that he keep his eye eternally alert for forms and combinations of forms that he can eventually put to use in his paintings. The wells of invention can go dry unless they are continually fed by intense observation.

GENERAL REMARKS

Now that we have taken a motif through several progressive stages from realism to abstraction, it is time to assemble the paintings that have been done and assess the results:

Phase 1, done representationally, is probably the least interesting of the group, since it was done simply as a record of direct observation.

Phase 2 is almost more of a diagrammatic study than it is a painting, but the information it contains is crucial to what happens in the two final paintings.

Phases 3 and 4 do not necessarily have to be done in that order. Sometimes I do one first, sometimes the other, depending on the subject or on my mood at the moment. When Phase 3 preceeds phase 4, the nonobjective composition becomes the climax of the problem, where the subject is pushed to its ultimate limits as a distillation of the very essence of the subject in purely formal terms.

When the nonobjective phase is done prior to the semiabstraction, however, it serves to clarify the design and reduce it to its simplest elements. The semiabstraction then becomes the culmination, bringing together the fundamental forms through a painterly treatment in which subject, design, and painterly textures are all inextricably combined.

Whichever one you choose as the final phase can be considered the logical conclusion of the entire problem, depending on your viewpoint and philosophy. For my own part, I regard the semiabstraction as the most demanding and by far the most difficult to achieve. Realism is simple if you have good training and are willing to take the time to paint things exactly as you see them; nonob-

jective design is also relatively easy if you have had good training and have an eye that is extremely sensitive to purely formal relationships of line, shape, and color.

But the average realistic painting can be boring because it depicts nothing more than what the eye sees. And the average nonobjective painting can be equally boring, because no matter how intricately and beautifully it has been worked out, it is lacking in subject matter or sub-stance and soon exhausts itself. One is short on form and the other is short on content.

The semiabstraction, however, is a complex balance of nature and geometry, and to effect a balance of that sort seems to me to be the highest achievement possible. It has been the struggle toward that goal—never reached—that has kept me painting all these years.

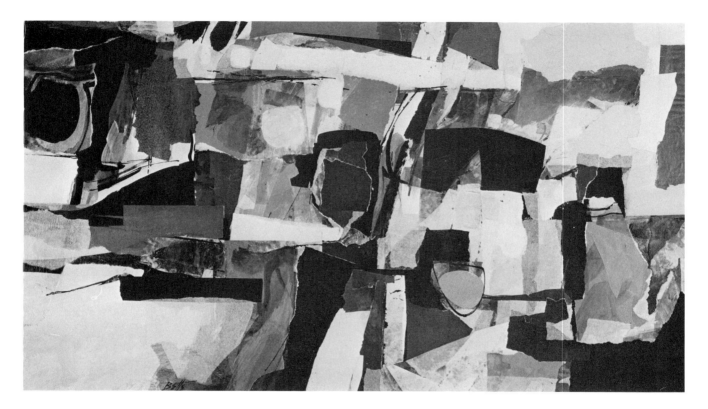

Frozen Quarry *Mixed media on illustration board, 17" x 28½". Private collection. If the hard-edge nonobjective interpretation seems a little antiseptic, the antidote is to be found in the more relaxed and informal treatment seen here.* Frozen Quarry *betrays its origins only through its title. Basically, it is a nonobjective painting that still retains a suggestion of sharp, rocky forms here and there, and some of the whites could refer to snow patches among the rocks, but essentially the quarry is no longer recognizable, and the picture's principal appeal is in terms of shape, edge, pattern, line, and texture. The quarry idea exists only in the very remotest sense—it may have provided some of the reasons for design decisions, but I would like to feel that it is possible to enjoy the painting without knowing its references. Through a series of variations on a theme, we have come full swing from observed nature to the edge of total abstraction.*

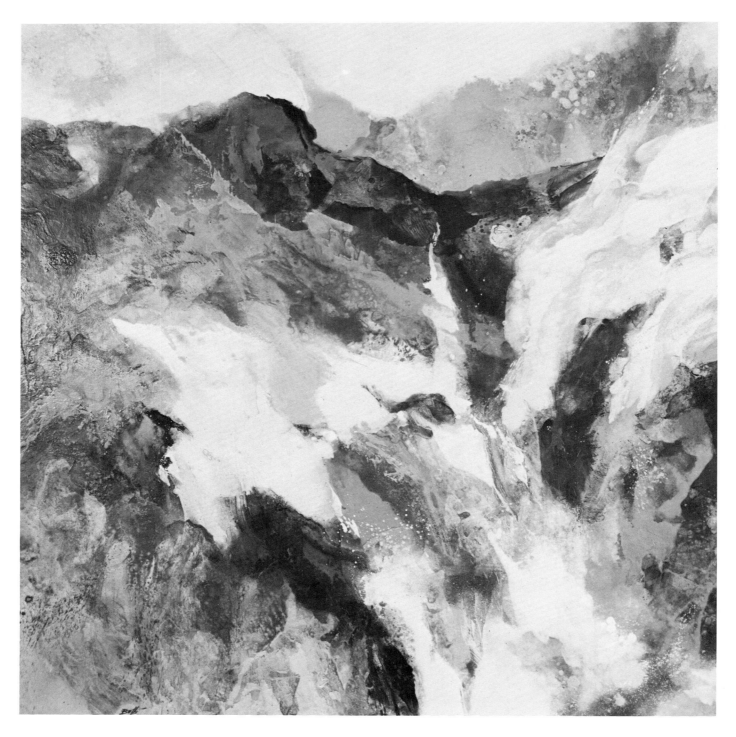

Cataract *Acrylic on Masonite, 48″ x 48″. Private collection. Photo courtesy Midtown Galleries, New York.*

11. Painting From Abstraction Toward Nature

If the sequence of events is reversed so that instead of starting with nature, the painting begins with abstract forms that are gradually developed toward naturalistic references, a correspondingly different attitude and state of mind are necessary. In the preceding chapter, nature was observed and then carried toward pure design through a predominantly intellectual process. In contrast, painting from abstraction toward nature is, as we have noted before, largely intuitive and spontaneous, involving a considerable amount of chance.

It seems to me that most painters tend generally toward one approach or the other. Their tastes and their personalities are inclined to be either classic, rational, and objective, or at the other extreme, romantic, intuitive, and subjective. Obviously, these opposing characteristics overlap in some individuals; but we usually find ourselves, in varying degrees, more on one side than the other.

Some of my students, for example, feel completely out of their depth when asked to let accidents happen and to trust their instincts, whereas others simply do not have it in them to organize the pictorial elements coolly and deliberately and to maintain disciplined control over the progress of a painting.

Painting from abstraction toward nature means that the artist must dispense with the essentially Renaissance notion that a picture is prepared through a series of exploratory sketches followed by compositional drawings, pattern and color sketches, detail studies, and a final cartoon. While all this has a certain orderly quality to it—and would certainly be necessary in, say, painting a mural—there are some painters who find it impossible to sustain genuine interest and enthusiasm to the bitter end in such a long, drawn-out procedure. Their final paintings are likely to be rather contrived, or worse, stale and lifeless. For such painters, who cherish spontaneity, freshness, and directness of approach, and a response to materials, it would seem that eliminating drawing as a basis for beginning a picture and discovering the subject matter through the creative act itself would be a viable alternative.

Admittedly, this manner of plunging into haphazard color areas at the very start and emerging triumphantly with a satisfying work of art is not for everyone. For those who depend upon the security of knowing precisely what they are doing at all times and who require a logical plan of action, improvisational techniques can often produce

only impatience, frayed nerves, and general confusion, with the added likelihood that these individuals may deceive themselves into thinking the picture is unified and resolved before it actually is. For such persons, improvisation might better be postponed for a while until they can muster their courage.

The painters who have the most success with intuitive methods are those who have extensive experience in, and knowledge of, painting from nature and who therefore have a deep reservoir from which to draw inspiration. These painters are sure enough of their professionalism to take certain risks, to venture into unknown areas without fear of the consequences; in fact, they are much less concerned with painting successful pictures than they are with discovering more about themselves and about the possibilities in painting.

In addition, they resist easy solutions and the temptation to stop before the picture is fully organized. They demand more of themselves and of their paintings—they won't tolerate loose ends or unresolved parts—and it is this insistence on quality, on full realization of all that is involved in the picture-building process, that separates superior from mediocre work.

BACKGROUND FOR IMPROVISATION

Because I have accepted and learned to live with my split personality, I paint my watercolors and gouaches knowing exactly what I am after, with everything planned in advance and with a clear idea of what the finished painting will look like. In my abstract acrylics, on the other hand, I feel my way along, with no idea at all as to what the final result will be. As long as I keep the two approaches distinctly separate, no confusion of purpose or technique results within the individual paintings.

In any event, for almost thirty years the greater part of my painting output has been done improvisationally or intuitively. I cannot remember now exactly how I fell into it, and certainly no one suggested it to me, but I have the feeling I became aware of the possibilities quite fortuitously.

Probably I was preparing a panel with an underpainting of bright casein colors and suddenly saw the suggestion of a painting appearing there, but one different than the one I had in mind. Probably, too, I followed my impulses and decided to develop the new idea instead. It must have turned out rather well, because from

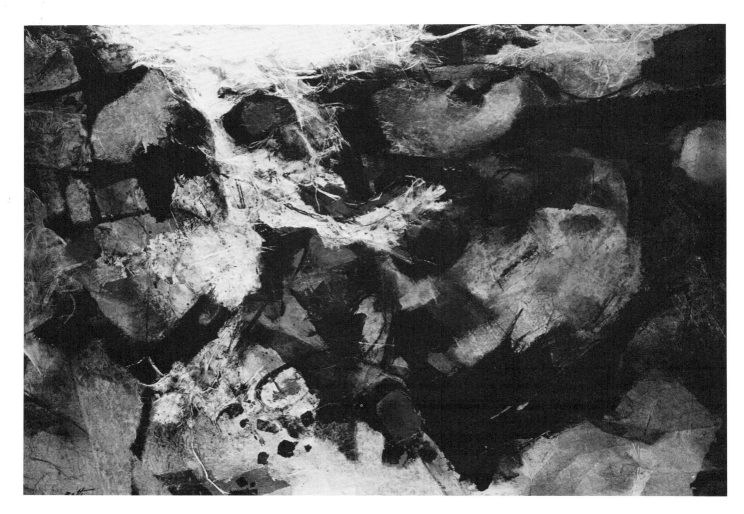

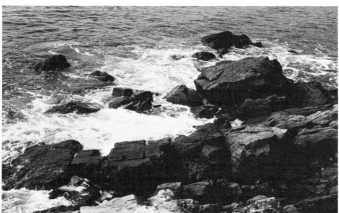

Rocks and Surf *(Above) Mixed media on illustration board, 24" x 34". Private collection. This picture was painted without any reference to sketches or photographs. Like all the paintings reproduced in this chapter, it was begun improvisationally without any subject in mind. The subject evolved out of the accidental relationships that arose from random areas of paint and collage. As these relationships stirred up memories or associations, I came to equate the forms and textures in the painting with the rocks and sea seen far down below me in my frequent walks along the Marginal Way in Ogunquit, Maine. Note that a very heavy-fibered rice paper was used to capture the feeling of foam rushing in around the rocks. Rice-paper areas of this sort must be glazed with some color so as to integrate them as thoroughly as possible with the rest of the painting. There are at least three different kinds of rice paper in this picture, and some synthetic paper, each one having its own particular degree of transparency.*

(Left) Ten years after the picture was painted I went back and took this photograph to demonstrate the close relationship between what happened in the painting and the actual arrangement of similar forms in nature.

that time on the pictures that evolved out of random underpainting pleased me far more than the conventional ones I had been doing up to that time. There was for me greater excitement in the process of painting because of the challenge of dealing with the unexpected things that occurred. From then on it was only a matter of exploring that approach in greater depth and perfecting it as a method without a method—one consciously kept so open and flexible that it could never become routine.

In particular, two trips to Monhegan Island off the coast of Maine, in 1948 and 1950, had a tremendous impact on me and on my art. My memory and experience of that island, with its harbor, pines, cliffs, and crashing surf, kept cropping up in all my paintings with insistent regularity, almost obsessionally, for more than twenty years afterward. But the interesting thing to me was that my representational paintings of that rugged island were academic and ordinary, pleasant but predictable, whereas the improvisational, semiabstract paintings were, I felt, more expressive of the rocks and cliffs and forest of Monhegan, more true to the spirit of the place.

This served to confirm my suspicions that the pictures which came out of my subconscious paint manipulations—guided and controlled by memory and emotional response and a knowledge of nature—were the best I had yet done. They were not great by any means, but they indicated to me a path to follow, a working method that might lead to better things. It was, in short, a highly gratifying coming together of an artist, a subject, and a way of painting.

So in order to experience a fresh way of developing a painting, that of starting to paint without a specific subject in mind, put your sketchbooks and photographs away, clear your mind of any preconceived notions as to what you are going to paint, select a panel, squeeze out your colors, take brush in hand—and then begin to paint. It's as simple as that.

OBJECTIVES

1. To paint a picture without using subject matter as a starting point.

2. To discover subject matter through the act of painting itself.

3. To create order out of the initial disorder of paint areas.

4. To experiment with a fresh approach to the creative process.

NOTES ON THE MATERIALS

For free-wheeling improvisational painting, there is a free choice of materials: transparent watercolors, gouache, acrylic, or mixed media can be used. I have personal reservations, however, about the appropriateness of transparent watercolor for such work. I know it can be used—and some artists do—it is just that I have seldom had much luck with it. I prefer opaque or mixed media, where I can revise and repaint indefinitely, and I would recommend those media over transparent watercolor, at least for any painters who may be trying this approach for the first time.

It has always been my conviction that watercolor is principally for those who plan ahead and know what they are doing. If the improvisational approach is undertaken in this medium, there is a fair chance that the painting will get out of control. So rather than strive for a customary directness and freshness, the artist using watercolor might do better to try to work accidents to his advantage or depend on the various corrective measures available to a watercolorist in redoing areas that are not coming along successfully.

To those brave improvisationalists who insist on giving watercolor a try, I suggest that they use only the heaviest high-quality rough paper, which will take a good deal of punishment in the way of wiping, rubbing, bleaching, sanding, scraping, and sponging.

If the surface of the painting does not reveal any fumbling, it is quite possible to produce an improvisational watercolor that is not in the least tired or overworked-looking but instead is characterized by lovely nuances of subtle color and texture, Look, for example, at the marvelous series of sea paintings done in watercolor by Emil Nolde. They are accidents raised to the highest form of art, where perception, idea, image, color, and medium are all indissolubly entwined.

An alternative attitude in doing improvisational watercolors is what might be called the "picture magazine syndrome," whereby as many as a hundred watercolors are painted, but only five are kept by the artist as successful examples, all the others being destroyed. Considering the high cost of a sheet of watercolor paper these days, I doubt this is an approach that will have a strong appeal for many painters; nevertheless, it does remain a possibility for those so inclined!

It might be strongly advisable, then, to use gouache, acrylic, or mixed media for first efforts at improvisation and try watercolor later, when a background of experience and confidence has been established and you have more of a fighting chance to outwit the medium.

BEGINNING THE PAINTING

A State of Mind. In painting from abstraction back toward nature, the artist's state of mind is of prime importance. For one thing, the mind must be absolutely free of any idea as to what is to be painted. To have even a vague plan of action or a motif in mind could inhibit a free, organic growth of forms within the painting, and the artist could very well find himself reverting to predictable images or repeating, even without intending to, elements from his own previous work or the work of other painters. So, a mind that is swept clean of all plans and preconcep-

tions is the first requisite.

Second, the painter must have deep faith in his own intuitions and responses. If there is anything that modern psychology has taught us, it is that the human subconscious has laws of its own and that we should feel free to discover what they are and use them for creative purposes. Even in the most rational, rigidly controlled paintings we often find a passage of pure inspiration without apparent reason or precedent. There it is, and it works! The artist may wonder what it was that possessed him to do that unexpected but remarkable thing; it was probably intuition, one of the creative person's most powerful resources.

Finally, the artist must be ready to thoroughly involve himself in the act of painting with the fullest concentration and enjoyment and to act as though he knows what he is doing (even if he doesn't). It does take a certain amount of nerve to attack a painting without a plan, without a preconceived image toward which to aim, but the picture should still be begun in a spirit of joy and relaxation, with no inhibitions whatsoever. After all, painting should be a celebration. Remember Robert Henri's advice: "Paint as though you are going over the top of a hill singing."

Beginning an improvisational painting is perhaps the best experience of all, because at that point the possibilities are infinite. If the artist has set his mind properly, he is in a position to make the most out of those possibilities.

Accident and Chance. How often have we seen an artist whose paintings are all so alike that we feel when we have seen one we have in essence seen them all? To deliberately provoke accidental effects in a painting is one way to ensure that you will not repeat yourself. Avoiding habit, formula, and standardized solutions should be a guiding principle for any truly creative painter, and one way to accomplish that goal is to set up totally new or unexpected situations and then try to deal with them freshly and adventurously.

I once asked a distinguished West Coast abstract expressionist if he were not depending a little too much on the accidents that occurred in his painting, and he answered with some irritation that there *were* no accidents. At first, I thought he was implying that his "accidents" were determined by heavenly powers, and since they had holy sanction they were therefore not to be thought of as accidents.

In the years since then, however, I have come to believe that an accident does not remain an accident after it has been contemplated esthetically and ultimately either accepted or rejected. Once it has been accepted and retained in the picture, if only for a short time, to me it then ceases to be an accident: a choice, a commitment, has been made.

I am thinking of accident as a means of stimulating the artist's intellectual and emotional powers, of probing the subconscious for suggestions unknown and unrealized until they are sparked into action by unplanned occurrences in the painting. Chance effects that are unproductive or unsuccessful—that do not release creative ideas or satisfactorily relate to other parts of the picture—must be painted out and replaced by others which either "speak" to the painter or fulfill a specific function in the picture. My first impulse when faced with an accident of questionable value is to try to find a way to use it, to make it work, to integrate it with areas already established. Failing that, I eliminate it immediately.

The point to painting improvisationally is that instead of imposing his will like a cookie-cutter upon natural forms, the artist is conceiving his picture in terms of the medium itself. He is enlisting accident to help bring about an interweaving of his paints with possibilities and probabilities, and with a personal vision, both conscious and unconscious. Improvisational painting is a way of taking an accident beyond the accidental, of giving it not only form but meaning as well.

Applying Paint. The whole spirit or mood of this sort of painting is identical to mixed-media technique. I have no one standard method of beginning to paint, but usually I start off by pouring paint onto the panel. The panel's surface may be dry, but often I spray it first with water or flow diluted acrylic medium on and then pour on the color and let it do what it will. This operation may take no more than three or four minutes. However, I am in no hurry to cover the entire surface all at once, nor do I want to have too many different areas flowing into each other so that they lose their quality of shape and edge. Therefore it is my habit to begin a painting at the very end of a painting day, so that it can dry overnight.

The following day more paint is poured—or flung—on. Some areas might be glazed with a wide brush or paint rag, other areas spattered or stippled or sprayed. At this stage, it is usually necessary to stop and let the paint dry. After it has thoroughly dried, I apply a coat of diluted acrylic medium over the entire surface.

Because of the amount of drying time inevitable with this method, I work on seven or eight paintings at a time, so that while one is drying I have several others to keep me occupied. At some point, when all the paintings are well on their way, one might begin to interest me especially and I may single it out to press on to a conclusion before any of the others. With a pour-and-flow method, of course, the drying periods are frustratingly prolonged, but if the improvisational method is carried out along more ordinary lines—painting and glazing with a brush, or in mixed media—the picture comes along much more rapidly and if all goes well can very easily be completed in a single day.

Uppermost in my mind right from the start is a deep concern with color relationships. The colors I choose to work with in the first five minutes do not necessarily set the color key for the final painting (I remember one recent painting of mine that began as red and black and ended up in delicate blues and greens), but the first col-

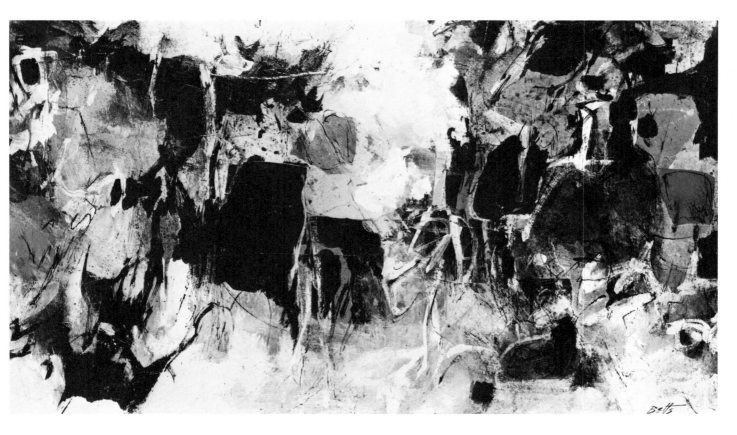

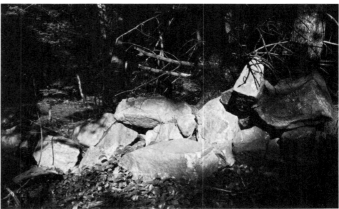

Forest Tangle (Above) Mixed media on Masonite, 14″ x 26″. Photo courtesy of the artist. Improvisational drawing played almost as much a part in the development of this picture as improvisational painting. The panel was covered haphazardly with paint then given a coat of acrylic medium diluted with water. Taking a bottle of black India ink, I drew quickly and impulsively, using the bottle stopper dipped in ink as my drawing tool. After the ink lines had thoroughly dried, I gave the panel another coat of diluted medium to seal off the ink. Sometimes the ink lines lift and blur very slightly when being brushed over with the medium, but I do not consider this a serious problem—in fact it softens some lines and gives them more variety. The next stage was the application of torn collage shapes, relating them to the lines and colors previously established. Then another layer of diluted medium and more ink drawing, sealed under still another layer of medium. At this point I went back to using paint again, drawing and scumbling with a rather small brush. The "control" image of a forest at the edge of a road I traveled almost daily came to my mind, and I thought of thorny branches and a tangle of weeds, sticks, dead branches, and boulders in a thicket. From then on it was a matter of hitting some balance between the random paint, ink, and collage relationships, and that idea at the back of my mind of the underbrush alongside the road.

(Right) This photograph, taken later, suggests the sort of situation I had in mind as I completed the painting, which of course was a generalized evocation of nature rather than a description of a specific scene.

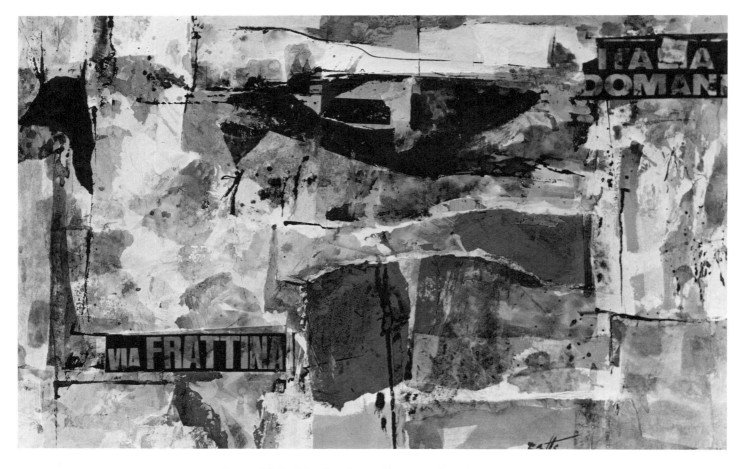

Roman Wall *Mixed media on illustration board, 14" x 21". Photo courtesy Midtown Galleries, New York. Weathered walls encrusted with fragments of peeling posters have long been a favorite subject with many contemporary photographers, and it seems unusually appropriate for treatment in mixed media and collage. I began with freely brushed areas of paint, and after these were dry I painted white over parts of the surface, applying it with a painting knife. Then followed a stage in which I glazed with both intense and delicate colors, and I also began to introduce some collage elements. The next phase involved more whites, using both brush and painting knife, and more glazing as well as spatter and flung paint. Black lines were sliced on with a painting knife and some ink glazes were used in various parts. When the image of a wall textured with posters occurred to me, I used a few bits of lettering from labels and magazine pages, incorporating them into the surface by wiping them with ink glazes or an occasional spatter. I kept the whole picture as loose and informal as I could without losing all sense of design and structure, employing a firm but unobtrusive horizontal-vertical grid that provided the casual shapes and textures with some degree of stability and order.*

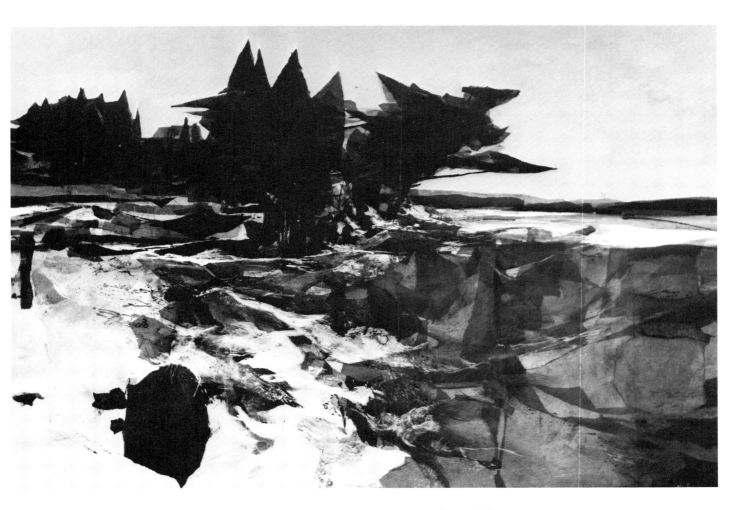

Summertime Sea *Mixed media on Masonite, 40″ x 60″. Photo courtesy Midtown Galleries, New York. Colored tissue papers were the principal materials in this picture. The lower right quadrant was painted with light color and then torn pieces of blue tissue paper were adhered to the surface in random fashion, so that as they overlapped each other in superimposed layers, various shapes and lines were formed that had a sort of design quality that reaffirmed consciousness of the flat surface rather than suggested a deep space receding into the picture. Earlier in the evolution of the painting, the entire surface was covered with tissue-paper collage, but as the sea and shore image emerged, I simplified the sky into a single flat color that would act as a foil for the active, complex relationships in the rest of the picture. The pine trees were done by superimposing tissues of several different intensities of green. Rice papers and white paint were used for beach and surf respectively, then glazed with color. Although the subject matter of this picture was decided upon at a quite early stage, it does not always happen that easily or that quickly; it is just that in this instance I was luckier than usual. Colored tissues are not to be recommended for anything more serious than private color experiments that are to be thrown away; most of this picture faded almost beyond recognition in a couple of years, and despite the fact that I tried to retouch it, it never looked as good again.*

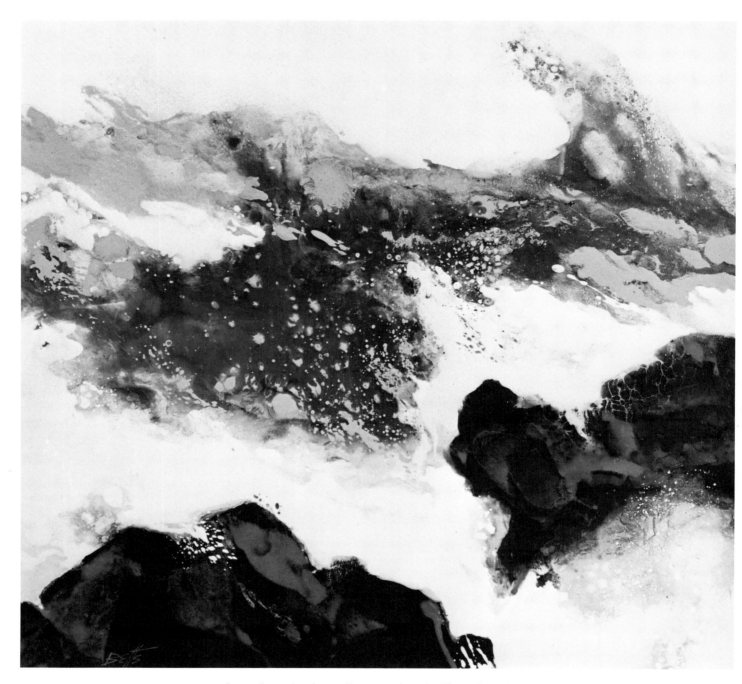

Storm Sea *Acrylic on illustration board, 18" x 18". Collection of the Rapides Savings and Loan Association, Alexandria, La. Photo courtesy Midtown Galleries, New York. Storm Sea is a recent painting, executed without using a paintbrush. In its early phases I flowed on color, pouring it from containers and tilting the panel to let the color roam over the surface. I spattered paint, lifted and blotted color with newspapers, and the area that first suggested a seascape was the major form of the central blue-green wave against a light sky. From there on it was a matter of developing the foam and spray and the foreground rocks, most of which were done by pouring on color and then lifting with newspaper. The whole idea behind this method is to get the paint to appear as though it had almost fallen into place of its own accord; then, too, anything that looked intriguing but did not apply to the subject matter had to be painted out and repainted. Many passages were repainted as many as eight or nine times until they were fully expressive, as well as looking casual and inevitable. I wanted the wave in the picture to be just as flowing, natural, and organic as a real wave, showing no indication of the struggle and frustration that had gone into it—a case of art concealing art. A square panel, by the way, would usually be considered an unlikely proportion for a sea painting, but I am always more than willing to take chances and see what happens; if I can surprise myself, perhaps I can learn something.*

ors, selected purely at random, certainly affect the choice of colors that follow.

DEVELOPING THE PAINTING

Discovering the Subject. Whereas accident and chance play a large part in beginning the painting, they become less pertinent as the picture goes along. If the picture is to have meaning or communicative qualities, the paint must refer to something other than itself.

After a while the haphazard areas of the painting have to assume some sort of direction, and the first thing I look for is a *design* in the largest possible sense, an overall arrangement of big relationships in shape and pattern. Then, as memory and associations are brought into play, I can begin to see suggestions of *subject matter*, which must be coordinated with the design. At this stage, it might be said that the painting is something like a glorified Rorschach test, in which I search the picture for clues to its eventual meaning.

It is the chance effects of paint, combined with a recollection of my own experiences and imaginings, that causes the image to emerge. Then the role of accident is immediately minimized, and further development of the picture becomes a far more conscious act. Even though technically I may still be using methods of paint application that are largely accidental, now they are being used with purpose, to evoke and clarify the image or idea that is central to the entire painting. Every stroke, every mark, every blot, everything added to or subtracted from my painting from this time on relates to the control image I have decided upon, and there is now a specific reason for everything I do to the painting. Accident has served its purpose as a catalyst and can be put aside; the main thrust of all subsequent painting is to work in terms of the governing idea and to achieve a structured, expressive organization of color, plane, shape, pattern, and texture.

FINISHING THE PAINTING

As I mentioned previously, finishing the painting can be a problem for some people, perhaps because they are not sure whether they want to leave the picture looking free and brushy and nonobjective or to carry it farther toward a more tightly controlled semiabstraction. In my own case, I may decide to keep the forms suggestive and ambiguous, or I may push the picture almost to the point of realism. Some paintings look almost nonobjective, with only the most obscure references to nature, and others seem closer to straightforward descriptive realism. My decision on this varies from painting to painting, depending on what has happened within the picture and what my feelings are in regard to what it should look like.

In any case, I have no rigid preconceptions as to what sort of appearance my work should have, either stylistically or regarding degree of abstraction. I am determined that each painting should be a separate exploration, that it live its own life (with my guidance), and that its final look be peculiarly its own.

HOW MUCH FINISH?

The degree of finish is, of course, a very personal choice, but it should be consistent with the attitude behind the painting of the picture. A freely painted, splashy picture would not have to be brought to the same finish as a tightly painted one where every square inch has been solved and meticulously dealt with. Sometimes, in fact, paintings can be *too* finished, with everything neat, pat, orderly, drained of all signs of the human element. Perhaps it might be better occasionally to leave in a slight awkwardness here and there, not solve everything too thoroughly, leave a passage blurred instead of sharp-edged. In short, keep it fresh, natural, and relaxed.

CONTROLLING THE IMAGE

One of the biggest problems in finishing the painting is the matter of the artist's control over the spectator's interpretation of his imagery. This is of no concern to a nonobjective painter, whose forms refer to nothing other than their own interrelationships so that no misinterpretation is possible. But a painter who is attempting to deal with a definite subject has to exert some control so that people see in his work what he wants them to see. It can be infuriating for an artist to paint a rocky landscape and then have someone mention to him that they see in it a little tugboat in a harbor or three pussycats perched on a hill.

I suppose there is no real answer to this. Where people insist on reading their own subject matter and their own associations into a work of art, the artist has already lost control and may as well sit back and let them play their games. The best he can do is try to eliminate confusing or unintentional ambiguities and see to it that all the forms apply as directly as possible to what he is trying to express.

Titles are sometimes a great help to the spectator because they usually furnish a hint to the subject underlying the painting; but there is no avoiding the fact that a person usually sees the picture before he looks at its title, so the picture should stand on its own merits as much as possible and not require explanatory labels. Actually, most of us develop thick skins and are not hurt by minor misapprehensions of what our work is all about, but it is also up to us to do all we can to express our visual ideas as clearly as we can without being obvious—which just might be a greater sin than being obscure.

Painting intuitively back toward nature is, as we have seen, an alternative creative process to the more analytical treatment of natural forms. Once you embark upon improvisational techniques, it is well to keep in mind the old saying, "A good watercolor is a happy accident," and especially the second part of that saying, "and the better the artist, the oftener the accident happens."

(turn to page 225 for *Demonstration*)

Color Gallery II

When this book was originally conceived, the guiding impulse behind it was that it would offer a number of options and alternatives. Since there is no one way to paint and no single way in which to deal with nature in terms of art, it was my hope that by displaying a broad spectrum of attitudes and methods the reader might find fresh solutions or discover some suggestions that would open up significant new directions in his own art. The paintings of mine reproduced in this color section were done over a period of some twenty-two years, and many of them represent my varying concerns during that time; others were done as technical demonstrations especially for this book. You can see there is a little of everything here; it is a kind of sampler, with the paintings chosen to illustrate as clearly as possible the many ideas discussed in the text. Above and beyond that, however, my ultimate aim in presenting these examples is to encourage you to trust your intuition, experiment endlessly, and give yourself over to the joy—as well as the pain—of creating your own world of paint and color.

Sea-Edge #4. 1969. Acrylic and collage on illustration board, 18″ x 14″. Collection of the artist. This is one of a series of twenty small collages grouped under the collective title *Sea-Edge*. In some ways, they are not at all characteristic of my work in general; my reason for doing them was that I felt my mixed-media paintings were becoming too fussy. I wanted to work with fewer shapes and more compact relationships in a simpler format. Here, I was thinking of a cluster of rocks at the edge of the water. The deep blue area at the top is transparent acrylic paint that was briefly tilted and allowed to flow slightly. The central group of rock forms began as a large piece of purple paper, used as a background for the smaller shapes. My main concerns, aside from the strong shape relationships, were the interplay of cut and torn, hard and ragged edges, and a strict adherence to a very limited range of colors, with the sliver of bright red acting as an accent to the stark white and the blacks and blues.

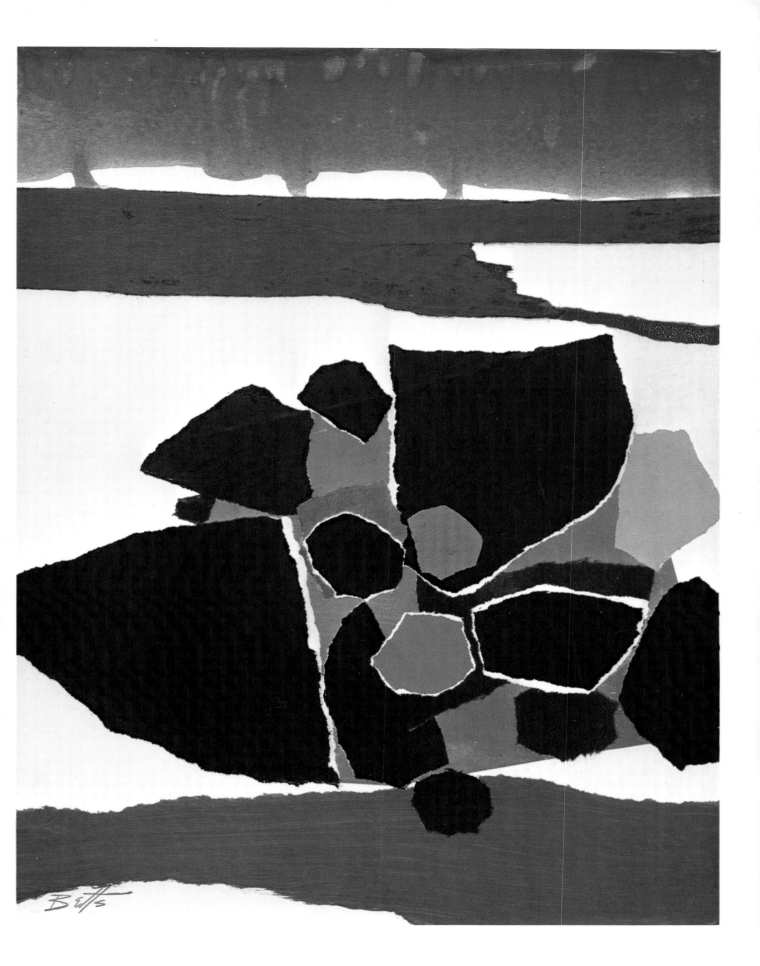

GALLERY OF COLOR PLATES 209

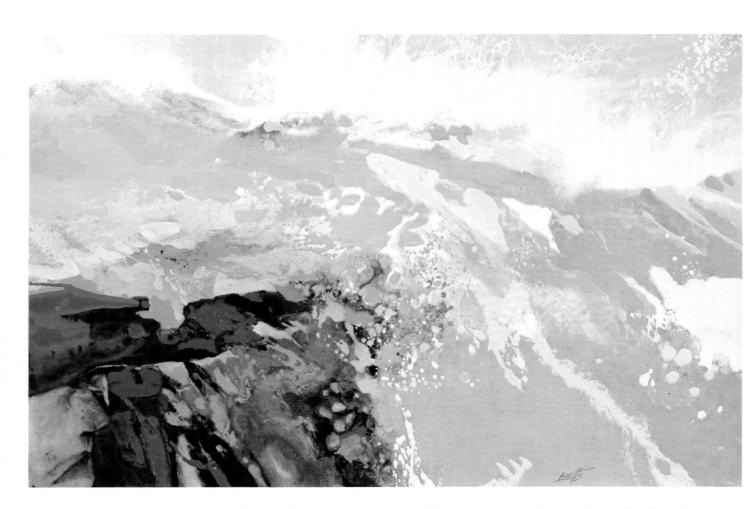

Suncoast *1974. Acrylic on Masonite, 17″ x 26″. Courtesy Midtown Galleries, New York.* This is a small painting that took almost a year to complete. There were several times when it could have turned into quite different pictures, but since none of them satisfied me I kept destroying whatever I had gained and pushed on. I usually insist on working until there is some content, or at the very least an implication of some kind of subject matter. The major advantage of acrylic is that it allows just this sort of continual revision until an image is found that is wholly acceptable. In the case of *Suncoast*, the area that first fell into place was the section at the top of the picture, which suggested either sea and foam or sky and clouds; very soon after, the central yellow passage seemed reminiscent of dunes or meadow or beach. At that point, the whole surface seemed too bland and uneventful; it needed either more shape and pattern or more color vibration. I continued to repaint the yellow area, using flung paint, spatter, and lift and transfer techniques, but still the picture failed to excite me. Finally, I became desperate, feeling the picture would probably never be solved. I abandoned all preciousness and caution and tore into it freely, almost violently—and in a relatively short time, I achieved the qualities that had eluded me for so long!

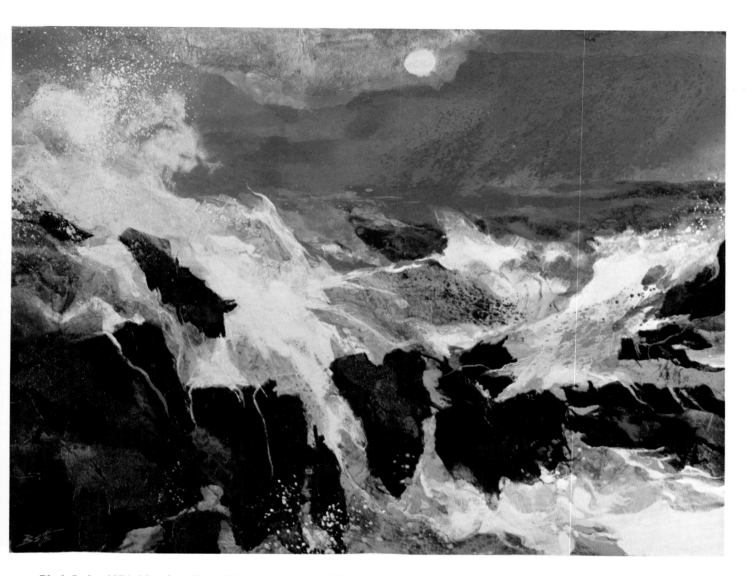

Black Ledge *1974. Mixed media on illustration board, 14″ x 19″. Collection of Mr. and Mrs. James R. Edwards, Champaign, Illinois.* My main reason for using mixed media is to build up complex textural effects that impart to the picture a painterly richness and a sense of weight and substance not obtainable with watercolor or gouache. In addition, I respond to the accidental relationships between the materials as a means of developing unexpected color shapes which ultimately direct the painting toward some sort of meaningful imagery. In this case, the materials themselves—which included tissues, colored papers, inks, rice papers, and sand—did not merely suggest the image, they actually *created* it. In the early stages, I let things happen more or less of their own accord. It was not until I randomly applied the first two pieces of rough rice paper that I was suddenly presented with an inescapable subject: surf. From that point on, I simply painted along the lines dictated by those pieces of rice paper, my foremost concern being to stress above all the starkness of the dark wet rocks against the whites of the sea foam and to merge abstract design with a kind of expressive realism. The semitransparent ochre toward the upper part of the sky was introduced to add a touch of warmth to the essentially chilly color range. The occasional use of glazed-sand passages in some of the rocks keep them from being too flat and monotonous, maintaining the feeling of harsh blacks tinged with a faint suggestion of color and texture variation.

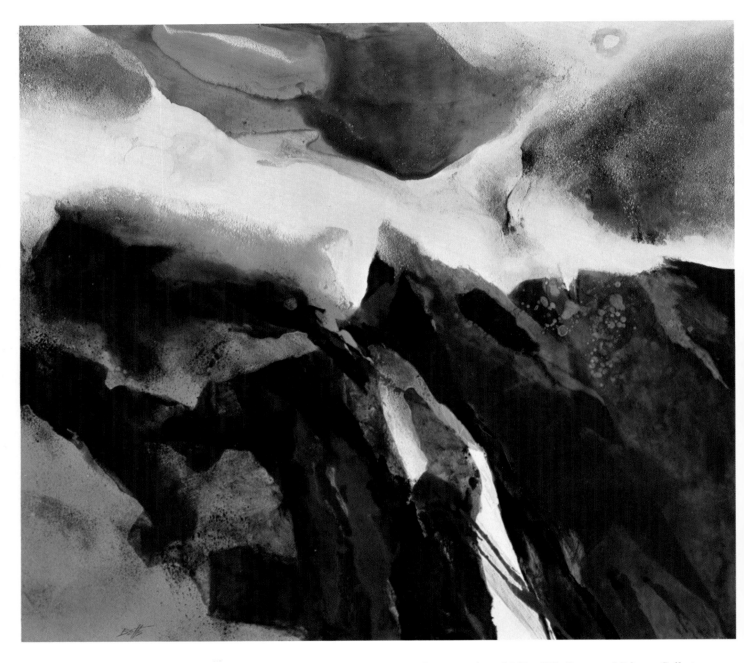

Island Memory *1975. Mixed media on illustration board, 21" x 17". Courtesy Midtown Galleries, New York.* Some degree of ambiguity and a use of private symbols can enhance a painting by giving it a touch of mystery, of things not completely revealed, of subjects or moods that are sensed rather than defined. At its very worst such ambiguity can be downright meaningless, so it is up to the artist to strike a delicate balance between clarity and obscurity, avoiding the obvious on one hand and unintelligibility on the other. While working in the final stages of *Island Memory* I was thinking, at the very back of my mind, of darkness and the sea, of stones and signs, of Maine and the Mediterranean, and of different islands, including Sable Island, "the sailors' graveyard." In the long run it is not important to me that the spectator identify these associations; this picture has to stand completely on its own as color and design, and in that respect it quite possibly leans nearer nonobjective painting than it does toward an abstract transformation of landscape or seascape.

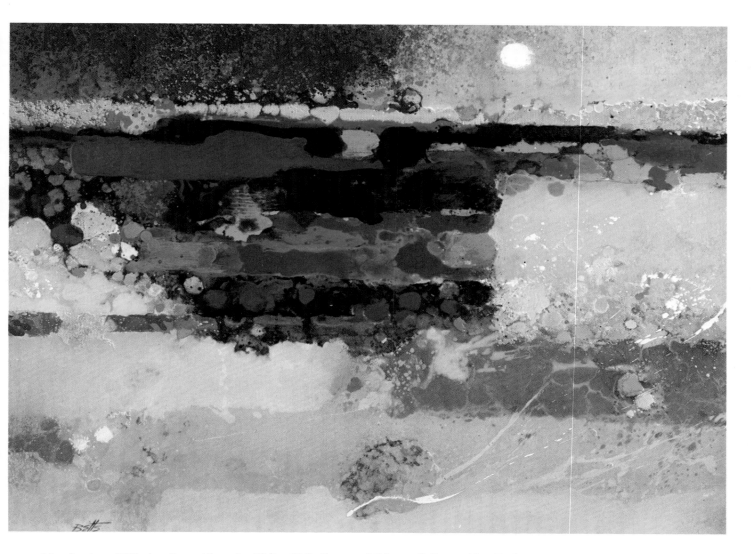

Morningshore 1970. Acrylic on Masonite, 22" x 30". Courtesy Midtown Galleries, New York.
This is one of the paintings that resulted from spending several months close to the shore at
Pebble Beach on the Monterey Peninsula in California. What I was most concerned with here
were the very intense color relationships and the shifting horizontal bands of ocean and beach
against the sun and sky. With the exception of glazed passages, the paintbrush hardly touched
the painting. It was developed out of several alternative methods: stipple, spatter, drip, flow,
and of course, flung paint. In some of the central horizontal blue and green areas, acrylic me-
dium diluted with water was applied across the surface, and the colors were then dropped into
it, both from a brush and directly from a paint container. Areas of equal color saturation, or
intensity, were placed next to or on top of each other to achieve the most brilliant possible color
vibrations, and the use of white paint was kept to an absolute minimum except for the glaring
white of the sun. Color brilliance is the result of using powerful color, not white paint, so the
colors were used almost straight from the jar and were chosen for their values—here blue for a
dark, there yellow for a lighter value. This is above all an experience in color and light rather
than tonal patterns.

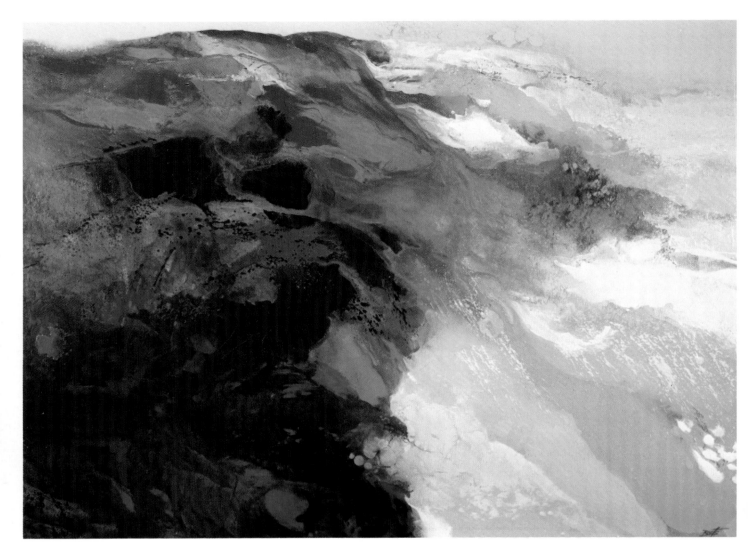

Big Sur *1971. Acrylic on Masonite, 36″ x 48″. Collection of Mrs. Edward Betts.* This might be called a seagull's-eye view of the Big Sur coast in California, an area of impressive, rugged grandeur, and one of the few truly overwhelming places where land and sea come together. My intention here was to capture, from a high viewpoint, the sweeping contours of the coastal hills dropping sharply to the beaches and surf below, but to do this in terms of color above all else. The colors of Big Sur are, of course, altogether different from the ones used in this painting: they tend more toward greens, browns, and tans. I chose to work with a range of color that was vibrant and highly intensified, selected with an eye to pictorial rather than descriptive purposes. The painting was executed without the use of any brushes, and most of the paint was applied by pouring and then lifting, or pouring and dribbling and then spraying with water to encourage a controlled flowing and spreading. Considerable glazing was used to build up the glowing reds at left, and much stipple and spatter where the land mass merges atmospherically with the sea. To me this is a largely representational painting in most respects, but it did not begin with Big Sur in mind. It began with color used for its own sake and then very gradually worked its way toward recognizable subject matter. And in the end, it is color rather than nature or design that remains the major force in the painting.

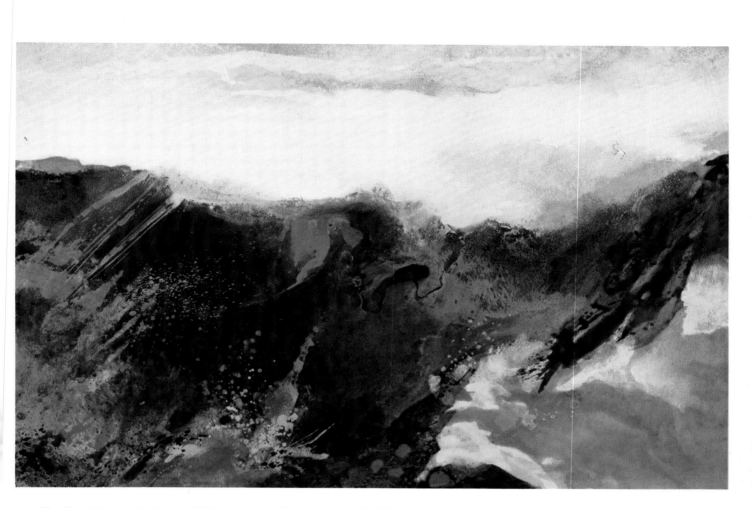

Headland Cove, Point Lobos *1974. Acrylic on illustration board, 20″ x 30″. Courtesy Midtown Galleries, New York.* An entire painting can sometimes evolve out of nothing more than one area of texture that evokes certain specific associations. In the case of this painting, it was the central portion with its delicate, granular texture fading into the lighter area above it that suggested to me the look and feel of the fog-shrouded rocks at Point Lobos, California. After I had worked with random color for a time, I poured a veil of extremely diluted white over most of the panel. In the central part of the picture, the paint film dried over the darker undercolor in an exceedingly subtle way, with a lacy distribution of the paint particles that reminded me simultaneously of rock textures and fog. From then on it was a matter of breaking up the picture surface into three general areas: sea mist above the rocks, the rocks themselves, and the surf rolling in at lower right. The upper area of fog or mist must have been repainted almost a dozen times until it had exactly the balance of whites and off-whites and softness of edges that I had in mind. The rocks were developed more freely, but with attention to transitions that would suggest fog fading into rock forms. I relied more on spatter, stipple, and lifting color with newspaper than on a paintbrush, and even the glazes, of which there are many, were applied and wiped with paint rags rather than with a brush. In general, the forms as well as the color in this painting are softer than in many of my other paintings. Even though this is a picture created purely out of paint and color relationships, it is, I hope, strongly expressive of the look of nature itself.

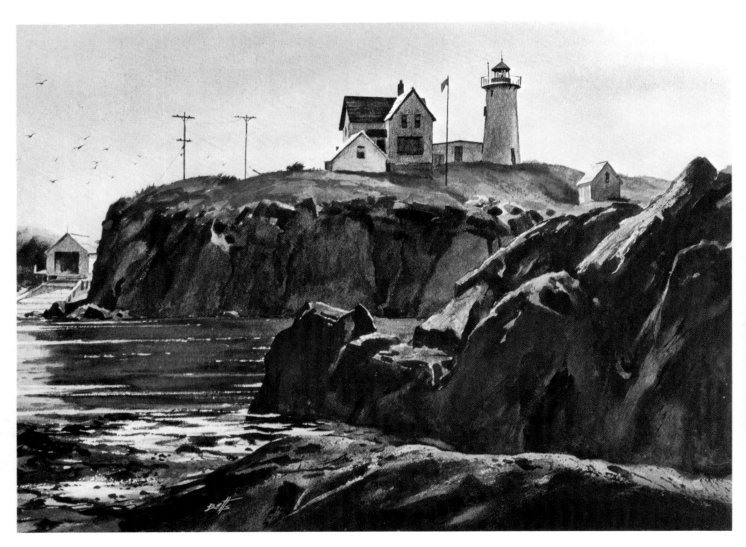

Nubble Light *1974. Watercolor on 300-lb Arches rough, 20″ x 28″. Collection of Dr. and Mrs. Morgan Powell, Champaign, Illinois.* This is a popular subject in southern Maine, and it is one to which I myself return again and again to paint, at all times of day and under a variety of light and weather conditions. Here, I was especially struck by the mass of rock and lighthouse set dramatically against the sky, and the sparkle of sun on the water and seaweed (at the lower left). Painting against the source of light in this fashion can be difficult: it requires sensitive separations and adjustments within the range of the many dark values to prevent them from becoming one, overall, flat silhouette and to create a sense of air and space between the rocks at the right foreground and the steep rocks directly across the channel. I was determined to put technique at the service of projecting as clearly as possible the quality of light and the massive solidity of the main subject. I used touches of detail and texture, particularly in the water, as a foil for the simplicity of the large rock formation, and I made every effort to avoid monotony in the darks by bringing out the color quality in them rather than treating them only as neutral values.

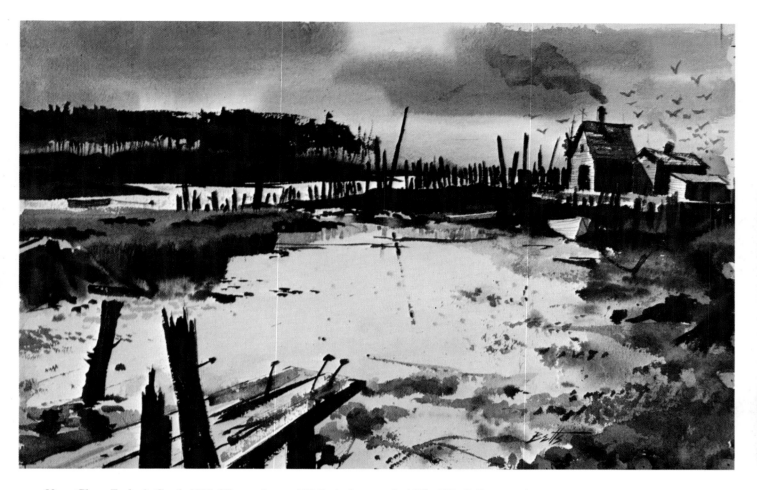

Noon Glare, Turbot's Creek *1953. Watercolor on 300-lb Arches rough, 15"x 22". Collection of the artist.* One of my favorite sketching grounds is Turbot's Creek, near Kennebunkport, Maine. I have depicted it at many different times of day, but here I was most interested in capturing the brilliant glare of the sun on the wet sand at low tide. Consequently, except for a few suggestions of texture, I saved the white paper for the strongly lit areas. In all the surrounding areas, I kept the values quite low in order to emphasize the contrast as much as possible. I also silhouetted the foreground pilings against the light, partly to reinforce that same contrast, and also to occupy the foreground with forms that would give it more depth. This picture is somewhat more casual and sketchy than my more recent watercolors; the whole idea here is to maintain simplicity and a minimum of distracting detail. Although I was using a full palette of colors, the effect seems to be that of a limited palette. At the time I painted it, I felt color was less important than the sense of light and contrast. Possibly, if I painted the same picture now I might work for a greater variety of color.

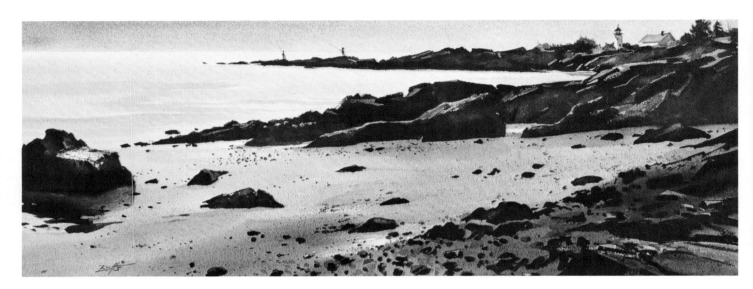

Low Tide, Ontio Beach *1973. Watercolor on 300-lb Arches rough, 11″ x 29″. Collection of Mr. and Mrs. J. Michael Campbell, Champaign, Illinois.* Here again the morning light on ocean and shore was the main impulse behind the painting. It was painted in the studio from sketches made on the spot at 7:30 A.M. When the picture was almost complete, I decided the beach was too pale and bland, and I had to repaint it twice more before I achieved the rich color effect I was after. Since the sharpness of the rocks against the light intrigued me most, I kept most of the foreground slightly more generalized or out of focus, so not every area is seen with equal clarity. The long, horizontal format of the painting helps express the expanse of sea and beach. At the end of the painting session, I used a razor blade to define and sharpen some edges and to scratch out whites that would suggest the glint of bright light on patches of wet sand and rock. The colors are not always true to nature. Nevertheless, by consistently intensifying all color relationships to about the same extent, I harmonized them convincingly. It is the middle tones and darks that offer the most opportunity for using rich, deep, saturated color.

High Snow *1975. Acrylic on Masonite, 25″ x 28″. Courtesy Midtown Galleries, New York.* Since I am neither a skier nor a mountain climber, the subject of this painting must be regarded as purely imaginary; the subject evolved out of a series of controlled accidents rather than out of any first-hand observation or experience. In the formative early stages, this picture went through a black-blue-purple phase, then into green-yellow-violet; finally, toward the end, as I became conscious of a world of glaciers, snow ridges, and swirling mists, I directed it toward a dominant blue range of color (phthalocyanine, ultramarine, and cobalt blues) to stress the extreme iciness of the landscape and to contrast with the pure whites. In order to bring in more color variation, I used some secondary colors—violet, a transparent yellow-green, and a few very dark purples. The only warm accents to relieve the general coldness are the small yellow sun and the slash of brilliant red. It seems to me that I recall hearing somewhere that red, blue, and yellow constitute a very poor color scheme for a picture, since they are all primary colors, but here as elsewhere I have never let consciousness of arbitrary rules stop me from at least trying out something and seeing if it can be made to work. I am convinced that once a selection of colors has been arrived at, it is the proportion of each color to all the others that really determines the success of that color scheme. True, there are rules or systems that might occasionally be a helpful guide toward color control, but they are not to be unquestioningly followed. Making personal color discoveries counts for more than blind obedience to rules and regulations.

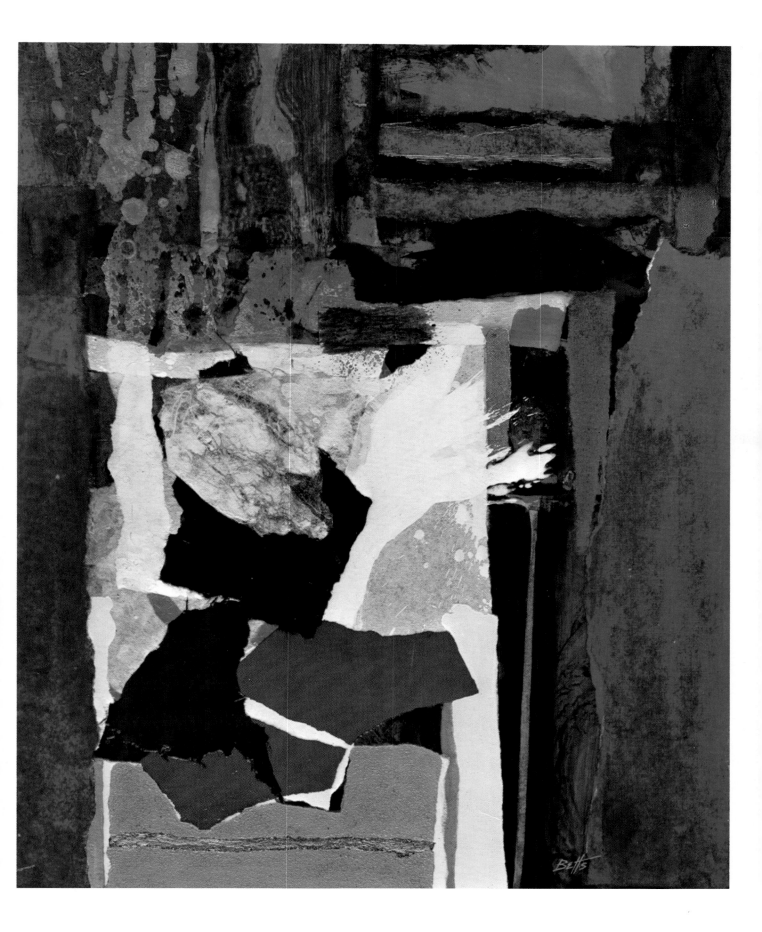

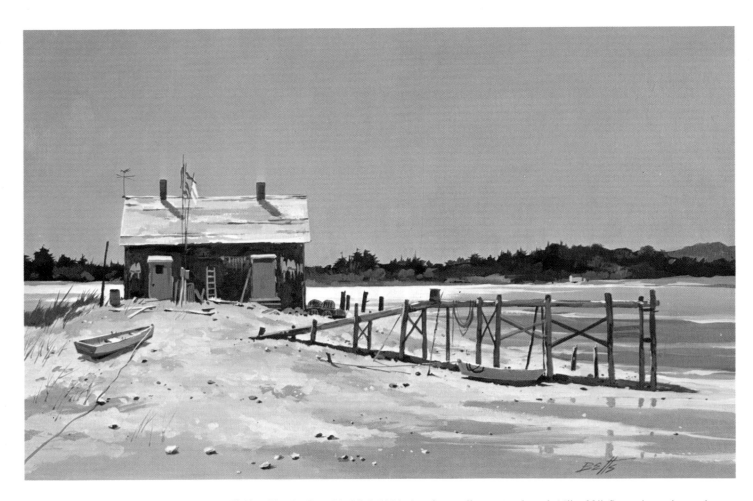

Fishing Shack, Cape Neddick *1974. Acrylic on illustration board, 15″ x 22″.* Sometimes, instead of painting a realistic sky with clouds, I like to see what can be done by treating the sky as a flat backdrop of single, intense color. Although the major part of the picture is handled in a tonal color range, the startling deep color in the sky gives the painting an unexpected lift and prevents it from being completely predictable. My plan here was to dramatize the shack with strong backlighting, to concentrate some of the purest accents of color in the shack and adjacent areas (the blue doorway, the bright yellow roofs over each door, the cadmium orange board, the tuna flags, the red barrel), and to use less color elsewhere in the picture. This identifies the shack as the climax of the composition—the area to which all others relate or build toward. Note, however, that on the distant shore (at right) I used a small bright note of red on a roof and heightened the yellow on a section of the shore, so that this part of the painting would not recede too much and would hold its own, in terms of color intensity, with the other parts. Even though this picture is based on value contrasts, some bright colors were introduced in a less literal and descriptive manner and integrated as part of the total surface.

Maine Barn *1974. Collage on illustration board, 14″ x 18″.* This is more in the nature of a color and shape study than a painting. It was done solely with prepainted papers—medium-rough watercolor paper coated with acrylic paints. Before I even began to cut the paper into the shapes that would form the design, I assembled on my painting table a group of colored papers that seemed to look good together. (I was more interested in color harmonies and juxtapositions than in colors that referred directly to the barn motif.) Although I did stay with the idea of red for the barn and greens that were based on the tree (at right) and grass (in the foreground), in general, it was a matter of selecting colors that related well or else produced striking optical effects. Aside from simplification of the shapes and elimination of extraneous details, the main idea behind this study was to treat the barn and its immediate surroundings as color planes acting within a very limited pictorial space and to create a clear sense of one plane's position in relation to another. This is done principally by means of color rather than value or perspective: some blues recede, others come forward; one green remains behind, while another is situated closer to the picture plane. Also, I worked for variety in the size and scale of shapes, with a range from large solid forms to tiny strips and accents. If all the shapes had been of equal size and color weight, I suspect the total effect would probably have been not much more interesting than a checkerboard.

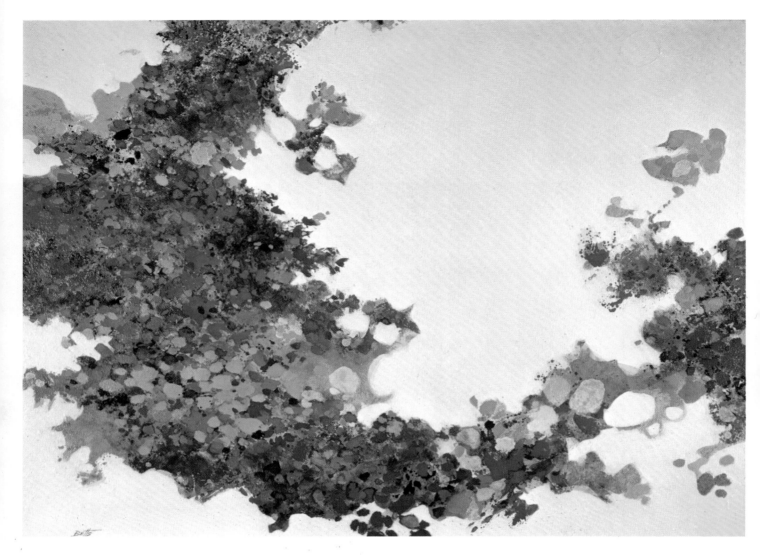

Frozen Garden *1968. Acrylic on Masonite, 36″ x 48″. Courtesy Midtown Galleries, New York.*
This painting was begun with random splashes and broad areas of color over the entire panel.
At some point, I decided that instead of working with large passages of color, I would paint in
smaller units of bright color touches and open up a major part of the surface as pure white,
relieved by some irregular textures underneath. It was not long before the spots of color came
to suggest flowers and the empty white space became snow, and this idea then became the
"control" for bringing the picture to completion. Most of the paint was applied with bristle
brushes of different sizes, as well as sumi brushes, but as the painting progressed I used spatter
with greater frequency, very often carrying color out into the white area, then painting back
into the colored area with white paint to bring about the various shapes, edges, and transitions
that I considered so important to the picture. I was also very much concerned with the size and
scale of the groups and clusters of color spots, as well as their relative placing, so that the dabs
of color would not appear too uniform or flow in too regular a rhythm across the picture sur-
face. Glazing was used in several places for subtle color effects and for oppositions of opaque
and transparent paint.

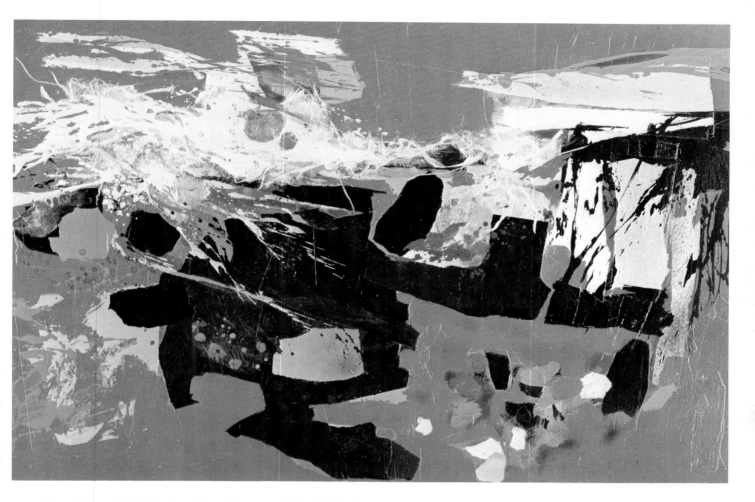

Pirate's Cove *1964. Mixed media on Masonite, 24″ x 34″. Collection of the artist.* This is one of those pictures which appear to some people to be highly abstract but which seem to me quite representational. This one is named after a rocky cove near my summer studio, but when I began the painting I was more interested in enjoying the manipulation of my materials and playing with combinations of shapes, textures, and color patterns than I was in capturing the subject. The materials used here include fabrics, colored papers from various sources, heavy rice paper, acrylic paints, and India inks. The way in which these elements came together and interacted with each other suggested to me the image of a rocky beach. The rice paper at upper left and center, with its various thick and thin fibers, was a natural means of introducing a feeling of sea foam washing against rocks, and a generous use of flung paint reinforced the idea of a splashy environment. Many pieces of black paper were assembled and overlapped to create the major shape of the large rock that moves across the picture, and smaller bits of paper were used for boulders and stones. I glazed over the black areas with a mixture of phthalocyanine blue and alizarin crimson to make the blacks richer in color than the black paint itself. The bright orange background refers simultaneously to sky and beach, with no attempt at a differentiation between the two, and the way in which the rock mass, reduced almost to a symbol, is set flatly against that intensely colored background limits any recession or sense of depth within the picture. The lavish use of color here is to be enjoyed for its own sake rather than for tonality or description.

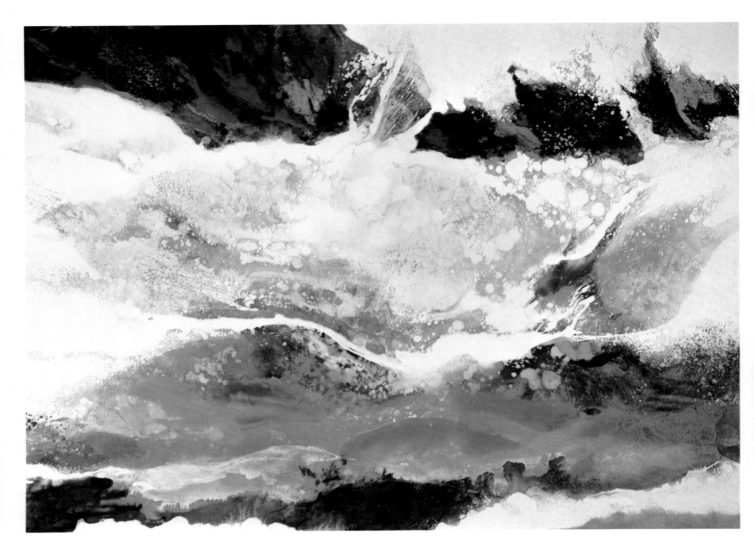

Offshore Reef *1971. Acrylic on Masonite, 36″ x 48″. Courtesy Midtown Galleries, New York.* The ocean and its unceasing movement is for me continually fascinating, and as a painter I find it a rich source of imagery. This is one of my many sea paintings, and possibly it is my favorite. My seascapes are abstract equivalents of various aspects of the ocean, and all of them have grown out of the natural behavior of the watery acrylic paints as they flow and merge on the painting surface. A splash of paint identifies itself with the splash of surf, and droplets of white paint or fine white spray easily become ocean spray, foam, and bubbles. The paint almost creates the forms and motion of the sea without much interference on my part. A great deal of this picture resulted from pouring very generous amounts of thinned pigment onto the panel, then placing full sheets of newspaper on the wet paint and lifting off some of the color. Every so often, the painting was given a coat of acrylic medium diluted with water, which acts as a clear, separating film between paint applications and adds to the sense of depth. As in traditional water-color techniques, I worked for this feeling of depth and transparency by builling up a succession of overlapping washes and glazes. Furthermore, I tried to avoid the standardized seascape composition by looking directly down into the midst of the water rather than across it toward a distant horizon—another way of limiting the recession of space within the painting.

Demonstration: Black Ledge

Step 1. In contrast to the advance planning that precedes a painting in transparent watercolor, most of my acrylic paintings begin with absolutely no subject or preconception in mind. Furthermore, I have no plan as to a color scheme, or even as to how realistic or abstract the finished painting will be. I simply clear my mind of all plans and expectations and start out in a spirit of not knowing where the voyage will end but with a willingness to follow along wherever the picture itself may happen to take me. The first step toward getting the painting underway is to get some color onto the surface, so once the illustration board is taped to my drawing board, I brush on a single color, selected at random, in this instance a coat of Acra red acrylic paint. This acts as a value and a color against which collage shapes can be placed and thereby start to activate the surface. Before proceeding any further, however, I first applied a transparent wash of acrylic medium diluted with water over the entire panel.

Step 2. Next I began to build up textures that would be more tactile and interesting than just paint alone. I could have used gel or even some modeling paste, but I chose instead to create texture by the use of accumulated layers of ordinary white tissue paper. The tissues were applied by wetting the panel with acrylic medium diluted with water then immediately laying down the paper, brushing it out swiftly and casually, and adhering it to the surface with another application of the diluted medium. This operation was done repeatedly, placing tissues randomly to cover a major part of the panel and sealing them in place by using a broad bristle brush and diluted medium, thus producing the accidental wrinkles that are the beginning of texture. When these tissues are built up in three or four layers they suggest depth and transparency, so that some shapes appear to be beneath or behind other shapes that are nearer the spectator, or closer to the picture plane. It can be seen, then, that in addition to creating textural interest, these tissue shapes begin to establish a sense of movement, not only *across* the surface, horizontally and vertically, but also spatially, *into* the picture. I regard this as purely a preliminary phase, and at this point I was still not at all interested in knowing what the subject matter of the painting would be. Before adding more paint I applied another sealer coat of diluted medium.

Step 3. This step represents a period of building color texture, playing about with color, shape, and surface, and keeping constantly on the alert for the painting to declare its subject matter. During this phase I put paint on and then partially wiped it off. I drew into it with India ink lines and applied color glazes, and here and there I sprayed on and spattered more color, mostly blues and purples. Every once in a while I took time out to seal the entire surface under a wash of diluted acrylic medium. I flowed on some colors and flung on others—each color immediately suggests the next. But still I was more concerned with creating a rich surface than in finding the idea toward which the painting would eventually turn; I was in no hurry and I let it grow naturally. Forms appeared casually and disappeared just as casually—everything was subject to continual change. Later I introduced some heavy rice paper, then spattered and glazed it with blue paint, some of which was wiped off before it had completely dried. Then I flowed a wash of very diluted white over the whole surface. As it dried, the wash settled into the valleys and depressions of the textured areas, and the variety of abstract forms and surfaces then began to offer several possibilities as to how the painting might be pushed toward a recognizable image. Improvisational abstraction had by now served its purpose as a stimulus to evoking associations, and from here on a more realistic view of nature would be the dominant mood in the development of the painting.

Step 4. I viewed the panel from different angles, and finally, after turning it upside down, I had a distinct impression of ocean movement—the surge and toss of surf—but the first thing to do was to simplify the surface and to consolidate a large, simple area against which the sea could act. The upper part of the painting (which used to be the lower) was covered with pieces of overlapping torn rice paper that had already been painted with blue acrylic, and as I brought the blue paper down the panel toward me I could see a sky taking form against the diluted white glaze that still remained from the previous phase. By now the picture called for very strong dark forms that would contrast with the rest of the surface, so I used shapes torn from prepainted black rice paper and adhered them to the surface. It followed naturally that the whites of the surf would be added next, but rather than using paint, I preferred to resort again to the extra-heavy rice paper with its thick, tough fibers which would help to create the feeling of sea foam spilling across the jagged rocks. As I applied the white rice paper I attempted to interweave it with the rock shapes in order to achieve a flow from area to area rather than a feeling of separation or isolation. Blue-green glazes were painted over the lower part of the picture, as well as a few semitransparent whites to carry some light accents into that section of the composition.

Step 5. Finishing the painting became mostly a matter of refinement. The surf was redesigned and enlarged at upper left, and more careful attention was given to edges and transitions. The lower right corner was developed with more consciousness of the movement of water flowing among rocks. A moon was put into the sky to reinforce the idea of a night scene, and some warm, semiopaque color to give a little warmth to the sky. The rocks seemed somewhat papery, with a sort of pasted-on look, so I painted areas of diluted medium on some of them and sprinkled on some sand, which was later glazed with dark blues and purples so that the sand textures were totally blended into the tones of the rocks. This made a clearer differentiation between rocks and sea foam and also gave more of a sense of weight and volume to the rock forms. Spatter and stipple were used to modify transitions between areas and to carry out the feeling of storm-tossed water. Finally, since this was a relatively realistic treatment of a seascape, the color was kept tonal and low in key, which served to heighten the contrast of the whites against the rest of the values throughout the picture. The completed painting, then, had arrived at both its subject and its composition, not from an observed scene or preconceived image, but out of a kind of dialogue between the painting and the painter, resulting in a gradual evolution from totally abstract relationships to a form of expressive realism. (For color reproduction of this painting, see page 211.)

Winterspace *Acrylic on Masonite, 48″ x 36″. Private collection. Photo courtesy Midtown Galleries, New York.*

Concluding Remarks

Having completed the series of exercises suggested in this book, what is the next step?

LOOK AT YOUR OWN WORK

First, I think, you might take all the paintings you've done and set them up around you in a room where you can sit and contemplate them. I am a great believer in paintings revealing to you who and what you are as an artist. Sometimes a painter thinks (or hopes) he is a certain kind of artist and that this is his style, whereas his work may indicate something altogether different.

Look at the drawings and paintings: varied and sometimes conflicting attitudes seem to lie behind all this work. Yet despite that, what thread seems to you to run through all the pictures? What pops up with some degree of regularity in almost everything you have painted? Do you find you are primarily an intellectual, impersonal painter with an urge for order and organization? Or are you an incurable romantic swinging a wild brush? Is color your strong point, or is it decorative line, dramatic pattern, or expression of mood and atmosphere? Which paintings did you enjoy most as you did them, and which did you find not so congenial to your tastes? Although you have always considered yourself a formal kind of painter, why is it that those casual, offbeat sketches seem so much better than your usual work? Do they indicate a new direction? Can their qualities possibly be incorporated in the work you plan to do next?

Answers to these questions and others like them are the first step in sorting out who you are as an artist. From your work itself you get clues to the general direction your style is taking (and it does have a direction of its own, so that you sometimes may feel you are only a vehicle) and the specific qualities that for better or worse seem to be your personal strengths or obsessions.

CULTIVATE YOUR STRONG POINTS

The second step is to cultivate those strengths, to push the work even farther in its natural direction toward whatever end it seems to be headed. It means that you drive toward that goal with intensity and passion, allowing no distractions or deflections from your course. I may shock some by saying this, but I strongly feel that an artist should improve and enrich his strong points and not waste time trying to improve his weak points along a broad front. If you do not draw cows very well, there is little to be gained in taking great pains to become a painter of cows. Put them in deep grass or forget them, leaving them to other painters who can paint them with

conviction. You should aspire to improve your own strengths to the point that what you already do well, you will do better than anyone else in the world. You might not reach that goal, of course, but it is certainly worth the struggle to see if you can.

ON BEING INFLUENCED BY OTHER ARTISTS

Every painter has influences when he starts out on an art career. You have to build on something; do not be ashamed of it. (My own idols as a very young art student were John Singer Sargent, Frank Brangwyn, Winslow Homer, Robert Henri, and the illustrator Dean Cornwell. Slightly later heroes included Cézanne, Braque, Soutine, Ben Nicholson, and Ben Shahn.) But do not copy your heroes. To make an outright copy of a work by your favorite painter may teach you a smattering of what you need to learn, but you are still dealing with something that has already been observed, selected, organized, and executed by someone else. It is far more to the point to determine your own subject and then try to imagine it through the eyes of the one you are emulating: How would so-and-so have painted it, how would he have dealt with its color and composition? In other words, go after the principles underlying the work, not just the outer manifestations of style. Even if you are heavily influenced at the start of your career, the longer you paint the more the influences drop away, one by one. Eventually, you are left with your own art, your own viewpoint, and the courage of your own convictions. Naturally, you will still enjoy looking at paintings by artists you admire, but they will no longer have a direct effect on your work. They will have become something completely separate and outside your own painting.

FINDING A PAINTING STYLE

What about painters who paint with equal fluency in several styles? Well, it means they are still shopping around for the style that suits them best and have not yet felt a genuine pull toward one in particular. If you want to look at it positively, you might say that painting in a variety of styles is evidence of versatility and that the painter has kept an open mind instead of becoming locked into one style for a whole lifetime. Open-mindedness is an important thing—it means you are constantly receptive to fresh ideas and different ways of seeing things, that you are unwilling to settle on a style from which you feel you can never deviate. However, style changes over the years, gradually, imperceptibly, and the true artist flows with it. He seldom makes arbitrary decisions about the direction

of his work because then he would be imposing his conscious will on something which should be left to develop and change naturally.

This is true even in the formative stages of a style. You do not go out and select a style as you would a jacket in a clothing store. Style evolves very slowly, without your really being aware of it, out of your own seeing, your own honest reactions to what you see, and especially your involvement with your subject matter. Surprisingly, style is not so much a matter of technique as it is the result of an attitude. If you paint directly, naturally, and without thinking so much about style, the style will appear by itself. You should try not to be conscious of it; let it happen and don't direct it intentionally. The main thing is to be relaxed about it and not grow anxious or impatient. In the creative arts patience is everything: time does not count, but art does.

A style should be an inevitable outgrowth of both the artist's technique and his philosophy. It should in no way be forced or artificial. Above all, the style should be flexible enough to express a variety of subjects and ideas. A style that imprisons you or limits your selection of subject is worse than none at all. If the style is forced or contrived in any way, it will add little or nothing to your painting. Judges in national exhibitions usually do not want a style thrust in their face. They are looking not for personal idiosyncrasy but for an overall balance of form and content and a mastery of technique.

You cannot paint with an eye to salability and you cannot paint just for competitions. If sales are your foremost concern, you will find yourself severely restricted as to what you paint and how you paint it. For one thing, you may be limited to noncontroversial subjects, feeling impelled to include a boy and his dog in every work in order to increase its sales appeal. Similarly, you may find yourself in the position of wanting to use a bright red splash but not daring to because it will offend buyers who want the standard decorator greens and tans.

And as for competitions, how can you guess how the judges will react? How can you know what they are really looking for? An abstractionist may just possibly have broad enough tastes to enjoy many forms of realism, and a superrealist painter may not be favorably inclined toward work that imitates a genre which he feels is exclusively his own territory and that is without need of any more imitators, good or bad.

I recall that a number of years ago the jury at the Pennsylvania Academy Watercolor and Drawing Exhibition included Stuart Davis and Andrew Wyeth. What do you submit to a jury that includes two such opposite stylists? Well, you forget personalities, you forget the artistic schools represented by the jurors, and you send in your very best work and take your chances. Jurors' tastes are not always as narrow as might be supposed, so all you can do is submit what you know to be your best recent work and not try to predict what the jury will go for.

Being represented at your best should be your main concern, not guessing games.

The best painting I know of comes out of compulsions and obsessions, out of deep love or hate, out of intellectual or emotional involvement with something that lies outside the painting itself. These are the things that ultimately form a painter's style.

A MATTER OF BALANCES

Out of my experience in the field of painting over a good period of time, I have come to the conclusion that the best art seems to be what the poet W.B. Yeats once referred to as "a mingling of opposites," the establishment of some sort of equilibrium between contrasting elements, such as intellect and intuition, formality and informality, the calculated and the accidental. I have already mentioned the idea of the inseparability of form and content. In addition to that, there are those who believe that art's greatness may lie in combinations of predictability and surprise, or in the collaboration between the creative conscious and the subconscious. These extremes have to be resolved somehow, and the effort to achieve that successful resolution is what gives the work of art a certain implicit tension and excitement. It is my belief, shared by others, I am sure, that the degree to which these opposites are reconciled is to a great extent the yardstick of excellence in any work of art.

Sometimes it seems that it does require two sides of a person's nature to paint a picture: a part of the artist is the inspired, imaginative visionary—the creative person; the other part is the craftsman-critic, the professional who puts it all together with a combination of technical skill and calm objectivity.

WATERCOLOR: THEN AND NOW

For a long time the aqueous media lacked the prestige of oils. Watercolors and gouaches were considered too fragile and too intimate in scale to compete on the same level with oils. Nor could they command equal prices. Now, however, this is no longer true, and watercolor has really come into its own.

The fragility of watercolor is true only to the extent that paintings on paper must be kept under glass. Outside of that, a watercolor done in 1750 with nonfugitive colors is probably in prime condition today compared with an oil painting done the same year. The oil will have undoubtedly darkened and cracked, betraying its age more than it should; the watercolor looks as though it was painted yesterday afternoon.

Whereas watercolors used to be tiny, intimate works (the British still call them "watercolor drawings"), contemporary watercolors are often done on paper that is five feet wide, and of course acrylic paintings on Masonite or canvas can be much larger than that. In terms of

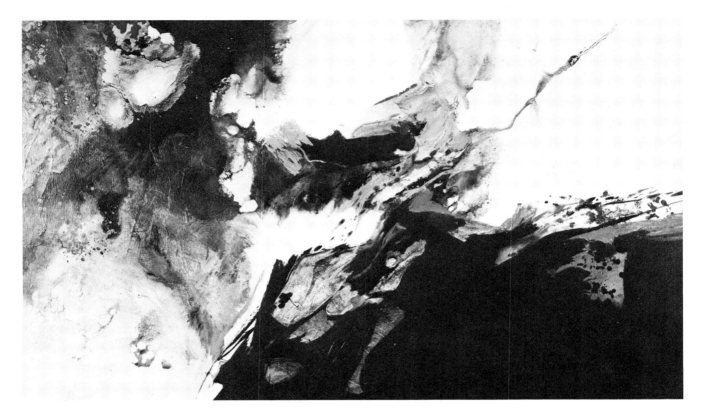

Mountain Storm *Acrylic on Masonite, 18″ x 30″. Private collection.*

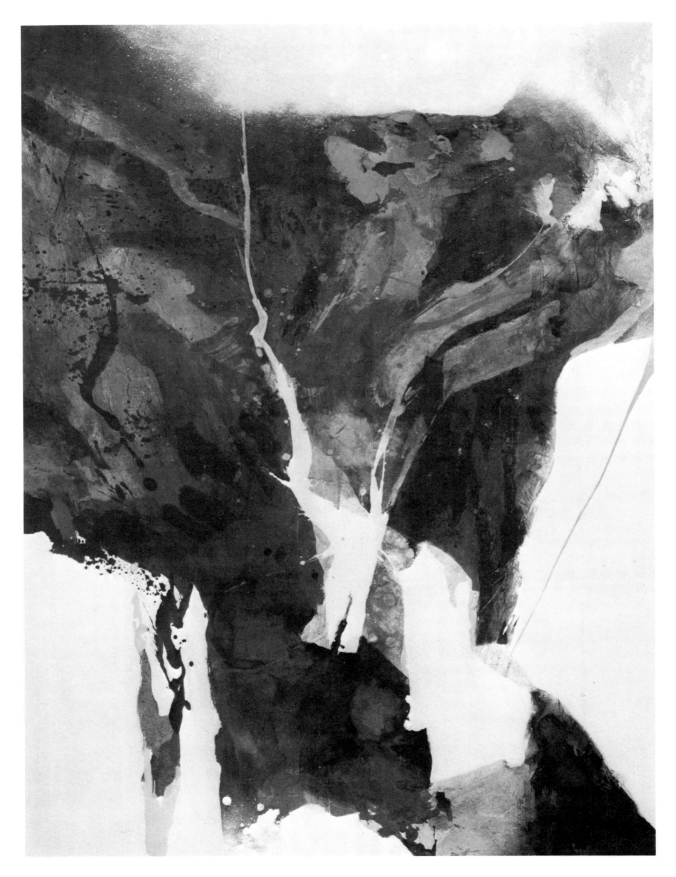

Snow Gorge *Acrylic on Masonite, 48″ x 35″. Private collection. Photo courtesy Midtown Galleries, New York.*

scale, too, the aqueous media are most certainly on an equal footing with oils.

As an aside, it is intriguing to me that some of the highest points reached in recent art have been in the works of the "color field" painters, who work with vast washes of glowing acrylic color on gigantic canvases. In the final analysis, this is only a logical extension and enlargement of an attitude toward and use of a medium that is above all else basically a *watercolor* conception.

In terms of prices, the old double standard is again something that seems to be equalizing. It is not at all unusual to see full-sheet watercolors by some of our finest living painters selling at $9,000 or more, and large acrylics bring even higher prices.

Finally, it is by now quite evident that the watercolor sections of some of our national painting exhibitions are frequently far superior to the sections devoted to oil paintings. Very often, the watercolor rooms contain work that is genuinely fresh, daring, exciting, and innovative, in which the artists are involved in experimenting in a spirit of commitment, breeziness, and buoyancy, as well as technical control. Certainly, it is difficult not to respond wholeheartedly to such a frank love of the medium for its own sake.

Watercolor is no longer a "minor" medium; in fact, it is my conviction that in the past few years we have been experiencing the early stages of what might be called a watercolor renaissance. If all of us paint with total dedication and insist on being uncompromisingly creative, I believe we can carry the watercolor medium to even greater heights than it has already attained, not only in the past, but in our own time as well.

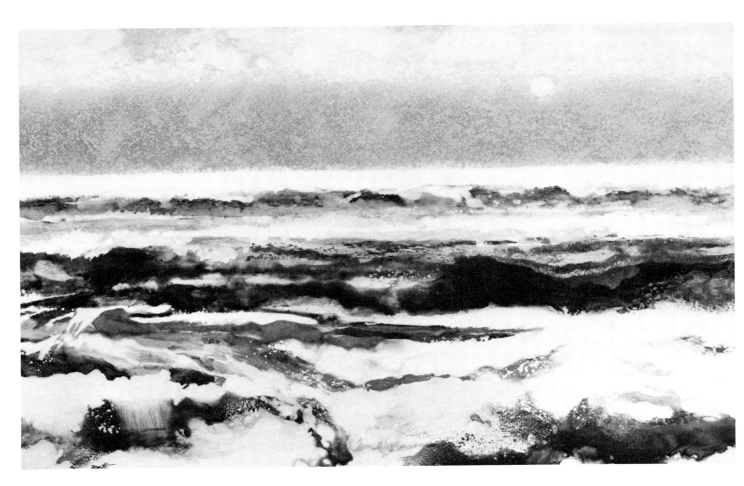

Early Morning Sea *Acrylic on Masonite, 32" x 48". Private Collection. Photo courtesy Midtown Galleries, New York.*

Suggested Reading

Baur, John I. H. *Nature in Abstraction*. New York: The Macmillan Co., 1958.

Blake, Wendon. *Acrylic Watercolor Painting*. New York: Watson-Guptill, 1970.

——— *Complete Guide To Acrylic Painting*. New York: Watson-Guptill, 1971

Blanch, Arnold. *Methods and Techniques for Gouache Painting*. New York: American Artists Group, 1946.

Blesch, Rudi, and Janis, Harriet. *Collage: Personalities, Concepts, Techniques*, rev. ed. Philadelphia, Pennsylvania: Chilton Press, 1967.

Brandt, Rex. *The Artist's Sketchbook and Its Uses*. New York: Reinhold Publishing Co.

Brooks, Leonard. *Painting and Understanding Abstract Art*. New York: Reinhold Publishing Co., 1964.

Chomicky, Yar G. *Watercolor Painting.* Englewood Cliffs, New Jersey: Prentice Hall, 1968.

Gilson, Etienne. *Painting and Reality*. New York: Meridian Books, Inc., 1959.

Gray, Cleve, ed. *John Marin by John Marin*, New York: Holt, Rinehart and Winston.

Kepes, Gyorgy. *The New Landscape.* Chicago: Paul Theobald and Co., 1956.

Leepa, Allen. *The Challenge of Modern Art*. New York: Barnes-Perpetua Paperback, 1961.

Loran, Erle. *Cézanne's Composition*. Berkeley and Los Angeles: University of California Press, 1943.

Mayer, Ralph. *The Artist's Handbook of Materials and Techniques*, 3rd rev. ed., New York: Viking Press, 1970.

Newhall, Beaumont. *Airborne Camera*. New York: Hastings House, 1969.

O'Brien, James F. *Design by Accident*. New York: Dover Publications, 1968.

Raynes, John. *Painting Seascapes: A Creative Approach*. New York: Watson-Guptill, 1971.

Reep, Edward. *The Content of Watercolor*. New York: Reinhold Publishing Co., 1969.

Seitz, William. *Hans Hofmann*. New York: Museum of Modern Art and Doubleday and Co., 1963.

Wolberg, Lewis. *Micro-Art: Art Images in a Hidden World*. New York: Harry N. Abrams.

Wood, Robert E., and Nelson, Mary Carroll. *Watercolor Workshop*. New York: Watson-Guptill, 1974.

Index

Edited by Margit Malmstrom
Designed by Bob Fillie
Set in 10 point Times Roman by Publishers Graphics, Inc.
Printed by Parish Press, Inc., New York
Bound by A. Horowitz and Son, New York